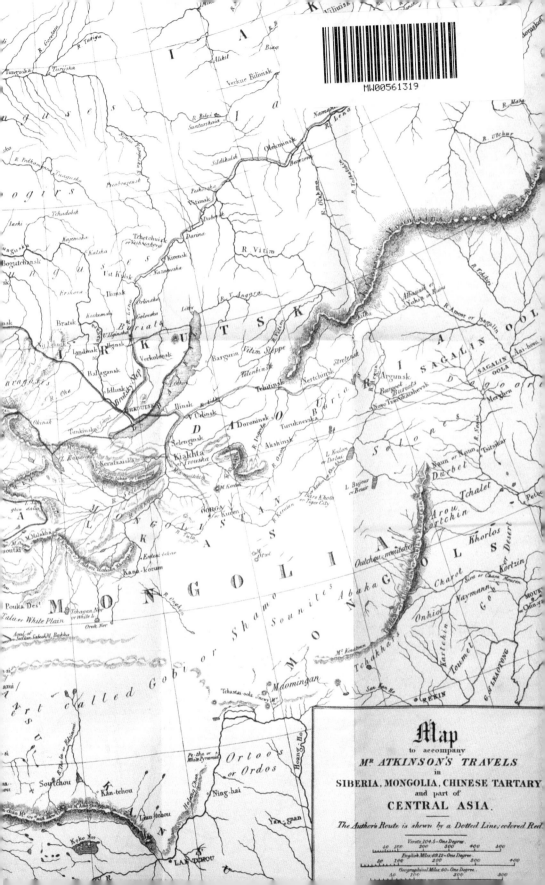

Map
to accompany
Mr ATKINSON'S TRAVELS
in
SIBERIA, MONGOLIA, CHINESE TARTARY
and part of
CENTRAL ASIA.

The Author's Route is shown by a Dotted Line, colored Red.

Versts, 104.5—One Degree.
English Miles, 69.12—One Degree.
Geographical Miles, 60—One Degree.

THOMAS, LUCY
& ALATAU

THOMAS, LUCY & ALATAU

The Atkinsons' Adventures
in Siberia and the Kazakh Steppe

John Massey Stewart

UNICORN

Thomas Witlam Atkinson (1799–1861)

For Penelope (née Lynex),
cellist, 1936 – 2015,
my remarkable wife of fifty years

Contents

Prologue: England and Germany 7

One St Petersburg and First Travels 21

Two Into the Altai 61

Three Into the Kazakh Steppe 101

Four Life and Death in a Cossack Fort 123

Five The Mountains, the Steppe and the Chinese Border 147

Six Eastern Siberia 189

Seven Barnaul, Belukha and back to St Petersburg 227

Eight Return to England 241

Nine Lucy and Alatau 257

Epilogue 275

Appendix I 281
Appendix II 291
Catalogue Raisonné 297
Notes 301
Bibliography 320
Glossary 330
Acknowledgements 331
Index 334
Illustration credits 343

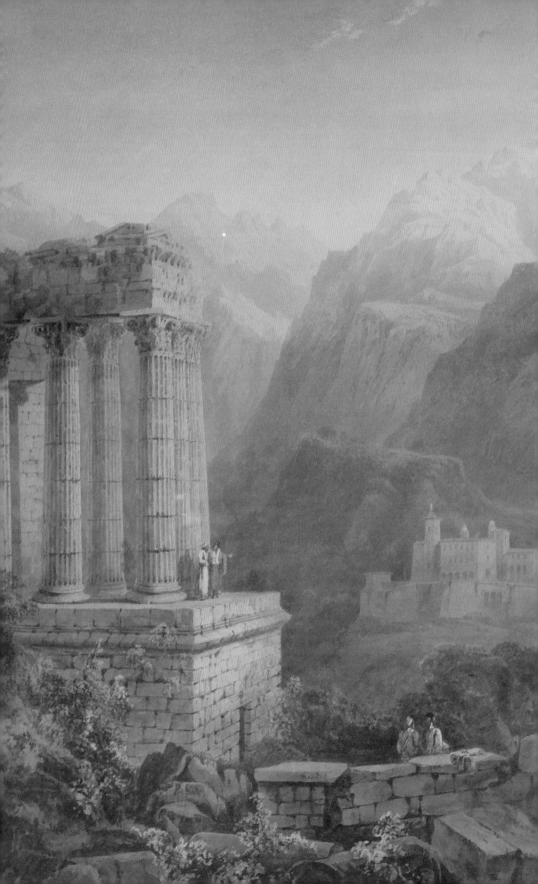

Prologue
England and Germany

WOLVES AND SNOWSTORMS, camels and unbearable desert heat; bandits, murder attempts and night raids by enemy tribes; precipices, dangerous rapids; convicts, Cossacks, nomads – as well as balls and a fourteen-course dinner party for an archbishop: all this (and far, far more) was experienced in Thomas Witlam Atkinson's seven years' travels with wife and infant son by foot, horse, sledge, carriage, boat and raft for nearly 40,000 miles in the remoter parts of the Russian Empire, resulting in 560 watercolour sketches and fame as 'the Siberian traveller'.

It had all begun in the year 1846 when a forty-seven-year-old, humbly-born Yorkshireman, stonemason and architect wrote the following letter:

To His Imperial Majesty Nicholas the First, Emperor of All the Russias

Sire,

The encouragement which your Imperial Majesty has always extended to Art and Science induces me to petition for your gracious permission to visit a province of Your Imperial Majesty's Mighty Empire, The Pictorial features of which have not yet been much developed.

It has been suggested to me by Baron Humboldt [the famous scientist, explorer and geographer] that the Ural and Altai mountains would supply numerous and most interesting subjects for my pencil.

I am induced to hope that my great experience in sketching and painting would enable me to bring back a vast mass of Materials that would illustrate these portions of your Imperial Majesty's Empire. As I should be accompanied by a gentleman who has devoted much time to Geology he would take notes of the Geological features of the Country and thus I wish render our united labours of great value.

Permit me Sire in profound deference to solicit permission to lay before Your Imperial Majesty my drawings of India, Egypt, Greece as a proof of my competence for such an undertaking.

With sentiments of Profound respect for your Imperial Majesty I subscribe myself

Sire,
Your Imperial Majesty's most devoted and most faithful servant
T.W. Atkinson St Petersburg 19 August 1846[1]

Opposite: Imaginary Greek landscape by T.W. Atkinson, probably painted before his Russian travels.

This is the extraordinary story of a village lad born a little over two hundred years ago who rose from nothing to being a successful architect, gave up all to travel with a passport granted by Tsar Nicholas I for remote parts of the Urals, Siberia and what is now Kazakhstan, returning with hundreds of watercolour sketches now mostly lost, of the books he wrote and the fame he won and his descent into near-oblivion today. It is a story too of his indomitable wife, Lucy, and of what became of her and of their son, Alatau Tamchiboulac Atkinson, born in a remote Cossack fort, and his own significant career in Hawaii. It is a story of a talented and ambitious self-made man, of determination, endurance, narrow escapes from death – and love. It is a story that includes many famous people both in England and Russia, embracing Queen Victoria and two Tsars, Palmerston, Charles Dickens, Livingstone and the famous Decembrist exiles. But it is a story too of the conflicting demands of artistry and reputation on the one side and fidelity on the other.

The village of Cawthorne, mentioned in Domesday Book, lies on a hillside in the lee of the Pennines. At the end of the eighteenth century most of the 1,000-odd inhabitants were labourers working on the land or in some trade, and the quiet, middle-class village of today (bypassed now but then on the main turnpike

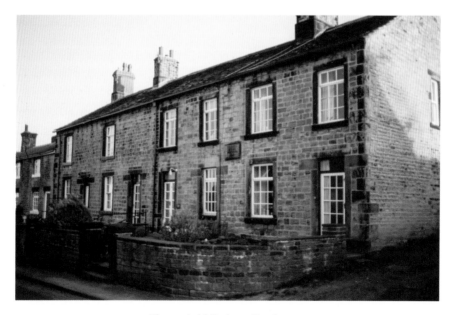

Thomas's birthplace, Cawthorne
Thomas was born in one of these two end houses in 1799. Next door was a Wesleyan chapel, but it is not known which was which.

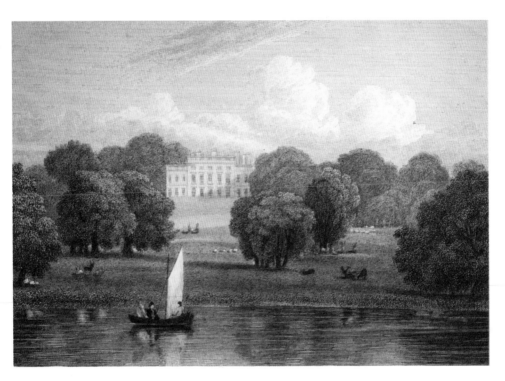

Cannon Hall, Cawthorne, Yorkshire
The home of the Spencer Stanhope family, who owned most of Cawthorne. John Spencer Stanhope, the squire, and his younger brother Charles had a major impact on Thomas, who in 1860 stayed as an honoured guest where he had once been a labourer.

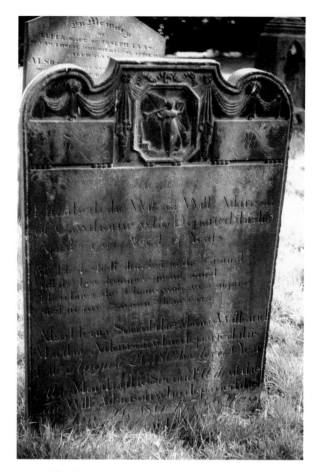

Headstone, St Mary's churchyard, Cawthorne

As a young man Thomas designed and cut this fine headstone to his parents and his
father's first wife. It was this first example of his talent that led to his executing the
altar tomb in the adjoining church.

road from Manchester to Barnsley) is bereft of those earlier coal and ironstone
mines, tanneries, mills and smithies and their bustle. Built of the local grey stone,
the village was basically part of the Cannon Hall estate owned by the Spencer
Stanhope family, and the eighteenth-century mansion set in a rolling, landscaped
parkland lies half a mile from the village. Head mason on the estate then was a
widower, William Atkinson, who fell in love with and married a housemaid in the
big house, Martha Witlam. To them was born on 6 March 1799, in their 'two-up
two-down' next to what was then the Wesleyan chapel, a son, Thomas.

He was the first child of their marriage (a second son, Henry, died aged only a
year old), and there were two later daughters, Ellen and Anne.[2] Tom attended the
one-room village school (today the seventeenth-century parish hall) on the edge

of the churchyard. Some of his schoolfellows described him years later as 'a lad of dull parts with no aptitude for learning' and 'no indications of future promise', but others thought he was 'likely to make his way in the world'.[3] Tom Atkinson, as his schoolfellows called him – only in adulthood did he add his mother's maiden name – often took part in boyish escapades as well as in the village sports, which he greatly enjoyed.

From the age of ten his father took him from school in the summer months to act as his labourer, probably in a quarry on the estate. The boy's innate intelligence luckily made up for this interrupted education, and the journals he was to write on his adult travels are both well-expressed and literate, bar some idiosyncratic punctuation and spellings (here retained). And he would at least have learnt from his father how to cut stone – fundamental to his upward progress. In the winter, however, he continued his schooling and, fortunately, his elder half-brother, Charles, who had been to a good school in Sheffield, gave the young Tom lessons in writing and drawing, 'and he soon displayed great proficiency'. Furthermore, at about this time he was given[4] a set of mathematical instruments, a great prize to him and an important step forward which unknowingly pointed the way ahead.[5]

Continuing to assist his father, he steadily acquired a stonemason's skills. In 1817, when he was eighteen, his mother died, aged forty-six. His father was to live another nine years, dying at fifty-six, according to the fine headstone at Cawthorne – 'considered at the time as a very creditable performance' – which the young Atkinson cut in memory of his parents and his father's first wife.[6] The headstone therefore negates the statement in the *Oxford Dictionary of National Biography* among others that he was left an orphan when a child; and there seems to be no evidence to support the assertion that 'he began to earn his own living at the age of eight, first on a farm, then as a bricklayer's labourer and quarryman, and subsequently in a stonemason's yard', although certainly he began his career as a mason's labourer under his father.[7] The suspicion must arise that Atkinson may have invented this story, either to solicit sympathy or to add admiration for his upward social climb.[8]

The year of his mother's death, he was walking every day to Barnsley, five miles east of Cawthorne, helping to rebuild the old St George's Church, now not only as a mason but a stone-carver as well, producing such fine work that, according to one source, he was 'recommended to move on'. At this time he was noted for his steady habits and profitably employed leisure time,[9] which perhaps meant studying the principles of architecture. Two years later, on 1 April 1819, aged only twenty and giving the occupation 'mason', he married in Halifax, a town known for its woollen mills and stone quarries, the twenty-four-year-old Rebekah Mercer,[10] daughter of a local shoemaker, about whom almost nothing is known.[11] Was this a 'shotgun marriage', given his youth and the disparity of ages? Yet a first child, Martha, was born only the following year, a second daughter in 1822 and a son, John, in 1823.[12] Or was it even a secret marriage, as it does not figure in any biographical entry?

It was, indirectly, the death of the squire of Cannon Hall, Walter Spencer

Stanhope, in 1821 that set the young Atkinson on his career. The genial Walter Stanhope, who had added 'Spencer' to his name on inheriting the Hall from his uncle, would present his tenants at Christmas with joints of beef – thus earning Cannon Hall the sobriquet 'Roast Beef Hall'. Educated at Oxford and the Middle Temple, he attended the wedding of Louis XVI and Marie-Antoinette at Versailles. He was an assiduous MP for thirty-nine years, representing five parliamentary constituencies, and a staunch supporter of the Younger Pitt, whom he claimed to have persuaded to colonise Australia.[13] His friend, William Wilberforce, the abolitionist and another Yorkshireman, often stayed at Cannon Hall.

Already wealthy from his estates and the Spencer iron and coal, Walter married – happily ever after – the heiress and youngest daughter of 'Coke of Norfolk', the famous agriculturist and later 1st Earl of Leicester. She bore him fifteen children (ten of whom were inoculated against smallpox by Baron Dimsdale, who had inoculated Catherine the Great's family),[14] and Cannon Hall became the centre of a happy family life.[15] The family was to produce in time its own artist, John Roddam Spencer Stanhope (1829–1908), a well-known Pre-Raphaelite.

Shortly after Walter's death the young Atkinson showed the sixth son (later the Rev. Charles, four years older than Thomas) his design for a Tudor-style tomb in Cawthorne church to commemorate the late squire. The future cleric felt it showed so much talent that he told Atkinson that 'he had his fortune at his fingers' ends but not as a mason' and 'I let him have no rest', he wrote much later in an unpublished memoir, 'until I had persuaded him to leave home'.[16]

John, Charles's elder brother and the new squire, was equally impressed and also did what he could for the talented young villager. John's wife, Lady Elizabeth Spencer Stanhope, was to write to her husband in May 1825, 'you have done a real good deed in introducing Atkinson to Westmacott' (Richard Westmacott, 1775–1856, well-known sculptor). Nothing, however, seems to have come of it, perhaps because Atkinson saw himself as a future architect rather than a sculptor.

Both brothers were nonetheless crucial to Atkinson's career. While Charles encouraged him, acted as a quasi-patron all his life and eventually wrote his life story, John, 'an amiable intellectual' and twelve years older than Thomas, fired him with the zeal to travel by his own particularly adventurous, indeed almost calamitous, travels as a young man. In 1810, aged twenty-three, with Westminster and Oxford behind him, he set off for Greece, and disappeared. His return to Cannon Hall three years later was 'the happiest day of his life',[17] signalled by great demonstrations of joy both in the Hall and Cawthorne itself, where he had been presumed dead.

For Atkinson, the young squire's adventures were pivotal. His 'desire for travel had been kindled at an early age by the[se] stirring incidents' 'and his young mind [was] so impressed with the romance of travel … that … [it] was imbued with the idea that to travel in an unknown land was the greatest achievement any man could aspire to'. It inspired him with his life's ambition: 'to emulate or even surpass' the researches of his former patron.[18] But all this was well in the future.

Around the year 1820 (when he would have been twenty-one), Atkinson

Altar tomb, St Mary's, Cawthorne
Thomas's headstone in St Mary's churchyard so impressed the two Spencer Stanhope sons that they commissioned him to produce an altar tomb in Gothic style to their late father, Walter, the previous squire, and Charles persistently urged Thomas to seek his fortune. A plaque was dedicated in 2015, in the presence of his descendants, to commemorate Thomas's handiwork.

moved to Ashton-under-Lyne, a market town on the road to Manchester dating from Norman times. Here he worked as stonemason on the new St Peter's parish church, showing his talent for carving and sculpture as at Barnsley,[19] and for some years taught drawing as well. When he drove by the church many years later, now a successful architect himself, he would point with his whip to the corbels he had carved in his early career.

After seventeen years as an architect (see Appendix I), he went to Hamburg, where he failed to win a major competition to replace a historic church burnt in a devastating fire. Coupled with this huge disappointment was an even greater one, the death at twenty-three of his only son John,[20] who seems to have come to Hamburg with him in 1844, only to die there in April 1846.[21] He had shown artistic talent young; taught by his father (they lived together in Hampstead for a time), he had exhibited in the Royal Manchester Institution aged only fourteen, and a five-line obituary in Manchester said 'his talents were various; as a marine painter they would have been great'. His sketch of 'The Phantom Ships' was said to be 'of a very high order'.[22]

13

PI 5.

A FINIAL FROM MINSTER CHURCH, KENT

Pub. by Thos Geoffreths. 8 Wellington St. Strand & Priestley & Weale 8gb St. Bloomsbury

A finial from Minster Church, Kent
From TWA's *Gothic Ornaments.* St Mary the Virgin, Minster, Isle of Thanet, Kent.

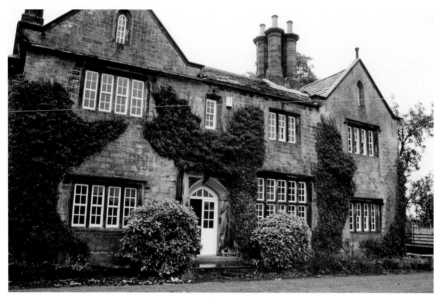

Barnby Hall, Cawthorne
Designed on the edge of Cawthorne for John Spencer Stanhope, who never seems to have
lived here, this is one of Thomas's few designs to have survived and overlooks open fields.

Thomas may possibly have travelled to Greece and Egypt[23] and perhaps even India in 1845/46, although there is a dearth of supporting evidence, but the famous geographer Humboldt, whom he perhaps met in Berlin, recommended that he should go to Russia.[24] Four months after John's death we find him in the St Petersburg of Nicholas I, having apparently abandoned his architectural career – unless he had entered another architectural competition of which nothing is known. What is certain, however, is that in the Russian capital on 19 August 1846 he wrote a letter to the Tsar that would transform the rest of his life, begin seven years of extraordinary travels and finally bring him, if not fortune, fame and distinction and three meetings with Queen Victoria.

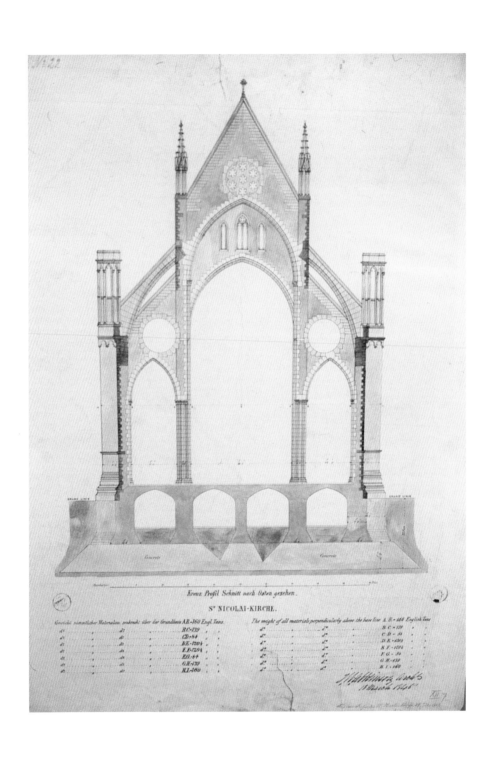

Kreuz Profil Schnitt nach Osten gesehen.

Sᵗ NICOLAI-KIRCHE.

Gewicht sämmtlicher Materialien senkrecht über der Grundlinie AB. 160 Engl. Tons. The weight of all materials perpendicularly above the base line A. B. 160 English Tons.

dᵒ	. . . dᵒ	. . . B.C. 129	B.C. 129	
dᵒ	. . . dᵒ	. . . C.D. 84	C.D. 84	
dᵒ	. . . dᵒ	. . . D.E. 1204	D.E. 1204	
dᵒ	. . . dᵒ	. . . E.F. 1204	N.F. 1204	
dᵒ	. . . dᵒ	. . . E.G. 84	F.G. 84	
dᵒ	. . . dᵒ	. . . G.H. 129	G.H. 129	
dᵒ	. . . dᵒ	. . . H.I. 160	H.I. 160	

Moscow 1846ᵗ

St. Nicolai-Kirche...(Atkinson's Entwurf.)

St Nikolaikirche

Two representations of Thomas's design, cross-section plan signed and dated by him, 13 March 1846, for the proposed replacement of Hamburg's great medieval church, destroyed by fire. The competition to replace it was won by the young George Gilbert Scott, an important step in what was to be a distinguished career.

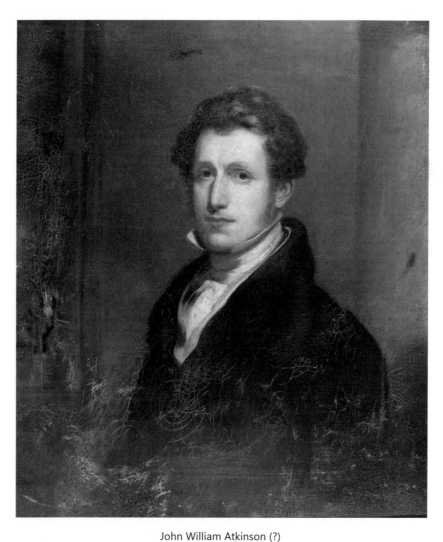

John William Atkinson (?)
This is believed to be a self-portrait (?) of Thomas's son John William. He moved with his father to Hampstead, North London, which attracted many artists, particularly Constable, and was taught art by TWA whom he joined in Hamburg.

Flint Castle, North Wales, 1845, by John William Atkinson
This is the only painting known by Thomas's son John William (known as Jack) by his first wife, Rebekah.
He died in Hamburg (cause unknown) in 1834 in his early twenties. Turner painted Flint Castle
in the 1830s.

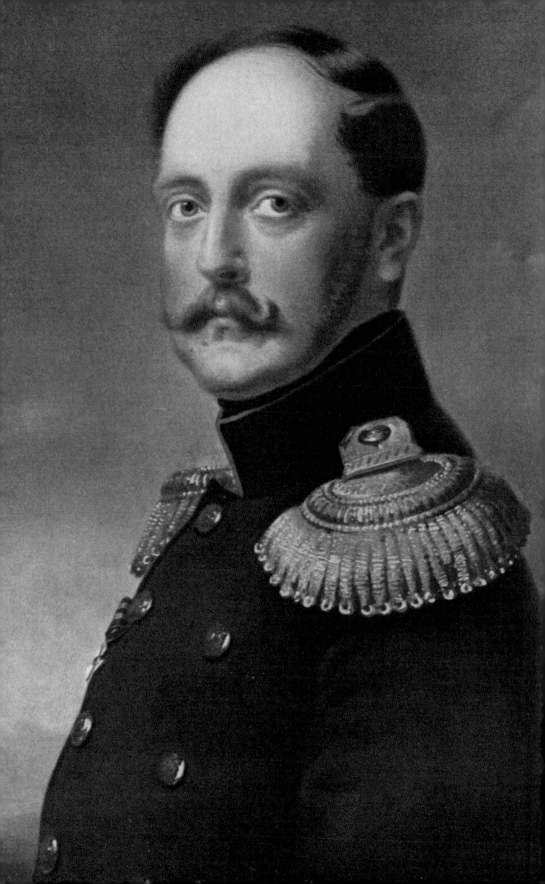

Chapter One

St Petersburg
and First Travels

I. St Petersburg, Lucy and the Urals' Natural Wealth

THOMAS WITLAM ATKINSON arrived in St Petersburg in the first half of 1846. He would have found Russia's capital much as we know it today, with its great buildings and the needle spire of St Peter and Paul's cathedral dominating the north side of the Neva. Across the river was the spire of the massive Admiralty from which begins the Nevsky Prospect, the city's main street, dead straight for most of its 5-km length; next to the Admiralty, facing the river, was the long façade of the Winter Palace and the Hermitage.

He would have come up the Neva, passing the fashionable English Embankment, so called from the wealthy English merchants who had built their houses along it in the mid-eighteenth century. Peter the Great had recruited Europeans to develop his new capital and by 1846 the number of British had grown into a large colony, with not only its Embankment but the English Church, seating 500, and the English Club, not to mention an English Park, Palace, Shop, Bookseller, Subscription Library and even a boarding school for girls.[1] As to the purpose of his visit, there is no evidence of any architectural project, and perhaps his objective from the start was to travel and sketch. At all events he had the luck at some stage to meet Admiral Peter Rikord (1776–1855) – spelt by Thomas in his subsequent book as 'Rickhardt' – who had been governor of Kamchatka, Russia's remote peninsula, 1,200 km long, on the North Pacific coast, and was able to give the prospective traveller much information about the route east (as Thomas acknowledges on the very first page of his future book).[2]

But it may have been Alexander von Humboldt (1769–1859), the great Prussian scientist and explorer,[3] internationally famous in his lifetime, who inspired Thomas's travels in the Russian Empire. Humboldt had preceded Thomas to Russia, and as a celebrity who had originally studied mining and been a chief mining inspector, he had been invited by Tsar Nicholas I for a six-month summer expedition in 1829 at the Tsar's expense to study mining and geology in the Urals. Thomas would have known of this eighteen years later, particularly because Humboldt gave him a letter (probably of introduction) to take to the Russian Admiral Lütke, co-founder member with Admiral Rikord of the Imperial Russian Geographical Society.[4] It is strange that he did not record his thanks to either Humboldt or Lütke along with other grand names in his first book, although it seems an obvious inspiration.

Opposite: Tsar Nicholas I by Émile Jean-Horace Vernet, detail

Why did he, at the age of forty-seven, set out on these ambitious travels, which (he could not know) were to last for seven years? 'My sole object', he wrote on his return, 'was to sketch the scenery of Siberia – scarcely at all known to Europeans.' Ultimately he produced 560 sketches, and in the preface to his first book he highly praised the 'moist colours' (by which he means watercolours in tubes) of Winsor and Newton's paints, invaluable in huge variations of temperature ranging from (he claims) 62°C 'on the sandy plains of Central Asia' to −54°C in the Siberian winter when they were 'frozen as solid as a mass of iron. With cake colours [i.e. the small blocks of colour in paintboxes] all my efforts would have been useless.'

When Thomas arrived, Nicholas I had been on the throne for twenty-one years. His reign had begun with the Decembrist conspiracy, an abortive rising by young aristocratic army officers which he reluctantly crushed with cannon fire and followed with the execution of five of the ringleaders, life imprisonment with hard labour in Siberia for thirty-one and 253 shorter sentences.[5] Thereafter he ruled with severity and tight control – establishing the 'Third Section', a secret police force abolished only in 1880. Physically, Nicholas was 'a perfect colossus, combining grace and beauty … his countenance severe, his eye like an eagle's and his smile like the sun breaking through a thundercloud'.[6] His reputation as an anglophile as well as his interest in art and architecture may have encouraged Thomas to write to him in August 1846 in appropriately deferential language (via the British *chargé d'affaires*, Andrew Buchanan,[7] in the Ambassador's absence). Thomas turned to the Emperor as he had learnt that the Russian authorities would give a passport only from one town to another, which would present a truly formidable obstacle to his hopes of extensive travel.

Buchanan evidently forwarded the letter on to Count Karl Nesselrode, Russia's Baltic German Foreign Minister.[8] Three days later[9] Nesselrode wrote to Buchanan, saying that he had shown the Tsar the letter and 'His Imperial Majesty has deigned to grant his agreement' to Thomas's request for 'un voyage artistique aux Monts Oural et Altai'.

The same day Nesselrode's office wrote to Vronchin, Minister of Finances, informing him both of the Emperor's permission and Nesselrode's order to the Urals' extensive mining administration to help the prospective traveller. Vronchin conveyed the Emperor's 'gracious approval' to the general director of the Corps of Mining Engineers, so that the latter could give the necessary orders and request the governors of the relevant *gubernias* (provinces) to be of service, and another four days later Nesselrode was informed that the heads of both the Urals and Altai mining operations had already been instructed to provide 'all possible co-operation'.

A little over a month later an all-important document reached Thomas to which was attached a large red seal:

LAISSEZ PASSER
By decree of His Majesty the Emperor Nikolai Pavlovich, Autocrat of All The Russias & etc., & etc., & etc.

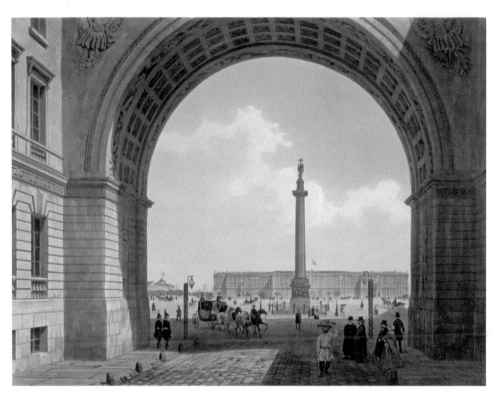

Palace Square, view from the arch of the army headquarters, St Petersburg
Beyond the great Palace Square lies the long façade of the Winter Palace, the eighteenth-century imperial palace, designed by the Italian architect Rastrelli. In the centre stands the Alexander Column, commemorating the reign of Alexander I. Colour lithograph after Louis Jules Arnout. Giclée print, *c.* 1840, by Lemercier, Paris.

The bearer of this [pass], a British citizen, the painter Atkinson with the supreme permission of the Emperor, is authorised to proceed to the Ural and Altai mountain ranges to produce views of local scenes. In consequence, the Town and Rural police departments of those provinces to which the painter Atkinson is heading, as well as those through which he may pass, are instructed to render him assistance where possible for his passage and the successful attainment of his journey's aim.

This pass signed by me and stamped with my coat of arms in St. Petersburg September the 21st day of the year 1846.

(Signed) Perovsky[10]
(Signed) Director of the Executive Police Department: Rzhevskii
(STAMP)

In the preface to Thomas's first book he said: 'Without his [i.e. the Emperor's] passport I should have been stopped at every government, and insurmountable difficulties would have been thrown in my way. This slip of paper proved a talisman wherever presented in his dominions, and swept down every obstacle raised to bar my progress.'

Oddly, the English geologist with whom Thomas hoped to travel was scarcely referred to in all this high-level correspondence, and never by name. One must assume he was given a separate *laissez passer*. Charles Edward Austin (1819–1893) was twenty years younger than Thomas and far more of an engineer than a geologist as he had been described to the Tsar. He had started his career as a pupil of Brunel's chief assistant on the Great Western Railway and worked on it till its completion in 1841. Moving to St Petersburg, he had studied navigation on the Volga and its improvement by steam and published a 'valuable treatise' on its river traffic and management. He was to set off with Thomas, who only mentions him very occasionally in his journals/diaries in his first year of travels (1847), and never once in his two subsequent books, and it is impossible to know just how much they travelled together.[11] We do know that Austin was back in St Petersburg in January 1848 to marry an Adele Carlquist.[12]

On 4 October Thomas wrote to thank Buchanan and, through him, Nesselrode 'for his extreme kindness' in procuring the Emperor's 'most gracious permission and for obtaining the valuable papers and letters so necessary for *our* [italics added] journey'. Having received through Nesselrode the Emperor's permission to submit a selection of his work, he sent off forty-nine folio watercolours, particularly of North Wales (a popular subject for English artists at that time), a few of England, southern Italy and Sicily, and a very few of Greece, Egypt and India.[13] And he added, in his second letter to the Emperor:

Having had the honour of painting some pictures for her Majesty the Queen of England and some of my works having been selected

by Her Majesty the Queen of Prussia [we have no record of these][14] permit me to solicit the patronage of your Imperial Majesty with the hope that your Majesty will condescend to make a selection from my works.

The perfection to which water-colour painting is at present brought in England [he may have been thinking of Turner, Cozens and Girtin] will perhaps be an excuse for my suggestion to Your Imperial Majesty that some of my works might be of great value as studies for the students in the Academy.

The funds which arise from the sale of my pictures I propose to expend on my journey through Siberia (for which your Imperial Majesty has graciously accorded me permission) ...

With sentiments of Profound respect for your Imperial Majesty I subscribe myself

Sire,
Your Imperial Majesty's most devoted and most faithful servant.

Unfortunately, the Hermitage, to which the Foreign Ministry sent on the drawings as arranged, pronounced them to be 'lacking the quality which one must expect from English artists in the area of watercolours'. And (somewhat contradictorily) 'although this significant collection of drawings by one artist is remarkable for uniformity [of style], it deserves nonetheless some attention.' When the Emperor learned the opinion of the Hermitage, he 'did not express His Supreme wish to acquire any'.

But Nesselrode nonetheless advised Buchanan that the Minister of the Interior had been invited 'à faire les dispositions nécessaires' so that on his distant voyage Mr Atkinson would meet on the part of the administrative authorities *all* the assistance and facilities that he could need. That must have been wonderful news to the prospective traveller.

There was, however, another very important development for Thomas in (or perhaps near) St Petersburg. He had met a young Englishwoman, Lucy Sherrard Finley, then twenty-nine, eighteen years younger than himself. For eight years she had been governess to Sofia, the only daughter of a Russian general; she was also from the North of England, in her case County Durham. According to the Protestant Dissenters' Registry, implying that her parents were either Baptists, Congregationalists or Presbyterians, she had been born on 15 April 1817 in Vine Street, Sunderland, a shipbuilding port to which the family had moved from London, and was the eldest daughter (and third child of ten) of Matthew Finley, a schoolmaster originally from London, and his wife Mary Anne Yorke, daughter of a London perfumer, William Yorke. They had married in 1810.[15]

The 1841 census finds the family – with Lucy already in Russia – back from the north and living in Stepney, in the East End. 'Being one of a large family',

Lucy was later to write, 'it became my duty, at an early period of life to seek support by my own exertions' and at twenty-two, if not earlier, she was 'a dealer in toys and jewellery' in the East End, probably with her own shop, thanks to a £500 legacy from a great-uncle. Then Russia beckoned, not really a surprising destination for her at that time: English, Irish and Scottish governesses were very popular there from the end of the Napoleonic Wars right up to the 1917 Revolution, their pay and social status distinctly better than in England, and 'their total numbers must be reckoned in thousands rather than hundreds ... a familiar institution in upper-class Russian society'.[16]

Lucy's Russian family was by no means an ordinary one. Her employer, General Mikhail Nikolaevich Muravyov, came from a large and distinguished family, one of the oldest in Russia. Both his father and grandfather had been generals and high officials, and two elder brothers were also, or became, generals: one of them, Alexander, one of the Decembrist conspirators, was in Siberian exile but was later pardoned and made both general and governor.[17] Lucy's employer became close friends for a time with the future Decembrists and therefore had been implicated in the rising and imprisoned in the St Peter and Paul Fortress for nine months, but had cleared himself and been exonerated.[18] He had married Pelageya Vasilyevna Sheremetyeva, of an immensely wealthy family, by the end of the eighteenth century 'the biggest landowning family in the world', 'almost twice as rich as any other Russian noble family excluding the Romanovs',[19] and she was the sister-in-law of another Decembrist, I.D. Yakushkin.[20] After three sons, a daughter, Sofia, was born in Grodno, now in Belarus, where her father was governor of the province for a few years, then governor of Kursk, after which the family returned to St Petersburg. And there in 1839 Lucy began her eight years as governess to the six-year-old, fair-haired Sofia (1833–1880), who had a 'peaceful and comfortable' childhood.[21]

Of Lucy's appearance we know very little, except that she was petite and dark-haired and must have been a delightful young woman, judging from her own memoirs written many years later. And Thomas fell in love with her. But he was surely in a quandary, torn between Lucy and the travels on which he had determined and for which he had effectively received the Tsar's authorisation. Perhaps Lucy encouraged him to choose the latter, agreeing to marry him after his return, possibly with the promise of future travels together.[22]

Meanwhile, Buchanan, as British *chargé d'affaires*, wrote on 30 October about Thomas to Lord Palmerston, then Britain's Foreign Secretary. It seems that the ambitious traveller was beholden to the 11th Earl of Westmorland, a soldier and diplomat, then British Minister Plenipotentiary to Prussia (perhaps Thomas had originally met him in Berlin). It was Westmorland who had requested Buchanan to intercede with Nesselrode for the Emperor's permission and had recommended Thomas 'to the protection of Her Majesty's Legation'. Buchanan also mentions Austin in his letter to Palmerston, though not by name, as an Englishman for some time resident in Russia, notes that the two intended to penetrate 'as far as possible into China' and therefore called Thomas's attention

to 'several points of political and commercial interest on which Her Majesty's Government might be glad to receive information, and he has promised to bear this in mind and report upon them ... on his return to St Petersburgh'. Was he therefore to be a spy? We shall see.

His open passport from high level was to prove an enormous blessing. Not only did it mean that he did not need a new passport for every stage of the journey but that he was assured of immediate relays of horses at the post-stations en route (every fifteen to twenty-five miles apart). Post-stations existed not only to deal with postal matters but to provide horses, sledges or carriages for travellers. To hire a horse a traveller was required to produce his *podorozhnaya* or government pass. Thomas probably had a 'crown' *podorozhnaya*, given to government officials and privileged individuals, requiring no payment,[23] and a government order could reserve horses in advance for important travellers.[24] He was to find that as a rule post-stations provided only hot water and no food, so he had to take it with him. Everything was to be a new experience.

He left St Petersburg by sledge, travelling south to Moscow in mid-February 1847, and found the road very bad. The amount of traffic had cut such deep holes that his sledge descended 'every few minutes with a fearful shock'. Three days later he reached Moscow in a great snowstorm, and on 5 March, after fifteen days there, set off east at 4pm (the diaries he began to keep are full of precise timings of arrival and departure).[25] 'The Minister' in St Petersburg had arranged for a postilion from the Moscow post office to go with him as far as Ekaterinburg in the Urals, and he sat with the driver. Thomas himself travelled with a deerhound (for reasons unspecified) and presumably with Austin in a vozok, essentially a long, windowed box mounted on a sledge, but too big for the horses to drag it over the ridges so that, writes Thomas, it descended 'with a tremendous bump which sends the head of the unfortunate inmate against the top with terrible force. In fact after a second day's travelling, I came to the conclusion that my head was well-nigh bullet-proof.'

He took with him a small gilt-edged gazetteer, three inches by almost five, printed in London at Temple Bar. Its leather cover, with a strap to fit into a slot, is now in bad condition with many worm or insect holes, but the back cover's gilt-stamped four-inch and comparative ten-centimetre rule are well preserved, as is the inside. It contains an astonishing amount of printed information of use doubtless to many British citizens but hardly to him. Then come twenty-four blank pages covered first with Thomas's itinerary, and after them, with tiny pencil-writing filling each page, basically a journal of the *following* year, 1848. Confusingly, he heads many of those entries '1847', probably having left blank pages for 1847 entries which he never inserted. After this follows seven-eighths of the book: 'Literary and Scientific Register, and a COMPENDIUM OF FACTS': 228 pages in all; and of course a detailed index, at the end of which the last entry reads: 'Witnesses, Rate of Allowance to'. Although most of this information would have been irrelevant to Thomas, the practical sections such as antidotes to poison, and astronomy when he was lost, could have been invaluable.

He started his journal entries with only one line of either departure or arrival per day, extending them gradually through the year to complete sentences or paragraphs of some twenty or so lines, basically descriptions of the scenery – albeit with idiosyncratic grammar, scarcely any full stops or commas, and misspellings ('ordered', for instance, is always 'ordred'). Russian proper names of people and places inevitably gave him trouble, and he transliterated as best he could. This first journal, in faint pencil, suggests that he must have had very good eyesight, particularly if he was writing by the light of a candle or camp fire. What is surprising is that he could write in his two books years later long descriptions based on such relatively short notes, although the later journal entries are certainly very much longer.

He set off east along the Vladimir Highway, known colloquially as the Vladimirka, a wide track through a vast open landscape. Nearly 200 km long, it had been in use since the Middle Ages. As Siberia became a place of exile the Vladimirka began to be somewhat synonymous with the passage of prisoners on their long way east, often entirely on foot.

He reached Vladimir with its five-domed cathedral and nearly two dozen churches 'at 9 oclock' the day after leaving Moscow but, with −15° C of frost, sketching was impossible, so the horses galloped on to reach Nizhny Novgorod on the Volga, 230 km and twenty-four hours later. He was shown into a sort of inn on the steep riverbank, hardly a pleasant foretaste of what was to come. Upstairs several large rooms were divided by wooden boards into 'pens or private boxes in a filthy condition' with hardly any furniture and no mattress, pillows or sheets provided for the bare wooden bedstead. Undaunted, Thomas rolled himself up in his fur and fell asleep, despite the angry and audible voices on one side. Next morning he paid his respects to the Governor, Prince Yurusov, and was invited to return to a dinner party. Thomas wanted to travel without delay, but the Prince insisted on the invitation and at least Thomas, with virtually no Russian, had the good fortune to find the Princess spoke excellent English.

Kazan, the capital of the Tatar khanate until Ivan the Terrible's conquest in 1552, was the next stop about 360 versts east along the frozen Volga. Four horses pulled the vozok at a furious pace along the ice. At one point they got stuck on the high steep riverbank and had to be rescued by a long caravan of sledges which unyoked three of their horses to help. A few versts further on the driver pulled the horses round sharply to avoid some tree stumps but they were on the brink of the bank, which was hidden beneath deep snow. Down they all plunged with a fearful crash that broke all the vozok's windows, and Thomas hit his shoulder so hard that he thought it was dislocated. Neither the driver nor the postilion was to be seen but, struggling to the other side of the vozok, Thomas found a pair of legs sticking out of the snow, pulled out the postilion and then unearthed the driver – fortunately unhurt among his horses in the deep snowdrift. The horses were laboriously extricated but the vozok was virtually wrecked, although a good length of rope enabled them to proceed haltingly to the next station and a four-hour repair. Thomas was in despair to

find his two mountain barometers[26] were broken and other things damaged – a bad beginning.

They reached Kazan in the early morning two days after leaving Nizhny Novgorod. Again Thomas had letters to the Governor, General Bariatinsky, and now to his lady as well, and was 'very kindly received'. The town was dominated by its picturesque Kremlin and churches and minarets above the Volga. He spent two days 'most advantageously' with several of the university's professors. Advised not to delay as he would find no snow further on, he set off again, soon to find signs of a rapid thaw. The road became so bad that progress was very slow. Six horses now tried to drag the sledge forward and when they found snow in the woods they were able to gallop on. But then came another breakdown and once again the sledge had to be roped together. A German-speaking officer at the scene invited this English traveller to dinner at his father's house in the next town and oversaw his baggage transferred to a *kibitka* (covered wagon). After midnight the horses were once more galloping along a frozen road, and then they were blessed with two days of heavy snow.

Three mornings later he was in Perm, at last in the Urals region. In an hour, having changed horses, they went off again and, despite pouring rain and a night as dark as pitch, covered the next twenty-five versts in only an hour and a half. (Times of departure, arrival and the length between them are constantly cited by Thomas. He seemed obsessed by speed, presumably because he was aware of the great distances. A hundred years earlier, the average was about 35 km a day.)[27] With the rain still heavy, he was advised at the next station to change to a 'post-carriage on wheels'. However, after a long dispute enlivened by a heavy whip, six horses were harnessed to the sledge, and 'with the rain still pouring down and every hour making the road worse … in many places it was with great difficulty that the horses could drag us along'.

At midday they reached Kungur, 'celebrated for tanneries and its thieves', one of 'several [post-] stations along this part of the road notoriously bad, demanding unceasing vigilance from the traveller'. A number of men gathered round Thomas's sledge, his deerhound jumped out and the postilion gave it some water. The dog quickly disappeared. The men standing around all swore that they had never seen it but Thomas noticed two men near a ramshackle building and, taking a pistol from his sledge, he put it in his pocket and followed them into a stable-yard, where he found a third man. He gave a whistle to which came an answering whine, then a bark through a door, but as Thomas advanced towards it the three 'black-looking scoundrels' moved to block his way. Two barrels were quickly pointed at them, and, as Thomas opened the door, the deerhound rushed out, growling loudly at the three thieves who put up no more resistance.

At last, after thirteen days' journey from Moscow, he (and probably Austin) reached Ekaterinburg at Easter time, 1847, at '10 oclock at night'[28] through thick fog and heavy rain. After a good night's sleep in this, the largest town in the Urals then and now, named after Catherine (Ekaterina) I, he delivered his letter from the Minister of Finance to the 'Chief of the Oural' (his spelling throughout, a

direct transliteration of the Russian name for Urals) who received him cordially and placed him in the care of a fellow Briton in Russian service for ten years with an 'amiable little wife'. Thomas thus felt at home, able to speak his own language, and was invited by 'the general-in-chief' to 'dine and see the ceremony of kissing', a tradition at Easter, which some fifty officers attended. He was to stay in the town for three weeks 'among kind and hospitable people, acquiring much useful information' for his future travels in the region.

The town appealed to him with its beautiful large lake overlooked by big mansions set on a high hill.[29] Wealthy merchants and mine owners had 'built themselves mansions equal to any found in the best European towns', decorated and comfortably (if not luxuriously) furnished with excellent taste, with usually large conservatories containing fine collections of tropical plants and flowers, surprising for this part of the world. One mansion, 'of enormous dimensions', was built by an immensely wealthy man who had started as a peasant and made a huge fortune from gold mines. Thomas found that its large and well laid-out gardens were open to the public in summer and made for a 'pleasant promenade'. There had been an excellent collection of plants in its greenhouses and hothouses, but they had been neglected for many years, since the two sons-in-law who had inherited had been banished to Finland for having flogged some of their employees to death.

He was to be met with much kindness through the Urals and he records his grateful thanks in his first book. Interestingly, he found little difference between the wealthy class of England and that of the Urals: here 'the ladies handsomely clad in dresses made from the best products of the looms of France and England; and [a traveller from Europe] would be welcomed ... on all occasions, with a generous hospitality seldom met with elsewhere. If asked to dinner ... [the repast] would not disgrace the best hotels of the same countries', and he found fish and game 'most abundant' and luxuries from far distant countries not wanting, while the finest wines were ever present, 'the only drawback ... being the quantity of champagne the traveller is obliged to drink'. A far cry from his own background, yet he seems to have carried it off very well. Where did he learn how to behave? Probably from observation and his native intelligence. Perhaps he was a 'born gentleman'.

He found the balls elegant 'and conducted with great propriety, and they dance well', while the older generation spent a lot of time at cards, thereby 'risking much money', and he greatly regretted that the young men were also much addicted; while he was there, indeed, one young officer shot himself because of his losses. The ladies also spent much time at the card table. Thomas was once assured that, while in England there were the daily papers, monthly periodicals and unrivalled literature as well as perfect freedom of speech, 'if we had such things to occupy our minds, we should not care for cards'.

Although he was to write nine chapters about his time in the Urals (more than he gives anywhere else in his first book), he describes the many parts he visited but never gives an overall picture of that mountain chain which, since

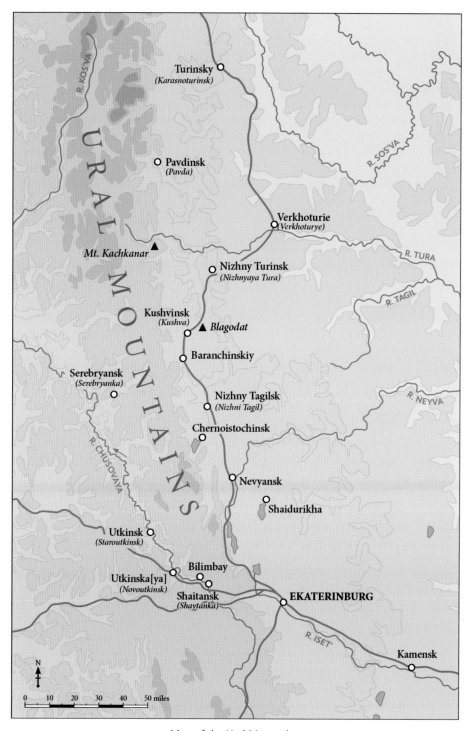

Map of the Ural Mountains

the time of Herodotus, has been regarded as the obvious boundary between Europe and Asia: the only north–south geographical feature (other than the Ob–Irtysh river system some 500 km further east) to bisect the world's largest plain, embracing all Europe and Western Siberia; it drops gently to the west and sharply to the east. Even then the Urals are not so much a mountain chain as a series of parallel north–south ridges.[30] Known in the Middle Ages as *Cingulus mundi* ('the belt of the world') – the word 'Ural' comes from the Tatar language meaning 'stone belt' – they form a range up to 150 km wide stretching over 2,000 km from Arctic tundra to arid Kirgiz or Kazakh steppe, but with an average height of only 400–500 m and individual heights of less than 2,000 m, so that today's travellers through the southern Urals (where the Trans-Siberian railway now runs), like Thomas before them, are disappointed to find only undulating hills.[31]

They have been regarded as some of the oldest mountains on earth, far older than the Alps, Andes, Rockies and Himalayas. And the Southern Urals particularly have yielded an astounding treasure house of minerals. 'Nature has been most bountiful', wrote Thomas, 'with seemingly inexhaustible iron and copper ore, gold and silver … masses of malachite as well as platinum, porphyry, jasper and coloured marbles plus 10,000 versts of thick forest' which provided the huge amount of charcoal necessary to smelt the iron ore. Omitted from his list were emeralds (first discovered by some children), amethysts, topaz and other stones of the Urals which he was to see being cut beautifully. And there were diamonds too.[32]

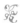

The modern history of the Urals really begins in 1558 when Ivan the Terrible leased to the spectacularly successful Stroganov family, trading in salt and furs, nearly ten million acres along the Volga's main tributary, the Kama, up to one of its own main tributaries, the Chusovaya, which rises in the eastern Urals. A decade later, Ivan more than doubled that lease by adding the lands along the Chusovaya itself so that the Stroganovs became 'the richest private landholders in Russia'.[33] In 1581 they sent a Cossack band under its chief Yermak, originally a pirate on the Volga, up the Chusovaya, the shortest route across the range, into Siberia to begin the Russian conquest of that huge landmass to the Pacific.

The Urals' next leap forward was in Peter the Great's reign when the son of a peasant blacksmith, Nikita Demidov (1656–1725), set up Russia's first good smelter in Tula, south of Moscow. It became the Russian army's main supplier with contracts for 20,000 flintlock muskets, producing arms and munitions twice as fast and twice as cheaply as its competitors, and in 1702 therefore Peter gave Demidov a foundry at Nevyansk in the eastern Urals, the foundation of a great iron empire of 10,000 square miles, using the Chusovaya river to carry 'barge loads of iron and munitions into the heart of European Russia'.[34] It could be said that both the Russian–Swedish war and the Second World War were won in no small measure thanks to the Urals' iron ore.

By his death twenty-three years later (now Prince) Nikita Demidov had become an armaments tycoon, employing thousands of workers.[35] 'Because there were few noble estates in Siberia (in 1830 only sixty-five in Western Siberia), mostly round the Urals, there were consequently very few serfs, the majority of peasants being "state peasants" living on land owned by the state and paying dues to it.'[36] Many of Demidov's workers were sent abroad for training so that there were serf-engineers 'in highly skilled and managerial positions',[37] becoming 'some of Russia's best foundry masters, metal workers and gunsmiths in the eighteenth century' (if not in the nineteenth century too).[38] The scale was extraordinary: by the end of the eighteenth century, the Demidov industrial empire included fifty-five plants and factories producing 40% of Russia's total iron and cast iron, and the Demidov dynasty was the wealthiest family in Russia after the Tsar,[39] in Thomas's time owning just over 3 million mineral-rich acres (12,200 sq. km), more than the size of his native Yorkshire.

Nikita's equally able and industrious son Akinfiy added eight new steel works and arms factories and began to mine in the Urals and West Siberia (finding rich deposits of silver and malachite in the Altai mountains) for which Peter granted him and his brothers hereditary nobility. Akinfiy's son, Prokofiy, now the third generation, turned on his inheritance at fifteen from being a reckless squanderer to a capable manager, modernising his plants, marrying the heiress of the Stroganovs' Siberian fortune, and giving lavishly to good causes (including four bridges in St Petersburg). His Moscow mansion is now occupied by Russia's Academy of Sciences. Through this remarkable dynasty Russia became the leading producer of pig iron (smelted iron ore) in continental Europe, producing as much as the rest of Europe combined.

With such extraordinary mineral wealth, particularly iron ore, it is not surprising that here developed one of the world's oldest industrial regions and the most important industrial area of the Russian Empire. Ekaterinburg was its administrative centre, headed by a general of artillery. Thomas found the Berg inspector or chief Director of Mines (to whom an official letter had been sent from St Petersburg enlisting his help) 'one of the most intelligent mining engineers in the empire', and to him and to his 'amiable wife' he was 'indebted for many acts of kindness, as well as for some of the most agreeable days he was to spend in the Altai'. He was to visit many of the zavods in order to sketch them, but not one image of them appears in his books nor is any watercolour known.

Nonetheless he was obviously greatly interested in – and impressed by – the Urals' natural wealth and its exploitation, and he wrote in very positive terms of the area's metallurgical industry. He found the government's 'mechanical works' were on a huge scale and 'fitted up with machinery and tools from the best makers in England', all superintended by a 'good practical English mechanic' for the past fifteen years. This man was credited with the machinery of the Mint which coined much copper money sent every year to European Russia, while the gold and other precious metals of the Urals were smelted in another building and sent to St Petersburg as bars. And close by in a 'factory' owned

by the Crown the semi-precious stones of the region were turned by skilled peasants into pedestals, vases and columns of the highest quality. But wages were paltry in the extreme: one man inlaying foliage into jasper vases in a style 'not excelled anywhere in Europe' was earning *three shillings and eightpence per month*' (Thomas's italics) plus two poods of rye flour to bake as bread. To be fair, however, the cost of living was extremely low.[40]

II. Travels in the Urals

Thomas was by no means the first British citizen to visit the Urals. 'English mechanics have been employed in the Oural', he wrote, 'from a very early period of its mining operations', and one or two became well known for their eccentricity, not just in their own generation. Later, in 1853, the Atkinsons found there were several English mechanics in Ekaterinburg, and Lucy noted that they struggled to outdo each other in splendour: 'One has his carriage and his tiger, therefore does not deign to associate with his countrymen who have not. The General [Glinka] patronises this family, and it is whispered, on account of the good fare he gets.'

Thomas tells a story about a British citizen in the Urals, who was very stout and loved a good dinner. His job was to inspect the works and machinery at the government zavods. On one particularly hot day he was travelling in the southern Urals and had dined very well. His tarantas (a four-wheeled light carriage) had stood all day in the blazing sun and was now like an oven. As he liked his comfort, it had a well-stocked compartment for food and wine which could be adapted into a comfortable bed. That night, the inspector found it impossible to sleep in the heat and so took off all his clothes and covered himself with a sheet. The carriage set off and with daylight they reached a post-station where the horses were changed while he slept on. The servant and yamshchik, seeing he was happily asleep, decided to have a glass of tea in the station, but while they were there something frightened the horses and off they galloped.

The inspector, tossed from side to side on the rough road, woke to find himself alone, pulled at frightening speed by four unstoppable horses abreast. It was impossible to jump out. The speed slackened when they reached a steep hill but he knew that on the other side an even steeper hill downward awaited him, four versts long. He sprang out near the top – fortunately surviving without injury. The horses went on at full gallop, leaving him alone in the forest with no shoes or stockings and no clothes except 'one scanty linen garment' (presumably some sort of pantaloons), surrounded by a horde of thirsty, humming mosquitoes. Fortunately, a peasant woman on horseback came near but stopped, shocked at seeing the strange figure.

'Come here, *matushka* [little mother]', he said. She summoned up enough courage to ask what he wanted. 'Your petticoat', he replied. 'I have only one', was her faint reply, 'take it and spare me', and she dismounted and handed it

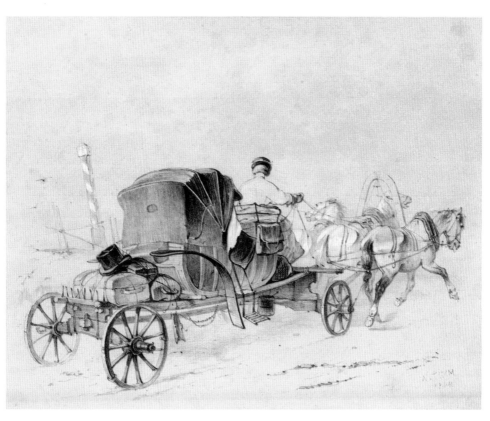

A Tarantas

On the great post-roads the Atkinsons travelled thousands of miles either by tarantas (their luggage piled beneath and behind them) or, in winter, covered sledge, by far the quickest way – particularly at night when the snow was crisper and their bell would alert other travellers. The four-wheeled, hooded, springless carriage was usually pulled by three horses – the troika – but occasionally up to seven.

over. Putting it on, he walked along the road and soon his servant and the yamshchik arrived at full gallop, relieved to find him safe, but, wrote Thomas, 'could scarcely contain their gravity at sight of his extraordinary costume'.

After several days in Ekaterinburg, Thomas began his travels in the Urals. He resolved to journey down part of the 600 km-long Chusovaya river. Remote as it is, this river is important in Russian history, not only as Yermak's route across the Urals in 1581–2 with his band of Cossacks to begin Russia's occupation of northern Asia, but because it also provided a heaven-sent route downriver to Perm on the Kama – where Thomas had had an overnight stop on his way east – and on to the Volga for the products of the Urals' seemingly inexhaustible mines.

The first river-port on the Chusovaya was built in 1703 on Peter the Great's orders to exploit the Urals' ores, and already by Thomas's time an immense amount of iron, often cast into ingots, had been transported by experienced bargees downriver to Perm on great wooden barges, each carrying as much as 200 tons. It was particularly in the spring floods (mid-April to mid-June), when the water level was four to five metres higher, that the barges (sometimes whole caravans) set off, but the fast, winding river was nonetheless very dangerous. Some 200 sheer limestone rocks, many with individual names, rise separately – and scenically – from the river banks in its middle reaches, some over 100 metres high. This was naturally the stretch that Thomas wanted to visit and to paint. Picturesque perhaps, but these cliffs were a major hazard to navigation. All too often barges crashed into them.

Thomas left Ekaterinburg the morning after the ice on the Chusovaya broke up, along bad roads, sometimes almost impassable. 'Even with five horses yoked to a very light carriage, we were five hours travelling twenty versts.' Their immediate destination was the iron-works of Count Stroganov where they were entertained 'most sumptuously' and he slept on the same sofa where the Emperor Alexander had rested the evening of his own visit twenty-four years before. The next morning they were taken to the nearby pristan where many workmen were busy loading nearly forty barges with bar and sheet iron for the great annual fair at Nizhny Novgorod on the Volga. They then 'descended the river rapidly' – thirty versts in two hours – to the pristan of Utkinsk, where most of these possibly unique barges (Thomas calls them barks or barques) were built.

> It was now a scene of great activity, there being four thousand men in this small village, brought from various places (some from villages 500 and 600 versts distant), all diligently engaged in loading the vessels with guns of large dimensions ... also with shot, shell and other munitions of war ... destined for Sevastopol and the forts on the Black Sea. These munitions of war are made with great care and accuracy under the superintendence of very intelligent artillery-officers.
>
> The barks are built on the bank of the Tchoussowaia [Chusovaya] ... flat-bottomed ... with straight sides 125 feet long ... a breadth of

twenty-five feet, and ... eight to nine feet deep; ... [with] the ribs of
birch-trees ... and the planking of deal; ... entirely put together with
wooden pins ... The decks are ... not fastened to the barque ... as
they are often sunk in deep water after striking the rocks. When this
happens, the deck floats, by which the men are saved. Each barque,
whose cargo has a weight of 9,000 poods, requires thirty-five men
to direct it; and one with a cargo of 10,000 poods has a crew of forty
men. Oars, usually of forty-five to fifty feet long, with strong and
broad blades, guide it at the head and stern; and a man stands upon a
raised platform in the middle to look out and direct its course.

It was now mid-April: the weather changed dramatically, and rain and a
strong wind produced a great flood which swept large masses of ice down
the river at speed, endangering the barges. Seven belonging to a merchant
from Ekaterinburg were already laden with tallow, ready to descend the river;
two of them were badly damaged by the ice. Thomas was invited to see the
priest bless the undamaged barges before their voyage, a ceremony on board
marked with much solemnity. A feast was then provided by the merchant,
and in an hour vodka had obliterated the memory of hard work and the
company 'were embracing each other with the fervour of brothers after twenty
years' separation'.

Next morning the storm and flood had subsided, the sun shone, Thomas's
friends at the pristan provisioned him well (adding some bottles of rum and
Madeira) and he and his crew set off down the Chusovaya, propelled by the
current 'at a great speed' with the helmsman offering up a prayer for their
safe voyage 'down this rocky and rapid river'. One side was flat, uninhabited
meadowland with occasional clumps of pine and birch, the other all hills and
almost impassable pine forest and morass, particularly so with all the streams
then in furious spate. Some parts were very pretty, Thomas thought, but he
regretted seeing no bear or elk, which he had been told were numerous here.

With his stonemason career behind him, he noted (as he was often to do)
the rocks he saw: here in some places the once-horizontal limestone strata had
been forced upwards by tectonic action into extraordinary forms, with other
rocks pushed through them. After nine hours covering thirty-five versts on the
river, it was dark and snowing, but a light from an iron-works furnace led them
to the director's three-roomed house (with a tiny front door only four feet high
and two and a half feet wide). Thomas showed the director his papers 'which
at once procured me every attention'. The same procedure was to become
axiomatic throughout his travels. A horse and cart brought his luggage up to
the house, and a boy brought him hot tea and preserved fruit. He put on a dry
pair of boots (perhaps he always travelled with two pairs) but could not change
his clothes as the lady of the house was continually in and out of the room.
And through a doorway he noticed six or seven pairs of inquisitive young eyes,
'wondering no doubt what sort of animal had invaded their quiet abode'. When

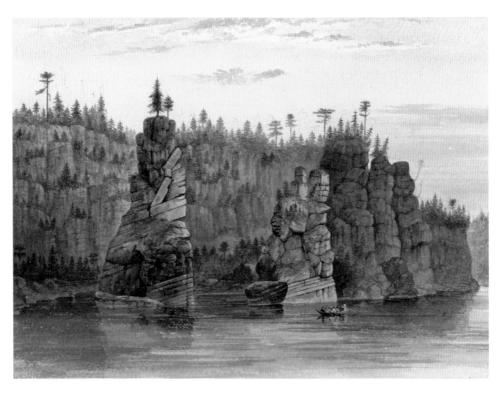

'Curious rocks on the Tchoussowaia'
In his first year of travels Thomas spent many days on the picturesque Chusovaya river, flowing from the
southern Urals and dominated by high cliffs of very individual shapes. He produced twenty-eight sketches
and would present Nicholas I with ten small watercolours of the river, which are now in the Hermitage.

their mother, whom he wanted to win over, re-entered the room with her youngest son, Thomas (a father himself) proceeded to toss him in the air, to the family's astonishment and the mother's pleasure.

What followed was a foretaste of Uralian hospitality. No conversation was possible (so Austin cannot have been with him), and he had to resort to his Russian-and-English dictionary, but all was good-humoured. At supper Thomas was placed at the head of the table with his host at one side, and he expected the wife to sit down opposite him, instead of which she sat down at the far end of the room. Thomas 'declined to partake of their hospitality' unless she sat with them – and won. His hosts urged him to eat and drink, with several wines on the table. He was introduced to *nalivka* (a strong, vodka-based liqueur) which he claimed every good Siberian housewife made from the local abundance of berries or fruit. He tried a glass, 'the colour of claret, but the flavour vastly superior', and sampled four more – 'most delicious'. His host produced a bottle of champagne and two, not three, glasses on a tray, for the two men. Their guest, however, presented his filled glass to the wife, much to her surprise and pleasure, and when a third glass was brought, the three of them emptied the bottle together. His hostess produced various Siberian (*sic*) liquors, all of which she insisted he tasted (*à la russe*, i.e. draining each glass). Finally his host appeared with more champagne. Only then was he provided with a sofa to sleep on: he does not say with what degree of sobriety.

At seven o'clock next day he was brought tea and bread, then shown round the iron-works by his host (a lot of bar iron was being made and sent by barge to the Kama) and returned to a breakfast 'of [once again] Siberian fare: fish-pasty, meat, several sorts of game, and tarts made of preserved wild strawberries, with plenty of their excellent *nalivka*; and it finished with a bottle of champagne'. Thomas presented the eldest child with 'one of my illustrated English books', writing his name inside so that it would be 'preserved with great care, and most probably handed down to the next generation' – and who knows, still remains in this remote place.

They all sat down for two or three minutes of calm or silent prayer, a custom which continues today, then kisses were exchanged and he resumed his journey. His host indicated that he and a friend wanted to go down the river, and Thomas was glad to give them a lift. After only two versts his host told the boy of the crew to fetch a bottle and glasses and once more the champagne flowed. His host's sledge was waiting for him on the riverbank – he had come only to show yet more hospitality.

On one side of the river soon appeared very high and craggy rocks, and once two large caverns, a hundred feet above the water. Thomas told the boatmen to stop and was put ashore, but after several falls he was compelled to stop climbing. He had hoped to find something in them worth drawing. Nonetheless his first book contains an engraving of the entrance to one cavern: two tiny figures dwarfed at its mouth, one seated sketching, show the scale, which must surely be greatly exaggerated. Again he noticed the strata's contortions, some curved,

some triangular, some almost perpendicular, 'giving great variety and picturesque beauty to these wild gorges'.

They arrived at Shaitansk pristan after a snowstorm of some hours and a very cold and unpleasant voyage. Three hours earlier 'six poor men were drowned' when trying to cross the Chusovaya in a small boat, and although several hundred people saw what was happening they could do nothing. And soon after Thomas's arrival another accident occurred downriver: the church bell sounded the alarm and people ran off fast with small poles. A large barque, loaded with iron, had struck a rock and sank immediately except for the deck, so the crew was saved.

Thomas and his own crew were ready to depart at eight o'clock the following morning, but a great snowstorm blew for some hours. He took shelter in the nearest building, a 'respectable cottage', where two kind women, understanding his plight, sat him down and brought him some preserved fruit and cedar nuts 'much liked here'[41] until the snowstorm lessened. Next day he walked up the bank, telling the men to follow him with the boat, sketched three views (which he considered would be 'exceedingly beautiful' in June and July when the many different shrubs and flowers would be in bloom), and, on reaching the next pristan, was greeted by his hospitable host of Utkinsk, who easily persuaded him to return to his home, promising to send him back in a boat. They set off in his tarantas: 'to make it more comfortable, a quantity of straw was put into the bottom, covered with a rug, and several pillows were placed at the back'. Six horses pulled the vehicle, four only yoked. They drove through increasing dusk and then night through a 'wild and gloomy' forest with magnificent pine trees, 'giants of the forest', hundreds of dead trees shattered by lightning and many saplings, and only after midnight were given a warm welcome.

Next morning, as promised, he was rowed back to Shaitansk through sunshine; then heavy rain and sleet almost blinded them all and he arrived 'completely drenched, and almost frozen with sitting eight hours in an open boat'. Early next day he set off with a local hunter towards the riverside village of Ilimsk, assured of 'some magnificent scenery': 'a deep and narrow gorge' with dramatic dolomite peaks and 'some remarkable rocky scenes' with limestone rocks broken and twisted, some into vertical jagged strata. He showed his coloured sketches to a new overnight host, continued downriver through a spectacular limestone gorge, explored two big caverns with pine torches, 'wrote up my journal[42] by the light of our blazing fire', and wrapped himself up in his cloak for his first night's sleep in the open air. Nearing Utkinsk-Demidov pristan where the whole output of the Demidov mines, having been sledged here, was put on board for Nizhny Novgorod and St Petersburg, the river's rugged character gave way to a forest and the river widened from two versts to three. Sheltered by high hills, green meadowland lay on one bank, 'a fine crop of rye' was springing up on the other and birch trees were 'bursting into life'.

He showed his papers to prospective hosts along the way – hospitality was always granted – and on one occasion given glass after glass of tea, which

enabled his host and his host's friend to ask 'a series of questions, few of which I could understand. They talked very fast … [I said] Yes! or No! in Russian, as the case appeared to require. At length I got tired of this, and began an oration in English, speaking as fast as I could which stopped them immediately'. But the moment *he* stopped they began again, and only by reciting poetry (probably remembered from school) could he silence them.

About 10 o'clock supper was announced and three women of Amazonian proportions, wearing very short shifts with red handkerchiefs on their heads, produced a large, evidently communal, bowl of soup. He could, he writes, 'endure hunger for a long time … eat black bread and salt without difficulty, but take broth … from the *same* soup-bowl I could not'. However, he 'managed to make a good supper out of the next course' – 'a great number of boiled eggs' – and found a wooden bench to sleep on but, now used to hard fare and hard beds, would 'be content with whatever turned up'.

He rose the next morning at half past four, ever the early riser, and after one cup of tea was on the river again. Later he found on the bank a simple stone cross on three steps marking the site of the birth of Nikita Akinfeyevich Demidov, the third generation of that impressive dynasty. Having sketched this scene, he was brought by the steersman 'a piece of black bread with a little salt, and a bottle of sap [tapped from the nearby birch trees] … a sweeter morsel or a better draught, I thought I had never tasted'.

After finishing the last of his twenty-eight sketches along the Chusovaya[43] – 'isolated masses of rock standing in the bed of the river' – Thomas continued downstream to an iron-works belonging to Count Stroganov (it had once been Yermak's base), where he found excellent quarters and spent 'a most agreeable evening' with his German-speaking host. Next morning the water level had risen by three feet due to a sudden thaw, and Thomas was persuaded to remain and visit the works, which produced both bar iron and a great deal of superior-quality wire which would fetch a high price at the Nizhny Novgorod fair, 800 km west. He returned to his night's abode and 'an excellent dinner, well cooked and well served': many varieties of game accompanied by 'English porter, Scotch ale, and champagne, with several sorts of Ouralian wine; of the last I tasted one kind for the first time, made from cedar-nuts – it equalled the best Maraschino'.

The weather changed again, to −6°C, and a strong wind made it bitterly cold. Very soon they were enveloped in another snowstorm for nine hours. All that time he and his little crew sat in the open boat – his last day and night on the river, unsurprisingly 'cold and unpleasant' – reaching their final destination, Oslansk, only at 2 a.m. His men were now obliged to return home and Thomas 'parted with them on excellent terms; a few roubles had rendered them happy, and, kissing my hand, they all declared they would go anywhere with me'. On parting, he headed for comfortable quarters in the house of the director of a Crown zavod on the Serebryanka river, a tributary of the Chusovaya. Of this area Thomas's fellow countryman, the geologist (later Sir) Roderick Murchison, wrote of his own expedition six years earlier: 'We … got into the forest, not

having seen a house or hut for fifty miles. The dense wilderness of the scene, the jungle and intricacy of a Russian forest, can never be forgotten. We had to cross fallen trees and branches, and to force through underwood up to our necks.'[44]

Murchison, who enters the story much later, had preceded Thomas to the Urals in 1841 and, as a result, named the last of the Palaeozoic eras 'Permian' after the region's ancient kingdom of Permia. Like Thomas, he was greatly impressed by the Urals' scenery, and in one stretch on the Chusovaya he found 'scenes even surpassing in beauty those higher up the stream, and to sketch it would require the pencil of a professional artist to do it justice'. Thomas, who quoted that in his first book, had the grace not to say that the artist had now been found.[45]

While on the Chusovaya he had fallen among rocks and cut his knee badly – he thought he would keep the scar all his life – and now on his way east across the Urals he began to suffer considerably both from his knee and a bad cold caught in the last heavy snowstorm. When he reached his next zavod, Kushvinsk (now Kushva), he was afraid it would develop into a fever, and the director immediately sent for a doctor who 'ordred' him to bed while a Russian bath was prepared for him to which two sturdy Cossacks carried him. Having been divested of all his clothes, he was placed

> on the top shelf of the bathroom within an inch of the furnace – if I may so call it – and there steamed … until I thought my individuality well-nigh gone. After about forty minutes of drubbing and flogging with a bundle of birch-twigs, leaf and all, till I had attained the true colour of a well-done craw-fish, I was taken out, and treated to a pail of cold water, dashed over me from head to foot, that fairly electrified me. I found myself quite exhausted and helpless, in which condition I was carried back to bed. I had scarcely lain down ten minutes, when a Cossack entered with a bottle of physic of some kind or other, large enough apparently to supply a regiment. The doctor followed … and instantly gave me a dose. Seeing that I survived the experiment, he ordered the man in attendance to repeat it every two hours during the night. Thanks to the Russian bath, and possibly the quantity of medicine I had to swallow, the fever was forced, after a struggle of eight days, to beat a retreat.

Although still very weak, he was keen to resume his travels and was given a lift north towards the Kachkanar massif, the second highest point in the Central Urals and the furthest north he ever reached. He stopped for a few days at the Crown zavod of Nizhnyaya Tura while arrangements for his visit to Kachkanar were being made, and produced several sketches, particularly of the large lake formed for the iron-works' water power: 'continuous clouds of black smoke, through which tongues of flame and a long line of sparks shot up high into

the pure air; these and the heavy rolling of the forge-hammers that now broke upon our ears, are truly characteristic of this igneous region'.

Such descriptions in his book are rare but he writes up at length many different landscapes and colours that he sees through his artist's eye. On this journey, for instance:

> One most splendid evening, the sun went down below the Oural Mountains tinging everything with his golden hues. From one part of the road we had a view of the Katchkanar, and some other mountain-summits to the north, clearly defined against the deep yellow sky in a blue grey misty tone; a nearer range of hills was purple as seen through a misty vapour rising from the valleys; while nearer to us rose some thickly-wooded hills, their outlines broken by rocky masses of a deep purple colour. From these to the lake in the valley there is a dense forest partially lost in the deep shadow.

Ahead of him and his two local companions on this occasion, guided by a veteran hunter, lay a tedious eleven-hour ride through dense forest, fallen trees, rocks and mud sometimes almost up to the saddle-flaps and the dreaded hum of 'The mosquitoes ... here in millions – this compelled us to make a fire and a great smoke to keep them at a distance. The poor horses stood with their heads in the smoke also, as a protection against these pests....'

Further on, he climbed up some rocks to see

> the jagged top of Kachkanar ... towering far above into the deep blue vault of heaven; the rocks and snow ... tinged by the setting sun; while lower down stood crags overtopping pine and cedar-trees; and lower still, a thick forest sloped along till lost in gloom and vapour.

He and his companions all had rifles in case of bears. In fact, he never seems to have encountered one, but they could be very dangerous. He tells the story of two small children who wandered away from haymakers to pick fruit until they came on a bear lying on the ground and approached him, totally undaunted. For his part the bear

> looked at them steadily, without moving; at length they began playing with him, and mounted upon his back, which he submitted to with perfect good humour. In short, both seemed inclined to be pleased with each other; indeed the children were delighted with their new play-fellow. The parents, missing the truants, became alarmed, and followed on their track. They were not long in searching out the spot, when, to their dismay, they beheld one child sitting on the bear's back, and the other feeding him with fruit!

When their amazed but anxious parents called, the children ran to them and the bear disappeared into the forest. Once Thomas came across a 'strong and active' woman, Anna Petrovna, widely known as 'the bear hunter'. 'Her countenance was soft and pleasing,' and nothing indicated her 'extraordinary intrepidity', yet by the age of thirty-two she had already killed sixteen bears.

Surprisingly, Thomas makes no mention of sables or other fur-bearers, but there was the perennial nuisance of mosquitoes. Once at Kachkanar he and his companions encamped but moved upward to a constant breeze in order to escape the 'cursed pests' and there, 'where a breeze kept fanning us, not a mosquito dared show his proboscis'. But in the Urals forests he was often tormented by them in hordes and must have found it difficult to sketch with his bare hands under attack. He 'tried various means to keep them at a distance – in vain'. He finally tried a device 'much used by the woodmen': hot charcoal in the bottom of a small sheet-iron box punched with holes, slung over the shoulder. The cloud of smoke produced might drive off the voracious insects successfully but, Thomas writes, 'the continuous smoke affected my eyes to such a degree, that I could not see to sketch – many of the woodmen suffer from the same cause'. So he gave it up 'at the risk of being devoured' and was glad to find breezes to keep them off.

At the Kachkanar massif they found a 'confused mass of rocks thrown about in the wildest disorder', some of huge size, and scrambled over it to a small valley carpeted with plants about to flower or already blooming: iris, geraniums, roses and peonies, 'amidst scenes of the wildest grandeur', among 'clumps of magnificent pines and Siberian cedars'. By the former he must mean the Siberian pine *Pinus sibirica* (as distinct from the far more common and widespread so-called Scots pine *Pinus sylvestris*) which grows slowly but can reach a great height and age: one in West Siberia's Altai mountains was measured in 1998 at 48 m tall and 350 cm in girth, and the oldest known, in Mongolia, had a cross-dated age of 629 years in 2006.[46]

Across a valley they began the actual climb (Murchison had been here before him), his 'sketching traps' across his back, up 'a chaotic mass of large loose rocks ... under huge blocks ... and further up large patches of snow', and at last reached the summit with its extraordinary jagged crest of hundred-foot irregular columns of rock: interspersed with up to four-inch strata of pure magnetic iron ore and, projecting from the sides, cubes of iron, three to four inches square. He saw it as 'a mountain in ruins ... the softer parts having been removed or torn away by the hand of Time'.[47]

He climbed one of the highest crags with great difficulty – and risk – taking only a small sketchbook with him and, with his feet dangling over the edge, wrote a note to a friend (Lucy perhaps?). He found

> the view to the east, looking into Siberia, ...was uninterrupted for hundreds of versts, until all is lost in fine blue vapour. There is something truly grand in looking over these black and apparently

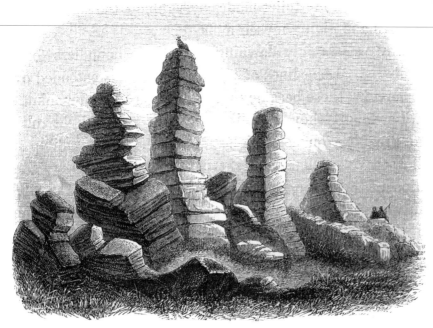

Summit of Kachkanar

interminable forests, in which no trace of a human habitation, not even a wreath of smoke, can be seen to assure us that man is there.

On the way down again, scrambling over fallen rocks on an intensely hot day, they stopped for a rudimentary lunch, and Thomas filled a glass almost full of hard frozen snow on which he poured some strawberry *nalivka* to produce a 'delicious' dessert for himself and his companions, tired, hungry and thirsty.

At one zavod (Kushvinsk), south of Kachkanar, he found the officers from all the zavods around had arrived for a dance on someone's name day, and it proved to be a jolly affair with dancing until half past two followed by supper. The next day everyone was off to a great festival at another zavod nearby. Thomas accepted an invitation to dine there, made two sketches on his ride, and was interested to observe such festivities, which included wrestling and swings. Girls with linked hands, dressed in bright colours, sang beautiful but plaintive songs. These 'rural pastimes', he wrote, 'reminded me of sports on the village green in the days of my childhood' – a far cry from his Yorkshire village of Cawthorne.

What turned out to be an unexpectedly dramatic expedition was to Blagodat, a few miles further south, a great hill still famous today for its high-quality iron ore[48] and known to contain magnetite.[49] On its summit was a small wooden chapel and tomb to the memory of a Vogul chief[50] who was killed and his body burnt here by his people for having betrayed the iron ore to the Russians. Thomas found that, although the Urals were visible from the top, the

45

Blagodat Hill
In the Urals in 1846 Thomas climbed the 350-foot 'highly magnetic pinkish-coloured rock' Blagodat, which produced much bar iron. With a tremendous storm approaching, he sheltered in the small wooden chapel on the summit. He was lucky to survive the lightning strikes.

whole view was otherwise of flat, dense pine forest. The day was fine, but he noticed a storm gathering far off, and when big drops of rain started to fall, he sought shelter for himself and his sketches 'and colours'[51] in the chapel at the summit. By now the Urals were obscured

in a thick black mass of clouds, tinged with red from which the lightning leapt forth in wrathful flashes.... For a few minutes a great dread came over me, knowing I was standing alone on a huge mass of magnetic iron, far above the surrounding country. The thunder echoed among the distant hills until at length it became one continued roll, every few minutes. I could ... hear the wind roaring over the forest; then came a blast which forced me to cling fast to the monument ... and made the little chapel tremble to its base. The cold gust of wind was instantly followed by a terrific flash of lightning, which struck the rock below me and tinged everything in red; at the same moment a crash of thunder ... burst into a tremendous roar, which shook the rocks beneath my feet. The rain now rushed down in torrents, from which even the little chapel did not afford me protection – for through its roof the water poured in streams. This was a truly sublime and awful scene – the lightning and thunder were incessant, indeed I saw the rocks struck several times. The storm undoubtedly revolved round the mountain, no unfit accompaniment to the dreadful sacrifice once offered up on its summit.

It was astonishing that he himself was not struck by lightning.

These journeys in the Urals were seldom easy, but Thomas was always game for more. Determination and ambition drove him on. There may have been on occasion a good track or a grassy flower-bedecked valley, but all too often he had to negotiate dense and 'interminable' forest, low branches and fallen trees, rocks and great boulders sometimes with trees growing round them, dangerous scree and mire in which the horses sank, leaving the riders wet and covered in mud; and often the rain poured down. Sometimes the 'roads' were corrugated, i.e. made of tree trunks, and this had surprisingly little effect on the *telegas* (baggage carts), 'made without either nail or bolt ... put together with wooden pins and withes – this permits them to twist about in every way – and to suit any road, rough or smooth; but not the traveller, who is almost shaken to pieces by the jolting'. And sometimes a snowstorm stopped all progress. Yet he seems to have enjoyed it all (except for fatigue, saturation and mosquitoes – and that illness), particularly the views from the heights which sent him into raptures, above all at sunset or dawn. And he appreciated the silence of the forest 'undisturbed by any sound except the shrill voice of the large red-crested woodpecker', as well as the great hospitality of the zavod directors who 'received me most kindly, freely giving me, as usual, every possible accommodation, and treating me with the greatest liberality'.

He and 'my men' then rode east across the Urals, visiting platinum mines near the crest, descended the east side, much steeper than the west, and proceeded to Nizhny (or Lower) Tagilsk to 'the hospitable house appointed for strangers', where he received from the zavod director 'the greatest kindness and attention' – even more so than usual – with every facility to sketch, men and horses when required, and a man who had lived several years in England assigned to accompany him wherever he wanted to go. At the time this was a town of some 25,000, and Thomas was very impressed by its many fine buildings of brick or stone (unlike the wood so often found elsewhere). He extolled the church, the splendid administrative building, the large schools, great warehouses, 'spacious houses for the directors and chief managers [and good hospitals] and very comfortable dwellings for the workmen and their families'.[52] He wrote that 'The smelting furnaces, forges, rolling mills ... are on a magnificent scale and the machines and tools of the best quality, some indeed from England', and others made under the supervision of a very clever local engineer who had spent several years in a top Lancashire works. And he considered that 'The manner in which these works are conducted, reflects the highest credit on the Director and his assistants in every department'.

In fact, Anatoliy Demidov, fourth generation of the dynasty,[53] who had employed leading scientists from Europe to survey his territory, spared no expense in sending several talented young locals from his zavods to France and England, allowing them both generous time and finance and giving some their freedom from serfdom. Many of his workforce had indeed become wealthy men – not surprising in view of the 'inexhaustible supply' of magnetic iron ore nearby in an open quarry about 80 feet thick and 400 feet long – 'material for ages yet to come'. Close by were copper mines with 300-foot shafts, and a few years before Thomas's visit an 'enormous mass of malachite' had been discovered. Murchison had seen this 'wonder of nature' and calculated it as 84 feet long by 7 feet wide, up to 15,000 poods in weight or nearly half a million pounds of malachite. Even then, Murchison tells us, 'it was traced downwards to 280 feet'.[54] The geological interest to Murchison, however, was not so much the size but that it indicated that malachite is formed by copper solutions trickling down through porous mass to form a stalagmite within a rock cavity.

Thomas and a small party then set off on an overnight excursion to the scenic Belaya Gora (White Mountain), visiting on the way another Demidov zavod, Chernoistochinsk, busy making bar iron (bar-shaped wrought iron), 'considered the best in the Urals', according to Thomas known in Britain as 'old sable-iron' from the Demidovs' sable mark and turned into the best British steel. They reached the foot of Belaya Gora through 'rich, park-like scenery' with great Siberian 'cedars', enormous pines (some 150 feet tall) and 'clumps of peony in full bloom'. After another hour they arrived at the 'beautifully sheltered spot' (no mention of mosquitoes) already selected for the night, where 'a huge fire was burning', a balagan or shelter was in place and 'carpets and a table-cloth were spread on the grass'. The hungry party was soon enjoying what

had been prepared for them, not least Thomas, who found that 'both the dinner and wines were excellent, and the London porter as fresh and foaming as the most tired traveller would wish to have it'.

Dinner over, the party 'inclined to sleep (a universal custom after dinner in these regions, indeed throughout Russia)' but Thomas set off with his rifle and a man to carry his 'sketching materials' of watercolours and brushes, water, sketchbook and bag, and sat down with a picturesque view before him of rocks and trees and distant mountains of blue and purple. Here he sketched and contemplated, becoming totally convinced that the whole range of the Urals would have once been much higher and that the original peaks were now 'shattered, broken, and tumbled about in every direction' under the elemental force of water which would have torn up 'everything in its course'. This explained, he thought, what he had seen, even the enormous rocks; he had measured some and found the average 8 feet thick and one 12 feet by an enormous 43 feet.

His next visit was through continuous forest to Nevyansk, north-west of Ekaterinburg, the Demidovs' first Urals zavod. Its population had grown to nearly 18,000 and he was given a room in the castle, a 'magnificent' Demidov mansion where no members of the family still lived but all was provided free for travellers, welcome day or night, including 'excellent fare and delicious wines – port, sherry, Rhine wines and champagne'. Thomas sketched the little town's early eighteenth-century leaning tower of brick, its most famous feature, which surprisingly boasts the world's first reinforced concrete, cast-iron cupola and lightning conductor as well as a seventeenth-century clock with clockwork bells made by Richard Phelps, the master of London's Whitechapel Bell Foundry, known for his large bell, 'Great Tom', in the steeple of St Paul's Cathedral (though none of this does Thomas mention).

The zavod here produced painted iron-ware and different items that circulated through the whole of Siberia via the great February fair at Irbit, east of the Urals, including iron-bound wooden boxes, usually painted blue or red, found in almost every peasant home. It also produced a huge number of rifles which, although they looked rough, were extremely accurate, and two were made specially for Thomas at the director's request, one small, the other large-bore, which cost him £4 15s for the two.

He travelled on south, nearly parallel to the Urals chain, through what had once been dense forest, felled for the neighbouring zavods to smelt the ores beneath them, but now growing up again, and in the southern Urals some fifty versts south of Ekaterinburg he visited a Crown zavod and an iron-works which stood in a pretty, well-sheltered wooded valley of the Syssert river. The whole place with its church, hospitals, furnaces and warehouses had 'a very imposing appearance' with 'well laid out streets', the cottages in 'a much better style' than usual in the Urals and the town clean and 'evidently under the eye of a master'. Mr Salemerskoi, the owner, lived here himself in a very large house where, being a keen horticulturist, 'cherries, plums and peaches … [grew] in

'Leaning tower, Neviansk' (Nevyansk)

great perfection', while his large orangery was full of lemon and orange trees, some 'in full fruit', despite the outside climate. The extensive greenhouses and hothouses with their differing temperatures grew 'splendid' flowers and tropical plants. In one, Thomas writes, were 200 species of calceolaria, almost all in flower. Thomas 'never saw anything more gorgeous – the colours were perfectly dazzling … in all shades from the deepest purple, crimson, scarlet, and orange, to a pale yellow'. All this apart, Mr. Salemerskoi was 'a man of good taste … [who possessed] valuable works of art', in addition a good musician – *and* had some fine English horses which he bred. So much for the unsophisticated Urals countryside 150 years ago!

After two days sketching the Syssertsky iron-works Thomas continued south to Zlataust, 'the Birmingham and Sheffield of Eastern Russia' as Murchison called it, during a big spring festival where the women and girls were dressed 'as usual, in very gay colours'. Thanks to the power derived from a dam, a large blast-furnace here smelted the ore and forging mills hammered

the pig-iron into steel bars. In an enormous three-storeyed workshop swords and sabres were being made, some of them etched and ornamented 'most exquisitely', and Thomas wrote that he had not seen in either Birmingham or Sheffield any establishment that could compare with them. This workshop had been designed, built and managed by 'one of the most skilful and ingenious metallurgists of the age', General Pavel Petrovich Anosov, who had been in charge of the entire operation for many years, had in the past investigated painstakingly 'the ancient art of damascening' swords and so on (inlaying or etching patterns into them) which had been long forgotten in Europe, and succeeded not only in 'rescuing the long lost art from oblivion' but reaching an unmatched peak of perfection.[55]

Thomas continued south over wooded, undulating country, past good fields of rye and 'fine pastures' for cattle, typical of the southern Urals, to the sheltered Miass river valley,[56] with its birch, poplar and willow – so unlike the country further north. Here grass grew in some places up to his shoulders, providing abundant hay in winter for the cattle, and 'every family in this region possesses horses, cows, pigs and often poultry and they always have good milk and cream', although they did not know how to make good butter. But they certainly grew 'every kind of vegetable' and there was 'plenty of wild fruit on the hills ... all ... delicious': strawberries, raspberries, blackcurrants. In the mountains there was game, in the streams many grayling and in the lakes pike, so they were living in a very unusual land of plenty. For Thomas this rural economy must have come as a welcome change after all those zavods and a salutary reminder that good earth is ultimately more important in what it can provide than what lies beneath.

He had been in the Urals for two months and had travelled some 300 km along the chain, apart from his journey down the Chusovaya; it was now time to depart. Before he left Ekaterinburg finally, his friends advised him, much against his wishes, to hire a servant, stressing that he had scarcely a word of Russian and an illness or accident in a remote place was always possible. He took on a twenty-four-year-old natural son of the Urals' chief medical officer who spoke fluent German, which Thomas knew slightly, and the authorities 'most cheerfully' produced the necessary papers for him. Almost nothing more is heard of this man. 'In spite of every effort', Thomas wrote on his departure, 'a feeling of deep sadness crept over me when I took my last look at the high crest forming the boundary of Europe.... But the die was cast; I gave the word, "Forward!" ... the horses dashed off, and we were galloping onward into Asia' – by which he meant Siberia.

III. Western Siberia and South into the Steppe

He proceeded south-east by boat and tarantas, with his portfolio of sketches ever growing. The horses would gallop through the night, the bells attached

'View looking down upon the lake'
This was Thomas's caption to the woodcut in his first book. Perhaps he never knew the lake's name –
Borovoye. The strange peak at the left is Okzhetpes ('Unreachable for arrows'). A growing resort area
today, Borovoye lies roughly in the centre of northern Kazakhstan, which the two Atkinsons did not visit,
so this must have been on his first, solo visit.

to a wooden bow – above the central horse's head if a troika – making a 'tremendous clangor: sometimes … a most melancholy sound … in the dark forest of Siberia'. The forest was set on the great West Siberian Plain, through immense wetlands, a 'place of Torment … [breeding] millions of mosquitos, apparently more blood-thirsty than any I had before encountered'.

At post-houses Thomas would give his papers to 'the officers who read them and ordered fresh horses immediately'. He found 'two meals a day … ample for travellers' in one region anyhow: 'both should consist of tea, with meat and eggs'. His route took him along rivers and through forests, and the country varied between 'beautiful' and 'most monotonous'. At one point he came on a large party of convicts on their way to East Siberia: ninety-seven all told, led by seventeen men and three women shuffling forward in chains on their way to Nerchinsk beyond Lake Baikal, more than 4,000 versts further. An eight-month journey still lay before them.[57] The rest trudged in pairs, heading for the nearer Irkutsk administration area, a mere 3,000 versts and six months away, followed by baggage-laden telegas, the whole escorted by strict mounted Cossacks. The prisoners marched for two days and rested for one, sleeping in barracks with well-guarded stockades, surrounded by fifteen-foot fences of sharpened tree trunks. Thomas considered in his later book that although the convicts certainly included many 'dreadful bad men', others would certainly have been driven 'by cruel treatment against their brutal masters'.

On his route he passed through the small town of Tyukalinsk containing 'many good houses', where, a few years before, the British 'Pedestrian Traveller' John Dundas Cochrane, walking across Siberia in 1820–21, had his 'passport, papers and every protection' stolen: a 'terrible disaster … entirely deprived of all testimony', but somehow he survived. [58] Thomas crossed the wide Irtysh river, at that time the frontier of the Russian Empire south of Omsk, guarded by a line of Cossack forts and posts with the Kazakh steppe beyond,[59] 'formerly inhabited by Kazakhs before they were driven back across the river' by the Russians colonising the territory. He set off east, then crossed the more congenial Baraba steppe towards the Ob. On reaching its high bank, 'a magnificent view' presented itself: 'one level plain, densely covered with dark pine-forests, as far as the eye can reach' and on closer inspection 'large tracts of open country … in a very good state of cultivation'.

Then, after twelve days – and nights – of travel, he reached Barnaul on the Ob. Here, in the largest town and administrative centre of the Altai region and its silver mines, he reckoned he had now travelled from St Petersburg 4,527 versts – and, unsurprisingly, he slept for twelve hours. Next morning he handed his papers to the Chief of the Mines who told him he had had instructions from 'the Minister' about him and was ready to be of service, gave Thomas 'most valuable information' about his onward journey, handed him the recommended route, invited him to dine and convinced him that the people of these regions were very civilised and hospitable.

Thomas was given a Cossack who knew the area ahead to accompany him

south, and a day later was in the 'offshoots' of the Altai mountains which he longed to visit. 'At every half verst they passed charcoal wagons on their way to the silver mines as well as several hundred small wagons' taking the silver ore to Barnaul. Over 150 versts south of Barnaul they rode into Zmeinogorsk, 'the richest silver mine in His Imperial Majesty's dominions', where the Director received him very amicably. However, Thomas had been feeling unwell, and although he set off for the high Altai, after some seventy versts had to return to Zmeinogorsk, where the Director at once summoned a doctor. For several days he was 'very ill in bed' according to his journal,[60] but he was 'carefully nursed – indeed treated with the greatest consideration … [and] bleeding, physic and starvation' restored him to health after a long eight days. Unfortunately, and not surprisingly, his journal at this point is partially illegible, but it seems he travelled with Austin, his sometime companion (who now reappears in the journal), south into the Altai mountains, producing four sketches in one day,[61] then on to Ust-Kamenogorsk on the Irtysh, the administrative centre of the area.

The arduous and apparently obsessive journey continued. They left the town's Verkhnyaya Pristan (upper landing stage) 'in a platform laid on two small boats'. But after travelling only two versts it began to sink and they had 'just time to get on shore'. Late that evening,

> some men arrived from the Camp bringing me some soup and bread – a most welcome supply. Having eat of this and wrapped myself up, I lay down by a large fire and slept until 4 oclock in the morning. I then roused up my men and ordred a March.[62]

He found Austin and the rest of the party only half an hour's ride away, and, in charge as ever, 'ordred some tea to be made. Quickly drank 8 Glasses. Then washed and shaved by the river'.[63] Thomas and his 'two men' went ahead; he made one sketch but was too tired to make another, and all swam their horses across the 'broad and deep' Bukhtarma river, one of the Irtysh's many tributaries. They rode into Zyrianovsk through a mass of barking dogs trying to nip the heels of the horses. 'Heavy whips … sent them howling, and raised a concert of canine music, enough to rouse the whole population.' He was found a decent room and after a meal 'lay down on some fresh hay', wrapped his cloak round himself, 'and was soon in the land of dreams'.

The town was noted for its valuable silver mines, and more than 2,000 horses transported the ore to the smelting works in small carts, then down the Irtysh, then by carts again, nearly 1,000 miles altogether. These silver mines were of great depth – down to nearly 500 feet – and Thomas was shocked by the failure of the water-powered pumps to drain out 'the vast quantity of water almost inundating the mines [and certainly drowning miners] … almost useless', he thought. He was to suggest in his first book that a 150 horse-power steam engine made in Ekaterinburg to a high standard would cut costs, save

hundreds of lives and keep both the mines and miners perfectly dry. There was a kind heart beating in him.

There were many other mining places, Thomas added in diplomatic tones, where efficiency could be improved. He deplored the cost of the regular Zyrianovsk parades of artillery generals, covered with decorations, processing between two lines of miners, caps in hands, cheering as they passed. 'If the Tsar could reckon the cost of these parades three or four times a month', Thomas wrote in his first book – which he dedicated to the Tsar, Alexander II, so he was on sensitive ground – 'I apprehend his Imperial Majesty would indignantly dispense with the show, which produces nothing else.'

In the next four days at Zyrianovsk he first rested, then visited the sites from which he wanted to sketch, achieved six new views, arranged and 'set' his sketches, and on the fourth 'was rather unwell', 'remained at home all day and wrote a long letter to Lucy'.[64] He then set off south with a Cossack driver and reached the Cossack fort of Great Narym, set in attractive countryside. The Narym valley supplied hay, the lower hills wheat and rye, the rivers plenty of fish and the mountains plenty of game; the soil was good, producing abundant vegetables, melons and water-melons, and the bees were plentiful, giving excellent honey. Not content with that, the Cossacks had the exclusive right to all fisheries in the great Nor-Zaisan lake (see page 244), the Irtysh and its tributaries *and* were permitted to trade. Thus he found them 'in good circumstances, possessing comforts and various luxuries' with clean and comfortable dwellings. Many of the men were indeed wealthy, and he met some who owned as many as five hundred horses.

In total contrast was a scene on the Irtysh which Thomas and his boatmen encountered one evening in a fierce gale, blowing rain and sleet. On the steep river bank stood a small, isolated log cabin, a shed at the back, a wicker fence to protect a few cattle from wolves in winter and a rudimentary chimney of an old barrel secured to a few stones with twisted willow branches on a flat, earth-covered wooden roof, with grass and plants growing on it. The men were all completely drenched, and there was no alternative, but it looked 'a most unpromising place for the night', and inside it did indeed prove to be: a room some fifteen feet by twelve, occupied by five men, two women and three children, 'much too many for the space' – and now Thomas's party of nine. It was 'a scene of filth and misery: the floor was thickly covered with thick grass … trodden for weeks, from which rose an effluvium' mixed with other smells which made the place almost unbearable even with the strong wind. 'Water was dripping in from the flat roof, and there was scarcely a dry spot on the floor', while the two small windows were closed with calico, making the place even gloomier. 'It is only those who have been in such an apartment full of people, with their wet clothing steaming from the heat of a Russian stove, that can fully appreciate the odour which greeted the olfactory nerves on entering'. He declined the offer of a space on the bench round the room – its walls and ceiling black from the stove's smoke – on which the inmates sat and

slept (as well as on top of the stove, Russian-style), and found a smaller room in which to take refuge. A stove was lit and he lay down to sleep on its bench as best he could in the howling gale, wrapped in a cloak and coat, keeping the heavy rain-drops off with a towel slung above his face on two horizontal sticks.

But it was the women and children living there who really shocked him. The men seemed strong and hardy from their outdoor life – but the women were really wretched beings with dingy, careworn faces, 'squalid misery stamped on every feature', with blue handkerchiefs on their heads and neither shoes nor stockings. One had scarcely a rag to her back, a piece of twisted hemp tied round her waist, and the other much the same except for a ragged *sarafan* (a peasant's sleeveless dress). The two children of perhaps two and four looked ill, the younger dirty and very sallow, the elder thin and emaciated.

> The sight of these poor creatures [made an impression] 'that I have not to this day forgotten. That we have many scenes of destitution and misery in our own land I am well aware; but the worst den in the vilest lodging-house that may be seen amongst us, could not equal this. They were peasants [he continued pointedly] employed in conveying the ores from which so large a revenue to the Russian Empire is obtained. I recommend their condition to the authorities in the Altai.

A day or two later he finished a long letter to Lucy, set his sketches and left with Austin for 'the Steppe'. Next day they and their Cossack guide stopped at a 'Gold Washing works' where the director offered them horses to get them south to the lake of Nor-Zaisan, gave them a simple meal, but 'given with a hearty good will', and even gave his own bed to a freezing Thomas, sleeping in a gale by a window without glass. He also gave him in exchange for a drawing one of his 'fine breed of Persian greyhounds' and Thomas chose the black one 'as she was well trained and most watchful, besides which she is really beautifull'.[65]

Further south he found 'a fine view into the Steppe, as there is nothing to intrupt the view':

> The sun was just setting over some high Mountains [presumably the Altai or Tarbagatai in the far distance] in most vivid yellow or gold. The Mountains were purple and cast their shaddows far over the plain. The distant part of the steppe was also purple and undefined in gloom, while the foreground was light Brown burned up grass, making a Splendid picture, shall sketch this before I leave.[66]

Having travelled through endless forest further north, this was now his first encounter with endless steppe. Later that day he noticed 'a large column of white Smoke' and as they drew nearer they discovered it was the steppe on fire.

'Oh', the journal records, 'what a picture awaited us. The fire was some twelve or fifteen versts distant and extending across the Steppe some twenty versts – at least, lighting up the country for miles round.... To day we traveled fifty versts'.[67]

Next morning he was 'Up with the sun and soon reach for my breakfast, my toilet here being washing only. As usual I had finished my tea ere my companion turned out.' (He evidently found Austin annoying. No wonder the two seem to have travelled together only occasionally.)

> At last we started a little before 9 oclock [very late for him] and crossed the country to resume the road across the Steppe. From the brow of one hill the Steppe lay before us like a map ... one perfectly level plain as far as the eye could reach ... [extending] for many hundred versts, but ... quite unknown except to the Kazakhs who feed their horses on it in summer. I found the fire had advanced at least twelve or fifteen versts and was burning with frightfull rapidity and great fury.[68]

They got horses at a large Kazakh aul to take them to Lake Zaisan, which Thomas was very keen to visit,[69] but approaching the lake they saw only reeds. He walked to the shore later and was greatly disappointed to see 'nothing but reeds forming the Boundary of the lake for miles'; he rode five versts along the shore's reeds up to the saddle-flaps in water, but still with no view of the lake. Some 250 km south to his southernmost point that year – for nothing.

But there was some consolation in staying in the chief's yurt at the aul, 'and we were soon sitting at our tea. Every thing we did afforded them much intrest and they watched all our proceedings carefuly'. Later the visitors were given

> some mutton with Buck wheat. As there were some leg bones my companion was a long time rumaging over his portmantua. I wondred what he was about when [he] stood up and said 'I have carried a marrow spoon all the way from Petersburg and now when I want to shew the use of it I have left it behind. I am greatly disappointed.' This really made me laugh as he wanted to display a marrow spoon for people who don't even use a knife and fork, but his vanity is great.

Trivial, but it shows his feelings of irritation for once.

Next morning he made a sketch of the lake – reeds notwithstanding – and they then rode back to the Irtysh where he sketched another view and at an aul (spelt 'howl') 'partook of a Lamb that had been killed on our arrival in company with many others who had no Knifes or Forks'. Again he 'ordred' horses for the return north, and they 'traveled at great speed', albeit stopping for the occasional sketch.

He spent the autumn and early winter in Barnaul including 'many happy hours' with Dr F.V. Gebler (which he spells as Gabler), the Inspector of the Altai Hospitals, 'which office he filled with great advantage to the peasantry, and to all under his charge'. Gebler, who had lived in Siberia for more than thirty years, was also a distinguished naturalist known in Europe for his astonishing collection of more than 17,000 specimens of insects, not only Siberian. Some he had sent to museums abroad including Britain. Sadly, his collection was sold after his death in 1850. Thomas also found in a Barnaul museum four stuffed Caspian tigers (*Panthera tigris virgata*), which had been driven by hunger across the Irtysh from their habitat in the Kazakh steppe and were in some cases killed only five hundred versts from Barnaul. He claims that many peasants did not even know their name and were quite unaware of their ferocity, so two at least of the museum tigers had cost lives as well as serious injuries.

In the New Year of 1848, instead of the blank pages of a gazetteer for his journal the previous year, he used the first of a series of unlined leather-bound notebooks, one for each year (in theory anyway).[70] Considering his meagre education, the long entries in his diaries henceforth are extremely well expressed, with a particular gift for description, albeit overlong, and perhaps inevitably have the immediacy his two subsequent books could not have. How he kept his journal more or less up to date in the difficult circumstances of travel is a wonder. And keeping it dry must have been a worry. Sometimes, having apportioned the days in advance and needing more than a third of a page per entry, he had to turn many pages on to continue the day's happenings, occupying several days' spaces at a time. There may be some gaps, but it is lucky that the diaries have survived both the adventures and the tests of time.

He tells us that he left Barnaul on 13/24 January and hurried back to Moscow to rejoin Lucy after a twelve-month absence. He spent a few hours only in Tomsk and a night in Ekaterinburg from where he wrote the last of his letters to Lucy; hitherto there had been more than one a week. He listed them all punctiliously in his journal in four columns: date, place and where posted, number of letter sent (total sixty-six, although he starts counting only at seven), and finally 'Dates when they should be received in St Petersburg', allowing, for instance, four days from Nizhny Novgorod, but twenty-nine days from remote Kushvinsk.

He adds only two entries to his journal during his long journey back west:

Thursday 15 – 27
The cold through the night and this Morning was really Frightfull – with deep Snow I had six Horses Goosem (that is in one line) but with these it was most difficult to get on.

Friday 16 – 28

Arrived in Tomsk at 6 oclock found it frightfully cold General Anossoff received me very kindly and ordred the police to provid me with good quarters He told me there had been 43 degrees of Frost. This accounted for my feeling so intensely cold.

Dined with the General and got all my letters [most, presumably, from Lucy].

He arrived back in Moscow on 9/21 February (or just before) and wrote one more letter to Lucy. She left St Petersburg with Sofia, her charge for the past seven years, on 13/25 February to rendezvous in Moscow at last with Thomas after a year and thousands of versts apart.

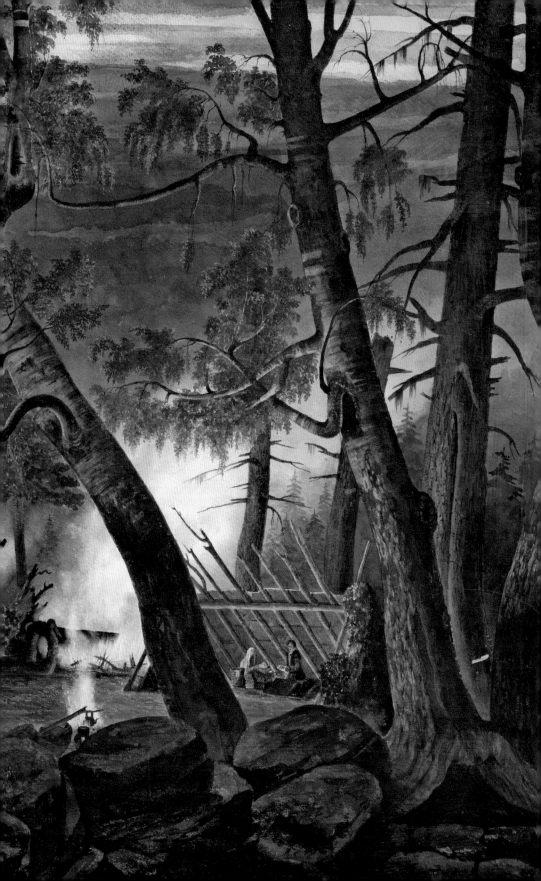

Chapter Two

Into the Altai

I. Moscow to Barnaul and Beyond

THEY WERE MARRIED from the house of the civil governor of Moscow, a relative of Lucy's general.

> Thomas Witlam Atkinson, Native of Silkstone in the County of York in England Widower, Artist by profession of the English Church and Lucy Sherrard Finley Spinster late resident in St Petersburg also of the English Church were married according to the Rites & Ceremonies of the Church of England this 18th day of February AD 1848 by me Christr Grenside Minister Moscow.

Thus the register of the Chapel of the British factory[1] in Moscow.

And we have no information as to what had happened to Rebekah, Thomas's first wife, or indeed his two daughters by her; we only know that their son, John, had died in Hamburg. Lucy, who understood that Thomas was a widower, arrived for the wedding from St Petersburg with her charge Sofia, then aged fourteen, a testimony both to their good relationship and Lucy's trusted position in the family.

Their stay in Moscow was short as they had to start for Siberia before winter ended – and before the roads became a quagmire. Another problem was that the *Maslenitsa* or Shrovetide festival meant many people were enjoying themselves and could not be found – even Nikolai, the manservant, and certainly the yamshchiks who as Lucy put it had made 'such frequent applications to the vodky'. Then two days after the wedding a rapid thaw flooded Moscow, making sledging difficult. Nonetheless, everything was ready and, despite many of their friends urging a delay, Thomas resolved to start.

However, during Lucy's short stay in Moscow,

> it became known to the families of many exiles that I was going to visit regions where their husbands, fathers, and brothers had spent more than twenty years of their lives. Each member of these families … [who] were destined never to meet again … had some message which they wished to be delivered. Nor could I refuse them this pleasure, although it would, I found, entail several deviations from our intended route.

Opposite: Detail of watercolour p.88

On 20 February (Western calendar) Thomas, his servant Nikolai and some helpers began to pack the sledge for a nearly 2,000-mile journey east to Tomsk of twelve days and nights; then all was covered with two large bear-skins.[2] At 3.30 p.m. they set off, seated behind the yamshchik and Nikolai, but the snow had been melting on a sunny day, so the galloping horses sometimes had to halt on bare stone, and Thomas feared for rocks in the snow ahead. At 5 o'clock a sentinel stopped them at the gate of Moscow, an officer examined their passports, and the barrier was raised in the great archway. Lucy 'seemed to be bidding farewell to the world … and thought of the many exiles who had crossed this barrier', among them 'hundreds whose only crime was resisting the cruel treatment of their brutal masters'.

Soon they were sledging fast along a straight stretch of the Great Siberian Road, and the yamshchik announced it was freezing – 'most welcome news'. The speed of the horses and the tinkling of the bells diverted Lucy's mind from her distressing thoughts, and on this fine night 'star after star appeared in the firmament, till it was spotted over with its twinkling wonders'. They stopped for Lucy's first – and memorable – impression of a post-station. It seemed deserted: all was dark. Nikolai was sent in to find someone and get new horses but did not reappear. Thomas called for him in vain and went into the post-station himself, discovering that everyone was dead drunk. He found their supposed manservant also drunk and fast asleep on a bench with his employers' papers and bag of money on the floor. 'He had forgotten both us and the horses,' wrote Lucy.

After a tedious delay the officer in charge was found, and the seal and signature of the Postmaster General brought him to his senses. The officer's whip produced some action including a search for four horses. Nikolai was severely berated and the papers and money transferred to Lucy, now 'minister of finance'. She was not cheered to hear that they would find 'the people drunk at every station'.

With no snow on the road ahead, the yamshchik turned into the forest. The morning found them at a post-station 112 versts east of Moscow, and Lucy had slept little and eaten nothing since their departure, so she was very pleased to see a hissing samovar brought to the table as well as their 'basket of provisions'. They ate quickly and were soon off again. And, because much snow had fallen in the night and it had become intensely cold, their progress was now considerably faster.

They arrived at the historic town of Nizhny Novgorod and found themselves in a filthy hotel, and Lucy was appalled to find that the sledge had to be totally unpacked. Thomas had promised to call on the town's governor, Prince Yurusov, who 'would not hear of our leaving the town without dining' with him and the princess. They had time to wander round the town with its churches beneath their 'star-bespangled domes' before turning up punctually at the dinner hour of

Opposite: Post-station. Every so often along the main or post-roads were post-stations where the horses could be fed, watered and changed, and travellers could spend the night uncomfortably on benches or the floor and get hot water but rarely food. They also had to show their travel documents – *podorozhniye* – in order to be allowed onwards. Travel was best in winter by sledge on the snow and worst in the thaw when the roads could be impassable.

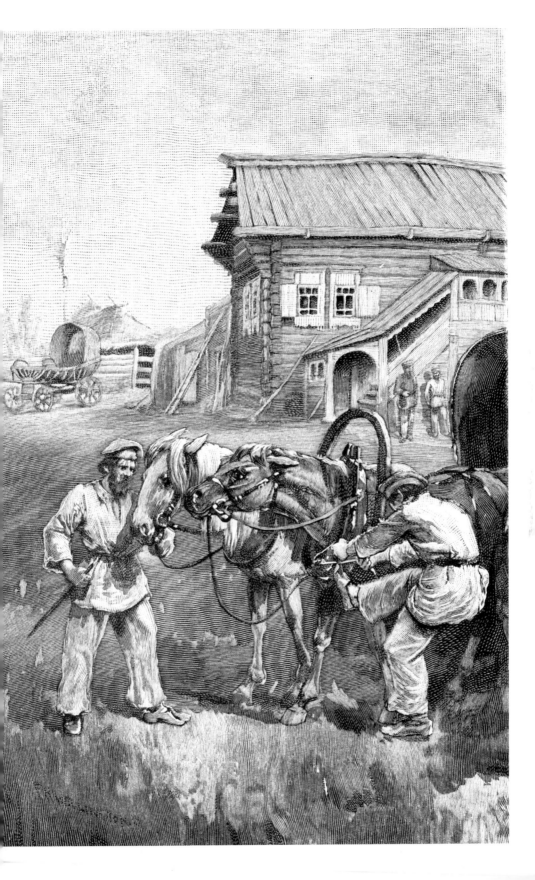

four o'clock at the governor's house, where they were 'received most kindly and hospitably by the family, and … welcomed like old acquaintances'. Their hosts were surprised that Lucy 'had the courage to undertake such a journey' as was contemplated and even doubted if she was strong enough for it. They wanted the travellers to stay for a few days to see the places of interest, but Thomas was anxious to head to Siberia's Altai mountains before the winter roads thawed.

They left the town at 10 p.m. for the frozen Volga. Lucy's heart 'beat rapidly as we descended its banks, it having been stated that we should find, in parts, even large holes'. Nonetheless, although 'everything looked dark and gloomy', Lucy slept soundly almost to the first station. The next day was extremely cold with a 'keen and cutting' wind, so that on arrival in Kazan, further along the Volga, Lucy found her 'face and lips in a fearful state' and very painful. She was assured that a piece of white muslin covering the head (standard practice at the time) would totally protect the skin from the frost, although, she noted, the Russian method of protection was 'never to wash the face from start to finish of a journey', as washing would dry the skin further. In Kazan, as in Nizhny Novgorod, they called on the governor, Lieutenant-General Baratinsky,[3] 'and there met a brilliant party' and were invited to a concert by the princess, his wife.[4]

Beyond Kazan the roads continued to be bad. Once, while waiting for fresh horses, they found themselves breakfasting with an officer and his civilian companion, who had partaken of more vodka than tea. Lucy commented that 'A Russian, without the slightest intention of being rude, often asks whence you come, where you are going, and your business, and some, even, what your resources are; and just as freely they give a sketch of themselves.' The 'cadaverous-looking' officer, 'now furnished with as many particulars as we chose to give', told them he had some maps which he would be delighted to show them. The maps were produced, accompanied by 'most significant nods and winks' and the statement that 'they were not permitted to be shown to any foreigner, but, out of the deep respect he had suddenly conceived for us [neither Lucy nor Thomas was a fool], he would allow us to take a peep at them'. Lucy was to add in her later book that she had bought the same maps the year before in St Petersburg. He offered to part with them for 40 roubles, then halved it to 20, both offers in vain, and then his companion, 'the little civilian, with his sharp, foxey face', produced a pack of cards and they both tried to persuade Thomas to play but were disgusted when he declared he did not really know one card from another.

They continued their journey with six horses, disdaining the proposal to put their sledge on wheels, and entered an area of dark pine woods. Lucy wrote that it was impossible to describe the beauty and the scenery they passed through and believed that

> the nights are almost more enchanting than the days, when the pale moon is shining, and darting her soft rays down on the ever-green pine trees. In the silence of these lovely nights, as I lie back in the sledge watching every turn of the road, I conjure up all kinds of fantastic images.

On one such night Lucy noted that Nikolai, hitherto asleep both day and night, now seemed to be wide awake all the time. In fact, he had been told that there was a band of thieves ahead. He was afraid to sleep, but Thomas prepared for trouble by reloading his pistols and checking his gun. However, it proved a false alarm and their 'own solitary sledge was the only thing on the road'.

At last they reached Ekaterinburg, the chief town in the Urals, on 6 March (no entries in Thomas's journal[5] until 21 March – he had, of course, done the same journey the previous year – so Lucy must be relying on her memories or perhaps kept a journal herself) and accepted the offer of hospitality from an English friend of Thomas's from the year before. Meanwhile, Nikolai had been sacked for 'neglecting duty and gross misconduct'. He was 'not to be trusted, and Mr Atkinson had always treated him with great leniency'. When in Moscow he had received enough money to buy everything he would need 'for a journey of two years', according to Lucy. Presumably that was all that was envisaged at that time. Just before they left Moscow Nikolai astonished Thomas by asking for more money, although he had already received a year's salary in advance. Thomas refused 'until he said he wanted to buy something for his "old mother" – he might have known his master's weak point'. But on arrival in Ekaterinburg they found that Nikolai had loaded in the sledge a lot of items to sell and was already 'occupied in disposing of them', while the poor 'old mother' received nothing.[6]

As it was Lent, the place was quiet and there were few dinner-parties, although the Atkinsons attended one at General Glinka's, now head of the Urals' mines.[7] While in Ekaterinburg one of the British inhabitants, Peter Tate, a mechanical engineer,[8] presented Lucy with a rifle to add to the pair of pistols that Thomas had bought for her in Moscow, 'so now we have each evening rifle and *pistol* practice, as it is advisable for me to be at least *able* to defend myself in case of an attack being made on our precious persons or effects whilst travelling amongst the wild tribes we shall meet with on our journey'.

And Lucy was told many stories of 'robberies and fearful murders'. One in particular happened during a previous Lent when a father and son had been travelling on the route that the Atkinsons intended to take. One late night they stopped at a peasant's house with only one room and, when all the family had settled down on the stove-cum-oven which serves as a bed and the two travellers had eaten the supper of cold meat they had brought with them, they went to sleep on the benches. Soon, Lucy writes, a man on the stove

> slid gently down, and, taking in his hand a hatchet, …with cautious steps approached the sleepers, and, lifting the instrument with both hands, brought it with such force down upon the head of the poor father, that he literally cleft it in two; he then turned to the son, … and despatched him likewise. The brutal murderer then returned to his berth and slept till morning.

The reason he gave the authorities for these two murders, according to Lucy,

was because they had committed 'the awful crime of eating meat in Lent', and, though he knew it was a crime, 'a voice kept continually urging him on … saying that he was only putting an end to sin'. Thus, 'to prevent such a fate', and knowing they would take the same road, Thomas was presented with a hatchet by the kind gentleman who told them the story.

For their journey ahead Peter Tate's wife 'prepared provisions of all kinds for us, as there was nothing to be procured on the road, especially during the fast', but Lucy speculated that in a few months' time they would not be too fastidious about eating peasant food. She already enjoyed 'amazingly' black bread which they could get at any 'cottage', but they took with them a good supply of white bread as well as butter.

Four days after leaving Ekaterinburg they reached Yalutorovsk in Siberia (Lucy spells it as 'Yaloutroffsky') off the great post road, for the first of their meetings with the exiles of the Decembrist conspiracy of 1825. Here they had a gun for 'Mouravioff' as Lucy calls him: Matvei Ivanovich Muravyov-Apostol (1793–1886), a distant cousin of Lucy's former employer in St Petersburg. He 'seemed to be in the prime of life' and when Lucy told him her maiden name (Finley),

> I was instantly received with open arms; he then hurried us into his sitting-room, giving me scarcely time to introduce my husband. I was divested of all my wrappings, although we stated that our stay would be short; he then seated me on the sofa, ran himself to fetch pillows to prop against my back, placed a stool for my feet; indeed, had I been an invalid, and one of the family, I could not have been more cared for, or the welcome more cordial.

He sent at once for one of his comrades-in-exile, whose family Lucy also knew (perhaps Yakushkin),[9] and the widow of a third Decembrist with her two children.[10] Lucy had many messages to pass on as well as small gifts for everyone. One message for the widow was to part with her children so that they could get a proper education. She would think it over, she said, and all present urged her to consent for the children's sake. She did, in fact, do so, and the children went to an aunt in Ekaterinburg whom the Atkinsons knew a little and who would give them great affection. 'Poor mother!', sympathised Lucy: a great pang of parting, but it showed her great love for them.

There was 'quite a little colony' of Decembrist exiles in this small place, 'dwelling in perfect harmony, the joys and sorrows of one becoming those of the others; indeed, they are like one family'. Lucy was to point out in her book that 'the freedom they enjoy is, to a certain extent, greater than any they could have in Russia', thus full liberty of speech, and 'the dread of exile has no terror for them'. On the other hand their movements were restricted, although lenient local authorities allowed keen hunters remarkably full freedom, which was not abused.

Muravyov-Apostol, the Atkinsons' host, was 'a most perfect gentleman',

Lucy considered,[11] and the long years of exile had evidently not changed 'his indomitable spirit; there was nothing subdued in him' despite having been sentenced 'as one of the most determined of the conspirators' to an originally two-year solitary exile in the marshy forests of the Yakut province, the coldest part of Siberia, with the coarsest food, no books or writing materials and under rigid supervision. To the official enquiry how he was spending his time the answer came, 'he *sleeps* – he *walks* – he *thinks*'.

Their host told them that on his long journey into exile the officer in command relaxed his authority after some distance from Moscow and treated his well-educated charges as associates, inviting one or two to share his meal. At one stop, the officer was breakfasting with Muravyov-Apostol and left the room to ensure departure was in hand, leaving his exile companion sitting inside at a table. A village official came in through the particularly low door and bowed humbly before the seated gentleman whom he took for the officer.

> He then entered into conversation which naturally turned upon the scoundrels … being conveyed into exile, and (continued this man, looking into his face,) 'there is no mistaking they are villains, of the blackest dye; indeed, I should not like to be left alone with any of them, and, if I might presume to offer a little advice, it would be to observe well their movements, as they might slip their chains, and not only murder you and all the escort, but spread themselves over Siberia, where they would commit all kinds of atrocities.' At this point of the conversation, the bell rang to summon them all to depart,

whereupon Muravyov-Apostol stood up and, when his visitor heard the clanking of chains, he looked totally aghast and, Lucy says, seeing 'the object of his terror about to move forward, he made a rush at the door, but, not having bent his head low enough, he received such a blow that it sent him reeling back into the room and sprawling on the floor; but he picked himself up quickly and bolted'.

They found Yakushkin was the most isolated of all the Decembrist exiles they encountered, his home 'as scantly furnished as the abode of a hermit; but books, his great source of delight, he had in numbers'. Having announced (surely unreasonably) that they could not stay long, the Atkinsons were still with their new Decembrist friend in the evening and left reluctantly, taking a present from him of three books, inscribed simply with the date and 'Yaloutroffsky'. (Where are they now, one wonders?) Thomas and Lucy promised to spend a day or so with these Decembrists on their return journey, but these were by no means the only ones they would visit.

They now travelled on quickly over good roads – to start with at least – and Lucy developed a useful technique for getting horses without delay. Their friend in Ekaterinburg, Mr Tate, had given her a horn in case she got lost in the mountains yet to come and, as they arrived at each post-station, she would blow the horn 'when out rushed all the people to know who it was, it was capital fun,

and gave great importance to our arrival; indeed, they were so amused that we obtained horses, without the slightest difficulty or delay'.

Sometimes they got stuck in deep snow and had to get help from local villages, and the landscape became a 'white waste, with a cold cutting wind'. Then, nearing Omsk, the roads became totally snowless. They reached the town at 4 p.m. on 8 April, a six-day journey from Ekaterinburg, and drove to the police-master's house since they had a letter for him from a mutual acquaintance whom they had met on their journey. After a furious reception by the police-master 'in a dirty, greasy dressing-gown', when Thomas had the temerity to have had him woken from his siesta – lessened only somewhat by him presenting his official papers – a Cossack had them taken to the town's outskirts 'to a most horrible place' where they had to go through a room where men were 'lying [on the floor] stretched out in all directions, some smoking, and others talking at the utmost pitch of their voices'. They were given a cold room but managed to get a fire going and found food in their sledge to assuage their hunger 'and were glad to spread the bear-skins on which to stretch our cramped and bruised limbs; for six nights I had not had my clothing off', wrote Lucy.

Next morning they called on Prince Gorchakov, Governor-General of Western Siberia,[12] with Thomas's official letters; and the request for an escort in the Kirgiz steppe which the Atkinsons hoped to visit was mercifully granted. Interestingly, the Tsar had given permission only for travels in the Urals and the Altai, but that presumably gave Gorchakov enough confidence to grant a simple request as the supreme authority in West Siberia. He was very angry on learning of their accommodation overnight and gave orders for 'proper quarters', of which the police-master oddly took no notice. But one hour after a second order Lucy 'was comfortably lounging on a sofa in a general's quarters'. It is intriguing that the two Atkinsons from their modest backgrounds were mixing with high society, doubtless because of Thomas's official letters authorised by the Tsar, and Lucy's former high-ranking employer had probably presented the pair with a general letter of introduction or even individual ones to high officials. Perhaps Lucy had learned how to behave in her employer's grand household, if not before, and Thomas's innate intelligence and charm got him to copy 'his betters' and be accepted by them.

Next day Thomas went to Gorchakov for 'his papers' accompanied by Lucy who 'went also to take leave of him' and was invited to dine as well if 'she would excuse the presence of a lady'. Leaving for Tomsk that evening, Thomas greatly feared that the frozen rivers would break up before they arrived. When they reached the town of Kainsk[13] he hoped to find his dog, which had strayed following a pack of wolves, on his return to Moscow on his previous journey in a hurry to see Lucy again. Since the dog was a favourite, the post-master had been instructed to take care of her if found, but Lucy 'had a kind of wish that we might not find her, as I had been told she slept in the sledge, and I had fully made up my mind that no dog should sleep in a sledge with me'.

On reaching Kainsk, Thomas whistled and, on cue, the dog, whose name was Jatier,

came bounding over the top of the low hut, disdaining to walk through the gate. As I [Lucy] looked at her I thought I never saw anything so beautiful; she was a steppe dog, her coat … jet black, ears long and pendent, her tail long and bushy; indeed, it was a princely animal; the red collar round her neck contrasted so prettily with her coat, and then to see the delight of the poor beast as she leapt into the sledge; I do not know which was happiest, dog or master … but the dog never once annoyed me by entering the sledge; when tired with running, she used to occupy Nikolai's [former] place beside the driver.

One night, tired out by 'continued shaking and bumping on the bad roads', they were both fast asleep when they were woken by the dog's growling. They found the sledge had stopped in the middle of the forest and two of their horses and the driver had gone, replaced by four strangers. Thomas leaped out of the sledge, called out for the driver in vain and 'demanded horses of these men' who insolently told him to get some at the next post-station. 'There was no mistaking into what sort of hands we had fallen.' The men approached and began to unharness the remaining horses, but Thomas told them, doubtless through Lucy, that he would shoot the first person who tried to take them. This had no effect, so Lucy 'passed him his pistols, the click of which, and his determined look' brought them to a halt. They then started to move into the forest, but Thomas said he would shoot the first man who stirred. When they claimed they were only going for horses, he told them one man was enough. After much talk, with Thomas and Lucy guarding the sledge, and Jatier continually barking, tail erect, one man went off and reappeared shortly with two horses, and they were soon able to proceed – Lucy noticing their absent yamshchik 'peeping out from behind the trees' who had failed in his attempts to rob and perhaps murder them.

On their way to Tomsk there was sometimes no snow and how they sledged on was a mystery to Lucy. They had to cross the river Tom and climb its bank before reaching the town, and 'the water was so deep on the ice that we feared everything in the sledge would be spoiled'. They were 'right glad' to arrive in Tomsk and Lucy believed 'it requires a pretty strong constitution to endure for days and days together' the rough travelling they had known: a succession of almighty bumps for 'versts and versts', so that 'the sledge is not smashed to atoms is a wonder'.

They were told that the poor couriers lived only a few years. Once in Tomsk, they were intrigued by the town's dining-rooms, established by a dwarf albino (probably British) and his wife, a German giantess: members of a circus travelling through Siberia who, tired of their lives, had married and settled down in Tomsk; the dining-rooms they ran relied on her excellent cooking and his very own brand of port.[14]

The Atkinsons were delayed in Tomsk, 'it being impossible to travel either by winter or summer roads' due to the thaw, and the post had stopped as the rivers could not be crossed. They arrived in the last week of the Easter fast, just

in time for the festivities. But first, Lucy went (rather oddly on her own) 'to make the acquaintance of all the notables of the town', mainly what she calls 'gold seekers', presumably gold-prospectors and goldmine merchants. One of the richest of the latter, Ivan Dmitrievich Astashev (1796–1869), whom Lucy spells as 'Astersghoff',[15] showed them 'some fine specimens of gold, weighing 25 lb and 30 lb each. These miners have magnificent mansions, and live in great state.' They visited the vice-governor, 'a most amiable and gentlemanly man' who, however, would have to leave his post as he had just married a gold-prospector's daughter and in consequence owned goldmines, forbidden to a government official. His wife was the only child of a poor peasant whose mother had died when she was very young and who ran about the streets shoeless for years. Fortunately her father found a rich mine and could now send her to school 'where she learned to read and write'. He had died two years before the Atkinsons arrived, Lucy noting:

> [he left] his daughter a rich heiress at the age of fifteen; her education is still being continued; her husband has provided her with teachers, who come daily. A more graceful or beautiful creature it has rarely been my lot to see. She receives her visitors and sits at the head of her table, as though she had been accustomed to her present position from her birth, and yet so modest withal.

The Atkinsons found two Englishmen in Tomsk. One was a Dr King,[16] practising in Tomsk and certainly not the first doctor from Britain in Siberia. (The first may have been Dr John Bell two centuries earlier, who accompanied a diplomatic mission from Peter the Great to the Emperor of China and has left an engrossing account of his journey.)[17] The two visitors spent 'many agreeable hours with him and his wife'. The other (unnamed) Englishman had been exiled for forgery, evidently unjustly, for it seemed he was innocent, 'but bore the blame for another, never supposing it would lead him into exile; that other never came forward but, it is said, basely deserted his friend', as Lucy writes. The exile was 'now living a most unexceptionable life, respected by all and in a position of great trust'.

The balls and dinner parties the Atkinsons attended were 'conducted' in much the same way as those in Moscow and St Petersburg except for the wives of the wealthy miners, dressed in good taste but wearing 'a perfect blaze of diamonds'. But there was one exception: a dinner party for forty in the house of a rich merchant. The archbishop was the guest of honour and champagne was liberally provided, but the hostess, Lucy notes,

> devoted to her distinguished visitor, … took care that he was well plied with English porter as well as wine, which he appeared to appreciate, if one might judge from the quantity he imbibed, and there was not the slightest difficulty in inducing him to do so. Dinner went on smoothly enough till the sixth course, fourteen was the complement,[18] when the archbishop decided to rise, having

already more than satisfied himself that the dinner was in every way excellent.

The hostess was appalled, knowing that, if he left, the other guests would do so too, and got him to sit down and begin eating and drinking again 'as though he had been deprived of food for months'. 'As for conversation, he was too much occupied for that', despite Thomas's valiant attempts sitting next to him, except for 'a few coarse jokes which, unfortunately, are everywhere tolerated in Russia'. By eight courses, the archbishop decided that everyone should be satisfied, but the hostess, alarmed again, 'was at his side in a moment; his leaving the table was not to be thought of, he must at any cost be made to sit still'. The dinner was little more than half over and it had taken days to prepare with no expense spared, so he was 'coaxed and persuaded like a spoiled child to sit still; but he would no longer eat, only drink' and sat sullenly while 'the hostess whispered soft soothing words into his ear' and scarcely left him. He 'gradually lay back' and dropped asleep. Both hosts and guests were greatly relieved, and the hostess could now continue to wander round, as was her custom, ministering to her other guests. Fortunately 'the noise of the revellers' mitigated the sounds from the head of the sleeping archbishop.

When all was at an end, no one took any notice when two guests helped him out, and a few days later Thomas received an invitation from him, as he wished to see some of his pictures, and sent men to collect them. Thomas's response was that 'if his reverence would call he should be happy to show him any drawings he had, but he never carried them to anyone, excepting to the Imperial family. The archbishop was, as you may judge, mightily offended.'

In mid-June (1848) the Atkinsons visited all their friends in Tomsk to say goodbye, and the Astashevs (he of the goldmine) called and presented Lucy with a very fine gun made by Orlov, one of the leading St Petersburg gunsmiths. Thomas finished his drawings of Tomsk[19] and packed them ready for their journey some 400 kilometres almost due south to Barnaul, the principal town of the Altai. He ordered the horses for 4 a.m.,[20] and, he wrote in his journal,

> Away we went having a splendid morning for our journey. The water in the Tom was still very high but at 10 o'clock we had crossed without accident and then our road crossed the valley, at this time one sheet of deep Orange Colour from the great quantity of Globe Anemony in some places. The pale blue forget-me-not covered the ground in large patches, while numerous shrubs gave forth their blossoms quite scenting the Air. Altogether it was a scene of Loveliness I had never beheld – on reaching the woods we found the ground covered with deep purple Iris and many other flowers quite new to me. Mrs A enjoyed the ride greatly. The views of the Town where [sic] greatly changed since we passed over the Ice when all was snow and frost.[21]

They made great progress during the night, 'but now began our difficulties in crossing the rivers which were all flooded and deep…. Oh, what a change since I passed over this road in January with forty-three degrees of Frost. Now the ground was covered with Luxuriant plants, and flowers of every colour but in places we still found snow' (this in mid-June).

A breakdown in the morning delayed them and in the evening they found a stream difficult to cross and then encountered some very bad roads in the night.[22] But the next morning,

> A fine Sun rise made every thing look fresh and gay [and] at 12 oclock we arrived on the Banks of the River Ob now about two versts broad and runing fast. It was no easy matter to get the carriage over some of the pools, the water runing over the Axles…. Having dined, we started on in the hope of reaching Barnaoul to dinner tomorrow…. Traveled on very well through the night.[23]

They stopped at 6 a.m. to breakfast and were warned they would have difficulty in proceeding as the Ob flood-waters covered the way ahead for a long distance. So they had six horses harnessed in the hope of success, and after a few versts reached the Ob and drove along its high bank from which they

> had a splendid view. The River had over-floun the valley in places more than twenty versts broad, the groups of Trees looking like small Islands in a large Lake. On descending into the valley we had the water up to the bottom of the carriage, no very pleasant prospect feeling that every step might take us into deep water…. I [NB, not 'we'] found it was impossible to cross, the mud was so high. There was not a place to put our heads in, only our carriage; a great Thunderstorm was ragin at a short distance but here we must stop the night and that too with only dry bread to Eat and a bad night to look forward too.[24]
>
> After passing a most uncomfortable night we turned out with the Sun. I urged the boatmen to take us over without delay – at 4 oclock we embarked and got over in three hours the stream running fast. On reaching Barnaoul we drove to My Friend Stroleman's [one of the officers of the zavod], accepted a kind invitation to stay and were soon making a good breakfast after our long fast.[25]

They were now in the Altai, a region called after one of the largest mountain systems of Central Asia, extending south into Mongolia, although in fact 'the Altai' also embraces extensive fertile steppe in the north-west. The mountains are not just one range, however, but a confusion of at least twenty-five different ranges,[26] set at many different angles and separated by gorges and river valleys. Surprisingly, each range and each valley has its own micro-climate, differing sharply from that of its nearest neighbours. The three highest ranges are covered

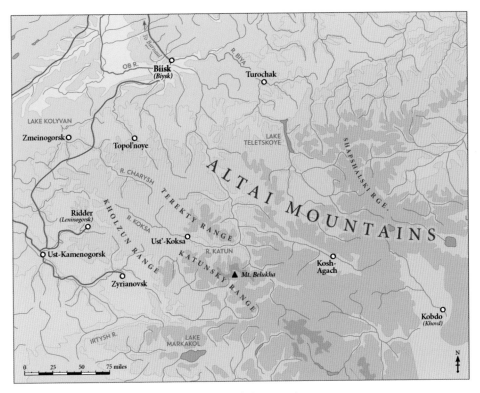

Map of the Altai Mountains

with eternal snow and glaciers, and from the glaciers below the highest peak, Belukha (4,506 m), flows the Altai's longest river, the Katun, 665 km long, with its swift current and many rapids, finally joining the Biya to form the great Ob and later joined in turn by its massive tributary, the Irtysh. Both start in the Altai and flow on north together to the Arctic Ocean as the Ob–Irtysh river system, one of the longest in the world.

But traditionally the Altai mountains are not just physical mountains. They have great mystical resonance and have been called 'the spiritual axis of the world', the location of Shambhala itself, the meeting place of heaven and earth, a mystical and mythical paradise of Tibetan Buddhist legend, the world's holiest place. These beliefs led to the theosophical works and intensely coloured paintings of Nikolai (1874–1947) and Elena Roërich who travelled in the 1920s through Tibet, Mongolia and the Altai mountains looking for Shambala. James Hilton's best-selling *Lost Horizon* (1933) positioned Shambala in Tibet as Shangri-La.[27] Myths notwithstanding, the indigenous Altaians,[28] whom the Atkinsons knew as 'Kalmucks',[29] regard Belukha, the Altai's highest and eternally snow-covered mountain, as particularly holy.[30]

Certainly legends have had time to develop here. Those great Altai plains north-west of the mountains have been inhabited for thousands of years by nomadic

73

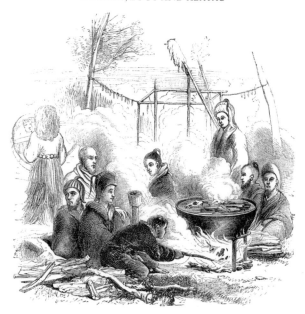

Kalmyk sacrifice
Thomas witnessed a Kalmyk sacrifice at which a ram was killed and flayed, its skin put on the pole and the flesh cooked in a great cauldron while a shaman chanted and beat his tambourine.

peoples, and Siberia's permafrost, subsoil permanently frozen since the ice age, has preserved – it would seem miraculously – the *kurgans* or burial places of tribal chiefs, the most famous the 5th–3rd-century BC Pazyryk valley burials of the Scythian iron age. The Atkinsons, particularly Thomas, may indeed mention ancient barrows and stone monuments, but the first Pazyryk site was discovered only in the 1920s; the tombs revealed superbly preserved fabrics including the world's oldest pile carpet, an intact funeral chariot, horses and a chief's tattooed body. And in 1993 the fifth-century BC so-called Ice Maiden or 'Altai Lady' was found, also tattooed, accompanied by six sacrificial horses. The grave had been flooded and frozen ever since, so all was immaculately preserved including her yellow blouse and white felt stockings.[31]

Barnaul, the chief town of the Altai where the Atkinsons now found themselves for a whole month, lay on the left bank of the Ob, and had wide grid-patterned streets built on deep sand. Like most Siberian towns of the time, it was constructed almost entirely of wood, with many people living in *izbas* (small log cottages); only a few buildings, including three simple churches, were of brick, but the town could boast a *gostinny dvor*, equivalent to a coaching inn, with some good shops where many European items were on sale at high prices including watches and jewellery, French wines and silks, muslins and bonnets, sardines, cheeses, English porter, Scotch ale, swords, guns and pistols. There was also a good market supplied by the local peasants, almost all of whom kept cows and horses, and there the Atkinsons found the prices, on the contrary, astonishingly cheap: thus a pood of beef could be bought (at today's equivalent)

for 40p, a pood of salmon for 30p and a hundred eggs for 20p (although further east food prices were much higher).[32]

The town's population at that time was under 10,000, including the 600–800 soldiers usually stationed in the barracks. Since Thomas's previous visit he had, he claimed, visited almost every Siberian town (far fewer than today) 'but in no town have I found the society as agreeable as in Barnaoul', which a few years later a visitor, the outstanding geographer and explorer Pyotr Petrovich Semenov (later honoured with the appendage 'Tyan-Shansky', 1827–1914[33]), called the 'Athens of Siberia'. He found, says Lucy, 'an excellent band … [which] executed most of the operas beautifully' under the baton of a St Petersburg-trained musician. Three ladies played the piano well and the winter saw three or four amateur concerts 'which would not disgrace any European town' as well as several balls which many young mining officers would attend, back from their posts in the Altai mountains.

Perhaps the place was exceptional because of the number of highly educated mining engineers based there, and the Atkinsons have certainly left us an interesting picture of its social life in the 1840s. Each family had to lay in their stores to last a whole year: 'woe betide the unlucky mortal who may have miscalculated his or her wants'. For every February the principal families would have to give the town's obliging apothecary a list of what they needed together with the necessary funds, and he would buy the items as well as the government stores at the great annual fair in Irbit, just east of the Urals, so that on his return journey he seemed like 'a wealthy merchant with a large caravan'. Lucy found that the ladies spent part of the mornings helping the governesses (yes, in Barnaul) educate the children and prided themselves on superintending the housekeeping.

> The domestic arrangements of a house … are rather a weak point with me. I never lose an opportunity of seeing all I can in this way; so into all the store rooms I went … [and found] groceries of every kind and description, with bins fixed round the room to contain them; then there are tubs of flour, boxes and boxes of candles [necessary before electricity] … and the neatness which prevails here, as in every other part of the house, was pleasing to see, and cleanliness reigned supreme.

The Atkinsons spent many a pleasant evening in Barnaul homes and on Sundays dined with the Director of Mines as did all the officers.[34] After dinner, Lucy says, all went home for a siesta 'without which I do not believe a Russian could exist' and in the evening between seven and eight the officers returned, now accompanied by the ladies. The younger ones would dance, the older ones play cards, at eleven supper would be placed on the table, and all would be home by midnight.

On Wednesday evenings one of the officers would entertain 'the little circle of friends' where the men played chess or cards and the ladies took their handiwork. Lucy found the first such evening 'a most agreeable one. I immediately felt at home, and as though I had known them for years. The time passed merrily.' Later,

the ladies begged Lucy to bring Thomas in with her and then she saw 'how much he was beloved by them; when he sat down they formed a circle around him, and told him he was the life of their Wednesday evenings', while on Friday evenings the two foreign visitors met under another roof for yet more enjoyable hospitality. 'What renders these meetings so agreeable', thought Lucy, 'was the simple and unostentatious way in which the people assemble together.' Moreover, almost every day in the summer someone organised a picnic, primarily for the children. 'The servants[35] are despatched beforehand with all the necessary apparatus for tea, and right merrily do all pass their time.' Young and old joined in games followed by 'charming walks in the woods' to pick mushrooms, wild fruit and flowers. On other days the men had shooting picnics, and Lucy found it 'mysterious' how they consumed all the wine they took with them 'and it often happens that a man returns twice or thrice for more champagne'.

One beautiful June day the Atkinsons attended a ball to celebrate the name-day of Madame Anosov, the wife of the Governor of Tomsk. It was therefore a special occasion. All dined at the General's at 2 p.m., the normal dinner hour, and there was dancing till late, interspersed by refreshments and strolls through the large gardens and 'really beautiful fireworks'; the whole day was 'one scene of gaiety'.

Thomas calls the General 'one of the most skilful and ingenious metallurgists of the age'. For many years he had run the production of steel here with a large blast-furnace, forging mills and all the processes to make steel. He had also designed the three-storeyed fire-proof workshops to forge swords, sabres and helmets; Thomas had not seen 'either in Birmingham or Sheffield any establishment that can compare'. Anosov had also, 'with much skill' and 'untiring assiduity', rescued from oblivion the long-lost art of damascening blades and perfected it. In the summer of 1847 he was made Governor of Tomsk and Chief of the Altai mines. Every year he would leave his many duties in Tomsk as Governor to spend three or four months in Barnaul, the administrative centre of the mines.

Below Anosov was Colonel Sokolovsky,[36] the Chief Director of Mines, in charge both of the mining officers and some 64,000 people in the mining areas. They were lucky to have two particularly able men in charge. Sokolovsky was not only a very experienced administrator but a well-known mining specialist and author of many scientific papers on the subject.[37] He had to travel each year more than 6,000 versts, mostly in mountain areas, by carriage, horseback, raft, boat and canoe, to inspect all mines and smelters. And annually between May and mid-October eight or ten young mining officers would be sent off, each with forty to sixty men, to explore closely the particular area assigned to them, each party provided with a map, dried black bread, tea, sugar and vodka, while they had to hunt their own meat – not difficult for the good hunters in each party.[38] Virtually all Siberia's gold would be brought to Barnaul for smelting and to be cast into bars which left for the St Petersburg mint, guarded by soldiers, twice in summer and four times in winter on the faster sledge roads, Thomas writes.

He was impressed both by the condition of the Altai's miners – in his

experience 'more wealthy, cleanly, and surrounded with more comforts, than any other people in the [Russian] Empire'– and by the mining engineers themselves,

> pre-eminent at the present day. No class of men in the Empire can approach them in scientific knowledge and intelligence. Among them are many in these distant and supposed barbarous regions who could take their stand beside the first *savans* [*sic*] in Europe as geologists, mineralogists and metallurgists.

Barnaul's distinction lay in being the main town of the Altai's immensely rich mineral deposits – copper and gold,[39] but particularly silver. A hundred years earlier the Crown had taken over the mines and metal works, and 90% of the Russian empire's silver soon came from the Altai, with its largest silver-smelting works in Barnaul. Thomas found the Mining Administration and all its officers lived here and, calling on Sokolovsky to present his papers, learnt that instructions had been received about him from the Ministry in St Petersburg (more than 4,500 versts away). The Colonel spoke a little English and had 'a most amiable' wife, and it was soon clear to Thomas 'that civilisation of a very high character had reached these regions, united with great kindness and genuine hospitality'. Sokolovsky as Director showed him round the silver-smelting works and the furnaces for gold-smelting (although these were not operating at the time), gave him a route allowing him much potentially interesting travel, letters to some of his officers at Altai mines and, most important of all, a Cossack guide who knew the region ahead very well.

He found the Ob 'a magnificent stream' in a valley twelve versts wide, split into many branches where large trees grew on islands. In June, the meltwater not just of the plain but of the Altai mountains to the south usually covers the entire valley between its two high banks. Only the tops of trees rise above the vast volume of water which moves slowly but relentlessly more than 2,250 miles (3,500 km) north across the great – and almost flat – West Siberian Plain towards the Arctic Ocean.[40] That year, 1848, saw the Ob unusually high so, unable to travel further, Thomas accepted an invitation in early July from Sokolovsky to join two others (and three dogs) in shooting double-snipe (*Gallinago major*) in the Ob valley, where 'thousands' could be found on the banks at that time of year. In less than three and a half hours Thomas had (with no dog) shot twenty-three, Sokolovsky forty-two, Barnaul's apothecary sixty-one, and Thomas's 'little friend from the Oural' seventy-two – henceforth known as Nimrod, 'the mighty hunter' – a total slaughter of 198 birds, according to Thomas's reckoning.

Thomas presented Lucy to all his friends in Barnaul from his previous visit, including the wives of General Anosov and Colonel Sokolovsky, and 'she was most kindly received by all'.[41] Next day the Colonel called, inviting them both to dine – 'we spent a few hours with them very pleasantly' – and Lucy gave their host Thomas's view of the Altai's Lake Kolyvan (which he had visited the

previous year) as a thank-you for the loan of his sledge, which had taken Thomas to Moscow and now brought him back with Lucy.[42] And after dining next day with General Anosov, they gave him Thomas's view of the Uba river, a tributary of the Irtysh.[43]

Although Thomas 'was working on his pictures', he succumbed to another day's 'splendid sport … These shooting parties are very pleasant and the Colonel takes care to have plenty of eating and drinking'.[44] When back in Barnaul, General and Madame Anosov called to see his pictures and 'were both much pleased. The General said I had painted Siberia as it is [and] that there was nature in all My Works and not Fancy.'[45] After dining with Colonel Sokolovsky the Atkinsons stayed till midnight for a dance. Then Thomas accepted Sokolovsky's invitation to a shooting (and sketching) trip about 250 versts east[46] to the river Mrassa and the upper Tom, leaving Lucy behind with their friends Colonel and Madame Stroleman, with whom they were staying.[47] It was, Lucy points out, Sokolovsky's annual visit to the goldmines.

The party was rowed down the Ob to a rendezvous with carriages (probably tarantas) and then set off fast[48] through 'thick woods' for many hours. At one point, finding plants growing higher than the carriage, Thomas got out and found that some measured 10 feet 3 inches high. Sokolovsky believed they had grown very quickly, and, on reaching the next village, established that they had indeed been under snow only five weeks before.[49]

While they had breakfast, Sokolovsky asked a Cossack why there were so many men about. He was told they were workmen meant to be going to the goldmines but refusing to go. Thomas's journal (which gives no reason for this refusal) records that Sokolovsky

> instantly sent for the Officer commanding the soldiers who said he had tried all he could to induce them to go but without effect. Having drunk our Tea, the Colonel opened the window and asked why they remained at the village. When one Man stepped forward and said they would not go, The Colonel ordred the cossacks to give him 50 strokes with the Rods. In a Moment his trousers were down and the rods at work. After receiving half a dozen he bellowed out he would go. In five Minutes they were all on the Road. Made two good Sketches on the River Tom.[50]

Thomas leaves his feelings unexpressed.

His journal entries for the Mrassa expedition end: 'This was a most unpleasant voyage. Six hours of Thunder and heavy rain. The effect of the Lightening on the river was very grand. One Moment a Flash that lighted up everything and

the next Thick darkness.' He resumes only eighteen days later, back in Barnaul, about to set off south on a major expedition, this time with Lucy. They left on 9 July (Lucy confirms) at midday, having sent[51] their spare baggage to remain with Sokolovsky, and arranged to meet him in Zmeinogorsk, some 300 versts south. The day was extremely hot and they found the level of the Ob had fallen nearly three feet, but it was nonetheless still very high. It took them almost five hours to cross, and on the other side it was difficult to get their carriage through the deep mud.[52]

They drove on and woke with the dawn to find they were travelling over what seemed a new country, flat, uninteresting and with very little forest. That afternoon they saw at last a dim outline of the Altai mountains, still very distant, crossed several small rivers, drank tea 'at a most uncomfortable place at 8 oclock' and then late that night Thomas found he had lost his shuba or long heavy fur coat (so necessary for winter, 'the only warm covering we had, and, besides, very expensive', wrote Lucy). Their Cossack coachman took one of the horses and went back to find it. Hour after hour passed. He at last arrived with the shuba about 5 a.m., having ridden twenty versts and back to find it, ironically, only about two versts from where they were.

At Biisk, their next stop, a small town in the Biya valley, the *ispravnik* (chief of constabulary) received them very politely and immediately ordered all preparations to be made for their onward journey, which included provision of 'an interpreter, another Cossack and "vodky for the men"'. Colonel Keil, the officer in charge of the Cossacks, 'a most gentlemanly man', Lucy calls him, called on them and invited them to tea.

The police chief entreated them to stay a few hours longer for the ball given in honour of his wife's name-day. Thomas's journal records solely that 'We supped with them and then departed at 11 oclock', but Lucy, far more interested in people than her husband was, recalls first that her own costume, 'though exceedingly pretty …, [was] not according to our English notions'.

> The material was grey *drapes de dame*, made short with Turkish 'continuations', black leather belt, tight body, buttoned in front, small white collar and white cuffs, grey hat and brown veil: in this costume, minus the hat, I entered the ball-room. Here we found the ladies seated in chairs, stuck close together all round the apartment, and each lady having a plate in her hand filled with cedar nuts,[53] which she was occupied in cracking and eating as fast as she could; their mouths were in constant motion, though every eye was turned upon poor me, who would gladly have shrunk into one of the nutshells.

The Atkinsons stood talking with Colonel Keil, and were sorry to see so talented a man, who was possibly of English descent, compelled to associate with the sort of people present.

He said he rarely mixed with them; there were times when he was obliged to attend these gatherings [at Biisk]; that night, on our account, he had been induced to accept the invitation. He continued: 'Not one single associate have I here, and, if you will come with me, I will show you how rationally they spend their time....' We ... found the gentlemen at cards, some quarrelling over them, others drinking hard, and, again, others who had already had more than a sufficiency. 'Drink', the Colonel said, 'I cannot; in playing cards, I take no pleasure; so I spend my time with my books, or I go alone to shoot: thus I pass my leisure hours.'

I [Lucy] enquired if the ladies were always as silent as I now found them? 'Yes; when any of the opposite sex are present, but when alone for a short time, the noise of these men is nothing in comparison with theirs; and now they have a theme which will last for months; that is your visit.'

At 11 the Atkinsons left, anxious to be off, and found the ascent out of the Biya valley difficult. The frequent vivid lightning kept them awake but allowed them to notice the landscape (and Lucy seems to have copied Thomas's journal here almost word for word):[54] for some distance small, round treeless hills overlooking the valley: 'the scenery ... very pretty, particularly at dawn ... dark Pine Forrests as far as the Eye could reach with fine bold mountains in the distance'. They arrived at the village of Saidyp, and almost immediately were greeted by a distant thunderstorm in the mountains. Cossack families, the only inhabitants, assured the Atkinsons 'for our comfort' that they would meet such storms in the mountains every day.[55]

They were at last entering the Altai mountain region, and here at Saidyp the travellers had of necessity to leave all inessential items behind. No carriage could penetrate any further, so the journey onward over mountains, through forest and across rivers had to be on horseback. When the horses were ready the women came to see Lucy off, following a short distance to wish her a good journey. 'One old woman with tears in her eyes had entreated me not to go, no lady had ever attempted the journey before. There were Kalmyk women living beyond but they had never seen them'.[56] Earlier that day the same old Cossack woman had offered to let her daughter come on the journey to take care of Lucy: 'however, when the daughter came in, a healthy, strong girl, some thirty-five summers old, she stoutly refused (to my delight) to move; the mother tried to persuade, and did all she could, it was of no use; and I was left in peace'. Lucy went on:

We now mounted our horses [and this was the beginning of many weeks in the saddle], I riding *en cavalier*. I must tell you that I took from Moscow with me a beautiful saddle, which I was occupied one day in Barnaoul examining, when Colonel Sokolovsky entered. He demanded what I was going to do with it; my reply was, 'To ride: I

cannot do so without one, and the Kalmuks, I presume, have no such things.' 'No!' said he, sarcastically, 'and they will be enchanted to see yours; but what will please them most will be the sight of an English lady sprawling on the steppes, or with a broken leg in the mountains. But', said he, 'seriously speaking, you cannot go with such a saddle: first, the horses are not accustomed to them; and secondly, in the mountains it is quite out of the question.' He then offered me one of his own, which I accepted, and left mine until our return; and thankful am I that I did so.... Our horses have stood on many points, where we could see the water boiling and foaming probably 1,000 feet below us; just imagine me on one of these places with a side-saddle!

The party now consisted of the *tolmash* (interpreter), '*my* [author's italics] Cossack' according to Thomas's journal[57] (why not '*our*'? one might ask), five Kalmyks and eleven horses. They reached the river Biya, here broad and deep, and found the grass and plants growing high above their heads even on horseback. Thomas shot several ducks and they caught good fish for their supper, Lucy records:

> That night, for the first time in my life, I had to sleep *à la belle étoile*, with my feet not ten paces from the Bia. First a voilok was spread on the ground, over that two bears' skins, so that no damp could pass through. I lay down, of course without undressing. The feeling was a strange one; sleeping in a forest, the water rippling at my feet, and surrounded by men alone.[58]

Next morning they rode off at 6 a.m. and began to climb 'over high and abrupt mountains, affording fine views of this vast mountain chain'.[59] They stopped at a Kalmyk village to 'dine off most exquisite fish, caught fresh from the stream', according to Lucy, proceeded with more difficulty and were ferried across another river, the Lebed (or swan). Unusually, 'Lucy began to flag', but they needed to reach a second Kalmyk village and did so in the evening, having travelled 65 versts that day, some of it in heavy rain.[60]

After some 'good Fish and Fruit', a balagan was erected for them, so Lucy for one slept better and, by hanging up a sheet at its open side, was able to undress. Thomas 'had been in the habit of sleeping among these wandering tribes' without undressing and, telling him she would soon be 'knocked up' if she did likewise, she advised him to follow her example, which he began to do to his benefit. In the pavoska she had 'invariably unfastened every string and button before lying down. How delighted I felt this night to stretch my weary cramped limbs!' Although Lucy did not feel in the least tired on horseback, the first two or three days when she was helped off her horse she could not stand for several minutes and, determined to conquer this weakness, dismounted on her own, refusing any assistance – and walked, for a moment fearing she would fall. Thereafter she had no more problems.[61]

The next morning, Lucy had 'rather a narrow escape' when they had to ascend some high granite rocks, which the horses found very difficult. Near the summit her horse stumbled and slipped back, placing her in great danger. But she managed to keep her seat, got her horse up 'and [was] proud enough, I can tell you, to have won the admiration of the Kalmuks, because they are splendid riders'.

After nearly fifty versts, now travelling over high and broken hills covered either by dense pine forest or tall grass and plants, they reached another Kalmyk village where they were given fresh fish and plenty of fruit. They were just ending dinner and about to depart when they saw a young, pretty black-eyed girl running fast towards the Biya,

> which, at this point [Lucy writes], runs boiling and foaming at a fearful rate over large stones. There was a look of wild anguish on her face. We then saw a man on horseback galloping after her and a number of others following. The instant she reached the stream, she leaped into the boiling flood; at the same time, tearing off her head-dress, she threw it at the man on horseback, and was instantly carried down the river at a frightful speed. A great rush was made to save her; several jumped on horseback and galloped along the banks as hard as they could; when some distance beyond her, one of them sprang into the stream and succeeded in catching hold of her, and with much difficulty brought her ashore.[62] [Here she was following closely the words in Thomas's journal.]

It then emerged that the man following her on horseback was her brother and guardian, come to take her back to their village and force her to marry a rich old man when she was enamoured of a village youth. To avoid this fate she preferred to drown. After a time, however, she began to show signs of recovery, and the Atkinsons started on the day's long ride. On their return, they descended the Biya by raft so were unable to stop at the village and, says Lucy, never learned the fate of 'the young damsel so miraculously saved; no one had expected she would be taken out of the water alive'.

Inevitably they were 'up and off early' next day with some very difficult passes to negotiate over granite mountains, in places 'quite perpendicular down to the River. Our Horses stood on many points where we could see the water boiling probably a Thousand feet below us. Lucy rode over these places without quailing in the least', wrote Thomas proudly.[63] Once descended to the river bank they found a good route ahead, the ground covered with bilberries 'on which we made a glorious feast', and after a very long ride stopped to dine at another Kalmyk village. Here they came across 'another curious scene' (both use the same words): an old woman surrounded by six men and nearby a group of girls round a very pretty girl of sixteen or so, cracking nuts with apparent unconcern. As soon as the Atkinson party appeared the girls came up to Lucy, offering her nuts, and some went off to pick bilberries for her. The pretty girl stayed where

she was but kept looking at the men and the old woman, who, it turned out, was her mother. The men, of very different ages, were the girl's suitors, one of whom, Lucy says, the mother thought 'a most desirable match', but the girl wanted none of them.

Thomas was 'now called upon to decide the case, whereupon he took his seat upon a piece of rock'. The mother and the suitors surrounded him, the Atkinsons' interpreter by his side. Lucy describes the scene:

> Each … [suitor] pleaded his cause with much earnestness and apparently with great eloquence and fervor, but their words seemed to fall upon the ears of the maiden without effect, as she remained immovable.
>
> One … described the impression her beauty had made upon him, another spoke of his rank, a third talked of his skill in the chase, a fourth of his strength … a fifth of the care he would take of her in sickness as in health; but the most eloquent of all was an old man, who became greatly excited in his long speech about his possessions, cultivated land, herds of cattle, and position as the chief of the village, and finally of the great love he bore towards the maiden; how he had watched her day by day from childhood…. The speeches were translated to Mr Atkinson, who … asked her … which of the suitors she preferred … if she were allowed to choose (she said), she should not consent to take any one of them; as none of those present pleased her.
>
> I then suggested' [Thomas's journal records] that the girl should remain with her Mother untill some one proposed … more to her wishes this satisfied all parties and our Court broke up.[64]

They rode on through a pine forest on a day so intensely sultry with not a breath of wind that Lucy two or three times fell asleep – and actually dreamed – on her horse. They stopped for the night at the last possible resting place before their objective, Altin-Kul, the 'Golden Lake' (now Lake Teletskoye). This was to be their furthest point east in the Altai, far east of Europe and north indeed of what was then Ceylon (now Sri Lanka). A large balagan was soon prepared for them, covered only with grass as there was no birch bark around, and a good wood fire was made close by. They settled into their bed and woke two hours later with 'the thunder roaring and the lightning flashing' (Lucy's words) and (now Thomas's words) 'the Rain pouring down in Torrents [and] our bed and everything drenched. In fact we lay in water without any means of shelter and thus we continued untill daylight'.[65]

When they rose before dawn it was more like turning out of a vapour bath, thought Lucy. But at least it soon looked like a fine day, and a good fire was made to dry their things. They 'ordred' tea as soon as possible and started off at 7. Scarcely a verst from their camp, Thomas's journal relates,

We found the rocks so high and abrupt that we could not ascend; this compelled us to go round a point jutting into the River which runs at this place over large stones making a great rapid. Round this point was a narrow ledge on which the Horses can go but up to the saddle-flaps in water. The greatest care is required to pass along. Once off the ledge you are in deep water and carried away amongst the Rocks. All past well except Lucy. The Cossack who led her Horse did not keep him close to the rock. In two or three steps he was in deep water and swiming. Our guide saw this and called to the Cossack to hold the Horse fast by the Bridle or they would both be lost. Lucy sat quite still (tho' the water filled her Boots) and was drawn around the point and landed in Safety. This was truly a most dangerous place. [Lucy's account here copies Thomas's journal entry almost word for word.] Our road was now along the Rivers bank for about two versts but now the mountain must be ascended, a work of difficuly and danger still we pushed on tho Slowly.[66]

The mountainside was indeed so steep in parts that their horses often slipped back – 'I do not exagerate', Thomas's journal records – and, reaching the summit at last,

a splendid view was spread out before us: immediately under our feet ran the River Bia which we could see winding its course among the mountains like a thread of Silver. Looking to the West the Mountains rose far above the Snow line, their Summits beautifully defined against a deep blue sky. The nearest mountains were clothed in beautiful Foliage of a fine warm green shading … into the distance with purple and Blue while the foreground on which we stood was covered with 'Feather Fern,'[67] large plants and long grass equalling in Luxuriant [luxuriance] plants grown under a tropical Sun. [Once again, Lucy uses Thomas's words here almost identically in her book.]

Three hours' ride took them to the far side of the mountain and the start of a very difficult descent to the Biya, 'without accident', which Thomas again underlined in his journal, and after another hour, as the sun was setting, they reached Altin- (or Altyn) Kul, from which the Biya flows. This long and particularly deep lake, known and famed for its beauty and clear water, is set among unspoilt and unpopulated steep forest-clad hillsides down to the water's edge. Thomas found it 'one of the Most lovly spots in the world….We stood looking on this picture for a long time enraptured by its beauty.'

Many Kalmyks gathered to 'receive' the Atkinsons – a great curiosity to the locals – and that evening they crossed the lake in a small boat to a Kalmyk aul or encampment of a few wooden houses with birch-bark roofs and a hole in the centre to let out the smoke, with only cooking utensils inside plus one

or two boxes for meagre possessions. Lucy was presented with a large bunch of wild onions which the visitors were to find in abundance on the lake's shores, eaten (along with many other bulbous roots) in large quantities both by Cossacks and Kalmyks.

Thomas was travelling with his flute (of which there has been no mention before in his journal) and half-way back across the lake he began to play several tunes 'to the great astonishment and delight of our new friends.'[68] On landing they all came round us and begged … that he would play again.' According to Lucy:

> The power he thus gained over these simple-hearted people by his music was extraordinary. We travelled round the lake in small boats, it was a tour of eleven days, and in all that time he never once lost his influence; like Orpheus, he enchanted all who heard him; without a murmur they obeyed him in everything; indeed, there was often a dispute to ascertain which might do his bidding; and there was no lack of hands to spin the line which was required to sound the lake.

They woke up next morning to what seemed a lovely day 'rendering the scene even more enchanting than yesterday' and spent it preparing for their long journey round the lake (approximately 78 km long but only 2.5 km wide). They set off in two canoes fastened together[69] 'having the good wishes of all our new Kalmyk friends for our success and safty'.

'As we advanced', wrote Lucy, 'each turn appeared to open out new beauties to our view' and Thomas found a good scene for a sketch looking east. He was struck by 'the fine cedar trees which extends up the mountain to a great hight' over-topped by precipices of dark grey rock. 'Looking up the Lake the Mountains vanish off to a great distance shaded from a deep Madder into rich purple and blue, forming altogether a most lovly picture'. Thus the artist.

> Having completed my drawing we passed on, but on looking west it was very evident a great Storm was following us. This made us push on as fast as the men could pull that we might find some place to shelter in case the Storm reached us…. The Kalmucks seemed to know what was in store for us [they had warned the Atkinsons that if caught in a storm – frequent on the lake – nothing could save them] and worked hard to reach a little head land formed at the mouth of the first small mountain Torrent. Having rounded the point they ran the boats ashore and hurried us out dragging the boats high out of the water. They then ran with us up to some trees in the hope of affording us shelter. These opperations did not occupy five minutes, but this was even too long to save us a wetting – I … found we were landed on a Mass of Rocks and Earth brought down by the Torrent, on which Cedar Trees of great size were growing. Under one of these we now stood….

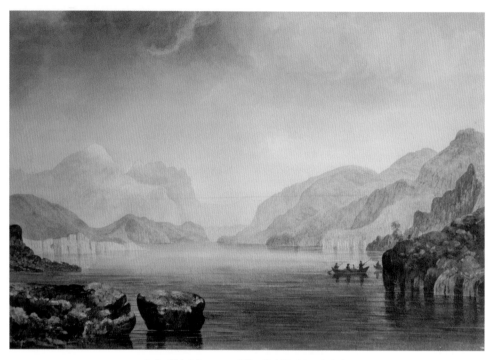

Lake Teletskoye or Altin-Kul (Golden Lake)
This beautiful lake in the Altai mountains, some 57 km long, delighted both Lucy and Thomas, who produced many sketches. They spent several days here being rowed round the lake in canoes by the local Kalmyks. A long description beneath the painting is possibly in his hand.

Turning westward, the Effect was awfully grand. The Clouds where rolling on in black masses covering the craggy summits near us in darkness, while above these white clouds were Rolling and curling like steam from some mighty chaldron. The Thunder was yet distant but the Wind was heard approaching with a noise like the Roaring of the Sea in a great Tempest. On looking down the Lake ... the water we had looked upon ten minutes before calm and reflecting everything like a mirror was now one sheet of white foam, driven along like snow. (Had we been caught in this our boats would have gone down instantly)....

The storm appeared at this moment to be concenterated over our heads and made us go, like the Kalmuks, further into the Wood for shelter. Having taken up our station under a large Tree, the Lightening began to descend in thick streams tinging every thing with red. Almost instantly I heard the crash of a large tree struck down not far from us, while the Thunder rolled over our heads in one continued roar. Lucy said 'I never understood the passage in Byron[70] before in which he said "The Thunder dansed."' The Storm continued for more than an hour, and then all was calm and Sunny.[71]

Thomas regarded Altin-Kul's 'magnificent scenery'[72] as offering him great scope. He made another view looking east where the lake expanded into a fine broad sheet of water with numerous jutting headlands covered primarily with birch and large 'cedar' trees, a pleasing contrast to the often sheer slopes leading down to the water.

Every day there were storms on the lake, as the Kalmyks had warned, and to Thomas, 'the Effect was very fine'. Of one some versts away in the mountains, 'the Echos amongst the crags and rocks where repeated many times, almost inducing us to believe the Thunder came from Each mountain as it died away in the distance'. But none ever made the same impression on Lucy as that first storm: 'awfully grand and never to be forgotten'.[73]

The scenery may have been magnificent, but food was a problem. There were only two poor villages along the lake, although a goat at least was procured from one. Thomas shot some ducks, but game was far from plentiful, and no fish could be had so far. (But this is a very rare discrepancy in their two accounts: as quoted earlier, Thomas found the fish 'the most delicious' he had ever tasted.) According to Lucy, necessity compelled them often to eat a species of crow, 'extremely disagreeable, hunger alone enabling us to eat them'.

Thomas's journal remains blank for ten days other than a note recording who sat in what boat. But Lucy takes up the tale: when the men reappeared after dark with the goat's carcass, the cauldrons were soon at work over blazing fires. The Atkinsons went off for a short walk along the shore and, on returning,

one of the wildest scenes I [Lucy] had ever witnessed came into view. Three enormous fires piled high were blazing brightly. Our Kalmuk

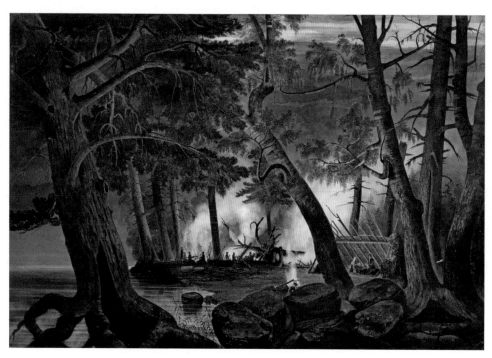

'A night scene at our encampment on the Altin-Kul [Lake Teletskoye], Altai Mountains', 1849

The Atkinsons are in their leafy balagan at one side.

boatmen and Cossacks were seated around them, the lurid light shone upon their faces and upon the trees above, giving the men the appearance of ferocious savages; in the foreground was our little leafy dwelling, with its fire burning calmly but cheerfully in front of it.[74]

Lucy had learned to shoot quite well, having practised in case of an attack. She was well armed, not only with the small rifle given to her by Mr Tate but also the shotgun presented to her by Astashev, as well as a pair of pistols she kept in her saddle. On one occasion she saw a squirrel in a tree and, having her rifle in her hand, somewhat astonished, shot it as she had never aimed at anything before but inanimate targets. One of the Kalmyks was delighted, patted her on the back, ran to retrieve it and begged her that he could have it for his supper. Lucy, who gained great renown for shooting the squirrel, agreed provided the skin was hers; she wrote that the Kalmyks seemed not to care what they ate and would always consume any lynx which Thomas shot. (But none were mentioned.)

One night on the lakeside the Atkinsons had a visit from some twenty Kalmyks, 'ferocious-looking fellows':

> seated around the blazing fire, with their arms slipped out of their fur coats … hanging loosely around them, leaving the upper part of their greasy muscular and brawny bodies perfectly naked, and nearly black from exposure to the air and sun, and with pigtails, like those of the Chinese [Kalmyk men shaved their heads completely other than a small section on the crown from which grew a long tuft of hair[75]], their aspect was most fierce; and still more so, when they all commenced quarrelling about a few ribbons and silks I [Lucy] had given to our men.

The latter had tied red strips from Lucy around their necks, so she gave some to the new arrivals too, thinking how ridiculous it was to see 'these great strong men' take delight in such childish pleasures. And yet, she thought, 'how many men in a civilised country take pride in adorning their persons … and these simple creatures were doing the same, only in a ruder manner!' Nonethelesss, the quarrelling still continued and Lucy realised they were drunk; only near midnight did the Atkinsons manage to get rid of them.

Ferocious-looking perhaps, but Lucy pitied the Kalmyks for having to pay tribute to both the Chinese and Russian emperors, being so close to the Chinese border. (This system of 'dual tributaries' lasted until as late as 1865.[76]) Lucy also found them 'extremely good-natured'. Whenever they saw her trying to climb up rocks to pick flowers or fruit, they would climb instead, even in really difficult places. Once when she saw from a boat some 'china-asters', *Callistephus chinensis*, growing in what seemed a totally inaccessible cleft in the rock, a Kalmyk landed from his canoe and clambered up, to Lucy's great alarm, hanging only on to slender branches growing from the rocks. In addition, whenever Thomas was busy and Lucy went off after flowers or fruit, their Cossack Alexei (whom she

writes of as 'Alexae' and he as 'Alexa'), 'a giant of a man', always thought it his duty to follow her at a respectful distance and, when unable to go himself, would send a Kalmyk instead.

As they returned to their original starting point around the lake, they experienced their last storm at Altin-Kul. It was 'grand to look upon – beauty of a different character', thought Lucy. And here they found (allegedly at last) 'some most delicious fish, about the size of a herring, only more exquisite in flavour; indeed [wrote Lucy], I never tasted anything to compare with them'. It must have been the same fish that had so enraptured Thomas. Salting a whole barrel, they sent it to Colonel Sokolovsky by a Cossack returning to Barnaul and left the 'Golden Lake' with regret; 'in years to come ... how many a pleasant hour we shall pass in recalling to mind these times! Even now, as I glance at the sketches each one has a tale to tell of joy, or dangers escaped'.

II. Zmeinogorsk and the Silver Mines

Since many of the Altai peaks are still unnamed and the Atkinsons seldom mention any names, it is possible to trace their route roughly only by the names of rivers and valleys. However, Thomas, if not Lucy, describes their ascent by horse and then foot up the north side of the 100 km-long Kholzun range (he spells it 'Cholsun') which rises to 2,599 m,[77] reaching one of its bare granite peaks far beyond the last stunted cedars, having passed a small depression where the horses trampled up to their saddle-flaps on a beautiful bed of aquilegia in full bloom – variegated blue and white, deep purple and purple edged with white. 'Fortunately', he writes in his first book, 'I obtained plenty of ripe seed' but, frustratingly, he does not tell us why or what he did with it. Nearby was *Cypripedum guttatum* (Spotted Lady's Slipper, a species of orchid) with white and pink flowers – which he had already found in the Urals – and also deep red *primulae*, flowering in large bunches. It is obvious that he obtained his knowledge of geology from those early years as a mason, but where he learned his botany, which he knew far better than Lucy, remains a mystery. However, it was the views that really mattered to him and he considered

> The views from this part of the [Altai] chain, (which is not the highest) are very grand. On one side Nature exhibits her most rugged forms, peaks and crags of all shapes rising up far into the clear blue vault of heaven; while on the other, mountain rises above mountain, rising into the distance, until they melt into forms like thin grey clouds on the horizon.

Leaving the mountains, they had a raft made, on which they descended the Biya back to the Cossack village of Saidyp. There the elderly woman, who had begged Lucy not to go to Altin-Kul as no woman had ever attempted the journey before,

now discovered that Lucy was planning to go roughly twelve times further, to the Cossack fort of Kopal in the middle of the Kirgiz (now Kazakh) steppes far to the south. Kneeling down before Lucy, she bowed her head to the ground and said, '*Matooshka moi*' [correctly *Matushka moya*, 'My little mother'] (evidently Lucy's eight years in Russia had taught her conversational Russian but very little Russian grammar), 'Pardon me, I have a great boon to ask of you.'

Amid many tears, she told Lucy that she had a son in Kopal and told her of his wretched condition with no house to live in and little food other than bread, while at Saidyp there was plenty. She begged Lucy to take him a present and Lucy naturally agreed, 'but, oh horror! she gave me sufficient to load a camel'. However, the load was finally reduced to a manageable parcel containing some wax, a tub of honey, and so on, but it was to give the Atkinsons a lot of trouble on their journey, as the honey – a great feature of the Altai then and now – kept oozing out of the tub. The Atkinsons found that every Altai 'cottager' kept bees, and everywhere they stopped they were brought a plate of honey, pure, transparent and liquid with an exquisite smell, 'and it tasted of almost every flower we had met with in the Altai'. The Cossacks themselves often got honey from wild bees. When later in Kopal with the honey she asked for the man, 'three came all of the same name' and it was handed over to one from Saidyp. A couple of hours later a Cossack 'quite breathless from running' appeared, the rightful owner, and Lucy was glad to hear that 'he got everything but the honey, almost all of which was consumed' by his colleagues. However, he was 'quite consoled by hearing news from home'.

The old woman had made Lucy smile by telling her she must not let any Cossack know the parcel was not hers, as there would be none left by the time they reached Kopal. Only later did Lucy understand from her own experience what she had meant. She and Thomas were to have many Cossacks in their service 'but never found them otherwise than willing, trustworthy men; without asking, they would never have taken a pin belonging to us; they might have been trusted with untold gold; but not so with regard to those who were not under their care and protection, they would then take the first thing they could lay their hands on'.

A Cossack officer later explained to Lucy that the Cossacks' pay was not enough for their needs, not even enough to buy a uniform, and yet they were always expected to have one in good order, 'and besides', he added, 'we must have a horse; so what are we to do? Why, steal one.' And not only horses, Lucy discovered. At one time the Atkinsons thought such conduct reprehensible, but they came to blame the system far more. As for the soldiers of the regular conscript Russian army recruited across the Empire, they found them a different race of men, judging (unfairly) from the only two they ever had as escorts; Lucy considered they could not be trusted with anything and were 'a low class of individuals [most would be illiterate peasants], whereas the Cossack is a gentleman, and most of them educated men', an over-generalisation, perhaps based on the individual Cossacks specially chosen for them.

From Saidyp the Atkinsons turned west to the north-flowing Katun river;

'again I made 1,000 versts on horseback', wrote Lucy. It took them three weeks thanks to Thomas's many sketches on the way (unfortunately, not in his list for 1847–8) and Lucy found parts of their route 'frightful'. One morning they crossed an interminable succession of plateaus, crest after crest:

> but when we did arrive at the highest point, what a scene lay before us! There stood the Bielouka in all his majesty, the sun was just shedding his last rays on this giant of the Altai, he appeared to stand out so proudly from all the surrounding mountains, looking like a ruby encircled by diamonds, into which his colour was slightly reflected. I was lost in admiration at the beauty of the scene, even the men drew up their horses and gazed at the spectacle, exclaiming '*slavonie*' [*slavnie*, glorious)].

That day they reached a point which only one horse could pass at a time. On one side were perpendicular rocks, on the other, wrote Lucy,

> a fearful abyss, down which, I know, few would care to gaze, and where rocks were strewn about in mild confusion; one false step of the horse would have hurled both him and his rider into the awful depth below. One of the Kalmuks wished to blind my eyes, and lead my horse by his bridle, but I would not consent to the arrangement, nor even allow anyone to touch my horse. I had learned from experience that where there is danger, it was ever better to trust to the sagacity of the animals, who appear to have a full knowledge of the difficulties they encounter. At times you see them place the foot and try whether all is safe; if not, they go to another place; and what hardy animals they are! None of them are shod – everything is nature here.

They now began the descent, far worse than the ascent. Rocks lay everywhere, but at dusk they reached a plateau where 'the men' proposed the party stay the night. Their Cossack, Alexei, however, said it was not far to the foot of the mountain, so they continued their descent, but each step was now worse than the last. When night fell they found they still had to continue 'as there was not a foot of ground on which to encamp'. In addition, the pass they were traversing became so narrow that they had to ride in single file with Thomas in the lead, followed by Lucy and then the others. For some time they had heard the roar of a waterfall to their right. Now it became deafening and brought down rocks and stones with it so that their escort was continually shouting out to keep to the left. But voices now could no longer be heard, so 'with a beating heart' Lucy stooped forward on her horse, 'trying to penetrate the gloom'. Now and then she caught a faint glimpse of her husband's white horse ahead and, finding it useless to even try to guide her own horse, gave it the reins, trusting it to carry her to safety, which it did.

'After some tense and weary hours' they reached the bottom of the pass, and

fortunately could proceed on level ground to the village of Kokshinska (now Kokshi) which they reached at last. Lucy had been on her horse for so long that day and on such an exceptionally difficult route that when she dismounted she found she could not stand and had to be led: 'my limbs were so benumbed.... There was no possibility of giving way to fatigue on this journey; I had all kinds of duties to perform'. But after lying down for only a few seconds she recovered, and the next day, after bathing, presumably in the Biya, she was totally herself again. Her stamina she attributed to her bathes almost every morning and evening in the summer – sometimes even in the middle of the day as well.

She was having breakfast the morning after their arrival when she noticed a peasant girl running at great speed: 'breathlessly she came into the room to gaze at the wild animals, who, by arriving the evening before, had raised such a commotion in their peaceful valley'. Lucy spoke to her but got no answer so continued her breakfast. The girl stood silently for nearly half an hour and Lucy, wanting to get rid of her, gave her some beads (of which she had a good supply) for a necklace. Still she would not go and, after critically examining Lucy, at last she spoke.

> They tell me you came down that mountain last night' [she said, indicating the Atkinsons' route of the previous day], 'is it true?' ['Yes' replied Lucy. The girl looked at her for some time, then said,] '*Ne oojalee pravda*' [is it really true?]; why, we look at that mountain with dread in the daytime, and you, you came down at night!' and again she stared as though her eyes would start from their sockets, repeating with even more astonishment than before 'but is it true?'

Lucy's audience grew steadily and the questions proved endless, for in this remote place women visitors were almost unknown and 'an Englishwoman was an object of which they had no conception'. A recurring theme was: had Lucy ever seen the emperor? Many times, she replied (having lived in St Petersburg for eight years), but never spoken to him. And what were the grand duchesses (Nicholas I's daughters) like: were they pretty? Lucy had to describe how they dressed and what ornaments they wore, and her hearers were excited to hear that the Grand Duchess Olga was married. So now, they asserted, she would wear a handkerchief on her head (the Russian peasant custom). Lucy had difficulty in keeping a straight face, but shocked her new friends by telling them that 'the daughter of an emperor never wore a handkerchief on her head either before or after marriage'. 'Indeed', she wrote later, 'I am not sure whether the Imperial family have gained in the estimation of their worshippers by my visit. They are looked upon as something divine by these simple-minded but kind-hearted people.'

What greatly astonished Lucy was the dirty habits of these inhabitants (presumably meaning lack of washing) of one of the loveliest valleys in the world. 'They are surrounded with every comfort they can desire; and a pure crystal stream running close to their dwellings, and yet they are swarming with

vermin of a most disgusting character!' Lucy preferred sleeping in the open air despite the creatures which crawled over her outside, which she felt were clean compared to those she met in the dirty 'cottages', yet their walls, tables and floors were kept spotlessly clean.

The Atkinsons had intended to go to the Altai's as yet unclimbed and eternally snow-clad Belukha,[78] Russia's highest mountain east of the Urals after Kamchatka's active volcano, Klyuchevskaya Sopka. The men, horses and supplies had been prepared for the climb, but after those previous days in the mountains, Thomas reluctantly concluded that they would have to return, the middle of August being far too late. A month earlier yes, but now 'had we persisted … we might all have perished'. Lucy, ever indefatigable, 'would gladly have accompanied him had he determined to go on', but she was relieved by his decision. So much snow fell one night indeed that their escort, sleeping in their long, thick shubas round the camp fire, had by morning become mere white mounds with the fire still burning brightly. The snow, they claimed, had actually helped to keep them warm as the wind could not penetrate the snow's protection. Riding onwards that day they looked 'like a band of wandering spirits clothed in pure white, riding on horses with black legs'. Descending to the Katun river they found much succulent fruit: masses of black and red currants and enormous raspberries, too big even to put into the mouth whole. They camped in a sun-drenched spot on the banks of the river, a welcome change from the mountains, but were plagued by mosquitoes and a small, bright green fly which bit Thomas's hand and caused him pain for many days.

They descended the very fast-flowing Katun in a canoe, steered by a Russian 'with great dexterity' over the falls. He was proud to land them safely and told them no one else would have attempted it, and this was indeed confirmed by his village. They planned their return to Altai Volost (the area of the Altai then under Russian administration, not the mountains) by a new route across the attractive, peaceful Yabagan river valley to reclaim their pavoska and stopped at an aul where an old shaman[79] was offering up the sacrifice of a ram 'for multitudes of sheep and cattle', accompanied by his 'wild chant' and much thundering of his tambourine, as Thomas writes. The shaman was horrified at being sketched by him, believing that the latter would always have power over him, but before the visitors left he beat loudly on his tambourine, offering up a prayer ostensibly for the Atkinsons' safe return to their native land, although Lucy suspected it was rather more likely to be a thanksgiving on their departure.

They set off at a sharp trot towards the village of Zyrianovsk across an uninteresting steppe, but stopped for a good view of the place and the picturesque Eagle Mountain beyond, behind which the sun had just set. Thomas once more enthused (exaggeratedly with artist's licence?) about the 'most gorgeous effect': deep yellow in the lower sky 'shading upwards into silvery grey; thin fleecy clouds of a crimson colour beautifully scattered over the horizon, rendered still more brilliant by their contrast with the purple tones of the Eagle Mountains … the foreground … a rich reddish-brown and dark grey'.

The party rode into Zyrianovsk at dusk, their progress impeded by innumerable barking dogs which tried to nip the heels of the horses. 'Some of them felt the effects of our heavy whips, which sent them howling, and raised a concert of canine music, enough to rouse the whole population to arms.' The village itself was situated at the edge of an extensive marsh which, together with its bad water, made it extremely unhealthy. At the time of their visit the hospital contained great numbers of the sick, and deaths were common, the numbers of workers continually replaced from other villages in the region, for Zyrianovsk at that time possessed the most valuable silver mines in the Altai with extremely rich ores. Thomas worried about the problem of flooding, as he had done at Zmeinogorsk (see Chapter 1).

They continued their journey back to Altai Volost, and the rain now started to descend in torrents. All morning they climbed, the track worsening for the horses and thick clouds enveloping them, so they were glad when they began the descent. They spent the night at the isolated dwelling of an old hunter and his wife, although Lucy, remembering the 'horrors' she had met at Kokshinska, would have preferred to encamp outside, despite the pouring rain.

She had not got her hat off before the ever-solicitous Alexei appeared in the room with a large soup plate of preserves and a wooden spoon which he placed before her, but she was too busy getting her wet things off to eat, soaked to the skin as she was. 'The most extraordinary thing', she was to write later, 'is that with all the wetting I got, I never took cold.' And while Thomas (admittedly much older than Lucy) was ill several times, Lucy was ill only once, when she was bled and had leeches applied.

As they had to get up early next morning, Lucy made the bed and lay down:

> Sleep is never long in overtaking the tired travellers. How long I lay I cannot tell, but weary as I was I was awoke by a horrid sensation on my body. I struck a light to see what it was, when, oh! Horrible, my nightdress and the sheets were one black mass of bugs. For a second I scarcely knew what to do; however, I commenced sweeping the invaders off by hundreds, I might say thousands.

At last she and Thomas cleared them off and she was just dropping back to sleep again when she was woken by the same stinging sensation, 'and the same ceremony had to be gone through'. An old coat she had thrown on to the foot of the bed was swarming with so many insects that she opened the door and threw it outside. She then kept the only lit candle they had to allow her to continue her

> wholesale warfare … and greeted the first streak of light with great pleasure, tired though I was. When the old hunter entered our room he asked with a profound bow how we had passed the night. When I told him he calmly said, 'Ah! They never trouble us; I suppose we are accustomed to them.'

Early that morning they said goodbye to their host who begged Thomas to present a petition he had had drawn up to the governor of Tomsk, asking permission to move his place of residence to another valley, build a small house there and grow corn (a revealing sidelight on the restrictions of a simple couple's movements in such a remote place). The Atkinsons were glad to be able to do something to return his kindness and hospitality both on their way to and from the Katun.

On their journey they were intrigued by the method Alexei used to procure horses. Whenever a change was required, he would send a man forward at the gallop to the local Kalmyk tribe, his cap held high on a long stick or branch, and, when the Atkinsons arrived, they always found the horses ready. Alexei explained that Cossacks always travelled in the service of the Emperor or with those under his immediate protection, hence the desire to oblige. Lucy observed laconically that she and Thomas 'often had occasion to observe the attachment of these wild tribes to His Majesty, but it rarely happens that their devotion is not abused'. The furs which were still at that time collected as tribute to the Tsar (a practice begun in the late sixteenth century)[80] were of the finest kind obtainable and very valuable. Lucy greatly regretted that 'these poor men' imagined they were received by the Emperor himself and that he knew from where and even from whom they came. In reality, she was to write, they were transmitted from one hand to another, at each stage being substituted for an inferior fur, so that when they arrived at their final destination, 'these simple people', if they had known, 'would scorn to present such miserable articles to His Majesty'.

Only well after moonlight did they reach 'the hospitable Tartar's dwelling' where they had dined on their way to the mountains. Everyone was already asleep but they all got up and made tea for the travellers. When Alexei brought it in he said, 'with a look of pity, "You must be very tired." I replied, "No; indeed I am not." "Well," said he, with astonishment, "we are men, and accustomed to riding, and you are not; there is not another lady could have done what you have done! And, now that the journey is over, I must tell you I have often wondered how you could go through all you have gone through." This was sincere praise, and I can assure you I felt not a little proud to have merited it.'

Next morning (it was now late August) they reached Altai Volost, regained their pavoska and were driven back west towards Zmeinogorsk (which Thomas had visited the previous year). En route, they reached Lake Kolyvan in the Altai foothills at sunrise, already well-known (at least locally) for the granite pillars on its shores 'of most extraordinary forms', Thomas writes, 'having the appearance of a ruined city … backed by picturesque mountains'. (Thomas's extant watercolour looks extremely exaggerated, but a later nineteenth-century representation portrays the same remarkably shaped rocks.) It was a useful visit: Thomas had collected on their journey 'jaspers and porphyries of great beauty' as well as quartz and aventurine, and he gave some of them to the Kolyvan polishing-works to cut. These works may have been smaller than those in Ekaterinburg, but what they produced was often 'on a gigantic scale', witness the great vases, columns and pedestals in St Petersburg's Hermitage Museum,

'produced in this far-off region, where Europeans generally consider there is nothing but barbarism'. On their visit about 120 workmen were employed, earning very little.[81] Thomas hoped that 'His Imperial Majesty will give these deserving men [presumably state serfs] their freedom and with it the privilege of putting a water-wheel on the stream which furnished the moving power to the Imperial Works'.

Travelling through the night again by pavoska, the Atkinsons arrived in the early morning of 31 August 1848 at Zmeinogorsk, a town of plain wooden houses belying their comfortable interiors, the administrative seat of the Altai's mines. This was the site in the south-western extremity of the Altai of what had been not only 'the richest silver mine in his Imperial Majesty's dominions' in Thomas's words, but the richest in the whole of the Old World, and had been popularly known the century before as 'the Russian Potosi'[82] after South America's fabulously rich silver mine. It had been surrounded then by an earthwork and ditch fortress nearly a mile in circumference, defended by twelve cannon and a company of troops, and in four years alone (1747–50) it had produced 850 tons of high-grade ore.[83] At the time of the Atkinsons' visit it was still employing a workforce of 7,000 and in the years 1851–63 was still to produce over sixteen tons of silver annually, although its productivity was to fall thereafter.[84]

Here in Zmeinogorsk the travellers had rooms assigned to them[85] by Thomas's affable friend from his previous visit, Colonel Andrei Rodionovich Gerngross, the director of its silver-smelting works and mining superintendent of the whole Altai mining region.[86] For the first time since their departure from Barnaul – according to Lucy's account, forgetting the night at the old hunter's and his bedbugs – she slept in a bed. 'Oh, what a luxury it seemed to be, and how I enjoyed it.' But Thomas had been feeling very unwell for two or three days and though they set off to see a new part of the Altai, they had to return after seventy versts, and Gerngross at once called in the doctor. Thomas was 'carefully nursed … [and] what with bleeding, physic and starvation, a great change was soon produced', but only after eight days.

Once Thomas had recovered he quickly became restless again. Gerngross and his wife helped the pair prepare for the next stage of their extraordinary travels: the long journey south into the Kirgiz steppe and the Cossack fort of Kopal. While repairs were made to their carriage, Thomas spent two days sketching the silver-smelting works' interior: alas, one of his many watercolours now lost. On their way to visit the works, Gerngross related that, returning home one bitterly cold evening, he had heard a low moaning apparently from one of the little wooden houses. He had stopped his driver and listened but heard nothing more and, thinking it must have been only the wind, went home. Next morning he heard that a woman had been murdered for her small savings. Such incidents, the Atkinsons learned, were not common and not until that episode was there any fastening to the houses. Even then the doors began to be locked only at night.

It was evidently the same in Barnaul until recently, they heard, with no locks on doors and nothing stolen. Now, thieves were bold enough to enter houses

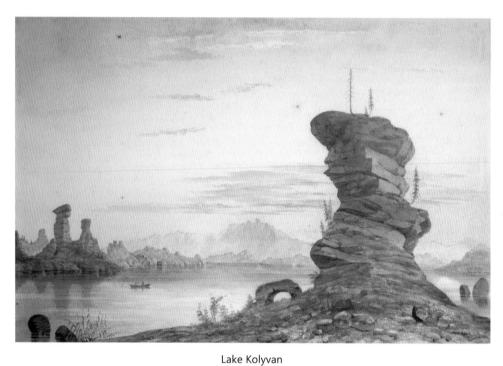

Lake Kolyvan

The other lake the Atkinsons visited in the Altai was Kolyvan. They had been told in Barnaul of its beautiful scenery, but Lucy was greatly disappointed. A long description beneath the painting is possibly in Thomas's hand.

and walk off with shubas. One lady in Barnaul lost three while the Atkinsons were there and, Lucy noted, 'they are rather costly'. In St Petersburg the citizens may have been content to have their cloaks lined with fox skins and the collar sable, 'but the Siberian ladies have them lined with sables; picture to your mind the cost of a cloak, sables inside and silk velvet out. It is evident there is no lack of money in Siberia.' (Lucy was only partly right; sables would have been far cheaper in Siberia, where they were shot or caught, than in the capital.)

On the day of their departure (2 September) from Zmeinogorsk they rose early to begin packing for their hazardous journey south. 'All our friends', Thomas's journal records, 'thought it would be attended with great danger.' At 7 p.m. they said goodbye to their friends, stepped into their carriage and were driven away fast by their Cossack coachman, Mikhail. They were to make their journey as far as practicable on the post road. Every 25 to 35 versts the system provided post- or relay stations: small buildings of unbaked brick, occupied by a picket of up to a dozen Cossacks with a few horses available (if necessary more could be requisitioned from nearby Kirgiz).[87]

That first night the travellers covered a distance of four post-stations, slept in their carriage and after a second night reached the small town of Semipalatinsk[88] (now Semei), on the banks of the Irtysh. Here, only six years later, Dostoevsky was to spend four years of exile and military service after his prison sentence for involvement in a subversive society. He was to describe it as one of the 'plain little towns built of wood' (with 1,000 or at most 2,000 inhabitants) of Siberia's remoter regions, and

> two churches – one in the town, the other in the cemetery – which are more like the prosperous villages of the Moscow region than real towns … [and] usually abundantly furnished with district police inspectors, assessors, and other minor officials … [and] in the streets, with their rows of little houses sunk into the earth … a savage barking of dogs which abound in provincial towns in alarming numbers.[89]

Here Thomas handed the 'police master' his letter from Prince Gorchakov, West Siberia's Governor-General, who had already sent instructions. They were then taken to their lodgings and next day the police master took them to visit the Tatar merchants[90] ('exceedingly amiable', noted Thomas), who showed them carpets and silks from Bokhara and Kokand and many beautiful things from China. Lucy described a visit to a Tatar school for girls, where twenty of them, their long nails painted pink, sat on a covered balcony reading in sing-song voices, dined and returned to their lodgings 'where our carriage was being examined by an Officer from the Custom House, and at 5 o'clock [on Sunday 5/17 September 1848] we left and drove down' to the broad Irtysh river, flowing north-west to join the Ob and form one of the longest river systems on earth. Beyond it lay no more forest for the travellers but the immense treeless steppes of Central Asia, the mountains on the Chinese border and many more adventures.

Into the Kazakh Steppe

AT THAT TIME the river Irtysh marked the southern administrative boundary of Siberia. To the south lay Central Asia: the great Kirgiz Steppe (as it was called then, today the Kazakh Steppe), within it one of the old Silk Roads – and south beyond the steppe Turkestan's three khanates of Bokhara or Bukhara, Khiva and Kokand and their oasis cities, particularly Samarkand. Today, what the Atkinsons called the 'Kirgiz Steppe' and the Russians knew as the Steppe Region (*Stepnoy Kray*) forms roughly the republic of Kazakhstan, 2.7 million sq. km,[1] the world's largest land-locked country after Mongolia, more than twice the size of Britain, France and Germany combined, stretching nearly 3,000 km west to east from the Volga delta on the Caspian to the Tien Shan mountains on the Chinese border.

The Kirgiz (or Kirghiz) people, as they were known at the Atkinsons' time and always so called by them, were in fact Kazakhs, the misappellation being partly in order to distinguish them from the Cossacks (in Russian *Kazaki*). The real Kirgiz were called Kara-Kirgiz.[2] But for the sake of simplicity and contemporary practices, the name Kirgiz has been replaced by 'Kazakh' throughout this text even in direct quotations. The Kirgiz themselves live primarily in Kyrgyzstan, south of Kazakhstan and one of Central Asia's five republics (colloquially known as 'stans').

It is thought that the Turkic-speaking Kirgiz/Kazakhs were formed from certain tribes of the Golden Horde,[3] the Mongol-Tatar army that invaded Europe under Genghis Khan's grandson, Batu, in the thirteenth century. By the nineteenth century they were inhabiting the vast Kirgiz/Kazakh steppe as nomadic pastoralists with their herds of livestock and had split from west to east into the Lesser, Middle and Greater Hordes.[4] Traditionally these were subdivided into clans governed nominally by khans and sultans, but in reality by the early nineteenth century internal disorder was not only common but increasing, with large areas of the steppe in revolt against khanate rule – quite apart from armed resistance to the Russian colonisers.[5] It was in the east among the Greater Horde that the Atkinsons were to travel at an early stage of the Russian Empire's relentless advance into Central Asia.

Twenty years later, in 1868, the expansion was to take Russia to the Afghan border and in 1895 to a mere ten miles from India – of particular alarm to Great Britain. For some fifty years the two powers were jockeying to control Central Asia, playing what was famously called the 'Great Game', which reached a major crisis in Russia's annexation of the Merv oasis in 1884. This was to lead to such 'mervousness', as *Punch* called it, that two British Army corps were mobilised in

Opposite: Detail of 'On the desert'

India. Back in 1801 the unstable Tsar Paul I had indeed sent 22,000 Cossacks with 44,000 horses (a spare for every man) and artillery to drive the British out of India. They had reached the Kazakh steppe when Paul was assassinated and the force was sensibly recalled in view of all the odds against it, not just deserts, mountains and lack of maps, but a potential war with Britain.

For 250 years (1550 to 1800) Russia's territorial expansion had been based on a whole series of defensive lines, not all contiguous, expanding east and south.[6] The major river Irtysh, flowing from south-east to north-west, lent itself obviously to such a line, and it was Peter the Great who had established one from Omsk 900 km to the east beyond Semipalatinsk. Now in the mid-nineteenth century, in an age of imperial expansion, Russia's immediate policy in Central Asia was to establish a line of forts south of the Irtysh from which Cossack troops could increasingly control and colonise the Kazakh steppe. Here the Cossacks would first establish defensive posts, surrounded by trenches, which could develop into forts and finally administrative centres.

Although Russia regarded the Kazakhs as her subjects, even though they lived beyond her formal borders, she had to fight constant battles to keep them in check. And:

> Against a cunning, fleet and bold enemy such as the Kazakhs only the Cossacks could operate with success; regular troops were far less effective in this region since they were not able to pursue a fast-moving enemy. The Cossack on the other hand with his two horses, his rifle and his lance was a source of terror for the Kazakhs.[7]

But the Cossacks as a military force were not enough on their own to secure the new territory against the Kazakhs, who waged a constant hit-and-run guerrilla war against the invader. So St Petersburg encouraged or ordered settlers, peasants and Cossack families to build up the Russian population in the steppe, based on an ever more southern chain of forts and administrative centres. The Atkinsons' destination was Kopal (today Kapal), the southernmost fort at that time, founded seven years before by West Siberia's Governor-General, Gorchakov, who had rashly authorised the British couple's visit, a decision he came to regret — he was indeed formally to acknowledge his error to Nesselrode, Russia's Foreign Minister.

The area at that time was anything but peaceful. The continual Russian encroachment, forcible eviction of Kazakh families, seizure of their best pasture lands, requisition or slaughter of livestock and imprisonment of innocent Kazakhs, quite apart from the taxes now levied and charges for crossing rivers: all this and more resulted inevitably in Kazakh rebellions. The most serious was that of the Middle Horde under Kenisary Kasim, an outstanding leader who at the height of his revolt commanded 20,000 men. In 1838 he had sent five lieutenants to Gorchakov with a detailed letter of protest, but his comments were ignored and the efforts to defeat him were simply intensified. Today he is regarded by his

people as a hero and the first Kazakh nationalist.[8] His rebellion lasted a full ten years,[9] ending only the year before the Atkinsons' arrival.

This was the unsettled steppe that the two were to enter in early September 1848. They boarded a ferry to a mid-stream island in the Irtysh across which their carriage was hauled to a second ferry, and finally reached a Tatar village on the far bank, altogether a two-hour process. They were now in the Kazakh Steppe and Central Asia.[10]

They were not the first British to visit what is now Kazakhstan, although they must have been the first British couple. In 1558 Anthony Jenkinson (1529–1611), merchant and explorer for the Muscovy Company and the English crown, travelled in what is now the far west of Kazakhstan. In 1736 John Castle, 'adventurer and artist', of mixed English and Prussian descent, went on a diplomatic mission for the Russians to a Kazakh khan; his journal was published (1784) with thirteen of his drawings, one of which was used for a recent Kazakh banknote.[11] And in the eighteenth century there was Jeremy Bentham's brother, Samuel (later Sir Samuel) Bentham (1757–1831), able engineer, naval architect and official. Employed by Prince Potemkin, Catherine the Great's favourite, he helped inter alia to win a

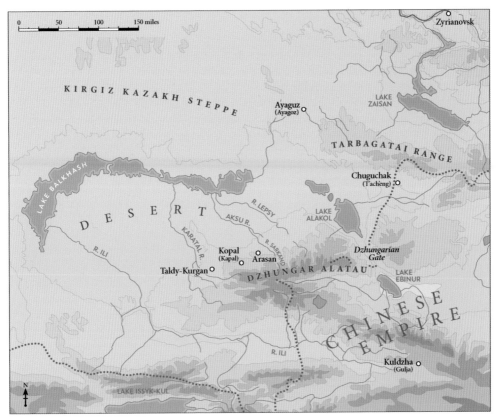

Eastern Kazakhstan

war against the Turks, commanded two battalions of 1,000 men in Siberia, and in 1789 travelled over 800 miles in Kazakh territory across the Irtysh, primarily to investigate mineral resources.[12] But the Atkinsons (and Austin) seem to be the first British to have visited what is now eastern Kazakhstan.

It was getting dark when they left the Tatar village with Cossack horses, a Cossack driver and a mounted Cossack as escort on either side of their carriage.[13] Once clear of the village they started at full gallop,[14] leaving a fine storm of thunder and lightning behind them on the north side of the Irtysh. Soon it became so dark that they often lost the way and a Cossack had to ride ahead to prospect. At 10 p.m. they reached their first picket (a chain of isolated military outposts stretched south across the steppe), were 'given tea'[15] – Thomas's usual term for 'given a meal' – and slept in their carriage, as the officer in charge said it was too dark for his men to find the way ahead.

'Before daylight the Officers had the "Tea Machine" [Thomas's appealing synonym for samovar] ready and called us.'[16] They set off while it was still dark across an interminable steppe, where rain had made the so-called roads almost impassable, slowing their pace to five versts an hour. At times it required eight horses to drag them out of the bogs, and frequently they had to stop and rest the tired animals. After a second stationary night in the carriage they started with the dawn and as the sun rose saw mountains at a great distance – the Arkat. At midday they reached the Arkat picket or outpost, where new horses were secured and Thomas, with art in mind, rode into the mountains with an escort.[17] He found their granite peaks[18] 'exceedingly picturesque' and, despite a cold cutting wind that penetrated his thin clothing, the fine views resulted in two sketches (one reproduced in his first book). In the hills en route Thomas, former stonemason, noted, as so often in his journal, the local geology, here the 'masses of granite protruding through the surface' with 'large veins of quartz' traversing the hills.[19]

Continuing their journey, they became stuck fast in a sluggish river, but the officer in charge saw them and sent men and horses to get them out in the gathering dark. They arrived at 6 a.m. at the last picket, in a narrow valley, before the fort of Ayaguz (now Ayagoz).[20]

Only a few months earlier this picket, now increased to twenty-five Cossacks, had been attacked in the night by a large group of Kazakhs who had murdered the eight guards on duty with their battleaxes. Many of the Kazakhs themselves had been killed in what had been a desperate battle, and the survivors carried them all away, afraid they would lead to the identification of the tribe involved. The picket's walls were still bloodstained, but the reason for the murders was unknown; perhaps, thought Thomas, 'an act of vengeance for some injury or insult to their chief'.

Nine hours later they reached the small Ayaguz river which had given its name to the fort, set among low and rocky hills. It was the first running water since the Irtysh, now 270 versts behind them: a clear stream running through the steppe over large stones, its banks covered in long grass, reeds and bushes[21] and with abundant game. Here the Cossack fort no longer had guns – Russia

had advanced beyond it to the Atkinsons' destination, Kopal, the next and last
fort south at that time, doubtless with the guns from Ayaguz – but 800 Cossacks,
mostly with families, were still stationed in 'small and miserable houses' in contrast
to the 'good and large' government buildings and offices. The one wide street
consisted of small adobe houses so low that everyone had to stoop in order to
speak to the inhabitants through their windows.

Besides the officers there was a chief magistrate with his secretary and assistants
to run the civil department: the governing power over the Kazakhs in this region.
Atkinson does not mince his words about Russian colonialism.

> The men sent to fill these departments look upon their positions
> as a species of banishment; and it has always been a principle
> among the employés to abstract the greatest amount of profit from
> the nomads, who are ground by every man, from the chief to the
> common soldier. This makes the Kazakhs give Ayagus a wide birth;
> nevertheless, means are devised to bring many of the tribes within
> the grasp of the greedy officials....
>
> The *sessedatal* [*zasedatel* – magistrate] was a tall, burly, and hard-drinking
> man from the south of Russia, and in no way scrupulous how profit
> was obtained from the inhabitants of the steppe. His duties are wholly
> with the Kazakhs; and he has officers residing among the different tribes
> wherever Russia has obtained any influence, who lose no opportunity
> of extending her power. The chief is courted, paid, and some mark of
> distinction given him; perhaps a medal, a sabre, or a gold-laced coat and
> cocked hat – with the privilege of attending a council at Ayagus once
> a year when laws are made to govern the tribes, that rivet still faster the
> fetters with which he and his people are being bound. From this meeting
> he returns to his aoul, 'dressed in a little brief authority'. A young Russian
> who understands his language is appointed to reside with him, to translate
> all official papers sent to him, and write the answers; to which he attaches
> his seal, without understanding a word they contain. The youth is also
> a spy upon him and those who visit his aoul, reporting regularly to the
> chief at Ayagus. Thus the power of the empire is quietly and gradually
> creeping on into the plains of Central Asia; and when it is sufficiently
> secured, the nomads will have to pay both in men and money.[22]

Having made no bones about Russia's administration in the Kazakh steppe,
Atkinson turned his attention to the problems of alcohol. Wine merchants would
always find their journeys to Ayaguz profitable and the traders would 'pay a
premium to the officers on the amount consumed'. This 'and the love they had
for it' set a bad example to the men, and the commander on the Atkinsons' visit

> was equal to any man in Europe as a toper. His regular quantity of
> wodky every evening was three bottles, 'taken pure;' for, as he said, 'no

good Russian ever watered his brandy'. Many of the officers tried to emulate his drinking powers; thus an example was set which the men eagerly followed, and an enormous quantity of this degrading spirit was consumed in Ayagus.

Orders had already been received to do everything necessary for the visitors. The officer in charge, in the commander's absence, gave them a room in the house of the magistrate and promised all would be ready the next day. They dined with him and he did all he could for them while his wife made provisions for their onward journey, as they were warned they would find nothing at Kopal, their destination nearly 350 versts south.

They 'slept like "Bricks" all through the night' according to Thomas's journal, and he and Lucy were up early next morning to prepare further for crossing the steppe. 'It was a busy scene we beheld from our windows', wrote Lucy:

> The Cossacks were moving about in every direction, and the Kazakhs who were to accompany us were waiting outside, with the horses and camels, to carry us and our packages across the desolate steppes. What wild-looking fellows they appeared, but with a great deal of good nature in the countenance; their Asiatic costume is exceedingly picturesque and beautiful, the shawls tied round their waists are by no means to be despised.

She noted, too, the Kazakh men's 'ungainly, rolling walk' due both to the number of khalats, the dressing-gown-type traditional robe, each wore – sometimes even four or five at a time – and to their boots, far too short for the foot, so their heel protruded part of the way up the boot. Kazakh men regarded it as below their dignity simply to walk even short distances because the saddle was their natural place.

'All was bustle and confusion,' continued Lucy, for the Cossacks who were to accompany them to Kopal joined in the packing – with all that that implies. Some of the Cossack wives tried hard to dissuade Lucy from the journey, relating to her 'the great horrors and miseries' endured by some of their number who had recently crossed the steppe with their families to Kopal.

> They were convinced I should die ere I reached the place. I laughed at their fears, and assured them that it would cause me much anxiety to be left behind, and, even though they told me that death would be my lot if I went, still I was firm to my purpose. You know I am not easily intimidated when once I have made up my mind. I started on this journey, with the intention of accompanying my husband wherever he went, and no idle fears shall turn me; if he is able to accomplish it, so shall I be. I give in to no one for endurance.

Since the Atkinsons had to take to the saddle from this point on, their carriage was now left in the care of the magistrate until their return. While their pack-camels were being loaded, etiquette compelled Lucy to go round saying goodbye to everyone who had shown her 'the slightest civility' at Ayaguz even though the two travellers had spent only one night there; otherwise it would have been considered 'an act of the greatest impoliteness'. Everyone had prepared something for her journey 'across these inhospitable steppes' in case she was really determined to proceed.

'One had a bag of succarees [rusks] cut in slices, with salt sprinkled on the top, and dried in an oven; another had sundry little meat pies; and the sessedatel in whose house we were staying, presented me with an enormous water melon', a rare gift since none were obtainable nearer than Semipalatinsk, nearly 300 km to the north.[23] Lucy thought this last would be a great boon to her husband, an 'indifferent water-drinker', whereas she invariably needed to quench her thirst in any stream or river, so always carried a small drinking cup in her pocket.

Unable to dissuade Lucy from her journey, the ladies of Ayaguz ended up by helping her into her saddle. All the men, Cossacks and civilians alike, came to see off the two foreign visitors and their three-man Cossack escort, Pyotr (Peter), their interpreter and 'the devoted follower of Mr Atkinson', Alexei, Lucy's tall and similarly 'devoted helper', and the twenty-year-old Pavel, whose duty it was to attend to the Kazakhs and ride with the camels. 'They were all three wishful of serving us to the utmost of their power', wrote Lucy. When this small party had ridden off a short distance she pulled up her horse 'to take a last look at the good folks of Aiagooz, [and] there was a great waving of caps and handkerchiefs'.

Their route now lay across low sandy hills, often bereft of vegetation.[24] For four hours they rode south along a small valley until they came upon their first aul, with its yurts, the circular and collapsible domed felt tents of Central Asia called in Kazakh the *Kiyiz üy* or felt house.[25] Two well-dressed Tatar women, mother and daughter, came out of one yurt to look at them, the daughter a very pretty girl with large black eyes, in black velvet trousers and boots beneath a khalat of striped, multi-coloured silk, a magnificent shawl round her waist. Her hair was braided into a multitude of plaits, each one ornamented with coins of copper, silver and even gold; 'thus', wrote Lucy, 'the young lady carried her fortune about with her'. However, having to reach a distant aul for the night, the Atkinsons declined an invitation to drink tea and rode on.

Another hour brought them to their night's destination, a prosperous aul on the banks of a small stream with occasional broad and deep pools. Thomas noted cursorily in his journal the obvious wealth of their Kazakh host, apparent by the great number of camels, horses, oxen and sheep, and the whole scene reminded him of the ancient Israelites.

Lucy was rather more effusive in her reaction:

> What a scene burst upon my view! Herds of cattle were seen in
> every direction, men and boys on horseback engaged driving them

towards the aoul, and a still stranger sight, women busy milking the sheep. The chief came forward to welcome us, and introduce us to the dwelling which had been prepared for our reception.... The yourt had been placed on clean grass by the side of a stream, and inside the floor, or rather ground, was covered with magnificent Bokharian carpets.... Whilst tea was preparing, I spread my bearskins and made my arrangements for the night. Happening to raise my eyes ... I perceived the voilok was raised slightly round the yourt and ... faces were peering under in every direction. Finding they were not driven off, several of them scrambled under and penetrated into the tent, touching and handling everything within their reach; but the instant the Cossack made his appearance at the door with the somesvar [samovar], there was a terrible scudding on all sides to make an escape. The women hold these men in great dread, but from what cause I could not ascertain.

She was strangely unaware, it seemed, of Kazakh–Cossack relations.

While the Atkinsons were being served tea, accompanied by dried fruits served on 'magnificent china plates', a black lamb destined for the forthcoming

'Starting to cross the desert'

feast was dragged towards them for their approval – without which it would have been freed and another chosen. A large cauldron was already in place over a brightly burning fire. Once slaughtered, the lamb would immediately be dressed for the pot, so they went for a walk, 'not desiring to be present during the … culinary operations, which, from experience I [Lucy] knew were not of the most dainty description'. The Cossacks cooked a portion separately in a pot for the couple, who sat down on the Bokhara carpets, using their medicine chest as a table, and partook of the 'exquisitely tender viand', thought Lucy ('delicious Kirgis Mutton' agreed Thomas), but somehow Lucy's thoughts 'would wander back to that dear little black lamb'.

A number of visitors came to scrutinise their eating habits: 'Our slightest movements', observed Lucy, 'seemed to interest them.... The tin plates, the spoons, knives, forks, indeed nothing escaped them; but what struck them most with astonishment was the attention paid me by Mr Atkinson, as our sex is looked upon by the Kazakh as so much inferior to the "lords of the creation"'.

Then it was the Atkinsons' turn to watch the Kazakh feasting. They sat in circles, the chief and his followers in the inner one. 'Alas!' observed Lucy,

> *no* wife sat near him; she, poor woman, was amongst the *outcasts*. There were neither plates nor knives employed here, the meat was placed on a board, and each helped himself according to his rank, the remaining portion being passed to the *outcasts*, whilst the inner circle commenced drinking from small bowls the liquor in which the meat had been boiled. This being ended, koumiss [fermented mare's milk, the staple drink of Central Asian nomads] was brought, accompanied by the pipes.

As night was falling and the Atkinsons had to rise early, they retired to their yurt which Lucy found preferable to a tent, being both warmer and snugger, 'and, a greater luxury still, I was able to dress and undress without being obliged to kneel, as I had to do in the balagan.... I slept soundly, having already been two months travelling continually.'

Before sunrise next morning they were woken by the barking of dogs, the neighing of horses, the lowing of cows and oxen and the bleating of sheep: sounds so new to Lucy's ear that she quickly jumped up and peeped out – but was glad to return to her furs as she encountered their first sharp frost. Once the Cossacks had reloaded the camels, they set off accompanied by their three Cossacks and now five Kazakhs. Their guide was their host of the night, accompanied by his attendants. He had presented Lucy with a long Bokhara rug (she reciprocated with a knife) and thanked the Atkinsons for honouring his aul by spending the night there.

Their track lay over barren low hills covered with small stones, which from a distance had appeared to Thomas's artistic eye a dark purple, but on closer examination proved to be burnt sienna and a deep green. After three hours

they reached some high ground affording an extensive view all around. 'A more desolate scene cannot be found', wrote Thomas in his journal. 'There was neither Tree or bush or any sign of vegetable life. All was a dark and arrid waste' relieved only to the west by a lake 'shining like silver surrounded by shores of rusty Iron ... a most singular effect which will remain long impressed on my memory'.[26]

They now turned east. Their Kazakh host was at a loss which way to proceed in order to find an aul: their view extended over the steppes as far as the eye could see but none was apparent. The problem was, Lucy noted, that the auls changed their camp-sites according to the seasons. After two hours they came on a small isolated hill on which were many ancient, conical stone tombs, each containing a large chamber with up to six graves.

That night they encamped far from any aul, and continued east, now along a valley where the Kazakhs found good pasture for their cattle, then turned south-east over more stony hills and descended into another valley with tufts of rough grass and crystallised salt on the ground, but no water.[27]

Here their Kazakh hosts bade them adieu, directing them across a dry salt marsh with a thin crust of salt. After about a verst their horses sank up to the saddle in a stretch of stagnant water amid a mass of long grass. Ascending another range of hills to the south-east, they found that, in Lucy's words, a 'marvellously wonderful' scene lay before them.

> The Steppe [says Thomas's journal] lay before us to the South like a boundless Sea; our view extended so far that all was lost in misty distance [Lucy's subsequent book used precisely the same phrase].... I found here some very good specimens of copper ore. We had now been on Horseback 7 hours. In a hot burning sun. Lucy was almost dying with Thirst and not one drop of water to be had.[28]

They looked in all directions for water but to no avail. At last Lucy spotted a beautiful lake shining in the distance:

> to describe ... the joy I felt is impossible, no words of mine can give an adequate idea of my feelings. I urged my horse on. One of the Cossacks rode up to me to say the beast would give in, if I went at such a speed. I pointed to the water and told him I only wanted to reach that, and then I should be satisfied. He shook his head and smiled, saying it was not water, merely a deception.

It was indeed a mirage, at times appearing quite near, then at a great distance, 'tantalising us poor thirsty mortals; our lips were black and salt'.

And still there were no signs of an aul or any living creature. Nothing could exist on this sterile steppe and neither Kazakhs nor Cossacks knew when or where they would find either aul or water. They rode on, completely parched. At last one of the Kazakhs descried a string of camels at a great distance, as yet

invisible to the Atkinsons. This gave them hope and on they rode at a good speed. In an hour and a half they met the caravan, but, alas, Lucy said, 'they had not a drop of water; they too were longing for the crystal fluid'.

At least, however, the caravan directed the party to an aul to the south-east and in another hour they saw a real lake shining in the sun and rode on at a sharp trot. Kazakhs came to welcome them. They rode towards it very fast as Lucy's thirst was now almost unbearable. 'Oh! The joy I felt at that sight. I became so excited that when near the yourts I appeared to lose all command over myself and horse', and her mount indeed swerved and threw her.

> I caught his mane and held fast to the reins. The men were off their horses in a trice; all laughed when they found I had sustained no injury at the way I clung to my horse; being assisted to remount, we hastened on, I foremost, and taking my drinking-cup from my pocket, passed it to one of the men who had come to meet us, exclaiming sou, sou (water, water), when oh! horrible, I was given to understand that this beautiful shining lake was *salt!*

Poor Lucy! The Kazakh women brought her some milk instead, 'a poor means of quenching my fearful thirst', and she sent for some water from the lake to make absolutely sure. 'Alas! It was all too true, it was perfect brine.' A samovar was prepared with it but of the resulting bluish-white tea Thomas noted 'dire necessity alone made me drink it'.

At least they dined – 'on broiled mutton' – but declined a large bowl of fat which a Kazakh then swallowed 'with much gusto' (preferring it to meat, like all his race). And Lucy found that whenever a Cossack put down a plate which she or Thomas had used, a Kazakh seized it and, in her delicate phrase, 'by a method peculiar to him, made it as bright and clean as if it had been polished with a leather. After this I never failed to see my plate washed ere I used it.' After only an hour, they pressed on – it was now mid-afternoon – as they were told they would find good water 20 versts ahead. Peter went off to a nearby yurt to obtain a fresh horse for Lucy, and the Atkinsons were alarmed to hear the report of his pistol. He had got into a quarrel and had fired at a Kazakh but missed him as he ran away.

Their course was now dead flat and for the moment directly south (in the direction of Lake Alakol, nearly 2,500 sq. km in size); to their right rose up high hills. The steppe was so smooth that they galloped along at great speed – the hoped-for aul was still far off, a passing Kazakh told them – and after three hours, as night was falling fast, they came to a stream but everywhere too deep to cross. At last they found a ford and, after two hours in the dark, reached the aul they sought, and a yurt was soon erected for them, 'tea made and some good mutton chops', wrote an appreciative Thomas, 'which we eat with a great appetite after being so long without food'.[29]

Next morning they left the aul and made their way through marshy ground

with tall reeds, bulrushes and rough grass high above their heads. Only after several versts could they find a place to cross the swamp. Spreading themselves out in order not to follow in the track of one another, they nonetheless sank up to their saddle-flaps once again. In the middle of the mire one of their pack-camels (wrote Lucy)

> coolly lay himself down, nor could he be induced to move till the whole of his pack was deposited in the mud. Mr Atkinson was in a great state of excitement, believing it to contain his paper, sketches, &c which would result in entire ruin to his projects.

But, fortunately, they proved to be on another camel.

At one point Lucy noticed the absence of their Cossack interpreter, Peter (or 'Petrusha', his diminutive), whom she had surnamed 'the Great, for he was one of the most consummate liars I ever met with; my husband said not so! He was only a poet.' When he appeared later he seemed even more loquacious than usual. Soon afterwards one of the Kazakhs came up to Lucy (to whom they invariably came if they had complaints, perhaps because she was more sympathetic and certainly because her Russian was much better than her husband's) and indicated in sign language and visible evidence that Petrusha had been thrashing him; his nose was grazed and his clothes showed he had been on the ground. Lucy asked Petrusha to translate what the man had said. After a moment's hesitation Petrusha explained, 'You see, lady … we do not proceed so fast today as we ought to, owing to these atrocious Kazakh horses! and that if we had Russian ones, we should be scampering over the plains like wild people!'

Petrusha's fellow Cossack, Alexei, was as astonished as Lucy was at this declaration and, no longer able to control himself, started off at full gallop, his peals of laughter ringing far across the steppe.

'Petrusha, it is not true', said Lucy. 'Looking at me with a stoical face he replied, "By God, madame, it is true".' Lucy could find no redress for the incident, but that evening at their next aul Thomas found that Peter had broken a gun stock 'while thrashing a Kazakh. This was indeed a misfortune; we however managed to glue it together', he noted with surprising lack of feeling.[30]

Next morning they awoke to a sharp frost and a clear sky to the south, and Thomas saw for the first time the snowy peaks of the Alatau 'shining like Silver against a deep blue sky. I called Lucy and showed them to her.' It was to be a day Lucy would *never* forget, she wrote. But the reason was nothing to do with the view.

They set off at 7 a.m., the aul providing guides and 'splendid horses'. As usual Lucy enquired the day's distance; when they heard it was 80 versts they thought nothing of it as they had often ridden more. But their Kazakh guide warned them that they must ride fast as there would not be a drop of water anywhere. At one o'clock they halted for a few minutes, to find the pack-camels were now far behind – small black specks on the sandy steppe they had crossed.

A Kazakh was sent back to urge the camel party on and the main group

proceeded more slowly, hoping they would catch up. The travellers were now both hungry and thirsty but, on declaring that they would have some tea when the camels arrived, were told again there was no water to be found anywhere. 'This was bad news', wrote a concerned Thomas.[31] At three o'clock they stopped to wait for the camel train, which caught up an hour later. Thomas now persuaded the thirsty Lucy to try the water-melon which had been given them by the magistrate in Ayaguz. To Lucy, who had never tasted one before, but was so parched, 'it appeared to me the most delicious thing I had ever tasted in my life'. But 'Eat we could not', wrote Thomas, 'our throats were parched. Our people had got cumis [koumiss], which they drank but we could not.' Extraordinary that they rejected it, despite their thirst.

Thomas was certain that by now they must have travelled the requisite 80 versts and got Lucy to ask the Cossacks how far it still was to the aul (proving indeed that Lucy's Russian was much better than her husband's). Hour after hour Lucy had been continually assured that they were only ten versts away. 'Tired of this nonsense', she now insisted on knowing the truth. The Cossacks confessed they did not know and the Kazakh pointed to a blue mountain in the distance, saying 'a *little* further than that'. Thomas, an excellent judge of distance, reckoned to Lucy's 'extreme horror' that it was between 40 and 50 versts away. 'It would have been useless to have complained, so we cheered up and on we went', wrote Lucy in true British style. Orders were now given that the camels should keep close to the main party, and a Cossack and two Kazakhs were sent ahead to prepare a yurt at the first aul they could find as well as to make a large fire so that it could be located at night from afar.

'The sun was now descending fast, tingeing everything a golden hue, while the distant mountains[32] were almost lost in misty blue.' (Both Thomas's journal and Lucy's book are identical here.) There was little twilight; as soon as the sun was down it was dark. All began looking out for the expected beacon light, but hour after hour passed and none appeared. It was now 10 o'clock at night. With no track, Thomas wanted to know how their Kazakh guide knew which direction to follow. The Cossacks pointed to the stars 'and I soon found the man knew well what he was about'.[33]

'It was now past midnight', Thomas's journal continues, 'and all were tired, but on we must go.'[34] About two o'clock in the morning Lucy said she could go no further. It was intensely cold; a cutting wind was blowing from the snow mountains and she had on only a dress, her warm jacket lost that day when it had become unstrapped from her saddle. Trembling with cold, she could now hardly hold her reins.

Thomas got her off her horse, spread a bearskin on the sand, and wrapped her up in his shuba. He insisted on her drinking some rum – they had brought about a pint as medicine – and half a wine-glass began to revive her. After half an hour she started to get warm and dozed off for a few minutes. Then their guide announced they must go on or all would be lost since the horses would not be able to continue without water after sunrise.

Fastening his shuba round Lucy with his belt, Thomas put her on her horse and tied a bearskin round himself. Away they went, Lucy now a little warmer and refreshed. But after another hour, at 3 a.m., her strength again began to fail her. Once more Thomas helped her down and now got her to walk about a hundred paces. She then remounted, but after another hour (her husband's journal recalls) she said:

> she could go no further and that she must be left and die on the Steppe. Again I got her to walk a short distance. And then she mounted again. I now held her on her Horse. In a very short time I saw a thin streak of light appear on the Steppe and now I knew the day was breaking this gave me hopes. And very soon I thought I heard a dog Bark. I told Lucy. She said I only fancied so or wished her to think so and go on but she said it was impossible, we must stop again.... We had not however ridden far before I heard several dogs Bark. No Music ever sounded so sweet in my Ears ... [journal underlining].[35]

And it greatly cheered Lucy up.

At 5 a.m. they at last reached an aul belonging to a poor mullah who did all he could for them. The women lifted Lucy off her horse, carried her into a yurt, began to rub her hands and feet and placed a carpet and cushions for her to rest on. She asked for water but their Cossack Peter told her it was unfit to drink. A fire was soon made of camel or horses' dung in the absence of any wood, and tea was produced which Thomas drank 'with infinite delight', but Lucy was now too exhausted to drink anything.

Soon the Cossack arrived who had been sent forward the previous day. His party had missed this aul in the dark and had gone to another twelve versts away where he had prepared a yurt for the travellers. Once Lucy had recovered a little, they set off for yet another two hours' ride to this yurt in a small ravine, where a stream at last provided good water and its banks good pasture for cattle and sheep: 'our Home for the day as we determined to have a rest'.[36] Lucy, now recovering, made tea, ate a little broiled mutton with it, and both lay down to a sound and very well-earned sleep, placing a reliable Kazakh guard outside their yurt.

For they now had a prisoner. The Cossack sent on to prepare a yurt for them had also wandered through the night to find the aul only just before daylight. When he had entered one yurt and ordered another to be specially prepared for the Atkinsons, a Kazakh had seized an axe and thrown it at his head. Luckily, he had ducked and the axe stuck fast in the yurt's door-frame. When Thomas heard this he 'instantly ordered this man should be taken to Kopal and be there given over to the officer in command'.[37] The culprit was immediately placed under guard.

> When I awoke [wrote Lucy] the sun was high in the heavens, and it was too late to think of starting that day, for we had ridden a distance of a hundred and fifty versts, without having tasted anything either solid

or liquid, with the exception of the rum and water-melon, neither had the poor horses received any nourishment the whole of that time.

They were shocked that the Cossacks had not learnt if water could be found on their route the previous day: 'the want of this when riding over the hot sand was severely felt by both of us'. And it is surprising that they did not blame themselves, as they had certainly been warned. Only the previous month of August, a party of Cossacks on their way to Kopal had lost five of their number here. 'We saw their graves', Thomas records. 'These caused sad reflections as it might have been our cases. We should then have been put into the sand without anyone knowing who or what we were.'[38]

> I cannot [his journal continues] speak too highly of Lucy's courage and endurance during twenty two hours horseback frequently riding very fast in the day and then riding through the Night across such a desert. Here we might have been plundered and overpowered had some of the Bands of Barantor know[n] of our March [he meant *barymta*: punitive raids launched against the auls of clan rivals to seize livestock].[39] Our Arms were all Kept in readyness and several would have bit the dust ere we had been taken.[40]

Late that evening – by which time they were 'quite rested … and could have gone on'[41] a Tatar merchant approached, told Thomas that the group's prisoner (who was now on horseback, frequently begging to be freed) was his workman and asked for his return, but Thomas refused and told him the man would go to Kopal.

They started again early next morning with good fresh horses and a strong party of Kazakhs. But they were still two good days' journey from the Lepsy river, their first proper river since the Irtysh, much of their route lying over a deep sandy steppe, one long continued ascent and descent in deep sand in which the horses sank up to their knees. They rode on, leaving the camels far behind, 'toiling and moaning most piteously'.[42] After six hours they arrived at a steep descent on to the steppe which, says Thomas's journal,

> lay before us like a Map with nothing to bound the horizon.[43] From this Elevation we had a view of the Snowy peaks of the Alatou with the Tops of some deep purple Mountains under them while on the Steppe we saw many Tombs some of them of great size … we sat on our Horses some time contemplating the Scene before us. There is something grand even in this Steppe streching as it does for Three Thousand Versts and peopled by a wild race who deem plunder no crime. Our little Band was like a speck on this interminable waste and our safety depended on our courage and care; I often practiced with the Rifle and Lucy also so that our Kirgis knew it would be death to any man who attacked us.[44]

The prisoner, also on horseback, continued to beg for his liberty, and the Tatar merchant appeared a second time to ask for his release, but once more Thomas refused. Down on the now grassy steppe they halted at an aul in a deep glen near some lakes of (drinkable) water to eat and to secure fresh horses, their own being tired after crossing the sandy waste. They stopped early at another aul for the night, as they were told it was very far to any other. 'We found a keen cutting wind blowing from the Mountains with nothing on this mighty plain to shelter us … [but] we had a fire made of dry camels Dung … [which] soon warmed the Yourt', wrote Thomas.[45]

They rose at daybreak, making up their fire against a frosty morning. 'We had a fine view of the Alatou Mountains', Thomas recorded. 'As the Sun tipped their Snowy peaks they shone like Rubies against the cold blue Heavens. How anxious I was to be among them.' Before them lay a long ride to the Lepsy river over, once again, a sandy steppe, but they had good horses and for the first two hours proceeded well. One part had evidently once been thickly inhabited as it contained many ancient barrows and tombs of sun-dried brick – so many indeed that from a distance it looked like a large town – and a wide area had obviously once been irrigated. The canals survived and in one ran a stream of beautiful pure water, a line of luxuriant large plants and long grass marking its route and proving to Thomas that 'labour is alone wanting to make this waste [into] rich pastures abounding with plenty. The present race will never improve. Labour to them is most irksome.'[46]

They now rode on south, parallel to the Alatau Mountains a hundred versts away: a splendid chain, Thomas thought, but the lower range still not visible. A visitor a few years later, the outstandingly able young geographer Pyotr Petrovich Semenov (bound for later fame), was even more impressed when nearer to the mountains: 'before us there extended in all its grandeur the gigantic snowy ridge of the … Alatau … which rises from the low-lying … steppe to far beyond the snow-line even more strikingly than the Alps from the Lombardy plain'.[47]

Several times Thomas noticed columns of sand carried up by the wind, 'each turning round [on] its own axis and moving Slowly over the Steppe. They sometimes rose to a great Elevation, when seen with the Sun shining upon them they appeared by pillars of smoke but when seen looking towards the Sun then they were dark wirling masses.'[48]

After getting lunch and new horses at an aul, they rode on towards some huge barrows, one at least 60 feet high and 150 feet in diameter. Thomas rode up a winding sheep path in the hope of a view of the Lepsy but could only see sandy steppe. For a few versts a grassy steppe now allowed them to gallop on fast, anxious to reach the Lepsy and find an aul before dark. But they found themselves again in 'a complete Labrinth of sandy Mounds' and once more their horses sank frequently up to their knees, greatly slowing their progress.[49] Three hours later one of the Cossacks pointed out a belt of reeds marking the river winding among the distant sandy hills. 'I no sooner heard this', wrote Lucy, 'than I gave my horse the rein and galloped off as hard as I could go … I drank freely of it,

and I thought it the sweetest water I ever tasted in my life.' The water indeed had its source in the glaciers and snows of the Alatau range, and the river was one of the many which gave their name to the region – Semirechye or Seven Rivers (a figurative total).

Having reached an aul on its banks for the night, Thomas went off to the high reeds to shoot ducks and on his return asked about the large amount of shot he had brought. It was nowhere to be found, and next morning the search was renewed, again without success to his great annoyance as he feared he would be unable to replace it.

Lucy continues the story:

> I was sitting mending some of our garments, whilst Mr Atkinson had again gone off in search of game, when [their Cossack] Peter, ever-ready with imaginative excuses, squatted down in front of me, as he usually did when he wished to commence a conversation. 'Ah!' he began, 'it is great pity that shot is lost.' 'It is,' I replied, 'Peter, and very careless of you, as you ought to have known its value.' 'Well,' he continued, 'I own I am in fault, and more especially as it had been confided to my special care. When the master gave it me he said, "There, Petroosha, there, there is shot for thee, take it, and treasure it up as gold, or as thou wouldest thy own life, for it is far more precious than either," and to think, after all, that I have lost it!' I said, 'Indeed, Peter, did your master say all that, could he speak so much Russian?' Not the least abashed, he answered, 'Ah! Madame, it is only when *you* are present that he does not speak; but when you are not there he speaks beautifully; far better than you do.' With feigned surprise I said, 'Is it possible?' 'By God it is true!' was his exclamation.
>
> When Mr Atkinson returned, we had a hearty laugh at Peter's poetical genius; and I believe it went a long way to console him for the loss he had sustained.

At long last, on 20 September 1848, after a journey of eleven days from Ayaguz,[50] they reached their longed-for destination, the Cossack fort of Kopal, at the foot of the Alatau mountains and at that time Russia's southernmost fort in the Kazakh steppe. Neither Thomas nor Lucy describes the fort, but it is likely to have been along the lines of Ayaguz, surrounded by a defensive adobe wall (or at very least a trench and perhaps palisade) and would certainly have had several cannons as well as a barracks and sizeable stables for the Cossacks' horses.

They found the young civil governor, Baron Wrangel,[51] in a particularly large yurt used as a common sitting-room. Later they were to discover that he had won glory in the Caucasus where he had been almost fatally wounded by a Circassian sabre. Thomas came to regard Wrangel, appointed political agent to deal with the Kazakhs, as a good soldier, with few scruples, and 'a most amusing fellow, believing himself equal to [Russia's foreign minister] Nesselrode in diplomacy'

and he would, he wrote, back Wrangel against Nesselrode 'were fiction and invention essential in the acquirements of a minister'.

Wrangel was wearing 'a dressing gown *à la Kazakh*', i.e. a khalat, with a small Tatar cap on his head, sitting cross-legged on a stool with a long Turkish pipe in his mouth. The engineering officer, Loginov, and the topographer were in similar costume. While the Atkinsons may have been surprised to see them thus, Wrangel himself was much surprised, wrote Lucy,

> at seeing a lady enter, and perhaps also at my appearance, for, to say truth, I was not very presentable. On our journey I had mounted camels [Lucy hated riding them, finding the movement the same as the pendulum of a clock and extremely unpleasant] and bulls [oxen] as well as horses, but the last day, having a stream to cross ... I found it too deep to ford pleasantly, as the water would reach to my waist.... [But] a Kazakh ... without ceremony walked into the water, and, placing himself before me in a stooping posture, patted his back and signed for me to mount, which I at last did, and crossed on the man's back.

The Atkinsons were allotted a small yurt such as Wrangel and his two colleagues each occupied, while a fourth yurt was used as a kitchen. 'Thus we formed quite a little colony', wrote Lucy. But, she observed,

> such a thing as a vegetable is not to be seen, either fresh or preserved, of any kind whatever; no butter, no eggs, nothing but meat and rice, not even milk, and as for bread, it is the coarsest and blackest I ever saw.... Even Mr Atkinson has some difficulty in swallowing it, and he can do more than I can in this way, especially when it is an act of courtesy; for instance, we once entered a Tartar dwelling; tea was given, but it was brick tea. I sipped, and sipped, at the atrocious compound till a fortunate moment arrived when the Tartar's back was turned, and then I poured my tea on the ground, but Mr Atkinson kept drinking glass after glass, just as if he enjoyed it. On asking him why he did not decline taking the horrid beverage, he replied, 'Surely you would not have me hurt the feelings of the poor man!' I own my disposition is not so amiable.

Lucy found that in fine weather their yurt was

> no despicable accommodation, but Heaven protect you when a bouran, or even a moderately fresh breeze, arises. Here in Kopal I have been awoke out of my sleep by the wind, and have expected every instant the tent would be dashed to pieces.... The hospital ... [directly opposite] has been completely hidden from view. These winds carry everything before them, bricks or anything that comes in their way; the safest plan, when one arises, is to throw yourself flat on the ground.

'Swimming a deep stream'

Fortunately, after a month they were moved in late October into a half-finished government office, still far from windproof, however.

> We have one chair [wrote Lucy], the only one in Kopal, *one* stool; but we are rich in tables, as we have *two;* our bedstead is composed of a few planks placed on two blocks of wood, with voilok, and then furs instead of a mattress. Think not we are worse off than others. No! our house is as well, if not better, furnished than the governor's, as he has nothing but the voilok to sleep on.

On 14 November she wrote, apparently to a friend, mentioning that writing at night was impossible as they had to be economical with their candles since nothing could be got at Kopal except tea:

> I never could get time to write before; each time I took my pen in hand I was interrupted.... But you are already asking what excuse I

can make for the two last weeks. Here I have a little family history
to relate. You must understand that I was in expectation of a little
stranger, whom I thought might arrive about the end of December
or the beginning of January; expecting to return to civilization, I had
not thought of preparing anything for him, when, lo! and behold,
on the 4th of November, at twenty minutes past four P.M., he made
his appearance. The young doctor here [Andra Ivanovitch], said he
would not live more than seven days, but, thank Heaven, he is still
alive and well. He is small, but very much improved since his birth.
I shall let him get a little bigger before I describe him. He is to be
called Alatau, as he was born at the foot of this mountain range; and
his second name Tamchiboulac, this being a dropping-spring, close
to which he was called into existence. The doctor says the premature
birth was caused by excessive exercise on horseback.

Doubtless, seeing I speak of the doctor, you imagine we have a
competent one here. Far from it, he is but twenty-three years of
age; theoretically he may be clever, practically certainly not. When
my husband applied to him in my case, he declared he had not the
slightest knowledge of anything of the kind.[52]

Those words are the very first indication in Lucy's book, published many years
later, that she had been expecting a child: not so much as a hint before. How
Lucy could have made that arduous eleven days' ride from Ayaguz nearly six
months pregnant is astonishing. She was certainly risking losing her only child.
And before the long desert ride there had been the many demanding weeks in
the Altai mountains, almost all on horseback. As she wrote,

The birth of my little fellow was a grand event in Kopal; several
children had been born within the last month, but not one survived;
several had been born on the journey across the steppe, but all died;
mine was the only one which lived.... I now often think what
would have become of me had we [still] been in a yourt when I was
confined. I believe both I and the child would have died.

In a yurt indeed there would have been little hope of survival, particularly that
night. With the baby, premature by two months, only a few hours old, a strong
buran drove so much snow into the room that it lay in wreaths on the floor. The
noise was 'so terrific that not a sound scarcely could be heard within doors. I
never closed my eyes that night; my heart was lifted up in thankfulness to the
Creator for all His mercies to me.' As it was, the new-born infant was wrapped
in furs and placed on a leather trunk against the stove to keep him warm – any
water in the room had turned to ice – and Lucy lay on her bed weak, hearing
her baby moan whenever there was a moment's lull in the storm.

Luckily help – of a sort – was at hand: a Madame Techinskaya, sound asleep

most of the night on the floor, wrapped in a sheepskin. This woman had been condemned to receive a hundred lashes for aborting her own child. But a Cossack, now second in command at Kopal, had offered to marry her and so, according to the law of the time, received the lashes instead – reduced to only fifteen. Husband and wife were living very happily together, Lucy observed, and she found Madame Techinskaya a very kind woman, willing to oblige, although she remained dead asleep on the floor that stormy night.

Lucy screamed to her to give her new-born baby to her but

> not a sound did she hear; at last after about two hours I managed to wake her, and make her understand; she took up the poor babe, and poking it at me like a bundle of straw, down she was again immediately; the instant the child touched me, it ceased its moaning. They had placed in its mouth a piece of muslin, containing black bread and sugar dipped in water, and indeed, this was all he had till the third day, when he received his natural food.

Lucy does not mention her husband during the whole event, other than to say it was fortunate he was at home, having returned the previous evening from a two-day shooting expedition. And Thomas's journal gives no clue whatever, either to Lucy's pregnancy or, frustratingly, to his feelings – or even behaviour – before or after the birth. Strangely, it is totally blank for that period. The praise in his journal for Lucy's behaviour that traumatic night in the steppe oddly makes no mention of her condition, which rendered her far more estimable still. Was he pleased now to have another son, having already lost his only son, John William, as an adult? Or could he have half-hoped even unconsciously that Lucy might miscarry, since a baby would surely be a major encumbrance hugely circumscribing all future travel? We will never know. But if the latter, he was very much mistaken, and the young Alatau seems to have curtailed nothing – rather the contrary, indeed. He may have added a major and inescapable complication to his parents' travels, but he was to win many hearts, and his young presence was to smooth the way for many future encounters.

Chapter Four

Life and Death in a Cossack Fort

THE FRIENDS THE Atkinsons made in Kopal in 1848 and 1849 were all amused – and doubtless amazed – at the names the couple gave their new-born son. The baby was big and the petite Lucy was told later that the fable was now reversed: instead of 'a mountain bringing forth a mouse' it was a mouse that had brought forth a mountain. Lucy had too keen a sense of humour to be offended, and indeed included the episode in her subsequent book. When first asked what Alatau should be wrapped in she opted for his father's shirt, which made her friends laugh and tell her she could not have done better or wiser, as a child enveloped in its father's shirt was, according to the superstition, 'sure to be lucky'. Friends had arranged, she discovered later, to make him a little trousseau, knowing she would be able to find nothing in Kopal. But they considered the infant could not possibly survive, so they desisted, feeling that such items would only be a source of pain, 'but, thanks to the Giver of all good! I have carried him safely. He is a hardy little fellow, and a more healthy one it would be hard to find.'

Two days after the birth Madame Techinskaya asked if she would like a bath. Lucy was delighted and accepted readily. The next morning she was awaiting a hip bath's arrival when her friend arrived in 'a kind of railway porter's truck, drawn by a bull [i.e. ox]' and announced that all was ready. '"What do you mean?" I enquired. "Why, the bath! Will you not go to it?" "Go to the bath!" I said, quite aghast at the proposal. The snow lay thick on the ground and, moreover, it was piercingly cold.' Lucy had once been to the bath so knew she would have to take off her clothes in a shed where one side was quite open to the steppe. They both laughed at the misunderstanding, but Lucy gathered that it was considered quite normal for a new mother to have a bath three days after the birth – 'and many, I hear, take cold from doing so, and die'.

Lucy began a fixed timetable for Alatau: a bath and clean clothes between 6 and 7 a.m. every day and another bath at 4.30 p.m., then bed at 5 p.m. She turned laundress too.

> In Kopal they considered me very silly for washing so often, saying once in two days was often enough … but the maxims of a mother are not easily forgotten; and mine had so instilled into my mind the necessity of cleanliness in my youth, that I determined to follow her injunctions. And, believe me, I am well repaid for my trouble, by the health of my child; he has never given me one day's uneasiness, or one restless night, since his birth.

Opposite: Detail of 'Caravans on the Irtisch' [Irtysh]

She also made Alatau a 'travelling dress' well ahead of their departure from Kopal, from a piece of Chinese silk bought from a Tatar merchant. She lined it with *dabi* or unspun cotton, but it got covered in dye from the silk. Never at a loss, to her husband's astonishment she plunged the silk into a vessel of water some fifteen times, changing the water each time, and the silk 'came out far prettier than when I bought it; true, it was flimsy, but it was now clean and glossy, and certainly most serviceable has it been'.

Inevitably, Lucy's new friends in Kopal urged her to swaddle her child – the Russian custom to this day. Lucy assured them it was not the practice in England but, after one friend urged its necessity, Lucy agreed in order to satisfy her. Her friend began first to stroke down the baby's arms and legs and then to bind him, 'but he very shortly showed her that he was a true Briton, and was not going to stand any such treatment, for he fought bravely' and the procedure was abandoned. 'How very odd!', exclaimed her friend, 'I could not have believed it had I not seen it; what a difference there is between English and Russian children!'

Baron Wrangel one day complimented Lucy on Alatau's good qualities. She reported,

> 'When first I heard there was a child [he said], I actually swore, such a hatred have I to screaming children; but I will do Alatau the justice to say I have never yet heard his voice', and thereupon made him a very handsome present of a Chinese silk of a most exquisite blue. If such a reward is merited by silence, I am afraid I should never get it.

One day when Alatau was about two months old he was very restless (which Lucy knew indicated a storm – 'he was as good as a barometer') and her visitor at the time 'proposed he should be 'baked'.

> 'Baked!' I shrieked. 'Yes!' Explanations were entered into, when I learned that it was quite a common custom to do so; but if I did not like to have him placed in an oven, I could cover him with a crust and put him on the hot stove, when hairs would come out on the back: these plucked out, the child would be perfectly easy.

Lucy discovered later that 'it is quite true that Siberian peasants bake their children' – the only way, they claimed, that they could be cured of a particular (unfortunately unspecified) disease. They would make a crust of rye flour, enclose the child inside like 'a fowl in a pasty', leaving a small hole to breathe through, then place it in the oven with the door closed for a few seconds 'and it is said that it proves a sure remedy'.

One disease 'fearfully prevalent' among the Kazakhs at that time was smallpox, and the Atkinsons found many badly disfigured by it, so they were anxious to have Alatau vaccinated.[1] Surprisingly, Baron Wrangel was able to offer them some vaccine, which he had received from Omsk, but after three attempts

that did not take – a torment for Alatau – they had to give up, 'so, trusting in Providence, we went forth amongst those very Kazakh where the disease was raging dreadfully. I felt no fear, and only on our arrival [again] in Zmeinogorsk did we have him vaccinated.'

Between them, Thomas and Lucy have left a very remarkable, possibly unique account of life in an isolated Cossack fort on the Russian Empire's expanding Central Asian frontier in the mid-nineteenth century. Thomas identifies briefly their chief companions: besides Wrangel, there was Captain Abakumov, head of the artillery, and the engineer, Captain Loginov. Thomas came to have a high regard for both: 'clever and intelligent men, who did honour to their profession', while he regarded the commander of the Cossacks, Ivan Ivanovich Izmailov, as thoroughly efficient, 'an excellent officer and a good man, though [like himself] not highly educated'. He mentions also two young lieutenants, sons of Cossack officers, educated in Omsk and on their first service. A third lieutenant had just arrived with fifty soldiers, accompanied by a young doctor, newly qualified, 'sent to cure, kill, and practice on His Imperial Majesty's subjects' and no use for Lucy's accouchement. There was also a topographer from Omsk – 'a very good fellow' – and a store-keeper. These, with the five wives of the officers, were to be the Atkinsons' close companions for what was to prove six months, and Thomas was conscious that 'to induce your companions to be agreeable to you, you must be amiable to them'. In addition there was a former Orthodox priest who, for unknown reasons, had been made a soldier and had recently arrived with his comrades.

Then there were the domestic servants. It was curious to find them there at all, but normal for the nineteenth century, even in such a remote place. Female servants, however, were not to be had and Lucy found it very difficult to find anyone to wash the floors. Although Madame Techinskaya had a female Kazakh servant and Wrangel a Cossack's daughter, the work was otherwise done by men, and from Lucy's knowledge of the female sex in that part of the world she was 'rather thankful … that they are not to be had; they are a strange as well as a dangerous set to have anything to do with'. Baron Wrangel, she wrote, was nearly poisoned by his Cossack help, who had developed a deep passion for him and, being a proud Cossack, thought herself sufficiently noble and worthy to be his bride. Her feelings were unrequited, however, so she prepared a distinctly dubious love-potion for him. Fortunately, the plan was discovered in time and she was severely reprimanded and banished from the house. In addition, Lucy says, Yarolae, Wrangel's Kazakh bodyguard, gave her a good thrashing and threatened to repeat it if she ever came again.

Rather more sinister was the case of Wrangel's laundress. Her Cossack husband had been a good-looking and very healthy young man but suddenly sickened, and his friends, who were particularly fond of him, feared he might die like so many before him because of the harsh conditions. One day, a workman who had fallen asleep in a building under construction was woken by the sound of voices and overheard the laundress plotting with a Cossack 'a most diabolical

scheme for ridding herself of her husband, the poison she was giving being too slow'. The workman watched them depart and went off at once to inform Wrangel. The laundress was tried, convicted and sentenced to fifty strokes of the birch from her husband, who had been present at the trial. Her punishment was promptly carried out in the prison with two Cossacks holding her, then she was placed on an ox and drummed out of the fort in the care (or otherwise) of her husband. What displeased Lucy about the affair was that her accomplice was neither tried nor punished: 'it was not even-handed justice'. 'Thus', she added, 'I am fortunate in being surrounded by the male sex alone; indeed, I am the only female who sleeps within the fortress' – indicating that the bulk of the population lived outside its walls.

The only other female domestic servant was Madame Techinskaya's maid, Sunduk, the beloved of a Kazakh youth, Adiyol, in Wrangel's service. His feelings were requited, unlike Wrangel's Cossack help, but a major quarrel blew up about Adiyol's *chimbar* or wide trousers. One day they could not be found and, as he was dressed at Wrangel's own expense, a thorough search was made. Adiyol protested he knew nothing about his missing trousers, and Yarolae feared being implicated himself as he was the first to have discovered the loss. Some days later Yarolae saw Sunduk in the lost trousers, leaped from his horse and seized her. She struggled violently, but being a powerful man, 'and apparently without scruples, [he] laid her on the ground, and, divesting her of [the trousers] … carried them home in triumph'. It turned out that Adiyol himself was to blame, having presented them to Sunduk as a temporary love-token and intending to replace them later with something else. It was a compound mistake on Adiyol's part for, apart from her public humiliation, Sunduk was convinced that Adiyol had been mean enough to bribe Yarolae to reclaim his present. Regrettably, Lucy deprives us of any further dénouement, so whether the path of true love was smoothed out we do not know.

Apart from their human companions at Kopal, the Atkinsons had considerable canine company. They had been followed by a 'very fine' large dog with a brown coat marked like a tiger and beautiful long black ears. Evidently he had been ill-treated, for he had a bad wound all round his muzzle as if it had been tightly bound. After many attempts, the dog at last allowed Thomas to apply some ointment, which was repeated daily for some time. 'It was shortly cured', wrote Lucy, 'and the poor beast's gratitude was unbounded; I never saw any animal love its master so much.' Amazingly, they called this dog Alatau too, and their Cossack attendant distinguished him from their baby by calling the latter 'Gospodin (Mr) Alatau'. One day someone stole the dog and tied him up with a thick rope, but he broke loose and came back with the rope round his neck. Another time he set off to the mountains and, unusually, did not return at night. Three days passed and the Atkinsons became increasingly concerned. On the third night there was a noise at the door, which woke Lucy, and in came the dog, 'making a most tremendous rattle and clatter'. He had been stolen again but had escaped once more, this time dragging an extremely thick long chain behind him: 'even *iron* is not enough to keep him from his master'.

But the dog was only one of five the Atkinsons had at this time. 'Madame Jatier', whom we first saw in Chapter 2, was the favourite. She was always the first to be fed and only she was allowed in and out of the yurt, their first home in Kopal, where she had her own corner to sleep in. One day when Thomas was away hunting, the four-legged Alatau with him, it was for Lucy to feed the dogs. Jatier ignored Lucy's call to be fed first, so Lucy began to feed Appoleck. Jatier arrived on the scene and tried to drive off her supplanter, but Lucy was firm and there was 'a grand scuffle'. When Lucy then offered Jatier her dinner, she sulked and would have none, so Lucy called Ashara to eat and there was another battle, with Lucy just as firm. Again Lucy offered Jatier her food but she would not approach, so Lucy now fed Actigoon, which made Jatier even more furious. With all others fed, Lucy again offered Jatier her dinner, but she would not come near and only when indulged with a clean plate did she consent to eat.

Shortly afterwards, Lucy was sitting on the carpet in the yurt, sewing, when Jatier came in. As she did not come to lie at Lucy's feet as usual, Lucy looked round to see if it was one of the other dogs that had dared to enter. But, as Lucy tells us, it was indeed Jatier, a mass of mud and scarcely recognisable, not a speck of her glossy black coat visible, wagging her tail and looking as impertinent as possible. Angrily, Lucy got up, seized her whip and cried, 'You dirty creature, how dare you come here!' at which Jatier was 'off like a shot … racing away over the steppe'. A little later she reappeared, 'as clean and glossy as ever', and silently resumed her accustomed place. Lucy was sure Jatier was fully aware of her horror of dirt and had rolled in the mud on purpose to annoy her for not allowing her to eat first. It was the first time Lucy had ever seen a speck of dirt on her coat and she must have gone some distance to find any mud, as there was certainly none near.

Earlier, Thomas had been lent another dog, Calypso. Jatier would sit in any balagan by the side of her master with Calypso at a respectable distance without. One day, however, Jatier had gravely offended Thomas so 'he gave her a thrashing, whereupon she deemed it prudent not to come too near'. Calypso now cautiously approached her master and sat in Jatier's place. Lucy

> saw Calypso screwing up her nose and making grimaces at Jatier; I make no doubt but they thoroughly understand each other. Poor Calypso's reign was of short duration, for Mr Atkinson, never long angry with any animal, once more caressed his favourite. No sooner had he done so, than she entered the balagan and gave Calypso a thorough thrashing, as if she had been the cause of her disgrace, and then drove her out, and reinstated herself in her former position.

At the time of the Atkinsons' arrival, Kopal was still a very new fort. Four years earlier, as Thomas describes, a battery of artillery – six guns and 100 men – had been sent into the Alatau mountains in order to found a military outpost and established themselves in a pass eight miles south of the later site of Kopal. But winter brought an eleven-day buran reaching hurricane force through the gorge

where they had encamped, and by mid-February thirteen men and fifty-seven horses were dead.

With this disastrous buran a new site for a fort was chosen just east of the river Kopal on a treeless, tumuli-dotted plain covered with coarse gravel and sand: a host of flowers in early spring perhaps, but the rest of the year an arid waste where furious storms would sweep up the gravel, producing a shower of stones and sand. Such was the spot, rather than a fertile, sheltered valley, chosen by two irresponsible (Thomas's adjective) generals,[2] where 500 Cossacks with their families had arrived on 20 August, a month before the Atkinsons, to form a permanent settlement with 200 others to remain three years to help construction. They had been told they were going to 'a warm and rich country where all kinds of produce grew in abundance, and their horror and dismay on reaching their destination' can be imagined, continues Thomas, particularly after a journey of great hardship; 'from comfortable homes … in a region of plenty' they had been sent to 'a dreary waste on which nothing would grow'.

Faced with an early first winter for them, Captain Abakumov, the head of artillery, located a forest of large pines in the nearby Alatau mountains, and set 150 men to work felling trees; the Kazakhs supplied a great many bullocks to drag the timber. The official buildings including the hospital were to be built straight away, but each Cossack had to cut his own wood, get it to Kopal and construct his own home. Many were built only twelve feet square, in which two families of ten were glad to take shelter, for many others had to make do in dug-outs.

By mid-October (1848) the whole chain of the Alatau was white and, with the Kazakhs predicting that the snow would reach Kopal in a few days, every effort was made to complete at least the wooden hospital. The beams were already in place, part of the planking done and each room made warm and watertight with a nine-inch layer of earth over the planks. The unfinished warehouse too was hurried on. Meanwhile, however, the flour and other provisions were exposed to storms of rain, wind and snow through which the unfortunate Cossacks ('poor fellows', empathised Thomas) had to work. In a fortnight both hospital and warehouse were waterproof, but their own dwellings were in a very different state. 'It was truly heartrending', wrote an appalled Thomas,

> to look upon their miserable families when the storms were raging; some were seen trying to shelter themselves under strips of voilok, and others were lying down to sleep in corners of the half roofed rooms. Elsewhere groups of women and children with haggard looks and shivering limbs were huddled round fires, cooking their scanty meal; and watching for the return of their fathers – wet and exhausted from excessive toil. These were not the scenes of one day – they were continued for weeks – and soon the fatal effects were visible. First, the children sunk under this severity, and were carried in numbers to the graves; the poor miserable mothers, worn out by anxiety, fatigue, and bad food, next fell victims to the fatal maladies which assailed them. I

'Falls on the River Kopal, Chinese Tartary'

have often watched the mournful processions wending their way to the hill selected for the cemetery, about two miles distant from the fort, and when they have passed have turned away with gloomy forebodings for the future. The endurance of the Cossacks lasted a little longer, but their turn was approaching.

Much has been said and written about the misery of our men in the Crimea; but what was theirs in comparison with the sufferings which these poor women and children endured? They had been torn from comfortable homes, where they lived in plenty, and transported to this desolate spot. Here they were reduced to black bread, salt and brick tea; vegetables there were none, and the Cossacks had no time to spare for hunting.

In late October a great buran began and for seven days snow fell, covering the steppe four feet deep and making it impossible for the Atkinsons to leave until winter was over. But bright sunny days followed, with the thermometer ranging from about −12°C to −19°C of frost, during which Thomas and a few others often went out in search of game, usually with success. By November, which brought 'fearful storms and greater cold', the Atkinsons had fortunately been moved before Alatau's birth.

On 10 November the thermometer fell most unusually to −25°C, and those poorly housed suffered particularly badly. Before the arrival of the doctor, Andrei Ivanovich, typhus had taken a great toll, so his arrival was very greatly welcomed, although at that stage the hospital, directly opposite Thomas and Lucy's new abode, was still without a roof and no medicine had been sent. After much effort the doctor was housed, 'a few boards were nailed together for bedsteads, and skins spread on them formed the beds and covering'.

> At first [wrote Thomas], when sickness seized the men, they deemed themselves fortunate if taken into the hospital…. This illusion was, however, speedily dispelled…. Before the end of a month, twenty-eight men were taken to their last resting place on the hill. Bad food, miserable dwellings, and crowded rooms brought on typhus fever, which carried off many women and children; the Cossacks also caught the disease, which quickly proved fatal. It was painful to see the men carry one, two, and sometimes three of their comrades from the hospital; and this happened daily.

Not unnaturally, Kopal's population came to the conclusion 'that if a man entered the hospital, he would not leave it alive'. When Lucy herself needed medical attention she refused to enter it and indeed no ill person would enter it willingly, so several people died in their own homes. Abakumov then ordered that at the first signs of fever everyone should be sent to the hospital, but all then tried to conceal their symptoms. Finally the epidemic became so bad that an officer and

guard were sent round every home and any sick man found was at once taken to the hospital. This created such feeling that one Cossack left his dwelling as the inspection party neared, 'walked out on to the steppe and shot himself, to avoid being carried into the ill-fated building'. This one suicide apart, Thomas observed that 'men were constantly taken to the hospital by the guard, and were speedily carried from it to the grave'.

Some time in November Thomas managed to obtain a rough, unfinished door and propped it up with four logs to form a table, enabling him to use his pencil and paints.

> My first work was a large water-colour painting, now in the possession of Prince Gortchikoff, and, I believe, the first water-colour picture ever painted in this part of Asia. While dabbling in my colour-box, discomfort, and even hunger, were forgotten, and the occupation enabled me to smile at the disasters of a stormy winter, and to enjoy the amusements of my companions.

He finished the painting on 19 November as a present for Prince Gorchakov and wrote the same day:

> When I had the pleasure of seeing you in Omsk in March last I then promised to make you a large drawing of one of my views taken on the River Irtisch. This has been my first work painted since I ceased sketching and now I beg you will accept of it and give it a place in your collection. I trust it may not be the less acceptable as being the first work ever painted in the Town of Kopal founded by yourself.

He then explains that since he had to sketch Altin-Kul and the Katun river in July and August, the best months to do so, he arrived very late in Kopal (on 22 September), since when he had made eleven sketches of the Kora river and several others near Kopal. Nonetheless, he continued, there still remained much fine scenery to sketch, but since it could not be done before the following April, he sought the Prince's permission to winter in Ayaguz and then sketch along the mountains as far as the River Lepsy (he calls it Lepsou) and other rivers where he had heard there were many beautiful views. He calculated it would take him five or six weeks and 'four or five Cossacks would be ample' for him.

He concluded by saying, 'I must not forget to tell you that on the 4th November Mrs Atkinson presented me with a Son. The first and perhaps the only Englishman that will ever be born in Kopal.'[3] Thomas, who unrealistically thought 'this circumstance' would delay them another three weeks, found the winter stranded them in Kopal until the following May.

The day after his letter all the officers came to see the painting (not yet in a frame and glass) and it 'astonished them greatly. The Baron was greatly delighted with [it]' and it was packed in an iron case and sent 'by the Post' to Omsk.

Gorchakov's reply to the letter does not survive but presumably was either a refusal or failed to find Thomas in Ayaguz, fortuitously allowing the Atkinsons a much more interesting time based on this new Cossack fort than on the older one of Ayaguz further north. Two days later Thomas was hard at work on a drawing (*sic*) of his beloved lake, Altin-Kul in the Altai.

The burans continued through November, and the snowstorms were so bad that visibility was reduced to only three or four paces and the inhabitants were effectively all prisoners, reduced to almost entirely 'bad black bread, salt and tea'. Fortunately, however – and surprisingly – the *ebi* responsible for the burans was a warm wind which actually raised the temperature to −6°C, but when the storms ceased it immediately dropped to −25°C, 'unpleasantly cold' in the inadequate dwellings.

In a lull between burans, Thomas and Abakumov decided to escape from their prison and visit a Tatar merchant, Minda-boi, who had encamped with his yurts forty miles away in a sheltered, wooded valley, Kizil-a-gash, with abundant pheasants. The two therefore hoped, in Thomas's words, 'to improve the condition of our larder'. They set off at daybreak across the deep snow and arrived at dusk to a warm welcome from their host and 'snug berths in his own yourt. The cold ride had sharpened our appetites; his mutton and rice required no other sauce, and we quenched our thirst with tumblers of tea.'

> Immediately after our meal an opium pipe with its apparatus was brought in and prepared by a Tatar. After spreading a large tiger skin and placing a cushion upon it, Minda-boi stretched his limbs, and the man handed him the pipe, which he commenced smoking with evident pleasure. In about ten minutes he seemed to pass from the ills of mortal life into Elysium, or into a state that appeared to afford him the highest pleasure…. Minda-boi still remained in his region of bliss, and I was left to my own musings.
>
> Opium smoking has become prevalent among the wealthy Kazakh, more especially with the sons of the sultans and chiefs: this is deeply to be regretted…. In a country where caravans have to make such long journeys, it is a great advantage to them, the article being of small bulk and of considerable value, as they sell it for its weight in silver…. The caravans … are met by Chinese, who purchase their whole stock, paying for it in silver, and these men smuggle the opium into the towns; then the merchant enters with his caravan of wares and silver ambas unmolested.

Thomas had seen that even after only a little opium smoking there was 'little chance of a man leaving it off' and when used often it produces a 'sunken eye and emaciated features'.

Early the next morning the party rode off after the pheasants; it was bright and sunny, 'though piercingly cold, and the trees covered with hoar frost, causing them to sparkle like brilliants'. But the pheasants had found shelter under the snow, up

to five feet of the white mantle made the hunters' task difficult if not impossible, and they had to return without firing a shot. Opium and tobacco were repeated a second night, while Thomas, furs thrown over him by a Cossack, 'slept soundly without the aid of either opiate'.

Next day they left early again, having learned that two large wild boar had been seen along the valley. They found them, pursued them and killed one after 'narrow escape[s] from his formidable tusks.... He was a magnificent animal, and had received nine balls before he fell.' After one more night with their host 'in a state of [induced] bliss', wrote Thomas, 'we left him, taking one of his camels to carry our spoil'.

Abakumov, after entertaining all his friends, invited Thomas for a moonlight ride in his peasant-style wickerwork sledge. Three wild horses being broken in were harnessed in troika fashion on the edge of a great open plain with a deep ravine some 500 yards away. The horses suddenly plunged forward, leaving Thomas in but throwing the driver out, and dashed off at full speed straight for the ravine. Fifty yards from it they turned and the impetus swung the sledge over the edge. They rushed on to a rough timber track which tossed the sledge from side to side, nearly throwing Thomas out, bruising his right hand badly and breaking a finger.[4] The horses galloped on until the reins got caught on a pile of timber, when those in pursuit secured them. Thomas leaped out of the sledge, unable to stand the next day, but was given 'a good steaming in a Russian bath'.

Inevitably, Lucy found life at Kopal very different from that in Barnaul or Ekaterinburg. There they had not only the necessaries of life but some luxuries also. Yet it would be difficult to find 'a happier or a merrier party than we form', wrote Lucy, and she must have made a major contribution herself. In the autumn they went riding and in the evening assembled in the *drawing*-room (Lucy's italics) where sometimes they had serious conversations and sometimes merry ones, for Wrangel knew many entertaining anecdotes 'and sometimes made us laugh immoderately'.

> Then we have musical soirées, vocal and instrumental, Mr Loigonoff, Captain Abakamoff, and myself, are the audience, and the performers the Baron and my husband; the latter plays the flute and the former the guitar. The evening usually concludes with the English and the Russian anthem. And now I must tell you of a ball we have had, decidedly the first that ever took place in this part of the world.

It took place during the Christmas holidays when each officer who had managed to make his dwelling habitable gave a ball – or the best possible semblance of one in the circumstances – and Lucy's description is worth quoting extensively.

> Having but one dress besides my travelling one, I drew it forth and looked with dismay at its tumbled appearance. I had a small iron with me fortunately, the only one in Kopal, so I dispatched our Cossack

'A dangerous ride'

to and fro to the kitchen to have it heated ... I managed to make it decent, and forthwith I commenced my toilet.... In the midst of my dressing a bouran arose; I was obliged to rush to one side of the tent to hold it down, my candle was blown out, leaving me in total darkness. Mr Atkinson ran outside to call the men, who were heard screaming and running in all directions, as the kitchen, with all the *delicacies* for the coming feast, was being nearly swept away; at last, with ropes and beams of wood, it, as well as our tent, was secured....

Having smartened myself to the best of my ability, we started; it was only three paces, for all our tents had been bodily removed to the vicinity of the house. We found our host in full uniform; he was scarcely recognizable; indeed, he laughed to see himself. Then there was his body-guard, a Kazakh, by name Yarolae, the grandest man in the place; he wore a magnificent new dressing-gown, a splendid shawl round his waist, and a tall-pointed silk cap, and red boots; altogether he looked and felt superb.

The room had wooden stools placed round; the carpenter had been several days busy preparing them, and at one end of it a few planks were raised from the ground; these were covered over with a carpet, and served for a sofa. This being the place of honour, I was seated here to await the coming guests....

Yarolae's bearing was usually calm and dignified, but hearing the wail of the camel he became quite excited ... and made a rush downstairs. He shortly returned, followed by two ladies; and ... announced, in a voice like thunder, 'Madame Ismaeloff [wife of the Cossack commander] and Madame Tetchinskoy.' The contrast between them and the gaily-attired Kazakh was too striking. The former lady was a soncy-faced old body, with a bright shining skin, a clean dark-coloured cotton dress, a white collar which reached to her shoulders, a white cap with a very full border, a lilac silk shawl, and brown worsted gloves, completed her attire; her companion, a small person, had a similar dress, but instead of the shawl she wore a pink satin mantle, trimmed with white lace. They came up to me, each giving me three kisses, and took a seat on either side of me, without uttering a word. Yarolae was again off; the next visitor was proclaimed by the roaring of a bull [ox]. The door was thrown open very wide, and 'Anna Pavlovna' was announced. My gravity was this time sorely tried, and more so as I glanced at the Baron; his face was irresistible, he went forward to shake Anna by the hand; her deep-tone, sonorous voice resounded through the room.

She was a tall stout woman, dressed in the Russian *sarafan* [peasant's dress], a cotton, of the brightest and most variegated colours, very short, and round the bottom it was edged with pink; a pair of good strong shoes, with nails, and *no* stockings, and ... round her head ... a red cotton handkerchief; as you may imagine, she was gloveless; but what an arm and hand she had! big enough to knock down anyone who approached her ungraciously. But her face was beaming with smiles and good nature; she, too, came forward like the others and bowing down low, saluted my cheeks three times, and then took her seat.

I certainly did not expect to see ladies of the first fashion; but I was not at all prepared for what I did see, as the husbands were gentlemen. Again the moaning of the camel was heard, and another announcement, which was the last, of the ladies. These two ... had more pretensions than the others. Madame Serabrikoff had on a woolen dress, and the other a faded green silk, with a patch in the skirt, of another colour; this latter visitor found means during the evening of telling me that she had not expected the *ball* to take place so soon, otherwise she would have had her *polka* ready to wear; it was a beautiful blue satin....

Tea, coffee, and chocolate were handed round by Yarolae. The

gentlemen assembled, and then came the musicians. We had a drum, two violins, and a fife; for the past fortnight they had been daily drilled by the Baron, in an attempt to teach them a polka. The ball opened by a polka danced by our host and myself. Afterwards we had quadrilles, in which my friend Anna Pavlovna was delicious, but in the Russian national dance she shone. Her great joy was to induce my husband to dance with her; his doing so certainly added to the merriment of the evening, and in spite of her strange costume, she was, with the exception of Yarolae, decidedly the most graceful person in the room.

At the commencement of the entertainment the ladies sat bolt upright, each trying to look more stately than her neighbour; voices were scarcely heard above a whisper, until the spirit, which at first they were rather coy of touching, had enlivened them; then their tongues were loosened and oh! how they did run on. I reproved the Baron for offering it to the ladies; his reply was, 'I know my company.' The gentlemen were not backward in imbibing their potations; those who did not dance played cards, and at each shuffle all but the dealer rose to do honour to the abominable spirit. Supper was placed on the *tables* at eight, and a little after ten all had taken their departure, unable to stay longer. We remarked that it was our host's own fault for pressing them to drink; he answered, 'You do not understand society in this part of the world, but I will enlighten you. To-morrow if you could enter the abodes of these people, and listen to their private conversation, you would hear them say what a delightful evening they had passed; whereas, if I treated them as in more polished society, they would be dissatisfied. And the sooner I render them in the state they like to be, the quicker I am rid of them; and now,' said he, 'let us have our supper.' He then resumed his Kazakh costume, and perching himself on his stool commenced a merry air on his guitar, delighted at having rid himself of his guests so quickly.

Then there were the New Year festivities of 1849. Thomas confided to his journal on 1 January:[5]

The people in Kopal seemed determined to enjoy themselves and usher in the New Year with mirth and jollity so far as it can be got out of Wodky. which is drunk in Large quantities so long as they can obtain [it] even some of the Ladies make themselves mellow with this delightful tipple. [Lucy, just quoted, calls it 'the abominable spirit'.] This gives a pleasing variety to their evening parties which are conducted with much state and ceremony. at the commencement. The Ladies ... [have] one virtue they seldom speak that is untill the wodky has passed and then Oh! Heavens how Their tongues do run....Their Lords are not idle as soon as a cup of Tea has been drunk

they assemble round a Table on which wodky and meat has been placed and now begins the serious part of their Evening pleasure namly to get drunk in as short a time as possible I have seen this accomplished in half an hour but some take a longer time....

Since the pages in his journal for 2 January to 5 February are totally blank, one must wonder if Thomas had also succumbed to the pleasures of 'the wodky'.

Beginning the third year of his travels, he had learnt his lesson on keeping a journal. No longer did he divide the pages of his new notebook into three and so run out of space. On the title page he has now inscribed 'Rough Notes for my journal 1849', which poses the question: did he envisage writing up a much longer journal (he doesn't mention a prospective book) and if the long entries are only 'rough notes' what more could he have had in mind?

By now, Lucy calculated, since leaving St Petersburg in February she had travelled 6,267 versts in a carriage, 2,040 on horseback and 760 in boats or on a raft. But the total of 9,067 versts (about 6,800 miles) comprised only the direct routes with horseback excursions accounting for much more, including, surprisingly, a 17-verst ride the very evening after their arrival in Kopal – as if, heavily pregnant, she had not had enough riding on their near-disastrous journey. As for her husband, who had started his Russian travels a year before hers, Lucy calculated his total at considerably more, a total of 14,485 versts (about 10,800 miles), quite apart from his many sketching trips of 40 or 50 versts apiece.

Lucy was long accustomed to 'a hard couch and hard fare' and when a friend in a letter suggested they send to an adjoining town for a bed, she and Thomas were much amused, as the nearest Russian town, Semipalatinsk, was at least 500 versts away. She readily admitted that she had learnt many a good lesson on their journey, one being 'how little is required to nourish our bodies'. On their arrival she may have been dainty, 'but all this has passed. The only thing I cannot bring myself to eat is horseflesh, though we have eaten it many a time unknowingly. One of the things I enjoy more than anything else is rice', which she invariably refused on their arrival as it looked dirty, 'but now after scraping off the outside, I really enjoy it, as you would also, were you deprived of every kind of vegetable'.

One day Baron Wrangel found her busy removing the dirt from the rice and presumed she must have encountered what he had found in the kitchen that day: 'beautifully white, well-washed rice' and beside it 'a horrible-looking cloth'. On questioning, Georgii, the soldier-cook, admitted that this cloth to boil the rice in was a 'foot-binder' – 'literally, the rag which the peasantry and soldiers wrap round their feet instead of stockings!'

Thereafter the rice on offer was distinctly more hygienic, for Georgii had to submit the cloth daily for inspection on pain of the birch. 'Scarcely a day passes', wrote Lucy, 'without the poor fellow receiving some two dozen strokes' for some offence.

If winter had made the Atkinsons complete prisoners and February produced two minor earthquakes – 'great shaking … [and] rumbling underground' – by

the end of the month they were walking or riding each day on the steppe, now covered by 'a carpet of grass and flowers'. The fine weather brought them Kazakh visitors, and all those coming to see the foreigners were announced by Yarolae. With any new arrival he would march into 'the apartment' (sic) with great state, motion for them to take a seat on the floor, and hand Thomas his flute, ordering him to play in a commanding tone. 'He imagines he is doing him a great service in making his talent known,' confessed Lucy.

One frequent visitor was old Sultan Souk, who would spend long periods in the Atkinsons' rooms (rooms, be it noted), particularly attracted by their small travelling mirror, which hung on Lucy's bedroom wall (amazing that she had a bedroom!), before which he would stand 'for an hour or more, making all kinds of grimaces and laughing loudly … probably the first time he ever saw his own face'. He tried to persuade Lucy to give the mirror to him but got instead a pair of scissors which his armourer then copied – the first ever made in the steppe, Lucy believed. Alatau, too, proved a great attraction. 'Kazakhs came from far and near to see him; one sultan sent a follower of his … 200 versts for some smoked mutton for the child *to eat* when he was *six weeks* old' (Lucy's italics). Many visitors would examine the Atkinsons' possessions and one sultan was so struck by a pair of Thomas's gloves that 'he ran out of the room with them on to show his followers'. On his return Thomas signed to him to keep them, but the sultan retired, then returned with Yarolae who translated that, if Lucy wished to give him anything, a towel would be more acceptable. Lucy gave him one, took back the gloves and left the room for a moment, returning to find towel, gloves and sultan all gone.

All nature was now looking 'smiling and lovely', which added greatly to everyone's determination to enjoy the oncoming *Maslenitsa* or Shrovetide, 'a holiday that every good Russian deems necessary to keep, and in doing so makes himself ill by eating "blinneys" [blinis or pancakes], preparatory to the forty days of Lenten fast'. Although there were no vegetables and the rye-bread was 'horrible',

> a good supply of pheasants … and rice boiled with dried apricots afforded us delicious fare [considered Thomas]…. The officers had sent a party of Cossacks to Kulja [Kuldja, across the Chinese border, three days' journey] for Chinese brandy [to supply all Kopal] as without that there could be no feast … abominable stuff, strong, fiery, and stinking…. Two days before the festival six camels were seen wending their way into Kopal, heavily laden with the spirits.

A high spot of the festivities was supplied by the soldier who had been a priest, indeed 'a distinguished member of the "Church Militant"'. In early life he had been studious and respected for his learning, but his tastes had grown both expensive and criminal, 'and to gratify them he used the power of his sacred office to screw all the roubles possible out of his flock', as well as, it was said, to strip icons of their jewels and replace them with paste. Expelled from his office, he had ended in Kopal, 'more suited for the musket than the crosier' in Thomas's words.

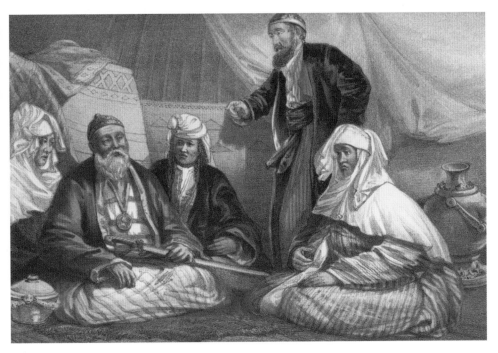

'Sultan Souk and family'
Thomas considered the eighty-year-old Sultan Souk 'one of the greatest robbers of the steppe' and, although too old for barantas, the plundering expeditions to other tribes, he still planned many. When some Kazakhs came to beg him to release their wives and children, his slaves from one baranta, he refused. He posed here for Thomas in a scarlet coat, gold medal and sabre from Alexander I 'of which he was wonderfully proud'.

At Christmas time he had put on a comedy, drilling a number of his companions so well in their parts that it was performed every evening, sometimes even twice nightly. This brought him great popularity, and he took the lead in all revels and carouses, while his previous career gave him a certain authority among his colleagues who called him 'Proto-Pope' or Arch-Priest. Now at the Maslenitsa festival he devised another entertainment for Kopal, which was awaited with great anticipation. Carpenters erected for him a railed platform at the top of a strong pole, the whole attached by axles to four gun wheels (by Abakumov's permission). Twelve artillery horses were then attached with their drivers and, before a crowd of spectators, the Proto-Pope, dressed as a priest in mock vestments, mounted the high platform to 'lusty cheers' and 'began solemnly chanting' from a book in a deep-toned voice which resulted in 'thundering applause'.

Religious sensibilities certainly existed. On Easter eve a Cossack came to Lucy, begging her to lend him her watch so that he and his colleagues could know exactly when midnight struck, marking Christ's resurrection. She did so willingly but did not know until Easter Day itself that the Cossacks, with Izmailov, their commander, in charge, had built a little shed to serve as a church for the most important festival in the Orthodox Church, and she regretted missing the service.

On the Sunday morning Easter's festivities began, and for many days it was to be 'one round of pleasure', Lucy found. At nine o'clock that morning the Atkinsons were visited by all the officers and the younger ladies for the first of the balls which each officer was to give. Each man carried a stool with him, knowing the two foreigners had only two chairs, and brought as well 'the mover of the fun … (viz., the brandy), as that was another article they were sure of not finding with us'. Musicians assembled, the room was cleared and, despite the morning hour, a dance commenced and 'all joined right merrily'. They then sat down and the brandy was passed round. After a second dance all went off to Baron Wrangel's where Lucy was amused to be asked if she knew how to dance the 'rococo'.

The watch that Lucy had lent the Cossack to time the arrival of Easter was returned with enormous gratitude. 'It afforded us pleasure to be of the slightest service to these men, they were always so good-natured and willing. Scarcely a day passed without one or the other coming, as our medicine chest was in great demand; they had more faith in us than in their doctor.'

One unusual medicine they had was a gallon of spirit and cayenne, given them in Zmeinogorsk by Colonel Gerngross. It had been prepared in large quantities for distribution at Nicholas I's order in case of cholera and was to be rubbed on the patient. The Atkinsons' gallon remained sealed until one day the Baron's laundress (of whom we have heard already) told Lucy that her husband's legs were very painful. After consulting Thomas, Lucy told the laundress that the patient should go to the *banya* (Russian bath-house) and when very warm rub his legs with the spirit, which Lucy then gave her. 'After this there was no end of symptoms; indeed this medicine was more in request than any other.' On one occasion Lucy heard that Mr Techenskoi was ill and found him 'moaning and groaning fearfully from inward suffering'. She proposed sending him some peppermint but he asked if

she had nothing else. No, she said, and after much further talk he told her he had heard she had spirit and cayenne and believed it would cure him. 'What?' said Lucy. 'Drink it! Why, it will kill you to swallow it.' Oh, no, he replied, he had taken it already several times without harm, and Lucy now saw very clearly why the medicine had been quite so popular.

Easter in Kopal was followed by a congress to settle the boundary between the Greater and Middle Hordes of the Kazakhs. The marauding warfare between them had kept much of the area between Lake Balkhash and the Alatau Mountains in a very unsettled state, making it dangerous for caravans, which were often plundered by one or the other Horde – or both. After much negotiation, Gorchakov as Governor-General succeeded in persuading the Kazakh sultans and chiefs to meet in order to resolve the matter.

In the early 1830s, before the Atkinsons' arrival, a chief Sultan of the Greater Horde such as Souk who had agreed to Russian sovereignty would be elected every three years, with two Russian and two Kazakh magistrates assigned to him as well as one secretary, two translators, three interpreters and two doctors. Under him would have been twenty smaller sultans governing regions (*volosti*) each with a secretary and an interpreter. And, since the steppe was divided into eight regions (*okrugs*), this new addition to the Russian Empire was costing around a quarter of a million roubles a year. Inevitably the Kazakhs were taxed: at the rate of one horse, cow or sheep for every hundred they possessed.[6]

Before the appointed day of the congress, 1 March 1849, many of the nomad chiefs arrived together with their mullahs and elders. The chief magistrate from Ayaguz (with whom the Atkinsons had stayed on their way south and who had given Lucy the prized water-melon for her parched journey) was to act as arbitrator or broker of the peace and attended with his staff, while several other Russian officials came from the tribes of the Middle Horde. On the day of the congress, the heads and representatives of the great tribes and families were assembled, 'many of whom had never met except in deadly strife when on their plundering expeditions. As each had wrongs to avenge, it was doubtful if they could be kept under control.'

Abakumov, in charge of the artillery, had been ordered to fire a salute on the first day of the congress, and the chiefs were delighted when they saw the horses gallop round with the guns and go through their rapid manoeuvres. At length the guns were placed in position a hundred yards or so from them and Thomas described how many Kazakhs rushed forward for a better view.

> Before they had gone half the distance the first gun belched forth its flame, smoke, and thunder, instantly checking their ardour, and causing a rapid retreat. As one gun after another echoed in the mountains, they gazed with perfect horror … and the display produced a great effect on their minds, forming a subject of conversation more interesting than that for which they had met; indeed they could not be induced to enter on the boundary question that day.

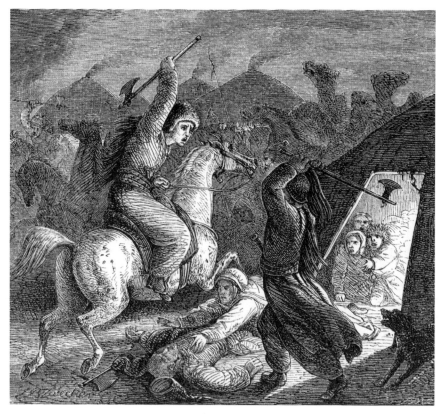

'Marauders at the Aoul'

Since more than a hundred people had assembled, a large flock of sheep had been rounded up from the nearest tribes to feed them and, as of course there was no room large enough within the fort, the deliberations had to be held in the open air. The magistrate and his assistants sat in the centre,

> their laps forming their desks, and ink horns ... suspended on their kalats. Such a display of writing materials appeared to produce great astonishment. Sultan Souk and his Mullah took their places in front of this formidable array, and the other Chiefs arranged themselves around it, forming their House of Peers – the outward circle being the House of Commons.

The magistrate opened the congress by stating that his Excellency the Governor-General Prince Gorchakov had sent a dispatch (which he thereupon handed to Sultan Souk, 'whose ancient descent and distinguished position gave him precedence') authorising him (the magistrate) to act as mediator and

recommending that the sultans and chiefs establish an agreed boundary between the two Hordes that would stop any future feuds or plundering. Once Souk's mullah had explained all this to the assembly, the magistrate expressed the wish that the deliberations should be held amicably, the only means of reaching a fair decision on such an important matter.

All eyes then turned on Sultan Souk, representing the Greater Horde. He had, he declared, considered the Prince's suggestions and was willing to adopt them, but the line of demarcation must, he said, be made according to his views which he believed his Greater Horde would approve. 'The boundary to which I shall consent', he said, 'is the Ac-sou, including the shores of the Balkhash. If the Middle Horde agree to this, it is well, if not the Chiefs will maintain their right, and seize every man and animal found on the pastures.' The Middle Horde's reaction is unrecorded but can be imagined, and the chief magistrate himself stressed that most of the pasture Souk was claiming belonged instead to the Middle Horde south to the river Bean. In confirmation he produced a map showing the boundary there as stipulated by the Russian authorities. Souk studied the map for some minutes apparently without comprehension, and then said:

> I cannot understand this paper, nor why you have marked the Bean and call it the boundary; it may remain so on the paper, but I will have the pastures to the Ac-sou. The prince has ordered the Lep-sou, the Ac-sou, and the Bean, to be placed where he pleased on this paper. He may have them so, but I order the boundary to be on the Ac-sou, nor shall it be changed. If the Middle Horde do not consent … they shall soon see some of my people on the Lep-sou.

Several other chiefs of the Greater Horde followed, supporting Souk's proposal 'and expressed a determination to carry it out to the letter by plundering every tribe that crossed the Ac-sou'. This not unnaturally caused a sensation and, though the chief magistrate remonstrated with Souk, the sultan remained totally immovable.

A chief of the Middle Horde then spoke. They had consented, he said, to meet the sultans of the Greater Horde to settle the boundary between them and were now told by Sultan Souk that it must be at the Ac-sou, not the Bean, though the latter had bounded their pastures for many generations. He would therefore follow in the same spirit as Souk: if any tribes of the Middle Horde crossed either the Bean or even the Kok-sou 'they would never return [and] his tribe would be ready to meet Souk and his marauders whenever they dared to enter the pastures'. On this acerbic note ended the first day's deliberations, and day after day passed with similar results. No arguments, no persuasion could bring any concession by either side. After a month the chief magistrate, tired out, broke up the congress without a single step forward, and the tribes separated more embittered than ever. The Russians had at least tried to promote peace, but there is no doubt they were the imperial masters, and Atkinson was exercised by their cynical and calculated methods in the Kazakh steppe.

When it was time to leave Kopal the Atkinsons had farewell visits from many of their Kazakh friends. 'Amongst the foremost', Lucy inevitably found, 'was the old Sultan Souk, with whom I was a great favourite who bade me tell my husband not to fatigue me so much by taking me with him the next time he visited the steppe, as he would give him any number of wives he liked; at the same time, he should always be pleased to see me.' The reason she had gained such favour with him was that 'the Kazakhs always think highly of a woman who can use her needle, and Yarolae had trumpeted forth my fame'.

Lucy had been making a little hat out of a small piece of red merino for Alatau to wear on their forthcoming journey and embroidered it with a little silk from her work-box, placing an eagle's feather in the front. When completed

> it did not look ugly. Yarolae was enchanted, particularly with the broad brim; I presumed because he was fond of the child whom he often used to take for a promenade, or to show to any newcomer, holding him as gently as I would myself; but what was my astonishment when this great big man begged of me to give the hat to him! I refused.

Several days in succession he came to plead, and at last Lucy asked Thomas to cut her another piece of pasteboard so she could make him one, assuming she could find enough cloth.

> When Yarolae heard this his joy was unbounded, he scarcely left my side. I made it perfectly grand by decorating it with beads and earrings, and when it was finished he walked off to the Baron, begging for permission to wear it. His master told me I had done him an ill service, as Yarolae was now never at home; for he had procured a horse, and was riding through the town every day displaying the magnificent acquisition to his toilette.

After many forays into the steppe and the mountains, the Atkinsons were to leave Kopal for good only in late May of 1849, and both Thomas and Lucy were glad to depart from this strange outpost after so long – the place certainly of Alatau's birth and first year of life, but of so much deprivation and death too. When they finally left, Thomas 'visited the cemetery on the hill, and counted 107 graves, proving how active death had been during eight months'. They, particularly the young Alatau, had been lucky to survive smallpox and the typhus epidemic, and as it was, Lucy was 'nothing but skin and bone; scarcely a pound of flesh left on me, nor is my husband one whit better'.

Later, in 1853, in Barnaul the Atkinsons met a young man who had been on government service in Kopal. He told them what had happened since their departure. Izmailov, the head of the Cossacks and to the Atkinsons 'a most worthy man', caring for his men, had rejected all the rye flour and grain delivered in the autumn by caravan as unfit for consumption and reported this to the authorities

in Omsk, urging that a replacement consignment be sent. A reply told him that 'his conduct had already been complained of' and he was rejecting flour 'of a superior quality' to what had been agreed, that the supervising general was quite satisfied and that Izmailov should not meddle with his superiors. Thenceforth his fate was sealed. Lucy says he was regarded as 'too dangerous to be left in a position where he could communicate with the prince [i.e. Gorchakov, the Governor-General], and measures were instantly adopted to prevent it'.

Up to then all official papers at Kopal were sealed in bags by Izmailov and sent off to Omsk. The unknowing prince now ordered that the bags henceforth were to be sealed by the civil authorities, who would forward them. Thus every letter or report from Izmailov could be intercepted, and his enemies produced certain charges against him, shown to the Prince, who summoned Izmailov to Tomsk to answer them. Aware that his enemies 'would stop at nothing to effect his ruin and that his bare assertions of innocence would have no weight … he placed two cartridges in his mouth [and] ignited them', leaving a wife and son.

The Atkinsons must have wondered what lay ahead of them, although the two were made of intrepid stuff and a sense of adventure seems to have been their lifeblood. Many adventures indeed were yet to come for parents and child.

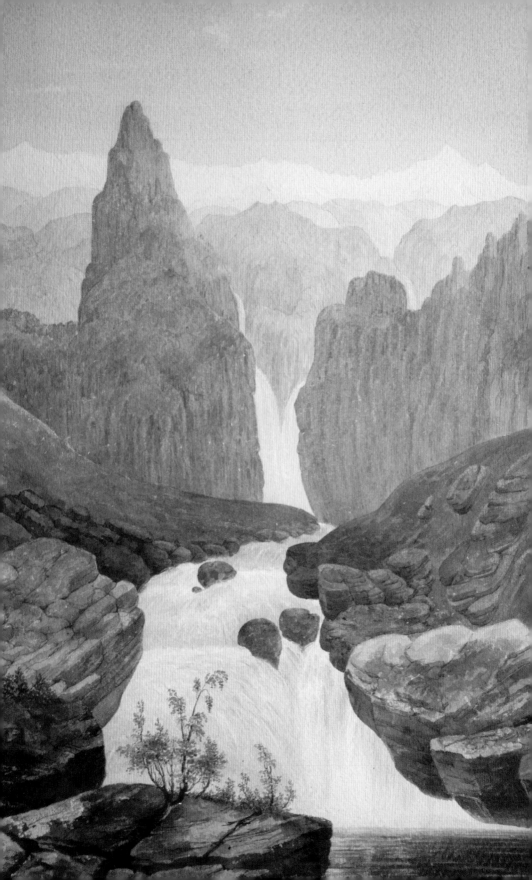

Chapter Five

The Mountains, the Steppe and the Chinese Border

ONE DAY IN 1849 Lucy wrote to a friend from Kopal, 'We are now about to wander in the stupendous mountain-chains which I have been looking at for months from my windows.' She meant the 400 km-long Dzhungarian Alatau,[1] only 15 km or so from Kopal, running north-east between the Tien Shan range and the Altai, which demarcate the border with China's far-western province of Xinjiang. They are considered by some as the northernmost spur of the great Tien Shan, with its thirty peaks above 6,000 m compared to the Dzhungarian Alatau's highest, at 4,622 m.[2]

Nonetheless, the Dzhungarian Alatau have their own majestic snow-clad peaks, permafrost and glaciers, the largest 11 km long, as well as earthquakes (it is a major seismic area) which 'often cause major rock avalanches and bring whole mountains tumbling down'.[3] The Atkinsons were to witness huge amounts of fallen rock and not only mountains and Alpine meadow but, on their further travels, steppe and semi-desert. And they were to find many narrow valleys in these mountains — indeed, dramatic ravines — due to the intense erosion of the northern side of the range by swift rivers in the annual thaw of snow and ice.

It was impossible to reach the highest mountains before May, so Thomas and Lucy — and sometimes Alatau too — would meanwhile make short excursions from Kopal into the nearer and lower heights. In early May, for instance,[4] the three Atkinsons made up a party to the Arasan, a warm medicinal spring in the foothills, supposedly known for 3,000 years and resorted to for many centuries not only by the Kazakhs,[5] who regarded it as holy ground (according to Thomas's journal), but by Kalmyks, Tatars and Chinese too. A yurt had been sent ahead to the furthest point horses could reach 'with all the necessaries for a tea party' and the group followed on horseback for some two hours along the river bank, 'very picturesque in many parts'.[6]

> The View from this place [Thomas's journal records on their arrival] was exceedingly beautiful; on each side Large Masses of rock rose up to a great Hight. Between these was seen some of the High peaks of the Alatou partly covered with snow while around us the Vegetation and the Flowers were most luxuriant. The rocks at this place are yellow and purple marble [also] exceedingly beautiful.

They found the Arasan spring in a small ravine 300 or 400 feet above the river

Opposite: Detail of watercolour p.149

147

Kopal. A large bath of rough stones 23 feet long had been built here by the Kalmyks, and nearby were the foundations of a Kalmyk temple. Thomas noted that the spring, which emerged as a small jet of water, was a constant 36°C winter and summer (although Lucy claimed it ranged between 68 and 74°C) and contained much sulphur and 'carbonic gas' bubbling up, so that ten baths would, Thomas was told, cure scurvy and 'eruptions'. (It is now known to be slightly radioactive.)[7] They bathed the four-month-old Alatau in it – the air very cold for him as he left the warm water – and, interestingly, a roughness on his skin from birth soon disappeared.[8]

After the inevitable tea they started back for Kopal but had not gone far when a storm threatened and, despite riding as fast as possible, they were caught a few versts from the fort and got soaked for the umpteenth time. Soon after their return home the lightning flashed dramatically and the thunder roared, all 'followed by a great *Bouran*'. And the next day was stormy, so Thomas could not go out to sketch but worked on his views of Altin-Kul, which they had visited the previous July and the pictures of which he had worked on back in December.[9]

Another expedition was to the picturesque spot at the foot of the Alatau after which they had called their son: Tamchiboulac, Kirgiz (i.e. Kazakh) for 'a dropping well'. Half-way up a great convex cliff face, wrote Thomas,

> The water comes trickling out of the rocks in thousands of little streams that shine like showers of diamonds; while the rocks, which are greatly varied in colour, from a bright yellow to a deep red, give to some parts the appearance of innumerable drops of liquid fire … the water drops into a large basin, which runs over fallen masses of stone in a considerable stream [and on to the Kopal river].

Large plants (unidentified) grew at the top, some hanging over in picturesque masses; Lucy found it 'an enchanting spot' and Thomas thought it 'magnificent' but regretted that the lithograph in his first book 'gives but a faint representation of its beauty'. The large watercolour of the scene is, alas, one of his many paintings to be lost.

Another time, higher in the mountains, on the edge of a great precipice they found a 'perpendicular face of snow, not less than a thousand feet high'. *Almost* perpendicular perhaps, but Lucy hastens to defend her statement: 'As travellers are generally accused of exaggeration … [I should] tell you that nothing of the kind shall enter into the account of our journey.'[10]

On 12 May they began to travel in earnest with Baron Wrangel, leaving Kopal south-west along the foot of the mountains for the valley of the Karatal, one of the many rivers of Semirechye ('Seven rivers') which all flow north and north-west from the Dzhungarian Alatau's parallel mountain ridges into Lake Balkhash. They had often come this way before, but this time Thomas observed 'that the ground was now covered with beautifull yellow tulips – and some other Flowers quite new to me'.[11] After four hours they reached the aul of Sultan Souk, 'a deep

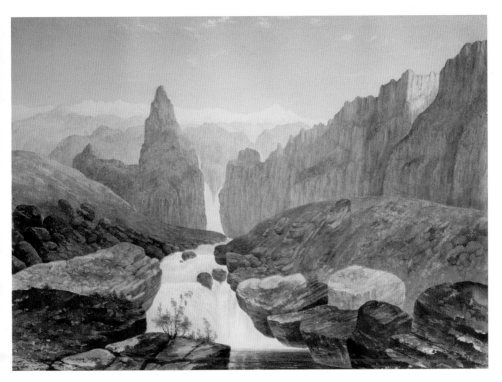

A waterfall in the Dzhungarian Alatau (?)

Waterfalls were one of Thomas's recurring motifs, particularly in mountain areas, and this is believed to be a scene in the Dzhungarian Alatau range in Kazakhstan, with its snow-capped mountain peaks in the distance. Once again he uses foreground rocks – often the same colour – to lead the eye into the picture.

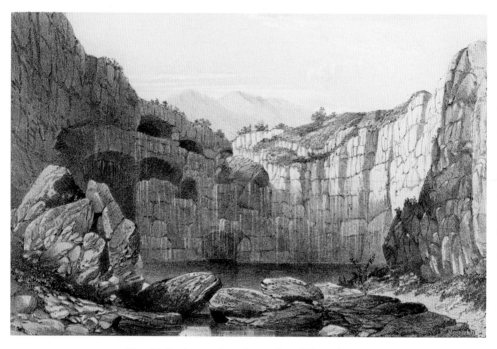
'Tamchi-Boulac, or dropping spring, Chinese Tartary'
At the foot of the Dzhungarian Alatau the Atkinsons found this 'dropping spring', and Thomas felt that his lithograph did not do it justice. The Atkinsons were so entranced that they called their son after it.

old Scoundrel', Thomas considered, but nonetheless there they spent the night.

Next morning they travelled over a high table-land covered with fine grass on which thousands of cattle would soon be feeding, as the Kazakhs were leaving the steppe for the mountains. At the river Balikty, which cuts through it in a deep gorge, were a great many trees including birch and aspen but, particularly, tall poplars, and Thomas, more interested in nature than Lucy, noted a great variety of birds, 'some with beautiful green Plumage on the Neck and Breast shaded into a brown on the Back and Tail, others with black heads a fine crimson on the neck the rest a dark grey',[12] besides very many pigeons. They passed that day a large barrow of stones some 25 feet high on which Kazakhs had placed horsetails, manes, hair, rags and other offerings as the tomb was held 'most sacred and in great Esteem'. According to Kazakh tradition this was the grave of a mighty Kalmyk chief, 'who ruled over his followers with so much justice that He still watches over those who inhabit his Kingdom'.[13]

Once Thomas had sketched the view towards the Alatau they continued their ride over undulating hills and soon came in sight of the mountains near the Karatal river. Two hours' sharp riding brought them down to its wide river plain, where a great number of large barrows proved it had once been thickly peopled, concluded Thomas, but Lucy claimed it was the scene of numerous past battles where many huge tombs testified to perhaps hundreds of victims – a 'matter for much speculation', she thought. Perhaps they were chiefs' burials? Now there were only a few Kazakhs tending their flocks. They rode on a few versts to the river Terekty, where yurts had been prepared for them, and found an invitation from a Tatar merchant to drink tea; next morning he sent Thomas a present of trout (a rare mention of fish).

On a hill to the west 'a great lama' had once lived, and shapeless masses of stone marked what had been his temple and dwelling. They crossed (or possibly re-crossed) the Karatal to join an old mullah (Islam had overtaken Buddhism) whom they had met in Kopal; he spoke tolerable Russian and gave them tea and fruit, treating them most hospitably. Thomas recorded in his journal:

> This man possesses more influence in his Horde than the Archbishop of Canterbury in his Diocese. His Ideas of our religion are very curious. He says all our Clergy are impostors, and the doctrine they preach humbuggery – everything they do is for gain and not for the love of God – whom he says they reduce to the State of Man when they tell you He Made the World in Six days and was then so tired that he slept the seventh. He says God can create in a moment nor does it require any number of days or even hours for the Almighty to attend his labours.[14]

Again Lucy writes almost identically, quoting the mullah's words that God 'has not to work like a cobbler for ten or twelve hours a day. What would our divines say to this?'

The next morning Thomas made a sketch of the Karatal river, valley and the lama's hill including many barrows; then they began to ride up the valley towards the mountain river Kora and two other tributaries of the Karatal, and found magnificent views on the way. They passed many auls and great numbers of Kazakhs cultivating the land for grain, some sowing (it took place twice a year) and others repairing irrigation channels which produced a crop 'one Hundredfold and often more'.

Thomas recorded in his journal that the Kazakhs

> keep breaking up fresh land that has been pastures for centuries. These people have a fine country producing everything they require with vast herds of Horses, Camels, Oxen, Cows, Sheep and Goats, all of which are pastured without one fraction of rent. They have game in abundance with wild Fruit in great variety and of excellent quality but unfortunately the Men are idle, the work having to be done by the Women … while the men visit each other and drink cumis, their

'Night attack on the aoul of Mahomed'

Once the Atkinsons stayed with Mahomed, an elderly Kazakh chief, in his aul where one night a mounted band of thieves attacked to steal about 100 horses. Mahomed's tribesmen leapt on to their own horses, battleaxes ready, the Cossacks seized their muskets and Thomas fired his rifle while the women and children panicked and the horses galloped round. All was confusion, but Lucy was determined not to miss it.

'A Kirghiz encampment – flocks and herds returning at sunset'

favourite beverage.[15] Walk they will not even for a short distance perhaps it is difficult to do so with their high heeled boots.... [He considered that their days were] spent in sleeply indolence, or planing *barantes* on their distant Countrymen whom they often plunder, carrying off at one time from one to Two Thousand Horses Five or six hundred Camels, and often Ten Thousand Sheep with their Women and Children, Yourts and all they possess; In these [*barantes*] it often happens that many are killed. After a successful robbery of this Sort they have great feasting until some stronger party commit a robbery in return.[16]

They crossed the Kora and after only half an hour reached the Chadzha, where they had yurts erected in an attractive spot by the river. Thomas 'found some excellent points to sketch where the river had cut a great gorge through a high granite mountain', and made their way through to 'a fine view of the snow Mountains towering many Thousand feet above', too steep and rocky to ascend. 'In the lower part there are many Tigers seen[17] and [I] should have been glad to try my wintofka [rifle] on them.'

A beautiful morning gave Thomas the prospect of sketching in the higher mountains to which he was determined to ascend. From one summit he sketched 'a splendid view' of the plain and the rivers below with the mountains behind, then rode along the ridge and well above the line of perpetual snow to another fine view and a great variety of flowers including many new to him.

To the East the mountains rose in long succession, their white crests cutting against a deep blue sky, so intense that on looking up it appeared almost black. Turning to the West I had a View over the Steppe as far as

the Balkash Lake which was like a plate of Polished Silver in the blue and misty distance.[18]

On the same day, having finished one sketch he rode for three hours to 'a most rapid and roaring torrent … passing Rocks chiefly of slate and in some parts porphyry – Bushes and flowering shrubs grew in the small ravines while the ground [was] covered with flowers up to the Snow line, and beyond it a white crocus grew in many places'. He returned to the yurt only at 7 o'clock 'somewhat tired after so long a ride to say nothing of being very hungry'. That evening

> A cossack arrived from Omsk with dispatches for the Baron. Their contents had an extraordinary effect upon him. If I had not previously known that he was a little wrong in his upper story His conduct this evening would have shewn it. He told me he must return to Kapal in the Morning as the paper[s?] must be answerd by Saturday Post. It appears from what he said [that] the Prince [i.e. the Governor-General of Western Siberia in Omsk] had written a very severe letter during the night. He [Baron Wrangel] was raving about his [own] capability of conducting a campain [probably a diplomatic campaign] against Bokara and Tashkent without the advice of the <u>Fools in Omsk</u> – with many other matters on which he believes that he alone understands.[19]

That night there was much rain and the next morning on reaching the Kora, tributary of the Karatal, they found it very difficult to cross. Here the Baron left for Kopal and Thomas started up the river valley.[20] 'Its outlet into the plain is truly grand', he wrote, 'it has cut through a mighty Mountain chain – the Rocks rising up for several Thousand feet.'

> I determined to go up as far as I could before sketching and then take any views I thought good on my return. We left our Horses at the mouth of the Chasm as it is impossible to ride further. Track here is none…. In other parts bushes and plants were growing in Tropical Luxuriance. A little more than a verst from the entrance was the farthest point I could reach. Here the rocks were quite perpendicular from the boiling flood … no man has ever placed his foot beyond this place, nor can this torrent ever be ascended in spring or Summer, and in Winter the Chasm is so deep in Snow … that it can never be attempted with success at that time. Thus the grand and wild scenes on this stream are ever closed to man – here the Tiger has his den undisturbed, the Bear his Lair, while the Maral and Wild Deer range the wooded parts unmolested. A very Large eagle is also found amongst these crags.[21]

After waiting an hour for a storm to pass, Thomas and his guides descended this gorge and he made another sketch, then they set off to the next river, the Balikty,

'Source of the Teric-sou, Chinese Tartary'

In the Teric-sou valley, rich in grass, Thomas found a large tribe of Kazakhs with their herds of horses, camels and cattle. He found also many tumuli, venerated by the inhabitants and testifying to a once much larger population. This was one of two watercolours bought at Christie's by Sir Roderick Murchison, President of the Royal Geographical Society. He bequeathed them to his nephew, who gave them in turn to the Society; they hang there today in the Tea Room.

where Wrangel had ordered a yurt for Thomas for the night. They rode hard but found the yurt only after three hours on a great mountain plateau covered with fine grass pasture for the Kazakh flocks that would soon arrive. It was then the middle of May.

> We arrived [a]bout 5 oclock tired and Hungry – shortly the clouds cleared off and gave me a most splendid view of the Actou [Aktau, White Mountains] which run up towards the Ilia [Ili river], the snowy peaks shining like Rubies in the Setting Sun, while all below them was blue and purple with the shades of evening creeping over the lower range. In the Foreground was my yourt with the Kazakhs cooking the sheep in a large cauldron over a wood fire while the camels and horses were lying and standing around the yourt. I could not resist sketching this scene which will ever be impressed on my memory – as well as the splendid sun-set over the steppe.[22]

Thomas woke the next morning to find it was raining hard and that the day would be wet and stormy. A long ride lay ahead and he wanted to make sketches of the nearby Balikty, so he started at 5 o'clock, reaching the river's rocky gorge, but the rain forbade any sketches. Climbing back to the plateau, the Kazakhs pointed to the clouds descending fast from the mountains and the storm soon drenched them thoroughly. A ride of five hours brought them to the mountains near Kopal, where there had been no rain and 'Another hour landed me at home. Lucy and Alatau were both delighted to see me' (a rare and affectionate comment on wife and child).[23]

Two days later he was off again, sketching this time a large Kalmyk barrow or *kurgan* about seven versts from Kopal, one of a vast number of barrows spread across the plain. This one was 'at least 300 feet in diameter & 30 feet high ... [and] a trench all round it five feet deep and 12 feet wide. On the Top of the Barrow ... [was] a circular hollow about 10 feet deep ... beneath this no doubt Body or Bodies buried' and he concluded that it had never been disturbed. On the west side he found

> four Masses of large Stones standing in circles. These I suppose to have been the Altars on which the Victims have been sacrificed to the Manes [souls] of the dead. But to whom these belong or when thrown up is a matter wrapped in the deepest obscurity which will never be unravelled.[24]

But following many excavations in Kazakhstan these *kurgans* are now attributed to Sak or Saka tribes of the fifth to third centuries BC of whom Herodotus wrote, probably a branch of the Scythians, and to the later Sarmatian tribes of the first and second centuries AD. In these tombs of chiefs has been found 'a staggering amount of golden jewellery [and ornaments], appliqués and horse trappings ...

in Scythian-Siberian style, including a skeleton in elaborate golden mail ("the Golden Man")'.[25] But of this the Atkinsons knew nothing and 'a ride over this plain', wrote Thomas, 'Makes one feel Melancholy to look at such numbers of graves. West from the Large one there are some Hundreds. In fact Kapal is built on a city of the dead.'[26]

In early May Thomas made a significant note in his journal:

> Fortunately we had a change in the weather this Morning Air felt soft and Mild and the snow melted fast in the Mountains. This I soon saw by the quantity of water in the Kopal [river]. I have now watched for a favourable change with great anxiety wishing to turn my back on Kopal at the earliest moment. Both Lucy and I are heartly sick of the place and people. We shall hail the day with joy when we can say adieu to all.

Surprising, perhaps, but they had been cooped up with the same handful of people all winter and indeed for eight months.[27] And the next day he began to prepare for their departure. But their one great difficulty was the lack of flour: 'without bread it was almost impossible to exist. We applied everywhere but none could be got. At last the Baron got us two poods from a Tartar, all that could be obtained', although another pood was given them by one of the officers who could ill afford to part with it and, though not well off, would accept nothing except some candles that had been sent to Thomas and Lucy. (Before they received them Lucy noted that they 'had been obliged to follow the example of the birds, that is to go to roost at dusk'.) They had the flour made into rusks, but certainly not enough for the three months' journey that was to lie ahead.[28]

In the next fortnight of preparations Thomas's journal is totally blank. And their last night at Kopal they chose to spend at the Arasan mineral spring once again, accompanied by Wrangel, Abakumov, 'Madam & Mr Serabrikoff [Serebryakov], Madam & Mr Vishigin' and, oddly, Timothy John – another Britisher? (the sole reference to these names by Thomas and never by Lucy). They cast their last look on the place with its numerous surrounding tumuli on 24 May and turned their steps to the east. Their other friends came to see them off, the men on horseback, the ladies 'on a miserable machine which had been made purposely for their accommodation … in the form of a char-a-banc'. The usually intrepid Lucy sat with them 'in great fear [for once], expecting every moment to be jolted off; beside which, a number of screaming women were clutching hold of me at every instant'.

The party passed the foot of one mountain sacred to the Kazakhs, atop which, traditionally, the beneficent daughter of a king had been buried. Her spirit was believed to wander abroad doing good and where she trod grass grew; certainly the summit remained green and luxuriant through the entire year, a surprising contrast in winter to the surrounding snow-clad peaks. That evening they arrived at the Arasan spring to spend the 'lovely [moonlit] night, undisturbed by even

a breath of wind' and 'until bed-time right merrily did the hours roll on' in 'dancing, singing, bathing, &c.' When 'a Cossack began playing on his balalaika … quickly dispelling the gloom all had felt [at the parting] … in a few minutes we were dancing Cossack dances on the turf to his wild music'. Chinese brandy from Kuldzha enlivened the occasion further, 'and no ball given in polite society ever passed off with more true enjoyment'. Surprisingly, Lucy says, none of the party had brought anything for the night other than 'night caps; neither combs, brushes, nor towels' (this last a particularly strange omission in view of the bathing).

Next morning the Atkinsons said goodbye to all their friends except Abakumov, who rode with them until they began to descend a pass to the steppe. Their Cossack Pavil (Pavel), of about twenty, who had been their faithful attendant for so many months,

> really sobbed again as he kissed Alatau for the last time. Poor fellow! – he had become quite attached to the child, having, I might almost say, nursed him from his birth, taking far more care of him than any woman would have done; and, besides, they were excellent friends…. Often has he stood by me, talking of his home and his mother whom he had left, and how much he wished to see her. He appeared pleased to find one who was a willing listener to his tales of home…. We, too, felt sorrow on bidding farewell to Pavil.
>
> Now setting off [once more almost certainly with a Cossack guide] I shall not fail in my promise of giving you[29] an account of any little incident that may take place, that is, if I am not made prisoner by some of the tribes we may meet with. I may be taken for a Kazakh, stolen from some distant *aoul* and disguised in, I will not say European, but an unknown costume. I look as scraggy and almost as haggard as any of their own beauties; I am nothing but skin and bone: scarcely a pound of flesh left on me, nor is my husband one whit better.

The three Atkinsons now began a wandering lifestyle (often in bad weather), staying with Kazakhs and sometimes travelling with them, impressed by their vast herds of cattle – and struck by seeing sheep with four horns, evidently quite common. Climbing one pass to the higher mountain ranges, they were enveloped in such thick fog that they could not see even ten paces ahead and, soaked to the skin, were led safely to an aul only by the barking of dogs. The fog had compelled Kazakhs to pitch camp there on the way to their high summer pastures: an unsuitable place, for next morning the Atkinsons found they were close to the brink of a precipice with the steppe 5,000 feet below. 'It was like a map,' wrote Lucy, copying Thomas's journal entry exactly; 'we saw the rivers Sarcand, Bascan, and Acsou [Aksu, meaning White Water] … shining like threads of silver until they were lost in the haze towards the [lake] Balkhash [nearly 100 miles to the north]. The higher summits near us were still capped in the clouds.'

Thomas noted that 'The Plants and Flowers have a Tropical growth; when you

ride amongst them you find they are far above your head.' Lucy picked many of the yellow roses that grew here en masse and pressed them with great care, but all were spoiled in crossing the rivers. There was also a large, yellow, sweet-scented poppy, a peony, acres of dense cowslips, a mass of pink primroses and many other flowers – besides flowering shrubs 'of every colour: how I envied my husband his knowledge of botany' (although Thomas's journal, from which she copies that list, admitted to 'a great variety of other Flowers' that he did not know). Lucy continues, 'I was only able to admire, and I did admire, the surrounding beauty, and almost envied those who dwelt in such lovely places.' Wild fruit, too, grew here in profusion: peaches, strawberries, raspberries, gooseberries, black and red currants, apples and other fruits that Lucy did not know. Yet, they found, the Kazakhs never ate them. 'Vegetables and fruit are for birds and beasts; they are made for the animals', one explained to Thomas, 'and the animals for men'.

Nearing the summit of one pass dense clouds thoroughly drenched them, but they found an aul with snow just below it so 'got water for Tea. Had a good fire made and passed a tolerable night'. Next morning they 'Turned out early' as usual, 'found the grass frozen' (this in June) and began a difficult descent into one valley, the cloud-covered summits above them. After four and a half hours they 'came upon a most frightfull chasm in which [the] River Terekta runs near the Brink…. It was no easy matter – even to walk down.'

They were particularly impressed by the sight from one mountainside, wrote Thomas:

> Looking over the step … there was seen a long line of Kazakhs with their Camels, Horses, Oxen, sheep and their yourts. On reaching the Pass we soon found it was filled with Kazakhs and their Flocks all marching towards their summer quarters in the Alatou mountains. We First came upon a flock of sheep several of which had four horns [which he was told were numerous]…. All together this was the most interesting scene there [were] Hundreds of camels … in line loaded with the household goods. We could not have passed less than a Thousand or 1,200. Oxen and cows … [with] many Women and children on their backs [and on one camel's back was] the chair of state [probably a ceremonial chair used by the head of a particular horde or tribal union] adorned with Peacocks feathers. There were also many Thousands of Horses loose as well as … [a] great multitude of sheep and Lambs giving us an idea of the march of the Jews. Thus the people are a wild looking race more like roving Bandits than peacable men.[30]

Riding ever north-east, they came to the long canyon of the 'small but turbulent'[31] Aksu river and rode up it as far as the horses could go: a place of more perpendicular rocks and a roaring torrent with large trees snapped asunder in their passage downriver. It was fearful to stand and contemplate such places, thought Lucy. They reached the next river, the Sarkand, on 2 June and pitched

their tent, intending to cross the next morning. But the bridge the Kazakhs had constructed consisted only of a few trees laid across the river from a rock near its centre, and the Atkinsons feared that the water, which was rising, could sweep it away overnight, so Thomas resolved to proceed at once. Did Lucy object, thinking of her own or her child's safety? We do not know, but it is surely unlikely, bearing in mind that Thomas was always very much in command and took the decisions ('I ordred' is a very common phrase in his journal) and Lucy certainly had a determined and adventurous streak. She wrote mildly,

> The crossing [that followed] was not agreeable, seeing the raging torrent under our horses' feet. One false step and all would have been finished. The noise of the stones being brought down, and the roar of the torrent, was so deafening, that we were obliged to go close up to each other to hear a word that was spoken. At last it became really painful; the head appeared full to bursting. I walked away some distance to try to get a little relief, but it was useless; a verst from the river the roar was still painfully heard. This din, coupled with the thunder, was awful ... fearfully grand, there being a short heavy growl in the distance, as if the spirits of the storm were crushing huge mountains together, and grinding them to powder; and the lightning descended in thick streams.

After six days in the Sarkand area they started for the Baskan, the next river east. Nearing it they were greeted by yet another violent thunderstorm which had evidently scared a fawn (a young maral),[32] so much that it had descended from the higher mountains and came near the Kazakh yurts. The Kazakhs immediately gave chase with much shouting, and the Cossacks galloped after them up the Baskan gorge. They soon returned with the maral alive and uninjured and presented 'the beautiful creature', a female, to Lucy. Once Alatau was in bed, she went into the Cossacks' tent to see the captive. They were trying to feed her on milk but she would not take it. When Lucy caressed her she tried to take some but could not, so Lucy asked the Cossacks to free her as being too young to be taken from her mother. They would do so, they said, when they had caught the mother; she would come down in the night and start crying for her infant, and they would soon catch her as she would never leave as long as she knew her young was there and would be sure to answer. Lucy's heart 'bled for the mother'; she was one herself, and she felt there was nothing the mother would not do for the sake of her young; and what indeed would the fawn do without her? She begged the Cossacks again to set the animal free, which they agreed to do once the storm was over – and meanwhile the mother might be caught.

Lucy found some light blue ribbons which she tied round the young maral's neck, much to the amusement of the Kazakhs: 'the colour contrasted beautifully with her coat'. As she did so, the animal raised her large soft eyes so piteously to Lucy's face that Lucy embraced her and at the same time loosened the rope with

which she was tied. Hardly had Lucy left the tent when she heard shouts and saw to her delight the graceful animal bounding up the mountainside. Cossacks and Kazakhs rode off in pursuit but failed to capture her again, and high up the mountainside the mother's voice could be heard calling to her young. Months later, Lucy had cause to rejoice, for she learned that her little beribboned protégée was taken for a sacred animal. Though many Kazakhs had seen her both with her mother and later without her, they forbore shooting her, and 'the tale of the sacred animal was always related with great gravity. When told by the Cossacks that I had tied the ribbon round her, they would not believe it, declaring she had been born so.'

When on the Baskan river Lucy was given a second maral deer. This one had been caught when young and was completely tame. 'I used to leave him at times with the different tribes we met with, and take him up on our return from the rambles; sometimes he trotted by us, and at others his feet were tied together, and he was seated before one of the men. He was a beautiful creature, with large expressive eyes.' Lucy was much attached to Bascan, as they called him (with their usual wayward spelling), and thought his love for Alatau remarkable. If in the evening Thomas took Alatau in his arms when they were setting up camp and Lucy was busy with domestic matters, Bascan always followed Alatau. Thomas told Lucy that Bascan's apparent affection was due to her lively imagination and, putting Alatau down, said, 'Now see, Bascan will follow me.' But Bascan never moved and lay down with Alatau. Thomas took up the child again and immediately Bascan followed, but this had to be repeated several times before Thomas was convinced.

Bascan also disdained any yurt other than the Atkinsons'. One evening Thomas had gone for a stroll and Lucy was doing some sewing, sitting on the grass outside their yurt to prevent Bascan entering as Alatau was in bed (oddly, Lucy once again calls him 'the boy' rather than 'Alatau'). But Bascan was not to be put off and Lucy had to jump up every few minutes to stop him. She therefore found some rope and tied it zigzag across the doorway as high as she could reach. This halted Bascan for the moment, but he kept wandering round the yurt and each time he neared the door he checked his speed and cast longing glances at it. Suddenly he took a leap and cleared the ropes. Lucy was instantly on her feet and darted into the tent to thrust him out when she saw a sight that arrested her attention.

> The creature had bounded to the child, and lying down gracefully beside him, was reclining his chin on the bed, close to the little fellow's face. My heart would not allow me to touch him, he seemed to watch over him as though he wished to protect the boy, so I left him in peace, innocence beside innocence; after this Bascan was a privileged creature, coming in and going out at pleasure – but, alas, for poor Bascan, his fate was a sad one. [He died of heat-stroke.]

Thomas's flute, which the Kalmyks had much admired in the Altai, was admired by the Kazakhs too. One of the sultans with whom the Atkinsons had been staying on their journey had been so struck by it that he travelled for two days with a few of his followers to hear it played once more and then asked permission to play it himself. After many attempts he handed it back, saying he would have nothing more to do with it: it was Shaitan and Thomas must have had dealings with him, otherwise why did the flute not answer him when he whispered to it? Thomas played on it again and once more offered it to the sultan but now he absolutely declined to touch it.

Far up in the mountains the Atkinsons came across many Kazakhs (probably moving to their summer pastures) whom they had met earlier on their original journey south into the steppe. All were delighted to see the foreigners again and particularly pleased to meet Alatau, now seven months old. Lucy reflected:

> How lucky it is that he is a boy, and not a girl; the latter are most insignificant articles of barter. I am scarcely ever looked at excepting by the poor women, but the boy is somebody. The sultans wished to keep him: they declared he belonged to them; he was born in their territories, had been fed by their sheep and wild animals, ridden their horses, and had received their name; therefore he belonged to them, and ought to be left in their country to become a great chief. The presents the child received whilst amongst them were marvellous: pieces of silk (which, by the way, I mean to appropriate to myself), pieces of Bokharian material for dressing gowns, *lambs* [Lucy's italics] without end, goats to ride upon, and on which they seat him and trot him round the yourts; one woman holding him, whilst another led the animal. And one sultan said, if I would leave him, he would give him a stud of horses and attendants; but I have vanity enough to suppose my child is destined to act a nobler rôle on this world's stage than the planning of *Barantas*, or living more like a beast than a man, and passing his days in sleepy indolence. Still he is to be envied, lucky boy! Why was I not born a boy instead of a girl? – still, had it been so, I should not have been the fortunate mortal I am now – that is, the wife of my husband and the mother of my boy.

Some of the tribes the travellers came across had never seen a European woman; and, Lucy continued,

> these believed I was *not* a woman, and that, I *being a man*, we were *curiosities* of *nature*; that Allah was to be praised for his wonderful works – *two men* to have a baby! One of our Cossacks I thought would have dropped from his horse with laughter. I was obliged to doff my hat, unfasten my hair, and let it stream around me, to try and convince them; but this did not at first satisfy them, still I believe at last I left them

under a conviction that I was not the wonderful being they had first imagined me to be.

One day a Kazakh woman took Lucy to see her baby of only a month old but so big that Lucy thought it must be a year old. Kazakh babies, she found, were strapped to boards naked but wrapped in fur until old enough to crawl and never washed from the hour of birth (unless drenched with rain) until old enough to run into a stream and take care of themselves. Lucy learned that when a birth was imminent, the mother was thought to be possessed by the devil and was lightly struck with sticks to drive him away. As the moment approached, they would call on the evil spirit to leave her.

> Poor woman! Her lot in a future existence, it is to be hoped, will be an easier one, as here she is a true slave to man, contributing to his pleasure in every way, supplying all his wants, attending to his cattle, saddling his horse, fixing the tents, and I have seen the women helping these 'lords of creation' into the saddle.

Thomas mischievously told Lucy that the Kazakhs had opened his eyes to what was due to husbands and that he was half inclined to profit from the lesson. He even thought of starting an institution to teach husbands how to manage their wives which he thought would be profitable and was 'much required in England'. Lucy lamented that the Kazakhs considered even a dog superior to a woman; when a favourite dog was about to have pups, carpets and cushions were given her to lie on and she was stroked, caressed and fed upon the very best. 'Women alone must toil, and they do so very patiently.' Once a Kazakh man, seeing Lucy busy sewing, making a coat for her husband, became so captivated by her fingers 'that he asked Mr Atkinson whether he would be willing to sell me; he decidedly did not know the animal, or he would not have attempted to make the bargain. With me amongst them, there would shortly have been a rebellion in camp.'

On one occasion Thomas was suddenly taken ill after sketching for a long time in the sun. The Cossacks, 'really good creatures', were greatly concerned, dug a hole in the ground, placed stones over it and wood beneath which they lit so the stones became red-hot, then covered the lot with a low voilok, and crept in beneath to throw cold water over the stones, 'making a tremendous steam'. Thomas made a small drawing in his journal. He was laid in this and given 'a proper stewing ... for which he felt all the better, walking back quite briskly'. She and Alatau, however, kept in perfect health on their travels by 'constant bathing in cold water; the ice had often and often to be broken [in winter] to allow us to plunge in', but it did not suit Thomas.

Lucy did not think that she ever saw anything more picturesque or pastoral than the Kazakhs with their cattle in what they called a granite crater 'like an immense portal': the sheep and goats wandering together as always: to hear the tinkling of the goat bells 'in the silence of this marvellous spot was striking' just

as it was to watch the goats ascend the precipices, seeming to bound and leap from crag to rock and 'almost like flies … cling to the face of them'. Above them on what appeared to be the summit nearly fifty gazelles stood quietly looking down on the humans far below, knowing they were safe at that distance from any gun. After some ten minutes they 'scampered off like lightning', disturbed by an enormous wild sheep with 'splendid curled horns;[33] a grand fellow to look at'.

At the crater the Atkinsons saw a magnificent sunset over the steppe 'spread out like a map, the rivers looking like threads of silver, while towards the great Lake Balkhash lay a boundless, dreary waste' and in the sky shone golden tints. 'Those who have not visited these regions can form no conception of the splendour of an evening scene over the steppe,' wrote Lucy.

Leaving one Cossack behind with the baggage, they took the other two with them together with a night or so's necessities, climbed the mountain – very difficult for the horses and camels – and on their ascent came across 'huge piles of granite, all piled up in confusion … like the remains of some gigantic statues … [or] the ruins of some mighty city'. At last they reached the summit,

'Argali'

and saw towering above them the Aktau, formed from white gypsum crystals,[34] their 'peaks shining like burnished silver'. Here they spent the night in a yurt as a violent thunderstorm erupted with rain and hail, and next morning they found (in early June) that six inches of snow had fallen. At breakfast a Cossack told them that a camel had just fallen on to rocks and had been killed outright, 'an event which reconciled us to some delay'. Later in the day, while eating a hasty dinner in order to leave the brink of a 'fearsome gulf', they heard the sound of wailing: a man had just brought the news that eight horses had fallen down the mountain to their deaths, three of them mares in foal. 'It was quite painful', wrote Lucy, 'to listen to these poor creatures, to whom one was unable to offer even the slightest comfort. We now determined to await the morrow, fearing to meet with a like disaster.'

Fortunately, the next morning was bright and sunny, giving them hopes of leaving their 'rocky prison'. The Kazakhs now recommended placing their baggage on 'bulls' (i.e. oxen) rather than camels for the precarious descent, and while they and a Cossack were getting this done, the three Atkinsons set off on horseback to the spot from which they had first seen a verdigris-coloured lake far below. They had first to ascend slowly up slippery rocks and only then descend, but this proved impossible on horseback, so they continued on foot, Thomas taking Alatau and the Cossack helping Lucy. In a couple of hours they reached a small plateau where they were astonished to find about eight yurts, previously hidden from view – astonished, as everyone had told them this mountainside was impossible to descend, but, wrote Lucy, 'my husband does not permit impossibilities, without proving them to be so himself': a fitting motto for Thomas Witlam Atkinson.

They were greeted as usual with the barking of dogs and Lucy, innocently, found it a 'most enchanting spot, – a perfect little Paradise'. She was in ecstasies and, taking Alatau with her, sat down recklessly on the edge of a precipice. 'It was a fearful sight to cast the eye below. The head seemed to grow giddy, and the heart throbbed quickly, at the frightful depth; where I was sitting, it was as near perpendicular down to the [verdigris] lake.' After standing for some time contemplating the scene, Thomas put his gun down by Lucy and walked off to choose a place for their yurt. Lucy continued to gaze in wonder at the sublimity of the prospect, finer than anything she had ever seen, she considered.

At length, turning to see why Thomas was taking so long, she was 'fearfully startled': their Cossack was surrounded by several Kazakh men with yurt poles, broken at their leader's command 'to knock our brains out with', Thomas was hastening to the Cossack's aid, other Kazakhs were seizing further poles to join in, and their womenfolk, arms moving wildly, were hurrying to the scene. But not a sound reached Lucy; she was too far away and all noise was drowned by a waterfall. Her heart beat rapidly and she concentrated hard on what to do as she knew Thomas and their Cossack had only their whips to defend themselves.

> At first I thought of putting the child down, and running with the gun,
> and then I reflected he might roll over the brink before my return. If

> I took him with me, and the Kazakhs saw me first, they might rush
> forward and seize the weapon; as with the two in my arms I should
> have no chance of outstripping my foes, although alone I should soon
> have done so. In this dilemma, I concluded it would be safer to trust in
> Providence, and sit perfectly still.

Lucy watched the men brandishing their sticks while Thomas and the Cossack
slowly retreated, facing their foes, who – especially the women – were following
'like demons'. At that moment the Atkinsons' other Cossack, who had been left
with the bulls, appeared round a mass of rock above and, looking below, saw what
was happening. 'Without a moment's hesitation, he rode straight down; how he
was not dashed to pieces, is to me at this moment [years later] marvelous.' As
soon as the Kazakhs saw him start to descend, they closed round Thomas and the
first Cossack. The latter struggled both with the attackers' leader and a woman
clinging on to him from behind but, being small, he could not extricate himself
from her grasp so managed to give her a tremendous blow which knocked her
down, and two of her number carried her off. Meanwhile two men had seized
Thomas and tried to pinion his arms behind him but 'they scarcely knew what a
powerful man they had to deal with' and he quickly flung them off.

Just at that moment the second Cossack arrived on the scene with Thomas's
rifle on his shoulder. He pointed it at the enemy to no effect, but the Atkinsons'
Kazakh, leading the horses down, appeared at this point and Thomas backed
towards his horse, quickly removed his pistols from their holsters and cocked and
pointed them. Faced with four muzzles, their attackers dropped their poles 'and
doffed their caps in submission'. Seeing that her small party were now 'masters
of the field', Lucy picked up Alatau and hastened to the scene of battle with a
double-barrelled gun.

> What a sight was there! On approaching, I heard the howling of the
> women, and on getting nearer I saw several with blood on their faces.
> Our little Cossack was pale, and breathless with the exertions he had
> used; blood was on his face, and his clothes were torn; but both he and
> the Kazakh had hold of, and had managed to bind with thongs, the
> leader, who proved to be master of the *aoul*. A more horrible sight I
> never witnessed; the man was actually foaming from the mouth. I could
> scarcely endure to look at him.

The Kazakh women brought him water but the two Cossacks would not let
them approach, so Lucy benevolently gave him the water and learned what had
happened. The ringleader, 'a very bad fellow', had taken possession of this place
and, determined that no one should approach, had called his people together,
urging them to kill the strangers, throw them into the lake far below – nobody
would know what had become of them – and take their arms and possessions.

The ringleader 'now became penitent, and promised not to interfere with

us'. Thomas ordered that he be unbound, but the Cossacks were most reluctant, saying he was a mad robber and would make another attempt on their lives. Thomas insisted, however, and when the visitors had retired to their yurt they saw him with several of his followers seated on a rock at the edge of the precipice, haranguing them loudly and continually pointing down to the lake. One of the Cossacks told the Atkinsons that the man was still bent on mischief, urging his men to kill the intruders.

Lucy urged a quick departure, but while they were drinking tea, their 'discourteous host' entered the yurt and sat down. Surprisingly the Cossacks had already offered him tea which he had declined. Lucy now also offered him tea which again he refused, looking round at the Atkinsons' possessions and starting to finger them; 'the guns and pistols especially had charms for him', and much to the surprise of Lucy and their Cossack, Thomas allowed him to handle them.

Unperturbed, Thomas prepared his sketching materials in order to descend to the lake and asked their antagonist for two men from his aul to accompany him. This was readily agreed but Lucy insisted on him taking a Cossack as well. However, 'no persuasions of mine could induce him to do so' – Thomas was always in charge – and he left 'our own Kazakhs' to guard Lucy and Alatau, agreeing at least to keep his guides in front of him on his way down to the lake.

The descent began and Lucy watched from the edge of the precipice until she could no longer distinguish them, then looked through her opera-glasses. (Perhaps she had used them in St Petersburg.) The master of the aul, observing her, began making signs which she could not understand and approached her. She rose from her seat and, determined to show no fear, 'stood perfectly still, merely placing my hand in my pocket and grasping my pistol'. Lucy was suspicious of one of the Kazakhs going back and forth to the chief yurt, and then a Kazakh woman tried to persuade Lucy to go there too which she stoutly refused to do, believing that she and Alatau would be made prisoners.

However, the master of the aul gestured for the opera-glasses which obviously intrigued him. Lucy handed them to him and he returned to his rock and soon seemed thunderstruck looking at the distant travellers, then looked with the naked eye and again with the glasses, 'his face all this time undergoing a variety of changes which it was amusing to see'. He then passed them to his followers, who all looked though them, each steadily more amazed. At last he returned them to Lucy, saying many times 'Yak-she' (good).

Lucy could no longer see her husband through the opera-glasses but only the horses, no bigger than ants, and even then could distinguish them solely because they were moving. Then she lost sight of them altogether as they descended even lower. Amid this dramatic mountain scenery she 'seemed to conceive a more vivid idea of the power and presence of the Deity' and felt that the Creator 'did not neglect to watch and guard even the least of His creatures.... What care had been bestowed upon us this very day! We had been three opposed to upward of twenty, besides women, and my heart swelled with gratitude for our deliverance.'

Lucy's reflections, however, were disturbed when she noticed the men leaving

the rock for the Atkinsons' yurt, and soon a woman, perhaps a wife of the 'host', advanced towards her. Lucy grasped her pistol, but the woman brought with her a Chinese silk handkerchief with mother-of-pearl decoration which she presented to Alatau. After the woman had gone, Lucy sent one of the Cossacks with Alatau's red hat, which she had made in Kopal, as a present for one of the Kazakh children; it gave enormous pleasure. (Alatau now had a felt hat which Lucy had bought from a Tatar, far more useful, but certainly not as fine.)

It was nearly dusk when Thomas returned (perhaps too unconcerned), and their host (for so indeed he now proved to be) had had a sheep killed so that, after the previous conflict, all could 'make merry'. The man who had intended that the Atkinsons should be his victims went forward to meet Thomas and shook both his hands. He entered their yurt, accepted Lucy's offer of a glass of tea and 'hardly knew how to be friendly enough'. Nonetheless, the Atkinsons took precautions in case of a night attack, and Lucy placed matches and her last piece of tallow candle by her side. Woken in the night by a noise, she was sure someone was in the yurt. She sat up and listened, heard their sentinel walking to and fro outside and supposed it was her imagination. Still, she determined to strike a light, but her candle had gone. She was now startled in earnest. Someone had certainly entered. She got up and looked for her one small piece of stearin (the chief ingredient of tallow) and then lay down with it and the matches in her hand, but in the morning, with no further incidents, she and Thomas laughed heartily as they realised it must have been the hungry dogs that had slipped in during the night and stolen the candle, and the disturbed voilok proved it.

On their departure that day their former would-be murderer accompanied them some way to (ironically) ensure a safe route, and 'as the sun was setting' they 'arrived at a lovely spot on the granite mountain' where a small stream ran between grassy banks and under more great blocks of fallen rock. Seven days after leaving one of their Cossacks on the Lepsy to look after their baggage, they returned and found him greatly relieved, as he had begun to fear for their safety.

They now began to descend to the steppe and all along the Lepsy's banks found Kazakhs encamped, gradually returning at the beginning of July from the mountains. Many were old acquaintances, and there were numerous invitations to stop and feast. But after the usual salutations the travellers felt they must continue on their way. One old friend they had often met at Kopal was Sultan Boulania, one of the leading Kazakhs of the steppe; with him, however, they felt compelled to dismount and take tea. He told them it would now (2 July) be unbearable on the steppe, but they had made up their minds to go.

However, their progress down to the plain was often steep and difficult. 'The heat became greater at every step, and then there were millions of mosquitoes, who bit us without mercy; and where we stopped, we had to fill the yourt with smoke, to drive out the enemy.' As they proceeded, they got glimpses of the country below, which resembled a sea of yellow sand (it was probably the Saryesk-Atyrau desert) with a stripe of green along the banks of the Lepsy winding away to the horizon.

Entering one of the ravines on their descent, they found, was like going into an oven. The blast of hot air was fearful, but it was even worse on reaching the plain. 'The sun, and the heat reflected from the arid rocks, positively boiled us,' wrote Lucy. The temperature, she said, ranged between 69 and 75°C.[35] 'While the yurt was being fixed my husband laid his gun on the sand, but when he went to pick it up, it burnt his hand, and the blister remained for several days.' On going into the yurt Lucy thought she would be suffocated, and to add to their discomfort they were forced to have a fire to keep off the mosquitoes. Having water poured over the sand, however, cooled the atmosphere a little. But, she went on,

> Poor Alatau was in a sad state; he was one mass of bites. No one could have recognised him. I was not much better. I placed the little fellow in bed, perfectly naked, and covered [him] with a piece of muslin, which we contrived to prop up but still the brutes succeeded in getting in.

Lucy was delighted, however, by their ride along the valley of the Lepsy. The easternmost of the river's branches meandered so peacefully through fine woods and a whole carpet of flowers, producing such a contrast to their previous dramatic scenery, that they named it 'the Happy Valley'. And high above them the Aktau's 'white crests rose far into the clear blue sky'. Three days later, when Thomas had finished his tasks (presumably sketches), they rose well before dawn for their return to the mountains. Lucy had a dip in the Lepsy despite the dark and the rain – and from its banks witnessed the dawn, 'a most lovely sight', the first time she had seen it over the steppe. For a few moments she thought it was a fire and that the rosy tints were caused by flames. Willingly she would have stayed to watch, she wrote, but there was no time to be lost as they had to be on their way by sunrise, it being quite impossible to travel in the intense heat of the day.

It is a wonder that Alatau, still only a baby, survived all these circumstances, but his parents did all they could for him. At each small stream they dismounted, took off his 'little dress' and poured water over him from a cup. It took only a few minutes and his parents had the satisfaction of knowing he was refreshed 'at the cost of a short gallop over the burning waste', as Lucy put it. And whenever they started early, Lucy would always let Alatau rest until the yurt was about to be dismantled, and then

> I aroused the little sleeper, to bathe, dress, and feed him. His toilette was soon completed, as it consisted of nothing more than one loose dress which I had made from some Bokharian material. This he wore with a belt round his waist. He never had shoes or stockings on his feet till [their return to Barnaul] … even now [writing from Barnaul later] I have difficulty in getting him to wear them. I very often find them on my table. He takes them off, and runs about without them;

but this is quite common amongst Russian children and is considered very healthy … grown-up persons do the same, and delightful, I can tell you, it is, especially on the sand.

One day, while still travelling among the Kazakhs, they had an intimation of 'civilised' society and an invitation to it: 'If Mr and Madame would be so good as to dine with me in the first hour, I will beg of them to bring *a pair of silver spoons* and a *pair of forks*, and *nothing* more will be wanting' (Lucy's italics). The Atkinsons found the idea 'too delicious to refuse', but whether they actually possessed silver spoons and forks, let alone travelled with them, we do not know. Their host-to-be on this occasion, Philonka, was a Russian merchant whom they had met both in Kopal and on the mountains. He had sent the Kazakh to find them and take them to his aul in a fine spot near the river Tentek ('wild' or 'savage'). There he had prepared for them a very pleasant little yurt, 'fitted up exquisitely'. The voilok was raised slightly all round so that a gentle breeze passed through on a sultry day. Their host's Kazakh wife and children came to make them tea, 'undoubtedly the best we had ever tasted', and brought Lucy cushions on which to repose until dinner.

A sumptuous one awaited them, but no details are given. Before leaving, their host presented Alatau with a tiny drinking bowl (he had sent him an even smaller one when a week old), and Lucy called at his yurt to say goodbye to his wife.

> After sitting with her for a while, she took me to a compartment separated by curtains, in which was their only son. He made me shudder to look at him. The child was about eight or ten years of age; his disease was the 'king's evil'[36] which I was told made frightful ravages among these people; his head was swollen to a dreadful size, and in an awful state. The father entered; we spoke of the little fellow, and he said, if we could only cure the child, he would give us half his flocks. I was glad to get away – it was too painful to look upon; and for two years he had been in this state.

One of the Atkinsons' Cossacks, whom they called Columbus, had a particularly enquiring mind. When they camped for the night or Thomas was sketching, he would squat down beside Lucy with questions. The first was always 'Have you seen the Emperor?' (Perhaps he did not want to take no for an answer.) He wanted to learn about England and its army, was particularly interested in geography and, after Lucy had shown him different countries on maps, borrowed them to show them to his companions, only to return with more questions after evident discussions. One day he said to Lucy, 'I hope I do not trouble you by putting so many questions.' She replied that she was very pleased to answer any that she could. She quotes his reply: '"Ah!" said he, "it is very different with you from what it is with our gentlefolks; whenever we put a question to them, they are sure to cheat us in their answers, so we never ask now for information. I am

so much obliged to you for all you have taught me; in two years I am going home, and I shall have so many things to tell them.'"

Riding on to Lake Alakol (or Ala Kul, meaning 'White Lake'), east of Balkhash and once part of that great lake,[37] the lower they descended the more intense became the heat. Lucy wore no petticoat but even her cotton dress was too much for her. Contrarily, the hotter the day the more clothing the Kazakhs would wear, keeping out the greatest heat with long shubas. Thomas could not wear gloves while sketching, so the backs of his hands were soon badly blistered by the intense sun. And despite the Atkinsons' hats, their faces became 'a nice mahogany colour'.

One evening they reached a Kazakh aul at sunset and heard much sobbing but were too occupied to pay any attention. The next morning the sounds resumed, only more protracted. They turned out to be prayers for the dead being chanted in a yurt, outside which stood a long pole with a piece of black silk at the top, denoting death.[38] Lucy was assured it would not be untoward to enter, and found inside two women, the wives of the deceased, kneeling before a pile of baggage, saddles and other items, moving their bodies to and fro and chanting together. It was evidently verse, and at the end of each verse they would bend forward, stop and sigh deeply. Lucy found they kept time extremely well and 'the notes were so exceedingly musical, and so expressive of sorrow, that the tears flowed from my eyes. It made me so sad that my husband would not allow me to stay.' She learned that, although the deceased had been dead for some months, it was the custom to offer up prayers for an hour at sunrise and sunset for a whole year.

It is really to Lucy rather than Thomas that we owe so much information about the Kazakhs in the mid-nineteenth century.[39] He was far more concerned with the topography and their actual travels, although Kazakh customs intrigued them both, particularly her, not least the practice of breast-feeding boys till the age of ten or even eleven. Another curious custom Lucy describes was for a sultan to place pieces of meat in the mouth of a favourite follower, who would stand with his hands behind his back. Sometimes the pieces were so large 'that a man has been known to die' but to let them fall from the mouth or touch them with the hands would have been an act of such rudeness that apparently the favourite preferred to choke instead. Once Lucy saw a Kazakh given a whole ball of meat: 'How the mouth got stretched to the size was inconceivable, and I verily believed the poor creature would expire, but he did not.' She was astonished also to find that the Kazakhs could go without food for two or even three days and then eat an enormous amount, and was actually told that a man could eat a whole sheep; 'one of them offered to treat me with the sight if I would pay for it, but I declined witnessing the disgusting feat'.

Travelling on to Lake Alakol, they rode in a storm down a rugged and gloomy pass with frowning masses high above them and the lake on its plain far below. Halfway down, the wind rushed through the ravine with such fury that they were really afraid of being blown over. All quickly dismounted and crouched down by the side of their horses, which tottered about. Despite so many burans,

never had Thomas or Lucy encountered such a wind, and she wrote, 'Had the men not seized hold of my dress, I should doubtless have been blown away; I had no more power than if I had been a leaf.'

Lucy was not exaggerating. She must have been referring to the *ibe*, a notoriously fierce and frequent winter wind that can reach hurricane force and last several days. It roars from the east, funnelled through the 46-mile-long Dzhungarian Gates on China's border, some six miles wide at the narrowest, connecting the Kazakh steppe and Xinjiang between two spurs of the Alatau range. Through these historically important 'gates' came nomadic peoples from the east to settle, and indeed through them in the thirteenth century came the all-conquering hordes of Genghis Khan. A rift valley, it has been called 'the one and only gateway in the mountain-wall which stretches from Manchuria to Afghanistan, over a distance of three thousand miles'.[40] However, finding that the foot of the ravine they were descending was blocked with fallen rocks (earthquakes again, perhaps), the Atkinsons were compelled to climb again and ride along a very difficult ridge before a five-hour descent. Then they were once more on the steppe, travelling at the foot of the mountains on sand so that the heat was really intense and, wrote Lucy, 'To tell you all I suffered from the heat is impossible. Suffice that at times I thought the poor horses would sink', and their dogs (to whom there are very few references apart from Lucy's engaging description of their behaviour) were howling piteously.

They pitched their tent at the foot of the mountains opposite Lake Alakol – even though dwarfed by Balkhash it is still 104 km long and 54 km wide, too far to see to the other side – and ordered a watch to be kept during the night as they knew that escaped convicts from a Chinese penal settlement were nearby. As the Atkinsons' escort had no tent and the night was stormy, they kept their arms dry in the Atkinsons' yurt. In the middle of the night Lucy woke to hear footsteps in their tent and gently woke Thomas to whisper to him. The intruder turned out to be Columbus, their Cossack escort. When Lucy asked him what he wanted, he said, 'Our arms. There are people about.' The Atkinsons jumped up at once. The admirable Lucy always put everything at night where she could lay her hands on it instantly.

> Placing my husband's pistols and gun into his hands, he started, bidding me lie down and keep quiet, but such was not my nature. If we were to be captured I was determined to see how it was managed, so put on my dressing gown and slippers, and out I went, with my single pistol in my hand; the other had been stolen. It appeared there were about six or eight men; they had come within fifty yards of our tent, but, observing the sentinels, had retreated across a little glen, and rode under the dark shade of a small mountain in front of us.

Thomas and the Cossack and Kazakh escort mounted their horses in pursuit, but the intruders had gone. What had seemed a vast and level plain proved to

be undulating and intersected with gullies where riders could easily hide. If the miscreants had stolen the party's horses as obviously intended, it would have been impossible for the Atkinson party to climb up the deep ravine on foot, and the intense sun, coupled with the burning sand of the steppe and lack of water, would soon have killed them all. And Lake Alakol's water was to prove salty and bitter.

Riding up a great ravine from the lake, they passed from a morning of intense heat to a night in snow-clad mountains. At the top of the pass Thomas shot a large black eagle, much to the delight of their Kazakh companions; Lucy regarded these birds with the greatest dread, 'in constant fear of them flying off with Alatau. They frequently carry off lambs, but I had not the slightest desire that Alatau should visit one of their eyries, to serve as a meal for their eaglets.'

On 26 July after further travels they returned to their old quarters on Alakol, getting up before sunrise for an early departure. The dogs had been very uneasy during the night, but although the Atkinsons were up many times to investigate, nothing untoward was seen. Then, just as they were to start off, one of their three Cossacks (whom they called Falstaff) noticed four men prowling about. Thomas ordered both Cossacks and a Kazakh to ride towards them and mounted his own horse to follow, leaving Columbus with Lucy, but she successfully entreated Thomas not to leave her and Alatau, knowing that he was a better shot than the three Cossacks put together. As soon as the four marauders saw they were to be pursued they rode off fast towards the head of the lake, 'our men' following at a furious speed.

'The chase was an interesting one', Lucy noted coolly. For a full twenty versts she and Thomas were able to watch it almost entirely. But they all became so small that 'even with the glass we could not distinguish them'. Suddenly those left behind noticed four men creeping towards them but, seeing they were observed, they disappeared and soon rode off, perhaps a ruse to draw everyone away from the camp – if so, unsuccessful. After some two hours the pursuers returned leading a camel, and George, their third Cossack, carrying a long lance. It appeared that they had caught up with the marauders, who attacked the Cossacks with the lance but missed, and George wheeled his horse round suddenly and grabbed it, at which the miscreant shouted furiously, 'We have tracked you for the last fifteen days, but you shall not escape us; we will take you yet.' After further skirmishes they rode off. The Atkinson party reloaded their pistols and followed them for some time, then decided it was safer to return to their camp.

In these journeys in Semirechye the Atkinsons had to cross many streams and rivers, not a few of them rapid. On the front flyleaf of Thomas's 'Rough Notes from my Journal' for the year 1849 he lists some of them: nine to cross and re-cross 'after leaving Philonka's aul on our way to the Ala-Kool' and another six 'between Bek Sultan and the Tarbogatie'. Some rivers the group had to ride into together to support each other, and Alatau was always on a parent's saddle. How he survived seems a miracle. The Kazakhs always made sure that Lucy was in the middle and held on to her dress to keep her safe. When there were deep and broad streams to cross,

'Sultan Bek and family'
The largest and wealthiest Kazakh in the steppes, according to Thomas, with 10,000 horses, and camels, oxen and sheep in proportion. In Thomas's sketch he is posing with his family and *berkut* (an Asian golden eagle, wingspan average 2.21 m), with which he loved to hunt deer: a Kazakh tradition that continues to this day.

I used to retire behind the reeds or rocks, as the case might be, and, stripping, put on my bathing gown, with my belt round my waist; and tying my clothing into a bundle, boots and all, I jumped on to my horse – merely holding tight on to him with my legs, there being no saddle – and swam him across in the company of a Kirghis, he gallantly carrying my bundle for me; when I would again retire with my bundle, to re-equip myself. These are the sort of things we have to do in travelling. At first I used to feel [I will not say timid, but] my heart beat quicker; now I think nothing of it. I am vastly altered since leaving Petersburg.

Another hazard was the wild horses the party sometimes had to ride, caught fresh from the herd, some perhaps never broken in – or even mounted before. Once Lucy was badly alarmed when she had Alatau on her saddle and her horse began to shy. Luckily she was able to quieten him. Another time, fortunately without Alatau, she had thrown her cloak round herself in a storm and when it cleared she asked Columbus, riding nearby, to take the cloak and roll it up, since her own horse was rather wild. But his horse was also rather wild and he found it difficult to approach her. The cloak fell from Lucy's shoulders, making her horse shy very badly. Columbus tried to ride up but this made Lucy's horse worse and he galloped off across the plain at full speed. 'No efforts of mine could stop him, so, sticking to him like a leech, I waited patiently till he should either tire himself or be caught,' as Columbus was now galloping after her. A Kazakh now joined in the chase and began hallooing as loudly as he could, but this only made matters worse and Lucy's horse sped on even faster. Only later did Lucy understand that the Kazakh was shouting for Columbus to stop his pursuit, and when he did so and Lucy's horse no longer heard galloping behind him, he gradually slackened his pace and slowed to a walk.

Lucy was afraid to turn him till he became quieter, so looked round and saw the Kazakh far off, walking beside his horse towards her, while Columbus approached carefully and seized her bridle, making Lucy fear the horse would throw her. But Columbus stroked him and was able to calm him. When the Kazakh arrived on the scene he patted Lucy on the back and indicated how proud he was of her,

and then showed me what a Kazakh woman would have done under similar circumstances. First, he commenced screaming, and almost set my horse into another fright, and concluded by falling from his horse. He remounted and again patted me with evident delight.... We had several miles to ride back, and I did not at all thank my animal for giving me a run for nothing. On reaching our party, I received so many congratulations at my safe return, as also for my bravery that I verily believe if we had stopped longer in the steppe, a woman would not have been looked upon as such a contemptible being as they consider

her to be; for the men now began to notice me, a thing they had scarcely deigned to do before.

Crossing the steppe between the large and small lakes of Alakol with the sun sinking fast, they pitched camp near the small sweet-water lake as far from its reeds as possible on clean white sand. All was still, 'but night came on like a race-horse, and then we heard a most unwelcome sound amongst the reeds … our old tormentors the mosquitoes commencing their music'. With an extraordinary degree of optimism, Lucy crept quickly into bed, 'hoping they might not find us'. For long they could not sleep because of both the vivid lightning and the heat from the ground, and when they did sleep they were soon woken by 'the blood-thirsty creatures. There were, I am sure, millions in our tent; they positively maddened me, and I became alarmed lest they should devour the boy.' Thomas rose and went outside to see what, if anything, he could do to keep them out, 'but his exit was not so rapid as his retreat back into the tent; he had not gone ten paces, before the horrible things seized upon him with such energy, that he was glad to array himself in his chimbar and boots'. Lucy prayed that a breeze would spring up to bring some relief, and her prayers were more than answered. It soon began to blow and indeed increased to a gale. The Atkinsons' yurt collapsed over them, and their escort, summoned urgently, propped it up so that the three trapped inside could breathe, and secured the outside with weights. But at least the gale 'entirely cleared us of the enemy'.

When they had gone to bed that night the lake had been like a mirror. Now in the night it began to break on the shore with a tremendous noise, and the wind whistled shrilly. At daybreak, with black clouds gathering, the party packed up the camp quickly and set off without breakfast. The rain soon caught them, however, turning the sand beneath them, so hard and dry on their arrival, into a quicksand into which they kept sinking, while on the lake the waves reached a frightening height.

They continued north-east and arrived in early August at a picket on the Chinese border near the town of Chougachac (Chuguchak). Their Cossack, Falstaff, tried to dissuade them from continuing, as a Tatar had told him that the Chinese would make them prisoners. But Lucy laughed at his cowardice, and when he saw that the visitors were determined to proceed, he 'pleaded indisposition', took over from Columbus near the camels and dropped well behind at the first sign of the border. As they approached the picket, the distant town and its minarets came into view – this was Xinjiang, a Uyghur[41] and therefore Moslem area, which the Atkinsons very much hoped for permission to visit. The picket was their first sight of Chinese (the border officials were probably Chinese rather than Uyghur) and Lucy was struck by their costume: their boots of black satin with high heels and thick soles, while their jackets, silk or satin for the superiors and blue cotton for the servants, pleased Lucy 'amazingly, and were really pretty'.

A ceremonial now began. One Chinese servant ran forward to announce their arrival, gesturing for the Atkinsons to remain where they were. He soon returned

and conducted them into a courtyard where the visitors were astonished to find the officer in charge playing with a goose. He stood up and Lucy was 'completely wonderstruck at his height, Mr Atkinson [who was tall – 5ft 11ins] appearing quite a small man in comparison'. He received the arrivals with great courtesy, ushering them into his room, bare of furniture except for a raised platform (his bed), on which he seated them, and soon the place was filled with curious Chinese. Why did they wish to visit China, the officer enquired? Thomas explained that, being so near, he would like to pay his respects to the governor and visit the nearby town of Chougachac (as Lucy spells it). The officer thereupon invited them to pitch camp and promised to send a despatch to the governor with a response likely that same evening.

The Atkinsons retired to their yurt and were joined for tea by their 'new friend' with his secretary and interpreter, who were intrigued by all they saw, 'examining everything most minutely', and Lucy was not sure whether she was not the greatest curiosity. They had, they said, been stationed at this picket for three years and, with another year to serve until they could rejoin their families, complained bitterly about the long separation from their wives.

Next morning two officers and three soldiers rode up to the Atkinsons' yurt, with short stirrup-straps like the Kazakhs', sitting their horses elegantly and slung with bows and arrows (although one carried a lance). All were tall, perhaps selected in order to see over the reeds and the approaches. The officers dismounted and went into the yurt but, having brought no interpreter, Thomas and Lucy could not understand a word. Judging from the officers' faces, however, they were delighted to meet strangers and accepted the offer of tea. But before Lucy had poured it out, the soldiers entered and said something. At once the officers got up, shook the Atkinsons warmly by the hand, shot out of the tent and galloped away fast.

It seemed that they had arrived from another picket to have a look at the, doubtless rare, strangers, and the Atkinsons soon saw why they had fled so fast: they had seen their superior officers and retinue on the road from Chuguchak. Two hours or so later their first Chinese friend came to announce the arrival of three officers from the town who, he said, would be very pleased to see them. Lucy put on her hat – decorum must be observed – and asked Columbus to take care of Alatau (she calls him again 'the child') in her absence. Their Chinese friend was really shocked to see that the Atkinsons meant to walk: far too undignified; so they ordered their horses. And when he realised they intended to leave Alatau behind, he was very concerned and insisted on him coming too, so Lucy put *his* hat on and told Columbus to bring him.

At the picket they found many soldiers, who parted for the little procession to pass through. Lucy took Thomas's arm and they proceeded first, with Columbus behind carrying Alatau and, behind him, George as interpreter. The superior officers were seated beneath a group of trees, 'quite a romantic spot, and so exquisitely cool': a stream on one side and a distant tomb on the other. They were sitting cross-legged on a carpet, the *kaldi* or chief officer in the middle with a low

table before him, and immediately they rose to shake hands cordially with the visitors. Stools were then placed for the Atkinsons and tea and sweetmeats offered them. Meanwhile Alatau had been seized by the *kaldi* 'who almost devoured him with kisses', and when his compatriots had had their turn they passed him back to him.

A conversation now began about their visit which had to be translated through four languages – unspecified, but presumably including Han or Mandarin, Russian and English. After each contribution by the Atkinsons, the Chinese's very handsome Tatar interpreter would turn to his three superiors, kneel on one knee and utter some words, then rise, cross his hands on his breast, bow and only then translate. When the *kaldi* responded, the Tatar would again kneel, repeat the ceremonial, then rise and turn to the Atkinsons for their next statement. (In Lucy's book of their travels, published many years later, there is a delightful engraving of the scene, artist unknown but not Thomas's style.)

Thomas repeated his request to visit Chuguchak, and the three Chinese asked many questions, cautious lest there be some hidden motive. They explained that the Atkinsons were the first English people ever seen in this part of China and that the governor could not allow them to enter the town until he had obtained authorisation from the Emperor. However, if the visitors would like to remain where they had encamped, a despatch would be sent off for an answer and meanwhile all would be done to make their stay comfortable and pleasant. Thomas, who liked nothing better than being on the move, demurred at once. After some further conversation, Lucy, undeterred as ever, ventured that as a woman she might be a different case. Surely there would be no impropriety in a visit by her, and she would have no objection to going on her own. The *kaldi* smiled and asked her what she expected to find. 'Merely the town and the people in it', she replied, 'and, never having visited a Chinese town, everything would be of interest besides a curiosity.' 'We have only our wives and daughters there', he answered, 'and the town itself is but a miserable place; but, if I dared, nothing would give me greater pleasure than to take you, for you would be the greatest curiosity we ever had in the place. If our laws did not forbid it, I would this moment take you[42] ... but my head would answer for my temerity,' and he significantly 'passed his hand across his throat.' However, they then intimated to Thomas that if he were to dress as a Tatar merchant and shave his head, he might enter the town as a merchant and no one be the wiser, 'but to this he would not consent, as an Englishman he would visit the place or not at all'.

After this formal – and undoubtedly protracted – conversation, the visitors accepted an invitation to dinner. Their hosts seemed pleased but apologised many times for the meagre repast of rice, meat and soup (the last to be served), then sweetmeats and finally tea. They tried to teach Lucy to eat with chopsticks and were quite pleased with her success, although George had sent back for a pair of spoons *and* forks, which much amused their hosts. On their departure 'Alatau was most fervently embraced,' wrote his mother, 'and as we passed down between the files of soldiers, they were no longer so stately as on our arrival, for they seized

'The English travellers' interview with Chinese on the frontier of China'
The Atkinsons were very keen to visit a Chinese town just across the border and were
interviewed by three Chinese officials, while Alatau was almost smothered with kisses by them.
This is the only known image of the three Atkinsons.

the child, and each one in his turn embraced him; there was not one let him pass, and I can assure you the boy was amused.'

Back at their yurt, Thomas and Lucy talked their options over (interestingly, Lucy's opinion counted – on this occasion anyhow – for Thomas's journal reads very egotistically) and they decided they should resume their journey in the cool of the evening, so sent a messenger to tell the Chinese. Soon flour and rice arrived for them to take with them; their Chinese friends probably knew that they would not be able to get either on their travels. When all was ready, Thomas and Lucy rode off to say goodbye and, no messenger having announced their approach, they found one of the Chinese without his uniform – 'greatly shocked; the other two were in full dress, and appeared to enjoy their colleague's mishap amazingly'. Lucy presented the *kaldi* with a purse, which pleased him, then all shook hands with regret and the Chinese kissed Alatau goodbye and gave the Atkinsons a guard of honour part of their way. The first officer, the one who had been playing

with the goose, presented Alatau with a giant cucumber which astonished him but, Lucy says, greatly pleased his father, 'not having tasted vegetable of any kind for a year'.

The next day the party 'rode for ten hours over burning sand without stopping'. This, and the sun's intense heat, left Lucy with a severe headache, and the glare affected Thomas's eyes badly. When they pitched camp Lucy felt so ill that she longed to lie down, 'but it could not be. I had Alatau to wash and bathe, which I usually did whilst the tent was being got ready, and the camels unloaded; and this ended, I had the bed to make, – how I knelt down to do it, I scarcely know. After this was done I fed the boy and put him to bed.' What Thomas was doing meanwhile we do not know, but, according to Lucy, each person always had his (or in Lucy's case, her) allotted task. Once Lucy's duties were done on this occasion – and they included seeing her husband seated at his tea – she lay down thankfully on a bearskin and thought she would never get up again. But after a deep sleep she recovered and was ready for her breakfast soon after 5 o'clock, having had no food for twenty-four hours as well as a ten-hour ride.

Food was indeed a perennial problem. At one point their rusks came to an end and they had no food left except the smallest crumbs of their dried bread; though salty, they considered them a luxury. Lucy ate hers dry, but Thomas poured boiling water over his to make a pap. In their entire time in the Kazakh steppes Lucy never knew what it was to have enough food:

> Without bread or vegetables it was impossible, at least for me, to feel satisfied. Fancy only meat and nothing but meat, then tea without sugar or cream. I was the worst off, having two to nourish; and … the keen air of the mountains sharpened the little fellow's appetite. One good thing, he had learned to eat meat; at first he ate morsels the size of a pin's head, but bread he did not even know the flavour of.

They were glad to find any vegetables and in the steppe they missed fruit badly. But in the lower mountains there was an abundance of many different fruits, some of which Lucy did not know. Yet, ironically, they almost always found they were either too early or too late for any fruit, and missed it all that summer of 1849 except for wild rhubarb, which Lucy stewed, and occasionally apples, 'sadly missed in the steppe', which they were delighted to come across, even though they were unripe and very sour. With no sugar, they tasted better stewed, and when in an apple area the Atkinsons ate a lot of them.[43]

Once in the Tarbagatay range, on the Chinese border north of Lake Alakol (probably much of it not yet thoroughly explored even today),[44] Thomas went off to sketch with Columbus and a Kazakh guide. Lucy begged him, if he found apples, to bring back plenty and gave Columbus a bag just in case. He was convinced none would be found, but Lucy was adamant, 'too hungry to lose a chance of procuring apples, sour though they were'. Hours later she was busy sewing – 'her skill in constant demand' – when the three came into sight. As they

'A group of Kirghis with two brides'
Two Kazakh brides posed for Thomas in their silk wedding dresses.
The musician playing the dombra was the chief of a band of robbers.

approached she was surprised to see a fourth figure on a horse led by Columbus. Lucy wondered if there had been a struggle and the man was a prisoner but 'was astonished to find it was a headless trunk, seated upon the horse'. Lucy was sad, thinking it might be a victim (like so many sheep) of the abundant wolves – and yet why had they not buried him in the mountains where they had found him?

Thomas explained that they had ridden further than expected and came upon veritable orchards full of apples, quickly filling their bag which the Kazakhs put on his saddle. Gathering flowers to take back to Lucy (an appreciative touch), Thomas was surprised to see Columbus suddenly take off his chimbar, tie each leg with string, fill them with apples and, fastening the top together, put the laden garment astride the horse, thus confronting Lucy with an apparently headless trunk.

Lucy had naturally more to do with the Kazakh women than had Thomas. When encamping near an aul she would ask them to do any washing for her (they made their own soap, though from what she does not tell us) and gave them in return (much-prized) pins, needles, beads, earrings and metal buttons, all greatly welcomed. The heat quickly dried the washing, Lucy folded it and 'it was beautifully mangled with the pressure it got on the road'.

On one occasion Lucy gave a tea-party in the steppe. Thomas had wanted to sketch several Kazakh women, and Lucy sent a Cossack to invite them as she could not make them understand what was wanted of them. They arrived in elaborate dress, among them a bride 'whose dress was really pretty': a short black velvet jacket edged with crimson over a gaudily coloured silk khalat and on her head a high conical cap, the upper part white, 'whilst a black velvet band embroidered with gold enclosed the face. A line of silver drops and coral beads hung over the forehead, from a broad band embroidered with coral; and over all this was thrown a white veil.... The husband was taking the object of his affections, or rather, his slave, to his own *aoul*', her face completely concealed by her veil, so her horse had to be led. Camels followed with her dowry. Lucy, ever curious, tried to raise her veil against slight resistance at first, then succeeded. 'She smiled and seemed pleased to see us, and surveyed me probably with as much curiosity as I did her. She looked very interesting, which is more than I can say of the generality of her countrywomen.'

But Lucy was impressed by the two very good-looking daughters of Sultan Bek who came to visit the Atkinsons. The younger, more to Lucy's taste, was very pretty, slim and exceptionally graceful in all she did. Beneath a 'coquettish-looking cap' poised on the crown of her head she wore her hair in a 'multitude of braids'. Lucy found her elder sister 'a perfect Amazon'. She had brought along her two- or three-year-old nephew, a fine young boy, and was sitting playing with him when she put her hand beneath him and, stretching out her arm full-length, held him upright, much to Lucy's wonder, as he was certainly not light. When she left the Atkinsons' yurt, she took the bridle, put her hand on the saddle and vaulted on to it with ease. 'Be assured, I envied her this accomplishment. And then to see her on horseback was a beautiful sight, she sat the animal so gracefully.'

Back to Lucy's tea-party: when Thomas had finished his sketch (today lost),

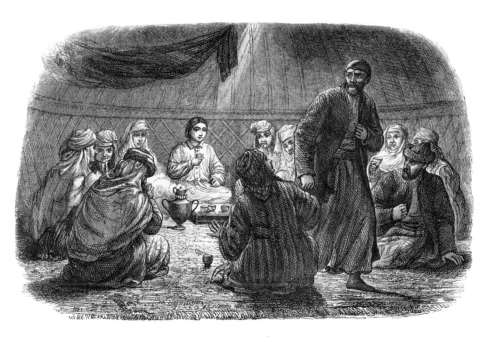

'A tea party in a Kirghiz tent'
The Atkinsons were shocked at the way the Kazakh men treated their wives – as slaves, they thought – and Lucy decided to give a tea party to a few Kazakh women after Thomas had sketched them. Two or three men attended as well, but on being deliberately given nothing to eat or drink they stalked out.

Lucy had the samovar brought in and

> mustering all the basins and glasses we were possessed of, regaled my
> friends with tea. I wish you could have seen the dismay pictured on
> the faces of the men, to whom I was cruel enough not to offer even a
> glass. Tea concluded, I had meat brought in and served my guests. This
> was the crowning point; the 'lords of creation' could no longer stand
> this slight, so arose and made their exit, and I saw no more of them that
> night. The women appeared to enjoy the fun of the thing. When they
> had ended their meal, I completed their happiness by giving to each a
> few beads and ear-drops.

Although Thomas's sketch of the Kazakh women is sadly lost, Lucy's book
contains a delightful engraving of the scene with her sitting cross-legged among
her female guests on the ground, while one man is clenching his fist with wrath
and another walking out in disgust.

One thing which struck Lucy was the marked – and frequent – disparity in

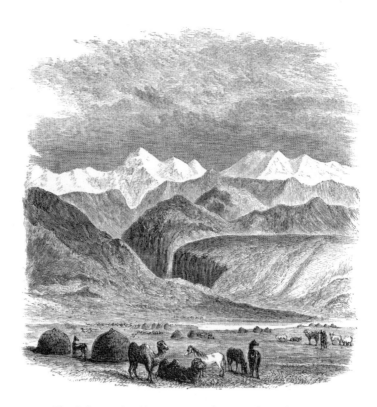

'The Dzhungarian Ala-tau mountain range from the steppe'

the ages of Kazakh marriages; she encountered a newly married couple, the wife about thirty who was correcting her husband, 'a mere child', as she would her own infant, and in another aul a healthy, robust young woman married to a paltry youth of fifteen. In such cases the reason was that the husbands were orphans, so they had been married off to women who could look after them and spare their guardians any further responsibility.

So, after three months in the Kazakh steppes and mountains and now with a ten-month-old child, the Atkinsons turned north back to Ayaguz where, rather surprisingly, they were to find their carriage. 'With sorrow we bade adieu to our Cossacks, who had been our companions through so much toil and so many dangers. And the child too, – they had become attached to him; many an hour had they passed in singing songs to amuse him on the way.' And Lucy was saddened when she saw 'for the last time the white peaks of the Alatau and Actau rearing their lofty heads far into the clear blue sky. I was loth to leave them; and when I did so, I could not restrain a tear from starting to my eyes.'

What Thomas and Lucy were not to know was that concern about their travels in the unsettled Kazakh steppes and mountains reached the highest level of the Russian government. In late December 1849 Count Nesselrode, Foreign Minister, wrote from St Petersburg to Prince Gorchakov in Omsk, Governor-General of Western Siberia, who had facilitated their visit:

> I have the honour to inform [you] I quite share your thoughts about not allowing foreigners into the Kirgiz Steppe before it is finally settled, but … I find it would be also inconvenient to refuse to give recommendations to those travelling in our country as citizens of those nations with which we find ourselves on friendly terms, as well as to inscribe in their passports, or to explain to them verbally, that in certain places of the Russian Empire entry is denied to them.[45]

They now returned to Western Siberia, and when they got back to Zmeinogorsk, after just over a year's absence, they had changed so much that their friends did not really recognise them at first.

> Mr Atkinson was in a terrible plight, his boots had been patched and mended with the bark of trees, till they would scarcely hold together. The first person in request was a bootmaker … whom we supplied … with leather. He looked at Mr Atkinson's foot, and was going away, when I stopped him, to say he must at once take the measure, as they were required immediately. 'Oh, I never measure,' he replied, and went away: we felt sure the leather would be wasted. In two days they arrived, when my husband declared he had never had a pair of boots fit him so well.

In Zmeinogorsk Lucy found the usual evening amusement was playing cards,

and when one hostess asked if she did not play cards, she said the only thing she did was to play patience or tell fortunes. Although Lucy insisted it was 'merely nonsense', for the next three hours she was 'obliged to invent all sorts of folly' to young girls and old ladies alike. Some weeks later she was in the same house and an old lady approached with her daughter-in-law to thank Lucy for foretelling the arrival of the son and husband, and 'both set bowing like Chinese dolls'. Needless to say, Lucy had once again to go through another ordeal of fortune-telling – which in London could have meant prison.

The first night Lucy, on an impulse, asked the servant to change Alatau's bedroom. Thomas was out and Lucy and Alatau were alone in the house. All was utterly quiet until Lucy heard a strange sound which somewhat startled her, then later another, followed by 'a creaking and a cracking … and a smash…. For a moment I was unable to distinguish anything, for the room was filled with either smoke or dust.' Then she saw that 'the greater part of the ceiling over the bed had fallen; had the child been there, he would have been killed.'

After a month in Zmeinogorsk they moved further north back to Barnaul on a bitterly cold October day of 1849, their none-too-warm rooms heated for a second time while they were at dinner with Colonel Sokolovsky. 'On our return the bear-skins were spread.' In the night Lucy was disturbed by Alatau's abnormal breathing and found he had a burning fever. Then she felt she had no strength, her pulses were throbbing fearfully and her heart beating wildly. She woke Thomas,

> who at once said there was a vapour in the room; he had been once before, in this same town, nearly killed by it. At last I arose to follow him to the door, but fell prostrate in the centre of the room, with the child in my arms. No sooner was the door opened, than my husband also fell in the passage; here we all lay full ten minutes, without the power of moving. The cold frosty air rushing in recovered us.

They woke the other inmates and gave the man responsible 'a thorough scolding…. Had the child not fortunately awakened me, I make no doubt that it would have been our last sleep.' Lucy notes that there were many peasant deaths from such carbon monoxide poisoning.

They spent the whole winter and spring in Barnaul, leaving only in June 1850. Thomas had a large room in which he could paint and Lucy spent time with her needle and reading books, 'a rare treat … having been deprived of this luxury for so long'. But they were never allowed to miss the evening parties – 'a sledge or carriage is always sent for us' and 'the longer I dwell here', wrote Lucy, 'the more I like the inhabitants'.

And there were more balls, marriages, private theatricals and so on. More to the point, continued Lucy, 'my son has made his *début* in the great world. He has been to a *bal costumé* dressed *à la Kazakh*; and a beautiful costume it was, the most inexpensive, but decidedly the most effective, in the room [even though] … some of the children wore most costly dresses.' Lucy thought the idea of taking

Alatau was preposterous to start with but considered Thomas's idea of a Kazakh costume brilliant and she worked hard to prepare it, particularly the elaborate boat-shaped hat, covered with red Chinese silk and decorated with 'gold lace, coral beads … Chinese ornaments and turkey feathers'. He arrived with his parents while the other children were making a terrible noise. At his appearance 'a sudden silence ensued for a moment, then came a scream from all sides, "It is Alatau! It is Alatau!" A crowd formed round the boy', and afterwards one of the children told Lucy that at first they had thought Alatau was a walking doll – he certainly caused a sensation.

Lucy ends her account of Barnaul with the story of the first cauliflowers ever grown there, and the dinner to celebrate them which the Atkinsons attended. The chef did an excellent job but sent them to the table on ice, to the great disappointment and anger of the host who went off at once to berate him and threatened his future if he ever produced a cold plate again. The rest of the dinner was served very hot, according to Lucy, including the ice creams on 'nearly red hot' plates.

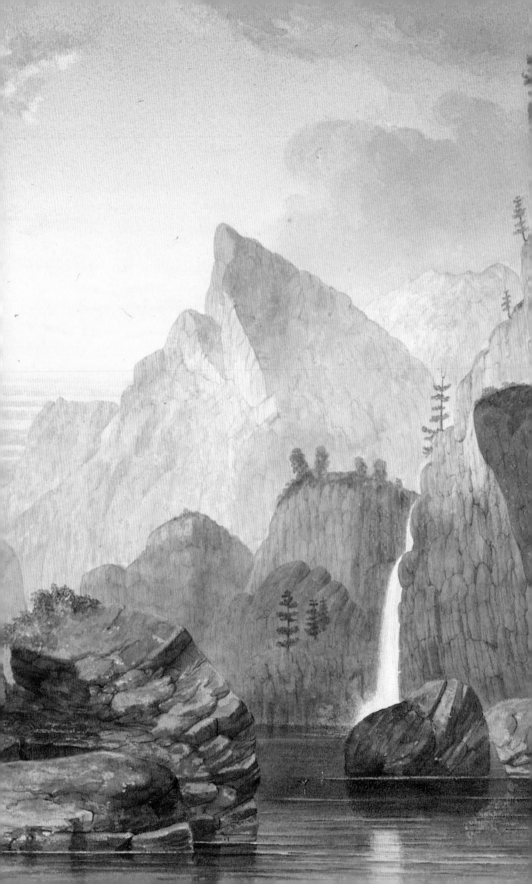

Chapter Six

Eastern Siberia

I

ON 16 JUNE 1850 they left Barnaul,[1] stayed in Tomsk for three days, inundated with invitations, and started into East Siberia – 'a frightful journey over roads fearfully cut up' after a month's continuous rain. On reaching the town of Krasnoyarsk on the Yenisei they were lucky to find, on a visit from his base in Irkutsk, the enlightened and reformist Governor-General of East Siberia Nikolai Nikolaevich Muravyov (a relative of Lucy's previous employer in St Petersburg) and his French wife. The next day both Thomas and Lucy had a long interview with him and, knowing no one else in the town, according to Lucy they dined with the Muravyovs every day for a week – a little odd, unless they were merely two of many guests. But Thomas's journal records: 'He offered to aid me in every thing that he could and gave me a paper to Travel in the Governements of Yenissea and Irkoutsk [Yeniseisk and Irkutsk] – ordering every thing to be open to me' and 'desired' the Atkinsons to reach Irkutsk by mid-August as he would be leaving for St Petersburg on 1 September. 'The General', Thomas added, 'was greatly delighted with my pictures of the Altin Kool.'[2]

While still in Krasnoyarsk the Atkinsons called on the Davydovs, Vasili Lvovich and his wife Alexandra Ivanovna, another Decembrist exile family. The two were later joined by their daughters, who had been cared for by relatives.

> As regards to Exiles I presume you would like me just to tell how I found them [Lucy was to write to her future publisher, John Murray]. You must know I was received by them all as a sister. I having lived in the Mouravioff family during eight years: when I entered the house of Mouravioff and Jakoushkin [both Decembrist exiles] and mentioned my maiden name [Finley], I was immediately recognised as I was always considered part of the family. Others of the Exiles with whom I had no acquaintance received me with open arms so soon as I said where I had been living. The name acted as Talisman. You must understand my General Mouravioff is brother to the Hero of Kars and cousin to Sérge Mouravioff who was hanged in Petersburg – he was likewise himself implicated in the affair of 1825 – he was nine months as prisoner in the Fortress.[3]

When her husband appeared on the scene he told the Atkinsons:

Opposite: Detail of watercolour p.205

> It was always a source of regret to me that we were betrayed by an Englishman: whether we were right or wrong is not the question; but that Englishman pushed himself into our society, feigning to be our friend, whereas he was acting the ignoble part of a spy and a traitor.

He was referring to John Sherwood, son of a mechanic from Kent who came to St Petersburg with his family in 1800 and joined the Russian Imperial Army. While serving in the south of Russia he came across some of the conspirators and wrote a letter exposing the organisation to the Tsar's Scottish doctor, Sir James Wylie, to be passed on to the Tsar himself (Alexander I).

They returned west to Achinsk by *perekladnoi*, 'a post-carriage changed at every station' – nearly 200 versts without springs – and had never been over such bad roads. Lucy found:

> It was impossible to sit, stand, or lie; and what made it worse for me was that I held the child in my arms, so that when the shock came he might not feel it. It was dreadful, not an instant of rest the whole way. How my poor neck ached! indeed, I ached in every part of me...
> [Why didn't Thomas help, one wonders?]

Further south, at Minusinsk, the police master invited them to stay; this 'most gentlemanly man' had been exiled on a political charge and later pardoned but still not allowed back to St Petersburg. He was a clever man with 'a vast amount of information', but his wife (a very kind, good-hearted woman) 'could not even read'. They had adopted two children, having none of their own – one of whom, now a young lady of seventeen, they had found lying in the forest; both were well educated by local Decembrist exiles (three of them living in Minusinsk at the time). 'It was painful to witness the desire they had to return' to the capital and 'appeared weary of ... existence'.

They took a 50 km detour from Minusinsk to the village of Shushenskoye[4] to see another Decembrist exile, Peter Fahlenberg. He had previously lived in Minusinsk where, to earn a living, he had begun a successful school until the authorities forbade it. Now an old man, he had moved to the village to grow tobacco 'for his support'. 'There was no mistaking the noble gentleman, in spite of his costume and all that encompassed him.' He was pleased to see the visitors and shook hands warmly. But, to quote Lucy again,

> I do not know anything more painful than to find a talented man with a highly cultivated mind placed in such a position as that in which we found Mr Fahlenberg. He owned to the justice of his banishment, but deprecated in no measured terms the severity with which he had been treated. 'I wished for nothing more', he exclaimed, 'than to gain an honest livelihood, whereas they have forced me to do this,' and with bitterness opened his window, and showed the field of tobacco

he was cultivating. 'This,' said he, 'is the noble work on which I am obliged to employ the few remaining years of my existence; surely the punishment we have already undergone is more than adequate to the crime we committed. Even my wife,' he continued, 'was persuaded by her friends that I was dead, so remarried; but she would never have done so had she believed I still existed; of necessity I had no means of acquainting her to the contrary.'

A few years earlier, Fahlenberg had himself married again – 'a very good and really a superior' daughter of a Cossack – in order to have someone to care for him in old age. They had two children – a seven-year-old boy, 'as rough and wild as any peasant', and 'a beautiful fairy-like' girl of eight or nine whom Fahlenberg spent much time in teaching and who now spoke French well. Her parents very much hoped to get permission to send her to Irkutsk to continue her education, but Lucy doubted if it would be as good as her father's tuition. Fahlenberg told the Atkinsons that 'his great enjoyment' was visits for a few days from his fellow exiles. But, when they left, he said, 'I am once more left to my solitude, which for awhile is almost unbearable,' for his young children and Cossack wife were not adequate companions for this highly intelligent and well-educated man.

Now in the heart of Eastern or Oriental Siberia, as Thomas was to entitle his first book, they rode along the banks of the Yenisei, one of the great rivers of northern Asia,[5] draining a basin of 2.5 million square km (nearly a million square miles) north into the Arctic Ocean – a graphic example of Siberia's enormous size. The Atkinsons found 'pretty scenery' along the river and camped in 'most lovely spots'. They saw the distant Taskill mountains, part of the West Sayan range, 'bedecked with a crest of snow, reminding us once more of our dear old friend in the Alatau'. They reached the village of Tashtyp where their Cossack escort at the time had been born – but had not visited for years – 'every step of the road' brought back some pleasant memories for him and yet more talk. He was very keen to see his adoptive parents: 'Such good old creatures,' he said, but as he had not heard from them for a year or more, he thought they might be dead. 'Though I am not their real son', he explained to Lucy, his eyes full of tears, 'I love them equally the same.'

They were indeed alive and begged Lucy to approach the Governor for their adoptive son's liberty so he could return to them and his childhood home 'at least till he had closed their eyes'. 'The Russians,' noted Lucy, 'especially the lower classes, have an extraordinary love for children, and even when they are not their own they still show love and regard for them.' When they left Tashtyp in a boat for the Abakan river, which flows into the Yenisei at Abakan, the old parents escorted them along the bank as far as possible.

They then bade us adieu, and, taking an affectionate leave of their son, blessed all; and, commending us to the care of the Giver of

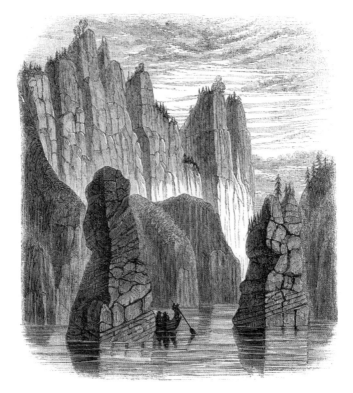

'Singular formation'

all good, knelt down as we pushed into the stream, and remained kneeling till a bend in the river hid us from their view.

Parts of the Abakan reminded Lucy very much of the Altin-Kul 'with the same lovely scenery', and every night they slept on its shores in a balagan. She wrote: 'I know nothing more agreeable than the falling asleep where not a sound is heard save the rippling of the stream close by, or the rustling of the leaves in the branches above us.'

In late July they returned to Minusinsk, again staying with the police-master. The weather was extremely hot and the rooms 'felt oppressive', particularly because they were kept dark due to the heat. When a servant announced lunch they did find a little light in the dining room and Lucy vaguely made out that the table was 'one black mass … every particle was densely covered with flies. Not a pin's head of the cloth to be seen.' Their host made light of the matter, explaining that every house was like this in summer and it would be impossible if they did not keep the doors and windows shut to keep out the heat. Lucy says nothing of any after-effect of that meal.

They then travelled north with three Cossacks along the east bank of the

Yenisei, and a few days later began to ascend the Abakan river. Thomas made several sketches on the river – 'very like parts of the Altin Kool' – before they returned to Minusinsk.

Surprisingly, they bought a large boat there (with what money? one might well ask), had it altered for their accommodation – a whole day's work but no details given – and all their friends came to take 'a most affectionate leave' of them on 23 July, each with a message to a friend in exile. But Fahlenberg said that the Atkinsons' visit had done him no good – he had forgotten his sorrows only temporarily and would try to forget their visit.

They went on some 300 km further north down the Yenisei towards Krasnoyarsk, 'a delightful voyage', thought Lucy, with pretty scenery, and stopped from time to time for Thomas 'to sketch some lovely view'. At night they bivouacked in the woods or at some village. At one such village the chief man entered their room, standing bolt upright at the door but, courteously received by Thomas, he relaxed and welcomed them to the village and, on being handed their 'road papers', gave them a very low bow. Having looked at them, he asked if they were Russians. No, they said. After a pause, he bowed low again and asked, smiling, if they were Germans. No, they said again. 'The poor fellow took a long breath, apparently at his wits' end' and for some ten minutes looked first at Thomas then at Lucy but still none the wiser. (At that time 'nemtsy' or Germans meant all Europeans, so they should have answered yes. No wonder he was at a loss!) 'At length he cleared his throat, scratched his head and, smiling very sweetly, once more bowed to the ground and inquired if we were Groogians (meaning Georgians).' At their third no, Lucy says, the poor man's hair

> appeared positively to stand on end; he looked at us quite aghast, and wildly exclaimed, 'Is it possible that you are Chinese?' and, throwing down the papers, rushed headlong out of the room, whither no persuasions could induce him to return…. All the inhabitants of the little village kept a respectful distance; ordinarily they crowded round us to have a sight of the wild animals.

When they reached Krasnoyarsk – founded in 1628 as a Russian border fort on the Yenisei[6] – they drove to the Governor of the province, Vasily Kirillovich Padalka, and his wife Elizaveta, daughter of a previous Governor-General of Eastern Siberia. Padalka was known – or was to become known – for developing the area's gold resources, and the Atkinsons remained with them till 5 o'clock and the next morning resumed their journey, receiving en route 'a most pressing invitation' to a priisk or goldmine further north, so Padalka's dinner talk could have proved most useful.

Ahead of them almost immediately, however, lay the great and dangerous rapids on the Yenisei, and it was very difficult to find boatmen who would take them. At the river station nearest to the rapids their old steersman summoned the two rowers to a prayer.

They instantly dropped their oars and stood up in the boat while the old man breathed forth a prayer for our safety over the coming danger. Lucy and I joined our prayers.... [Thomas's journal, copied word for word in Lucy's book.] Our men then plied their Oars and soon took us into the Middle of this mighty Stream ... about 8 versts distant from the Rapids we could hear the Roaring of the Water and ... [soon] we looked upon the Boiling flood. Three minutes carried us like a shot on a line with the first Rocks. At this moment the scene was truly grand. Our little boat was tossed like a feather and carried on at a fearful speed. We soon reached a place awful to look upon. The water recoiled from some sunken rocks and was tossed up in waves which looked as if they would swallow our little craft – there was not a heart on board that did not quail at this site. A few moments carried us over this into the boiling current and on we shot.

By 16 August[7] they had reached the confluence of the Yenisei with its tributary, the Angara, 'a fine river', thought Thomas, as 'clear as crystals', and the waters of the two rivers could be seen side by side 'for a great distance'. Oddly, both Thomas and Lucy mistakenly but consistently write of 'the Tunguska river' instead of the Angara, perhaps simply confused, maybe indeed deliberately, as the Russians would not have wanted an uncontrolled Siberian gold rush. Thomas was very keen to visit the priisks to which they had been invited, and 50 km up the river they left their boat at the village of Motygino and travelled on *perekladnoi*, changing carriages or horses at post-stations with their luggage, passing through miles of burnt-out taiga: all 'blackened and charred stumps of trees ... scattered in all directions, some still smouldering', Lucy noted. The fire had been burning for two weeks across an enormous area and was put out only by some heavy rain. Lucy saw that fire in the taiga was not uncommon since everywhere was 'so dry that the least spark will set them burning, and the Cossacks and hunters are exceedingly careless'.

They found that the gold-mining area was one of 'low hills covered with dense forest of larch and picta', with rocks of slate difficult to drive through, 'while along the vallies is a deep Morass impossible to traverse without the wooden roads [made of logs or planks] which had been constructed'. In this remote province gold had been found in 1832 and then in many small rivers through the 1830s. It was unsurprising that the Atkinsons' gold-mining friends were wealthy: the most profitable river (the Small Kalami)[Kalmanka?] produced 1,704 poods (about 28 tonnes) of gold in the years 1842–66.[8] According to the Atkinsons, the gold was found in slate 'washed down from the hills, covered by a bed of earth about 3 feet thick.'[9] An astonishing workforce of 9,000 men – all convicts – was washing and digging for the precious metal. All of them had been deported from European Russia and were guarded by only eighty Cossacks – enough, it proved. In rain their work was 'really frightful', wrote Thomas, but the men were well fed and given vodka on some feast days.

Mr Vassilievsky, the mining area's senior police officer,[10] took the Atkinsons to his house at Peskino, on a small river,[11] where he had invited an English couple, Mr and Mrs Bishop, to meet them – 'most agreeable people' (presumably the husband was working at the priisk). They felt very at home, passing 'a most delightful evening', and next day had 'a good English dinner of Roast Beef'. Thomas made a sketch of Peskino, its priisk and two others and had himself and Lucy weighed on a scale doubtless used for the gold. In five weeks she had gained 2 lbs, and was now 2 poods 27 lbs, while Thomas had lost 7 lbs and now weighed 4 poods 7 lbs.[12]

While at the priisks Alatau, now nearly two, was ill for five days. For once Thomas mentions him in his journal. Alatau was very unwell: 'a good deal of fever caused I fear by his remaining so long [in] the river bathing', and Lucy agreed – 'once three quarters of an hour, when the water was not very warm'; 'he was so passionately fond of bathing' that it was difficult to keep him out of the Yenisei.[13] Lucy was proud that her young son had learned to walk at the age of nine and a half months without being taught, but contrarily he was late to talk – his parents were afraid he might be dumb – and then began talking in whole sentences, probably confused by the English in which his parents (particularly his father) spoke, whereas strangers spoke in Russian. He had grown tall and, Lucy says, 'was as wild as a young colt; never quiet but when he has a book, then he sits for hours and talks to the pictures. Toys he has none, nor did he ever have any.' 'And his hardy conduct' won him admiration from all sides, preceding his arrival in Irkutsk, where Governor-General Muravyov, whom they had already met, told Princess Volkonskaya (of whom more anon) that 'he should like to steal him. I [Lucy] can tell you I am mightily puffed up at all the praise he receives.'

After visiting several priisks they stayed at Motygino, where they had left their boat with one of their two owner friends, the wealthy Astashev of Tomsk. He was there with his wife, and Lucy found that their 'little expedition' was made 'most agreeable [by] the presence of two or three ladies who had accompanied their husbands for the summer'. But it sometimes stopped the ever-interested and ever-observant Lucy seeing all she might have done 'as without them I might have wandered about everywhere, and now I was obliged to associate with my sex'.

Astashev himself, she continued, was

> a most gentlemanly man … who received us with all the kindness imaginable. Alatau so won on the affections of himself and his wife during the two days we stopped with them, that, having no children of their own, they wished to adopt him, said he should inherit all they had (and they were rich), and endeavoured to show how much happier the child would be, settled quietly down, than leading such a roaming life as we are doing; but, as you may suppose, it was of no avail.

The first night there Lucy bathed him and put him to bed, then Astashev asked

to sit with him 'till he fell asleep'. Lucy heard him telling Alatau not to wake her when he woke next day but to collect his clothes and leave the room, and Lucy was to find the director 'had himself bathed and dressed the child, who was comfortably seated on his knees, perfectly happy, and as though they were old friends. And the night following, on going into the room, I found the child asleep with his hand lying in that of this great man.' On the Atkinsons' departure, the Astashevs took them part of the way 'and I verily believe it was to have the pleasure of carrying Alatau; they would not permit me to touch him, or to do the least thing for him, and when we bade adieu tears stood in the eyes of the director'.

Their carriage had meanwhile been forwarded nearly 200 km east of Krasnoyarsk to Kansk and they were lent another one to get them there, from which they went directly on to Irkutsk, capital of East Siberia. They arrived on 11 September 1850,[14] obviously intending to stay for some time – surely so that Thomas could transform his sketches into finished watercolours – as they rented (for 45 silver roubles a month) from a merchant's widow, Madame Sinitsyn, a house pleasantly situated on the bank of the Angara river, with the Governor-General's official (and grandly porticoed) residence a couple of hundred yards along the embankment, designed by Catherine the Great's famous Italian architect Quarenghi and now known as the White House.[15] For the first time in

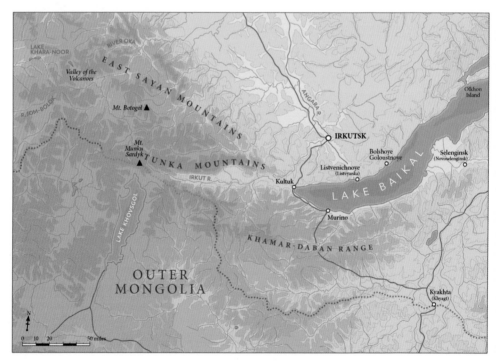

Lake Baikal and surrounding region

all their travels the Atkinsons now had a house to themselves: four nice rooms with a kitchen and its own entrance across a yard from the main dwelling house.

A few days later they woke to find the ground covered with snow, and the snow continued to fall. Thomas found it 'most Strange to see the Swallows flying about seeking their food on such a Wintery Morning'.[16] He spent three days working on a watercolour of the Altin-Kul for Mr Vassilievsky, their friend of the Peskino priisk. The first day he sketched it, the second day he 'Began colouring' it and the third day he finished his 'drawing' and thought 'It makes a most beautiful picture'. And the next day he was 'At work on my view number 158 of the Altin Kool. There is much labour in this Picture but the general effect will be grand.'[17] After another three days' work he finished it 'and a splendid picture it is. Prince Troubitskoi [one of the leading Decembrists] and Mr Taskin[18] thought it a great work'.[19] The following day he was 'Working at the Waterfall number 149', his third watercolour (at least) of the Altin-Kul – 'I expect to produce a fine Effect with the Trees that are tumbled down the Rocks.'

That day had begun with 'A fine Frosty morning with a fog rising from the Angara. The poor swallows are still here altho the snow is laying on the ground. How anxious the[y] seem to be to get into the sun – they sit on our window shivering with cold':[20] one of Thomas's occasional sympathetic comments on the animal kingdom. He obviously loved dogs, but he and Lucy must have tired out many horses, with only one or two acknowledgements of them in his journal, and he empathised with certain humans – although not all.

Lucy meanwhile 'had to go through the usual round of visits necessary for strangers to make on their first arrival'. Madame Muravyova, the Governor-General's wife, whom the Atkinsons had got to know in Krasnoyarsk, kindly invited Princess Trubetskaya, the Prince's wife, to meet them (probably leading to the visit by her husband), and she provided for them a list of 'the persons to whom it is considered indispensable for us to introduce ourselves'. They had, too, letters of introduction to Princess Volkonskaya, the leading Decembrist wife, known as 'the Princess of Siberia' and widely loved in Irkutsk for her good work in the local schools, hospital, new theatre and concert hall and 'her benevolent influence on Governor Muravyov, … [to her] 'the most loyal, kind, and gifted man on this earth'.[21] And it was these three ladies whom the Atkinsons tended to visit most. In the Trubetskoy and Volkonsky houses they 'generally meet their companions in misfortune and some of Russia's cleverest men grown old in exile'. But besides the Decembrists there were many other exiles in Irkutsk who had settled down well, some in 'very handsome houses'.[22]

Lucy found that Princess Volkonskaya[23] (who, incidentally, had had an English governess) was 'a clever woman' but had 'lived to regret her voluntary banishment'. She had chosen to join her husband – 'whatever your fate I will share it'[24] – after only one year of marriage, aged only twenty-one, leaving her new-born son behind with her mother-in-law, and probably did not realise she would never see him again. Travelling some 4,500 miles by sledge in the freezing winter with only a maid to accompany her, she found her husband shackled

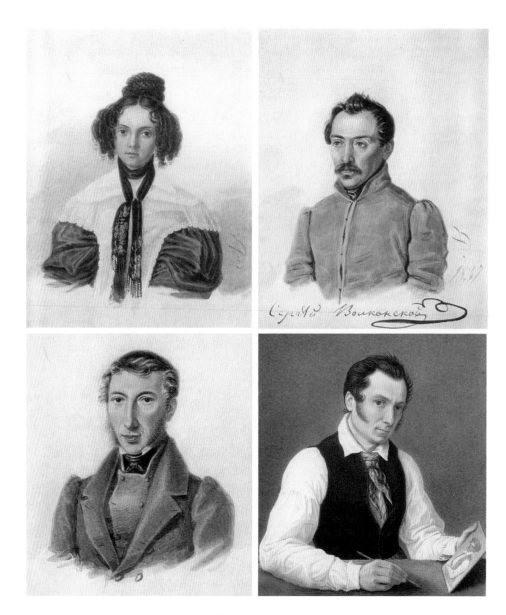

The Decembrists: Maria and Sergei Volkonsky, Sergei Trubetskoy and Nikolai Bestuzhev
The Atkinsons visited many Decembrists in Siberia including, in Irkutsk, the Volkonskys and Trubetskoys, whom they got to know well. (Prince Sergei Trubetskoy had been one of the organisers of the Decembrist movement.) In both cases their wives had joined them; all were stripped of their titles and great wealth. Southeast of Baikal the Atkinsons visited Nikolai Bestuzhev, a talented artist farming with his brother (and sisters), who painted himself and many of his fellow Decembrists. Volkonsky was one of only nineteen of the 121 exiled Decembrists to return to Russia in 1856, broken in health but still true to his beliefs. He died in 1865, two years after Maria.

Decembrists' house in Irkutsk
In this house, now a Decembrist museum, lived Princess Maria Volkonskaya, wife of the
Decembrist Prince Sergei Volkonsky, who chose to live across the courtyard.

in the dark, underground in the silver mines of Nerchinsk far east of Irkutsk, and 'knelt on the filthy floor and kissed the chains'.[25] Altogether she and ten other Decembrist wives or fiancées had followed their menfolk to Siberia[26] and only in 1835 was Prince Volkonsky freed from hard labour, replaced by lifetime banishment. And not for another ten years were the Volkonskys and Trubetskoys allowed to settle in Irkutsk, East Siberia's cultural centre. Volkonsky told Lucy he had been an impetuous youth who visited France, England and Germany and, as she went on, 'then returned to my own country, where I unfortunately found that the effect of those travels [the exposure to democracy] was to lead to Siberia and the mines' [i.e. Nerchinsk]',[27] along with his fellow plotters for about a year before being transferred to Chita.

But despite her sacrifice and dedication, the Volkonsky marriage did not prove ideal. He, Sergei, spent much of his time on the acres he had been allotted near Baikal, and when in Irkutsk lived in a hut in the courtyard of the large house where Maria lived with her later children. The Atkinsons found him 'simple and unostentatious' and, according to Lucy, he was well known to all the peasants in the market where early each morning he would buy his family's necessities for the day – after haggling and hearing the latest news from his many peasant friends. Then

you might see him wending his way home with geese or turkeys, or

something or other, under his arm, and wearing an old cap and coat which would be almost rejected by the poorest peasant, but with a mien dignified and noble, and a countenance that it would do your heart good to see.

'He is never to be seen among the gentry' of the town, Lucy wrote, only the peasantry, and he explained he always liked 'to keep his place', having been stripped of all his ranks and noble title. On one of his many visits to the Atkinsons, he brought 'a companion in exile [Borisov] who has a great taste in drawing' by which he was able to maintain both himself and his brother, 'unfortunately deranged' through grief. The artist's flowers and birds, painted 'in most exquisite style', had unfortunately faded away badly after a few years as his watercolour paints were bad, so Thomas presented him with a box of Winsor and Newton watercolours which Borisov greatly admired. He in turn presented Lucy with six 'superb' drawings of Siberia's birds, fruit and flowers 'made expressly for her album', which she greatly appreciated.[28]

Lucy mentions an interesting belief in the *domovoi* or house spirit: goodwill offerings are 'daily made to him', and if the occupants move, they tell him they will take him with them and offer him a broom to travel on.

Their first week in Irkutsk Lucy asked their landlady if a *banya* (traditional steam bathhouse) could be heated and arranged so that Thomas could go first, as she found the great heat 'insupportable'. When all was ready she asked if Madame Sinitsyn's coachman could go with him (customary in many places) and looked aghast at the idea of Lucy not going – 'the very idea set me off into a fit of laughing, which highly offended the good creature' who maintained that every good wife should wash her husband.

One day Lucy heard the story of a woman she saw in the bazaar. Past her prime 'but still good-looking', she had been lost and won at cards. Married young – 'a Siberian beauty' – to a rich but carefree man, 'a great gambler' as so often in Siberia, in a few years he ran through the greater part of a large fortune. His wife knew nothing of this; but her eyes were opened when one day 'a gentleman arrived at their home ... and claimed her for his property'. All through the previous night and well into the morning the two men had played, and the formerly rich husband was now ruined, having lost every kopek as well as 'land, house, furniture, horses, and even wife; she was his last stake'. Yet, against all the odds, she had now 'lived with her victor for twenty years, leading a most happy and exemplary life'.

Having arrived in Irkutsk in mid-September 1850, Thomas wrote to Nicholas I the next month explaining that, when four years earlier he had petitioned His Imperial Majesty's permission to visit the Ural and Altai Mountains[29] to sketch their scenery, he believed the Altai chains extended from the river Irtysh (tributary of the Ob) to the sea of Okhotsk (on Russia's far eastern coast), but was now informed that the Altai did not extend beyond Lake Baikal (indeed it ends some 800 versts short of the lake) and that he could not proceed further

without his Imperial Majesty's gracious permission. He continued, 'Having now devoted four summers in sketching the scenery of this great Mountains System' in which he had made dozens of views (according to the lists in his diaries) of scenes never before attempted, he now humbly solicited the Tsar's most gracious permission to continue his journey 'and sketch, in the provinces of the Grand Baikal, Nertchinsk, the Yablonoi [Yablonovy Range], and Stanovoi Mountains, also the Volcanic Region of Kamchatka, as this would enable me to complete my views of this great Mountains System'. And he ends as before with his usual deference as: 'Your Imperial Majesty's most devoted and most faithful servant, T. W. Atkinson.'

This is a curious letter for several reasons: he would surely have known before setting off from St Petersburg that the Altai (probably considered more than one chain then) stopped well before Baikal and the Sea of Okhotsk and that the huge area he mentions is hardly one great mountain system but several; and he perhaps tactically omits the Kazakh steppe and mountains for which he only had permission from the Governor-General of West Siberia. It is possible, of course, that Governor-General Muravyov may have told him to try his luck with the Emperor. In the event permission was not forthcoming. It is also quite remarkable that he wanted to continue their epic and lengthy travels – for perhaps another three or four years.

Thomas ended his journal for 1850 the next day after his letter to the Tsar, following it with a 'Catalogue of Sketches made in 1850' (in fact only between 9 July and 15 August), basically of the Yenisei and Abakan, numbering and dating each: a total of twenty-eight, sometimes two in a day and quite obviously sketches only, perhaps simply pencil in view of his statement about adding colour. He resumed his journal only in June 1851, the day they left Irkutsk, nearly seven and a half months later. We do not know what he was doing all this time but we must assume he was painting up some of his many sketches while waiting for the Tsar's permission, which never came.

Towards the end of March 1851, the Angara thawed and the Atkinsons had to shut all their doors and windows as in winter the town's refuse was dumped on the river banks in an attempt to stabilise them, so that the sun produced 'anything but a perfume of roses' which led to much mortality, particularly among children. This worried Lucy, as Alatau had suddenly been taken ill and she was 'forced to walk about continually with him', which was difficult as he was getting heavier and would not allow his nurse (more expense!) to come near. His parents too were affected by the fetid air and resolved to leave the town early.

Lucy, doubtless remembering the useless young doctor at Kopal, would not hear of consulting a doctor but wanted to leave it to nature, where at least there would be a chance of survival, she felt. Alatau had become a great favourite of the Trubetskoy family and the Princess called to see him, knowing he was ill. She felt his looks had greatly improved since their arrival seven months before and Lucy, caring mother as she was, told her that she and Thomas had been horrified by his appearance when new-born: 'anyone more atrociously ugly I

never beheld' although 'the most good-natured brave little fellow'. The Princess consoled Lucy by saying he would grow up 'a very handsome man, all ugly babies do, and instanced her own children'. 'Not that Alatau is so ugly now', Lucy considered, adding, 'At least, there is a satisfaction in knowing that it is not his looks that gains him so many friends.'

But she was increasingly concerned about Alatau's health. He 'became very ill indeed, daily growing worse', and everyone urged them to put off the journey they had planned to Lake Baikal. Instead, they decided to leave Irkutsk early in order to take him to a hot mineral spring. So in early June[30] they left Irkutsk for what was to be four months. Thomas made two lists of the items they deposited with the mayor, Mr Basnin, and it is intriguing to see how much they had accumulated. His first, short, list was of his watercolours, which he calls either views or pictures: one of the Altin-Kul framed and in glass, eleven other views, two of them unfinished. (His previous sketches of the Urals, Altai and Kazakhstan must have been left in Barnaul to pick up on their way west again.) His larger list includes three large black boxes with shubas, clothing, books etc., a 'Large Tin Colour Box, Medcine chest, Pistole case, candle box and Bonnet box'. How they thought they could stow all these on to a sledge back to Moscow is a moot point.

They set off to the spring, sleeping at Kultuk on Baikal's south-west lakeside where they found Alatau worse, unable to walk, and Lucy began to reproach herself for leaving Irkutsk despite all their friends' advice. Thomas believed that if the spring did not help they should return to Irkutsk. The next evening they reached the mineral spring they sought, one of an astonishing 300 in the Baikal area, many of them hot (up to 75°C) and with medicinal properties. Lucy was very anxious till she had immersed Alatau briefly in the bath into which the spring ran, then put him to bed, where he fell asleep so quickly and soundly that the Atkinsons went for a stroll, leaving a Cossack with orders to send for Lucy if the boy woke.

Six years before, the Archbishop of Irkutsk had built here 'a small but pretty church' and a tiny monastery among the trees where pilgrims and visitors could stay. Lucy found it a beautiful place: 'so calm and quiet; and shut out from the noise of the busy world, with no other sound save the murmuring and rippling of the water as it flowed over the stones', and Thomas was to produce here one of his best paintings.

While there they encountered a priest who told them they must avoid bathing Alatau in the spring,

'for,' said he 'if you do, you will kill him certainly. Many,' he continued, 'come here thinking to cure themselves by these waters; but all die who bathe in them, not one survives; and I always warn them, but they will not be persuaded; we had a man died here about a month since, who came imagining this place would do him good.' You may suppose [wrote Lucy] that every word he uttered went like a dagger

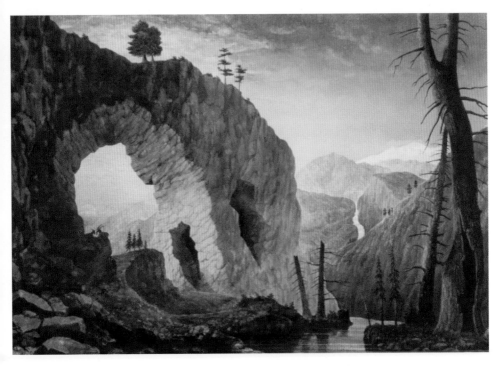

'A natural arch on Nouk-a-Daban, Oriental Siberia'
A mountain in the East Sayan range. Thomas included this (exaggerated?) arch among the lithographs in his first book. The river at right is possibly the Oka which, in another location, threatened the Atkinsons' lives with its rapid and unparalleled rise one night.

to my heart, for I had been similarly advised in Irkutsk, but would listen to no one.

The priest entered our room, where he sat chatting a long time. I never watched for the departure of a guest with such anxiety as I watched for his; at length he took his leave, when I gave vent to my pent-up feelings in showers of tears. I had not courage to tell him that I had already bathed the child; and, with a heart over-flowing with grief, had been obliged to be gay and talk, the poor priest little guessing what anguish he had caused me.

Lucy cried herself to sleep and was woken 'by a little voice calling out "I am hungry"' – not surprising, as Alatau had eaten nothing since leaving Irkutsk three days before and was not strong enough to stand. Lucy found it was 5 o'clock and before breakfast she 'plunged him in [to the bath] again, and from that hour dated his recovery'. The spring in fact improved him so much that his parents decided to stay on for a couple of days, after which he was very much better and able to walk again. 'It seemed almost miraculous' that such a change could have been produced in such a short time. But Lucy was very cautious about leaving him too long in the bath – 'in the morning a single plunge' and in the evening just a wash. Amazingly, this was almost the only time that Alatau was ill in that extraordinary childhood.

With him recovered they rode through the area looking for good views for sketches; a few days later, after a three-hour ride entailed crossing the Irkut river, a meandering tributary of the Angara that had given its name to the town, they rested on the bank 'for two hours to give our jaded horses the means of getting a dinner': one of the rare acknowledgements of care for their horses on which a lot of the seven-year journey depended.

Ahead of them now lay the mountains round Baikal, and Lucy writes of the 'scenes of winter and summer' they passed over, sometimes a night spent on 'a carpet of flowers', another on bearskins spread on the snow. In some places nothing had started to grow, in others flowers were in full bloom, and once they rode over a bed of ice from which emerged trees in bud. They rode on through thick woods with some views of the 3,000 m Tunka Alps, a branch of the Eastern Sayan range, 1,000 km long. Thomas found one of the summits 'the most singular place' he ever saw – a 'Labrinth of Rocks and Lakes', and rode back to his party camping in a beautiful valley. 'I found Lucy had tea and a large blazing fire both of which I enjoyed.'[31] Next day 'a large assemblage of Bouriats'[32] gathered. They had come to look at 'such strange animals who had come from so distant a land'.[33] Lucy found the men were more industrious than the Kazakhs 'though not so gentlemanly-looking; whereas the women, some of them, were really pretty ... probably owing to their not being so hard worked'. The night was very cold. Alatau called for water about midnight which proved full of ice – in June – and the next day snow 'began to fall fast and soon covered everything'.

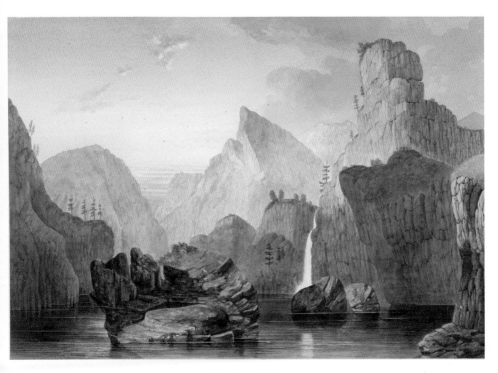

The Black Irkut

The Black and White Irkut rivers, south-west of Lake Baikal, join to form the Irkut, from which the city of Irkutsk takes its name. Thomas found 'several striking scenes' to sketch in the Black Irkut valley as well as precipices of limestone and beautiful white and yellow marble of the highest quality. At one point the ravine was filled with snow and ice, the tops of large poplars protruding – and in full leaf.

After several days they reached 'Nouk-a-daban', 'a mountain up which it is possible to ride' – but in their case only with difficulty because of the heavy rain and melting snow – and once more the horses sank 'above their saddle-flaps' in a morass. They were then enveloped by fog, dangerous because of the 'tremendous precipices' in the area, but when the fog lifted 'a bright sunny morning with a clear blue sky … afforded a fine view of the Eastern Sayan's highest peak', Munku Sardyk (3,491 m, meaning 'eternal snow and ice', spelt Monko-Seran-Xardick by Thomas), which straddled the Russian–Chinese border. They descended by a pass and then a ravine where Thomas found a spectacular natural arch of limestone, which he depicted graphically in his first book.[34] He had nearly finished his sketch when he was 'startled by a rushing noise far above' which lasted for two minutes, then suddenly stopped, succeeded a few moments later by 'a terrible crash': a great avalanche had plunged down the side of Munku Sardyk into a gorge.[35]

They spent the night at the mouth of the White Irkut – a mountain torrent 'always white and foaming' – and next morning Thomas and three men (perhaps Cossacks and a Buryat) began to ascend the Black Irkut, which joined it – 'black as Erebus' (considered Lucy); he sketched two fine views including picturesque shapes of the river, slate and limestone rocks and then walked up the bed of the White Irkut (impossible to ride up), impressed by the water rushing through a narrow chasm with perpendicular rocks up to a thousand feet overhead.

They descended into the valley of the Oka, northward-flowing tributary of the Angara, when the rain began cascading down, which made them glad to stop, but in their canvas dwelling 'with the rain pouring in torrents outside' (how often have we heard of those torrents already?) they were, however, not 'the most miserable beings in existence'. With a frail shelter, Lucy tells us, from

> a raging storm; with a cheerful blaze in front, appreciated the more on account of the difficulty we had in raising it; – and with a glass of hot tea, we thought ourselves superlatively happy, especially after what we had passed through: even the boy crept close to us, and looked with a pleased smile on the crackling logs.

Their destination now was the summit of a remote mountain top, 2,000 m or more high, in the Eastern Sayan west of Irkutsk. They knew that here atop Mount Botogol was an astonishingly rich deposit of pure graphite being developed by a Frenchman, Jean-Pierre Alibert, who had been looking for gold in the area. He had not discovered this deposit himself but bought the rights three years earlier from a local Russian who had been told of it by a Buryat hunter.[36] The Atkinsons ascended the dome-shaped mountain above the Oka river past a series of lakes and a deep morass (again) 'where we were floundering in mud and water at every step we took', but they 'had crossed worse places; and we rather astounded our host [Alibert] when we told him'. The eighth child of a draper, Alibert had worked 'from the age of fourteen in a London furriers' which sent

him at seventeen to Russia to hunt fox and ermine until gold-prospecting in Siberia took over.

Surprisingly, the visitors found all necessities in this inaccessible spot. Alibert had made a road down to the river and started a farm ten versts away to supply his workforce – followed later by a church and even hippodrome – so he had butter, cream and vegetables supplied daily (Lucy 'never thought to have even a potato'). All this, considered Thomas, was 'a work of great labour and expense and proves that He is no mean Engineer'.[37] And 'All the works which he has executed are far superior to anything I have seen in Siberia. Considering the work people he has to employ, I am greatly astonished to find all his plans so

'Principal gallery in the Alibert graphite mine'

well carried out.' Lucy indeed considered that they found everything they could desire except cleanliness, 'the black lead [graphite] penetrating everything'. At least Alibert 'had wisely built a bath, a very necessary precaution', thought Lucy.

Next morning it was 'raining tremendously … every mountain was covered with clouds' and three hours' ride took them to the mine on the summit. Alibert took Thomas in but it was 'so covered in ice that it was impossible to distinguish one mineral from another'. He showed Thomas 'some beautiful specimens of Black Lead which as far as he could judge were quite pure' and not as hard as Brookman's pencils. (Thomas does not tell us what he was using himself.) Thomas was very impressed: everything had been done in the best way with no expense spared, plans 'well considered and most scientifically executed'. He had,

his journal records, 'seen no Zavod or Priesk inside Siberia' to equal it – or to equal his workmen, better fed and clothed than anywhere else he had seen. So, Thomas wrote, he hoped Alibert 'will be successful and obtain a large return for the capital and time expended'.[38] 'Should this lead prove of a good quality ... He may supply the pencils for the whole world for ages to come.' It was only in his seventh year that Alibert had found graphite of even better quality than that of England's Borrowdale, until then the best in the world, and he was to sign an exclusive contract with the German firm of Faber (now Faber Castell) which saw his pencils sold all over the planet.[39]

Alatau found it very difficult to move in the nearby morass, so Lucy says they 'invested a little money' in a pair of reindeer which they bought from apparently the only Samoyed family in the region – one of the Uralic-speaking peoples of Siberia – in this case probably the now extinct Sayan Samoyedes, living in conical, skin-covered tents.[40] It was, however, a failure: after the very first day the saddle kept on getting twisted, and when 'our man' said it was difficult even for an adult to be comfortable on one, Alatau was thenceforth strapped on to a horse which he 'rode very comfortably', although he often got tired after riding too long and would fall asleep, when his parents took turns to carry him.

They rode on north-west through the East Sayan mountains to Okinskoi Karaul,[41] a Russian border post on the Oka river. Thomas spent several days sketching in the river valley, 'a most romantic spot', he thought,[42] and he produced a striking watercolour of the small Jom-Bolok river, tributary of the Oka, where it falls vertically over an 'immense' bed of lava apparently 86 ft thick with a large cavern behind the falling water. 'It is dark, – almost black: indeed, the eye cannot penetrate its shade and depth.... The scene had a dreary aspect, but the colouring was exquisitely beautiful.'

Thomas was fascinated by the lava and determined to find the source, which he thought was somewhere in the Jom-Bolok river valley. He set off with two Cossacks and three Buryats, the latter doubtless with the greatest reluctance as Buryats dreaded the valley, avoiding it at all costs, badly scared of Shaitan's (Satan's) presence. Thomas was not surprised, as 'a more savage and supernatural valley I never saw', although Lucy found it 'beautiful but singular'.

Next morning they found that the Jom-Bolok at times disappeared for ten or fifteen versts beneath the lava and then rushed out again. Sometimes they rode at the foot of high precipices along the edge of the lava, sometimes on its surface, but those deep fissures required great care. Lucy, however, insisted she had been trained in a rough school 'and nothing would daunt me now'.

They dined in a beautiful spot with a waterfall and 'our carpet was soon spread in a garden of roses and other flowers, and Alatau was quickly in among them gathering nosegays, for flowers are his delight; our hats and horses' heads were always decked with fresh flowers when we were in their region'.

Still in the forest, they came on a 'most wild and rugged scene; huge rocks ... hurled on to the bed of lava from the precipice above'. When riding was

'River Djem-a-louk [Jom-Bolok], Oriental Siberia'
Exploring the East Sayan mountains, south-west of Lake Baikal, the Atkinsons came across this river, whose course had been intermittently blocked by lava for some 70km. Here it flowed over the deep bed of lava originating from the volcanoes nearby, one of them now called the 'Atkinson Volcano', since he discovered it.

impossible thanks to the deep chasms, Thomas set off on foot with some of the men, leaving the others with Lucy and 'the boy'. They began to cross the lava – a difficult hour's walk – 'our boots being cut at every step to say nothing of the pain caused by the sharp points of the Lava'.[43] (When they finally returned after four days their boots were cut to pieces.)

The lava had evidently flowed at a great speed as it was sometimes in mounds 50 or 60 feet high, over which they had to climb. It continued through the adjoining Khi-Gol valley along which they proceeded:

> On turning a point of some high rocks I saw to my infinite delight a cone … we stood on its apex and looked down into its deep abiss … nothing but ashes and a redish pumis stone … so steep and the ashes so loose that if once at the bottom it would be almost impossible to ascend. I made a sketch from the summit looking south to another cone at about two versts distance [and] … we took up our quarters under some large masses of Lava one of which formed my bed on which to rest but not to sleep, as that was impossible.[44]

Thomas is officially credited in Russia today for having discovered this extinct volcano, which indeed is now called 'Atkinson sopka' ('volcano'). He found

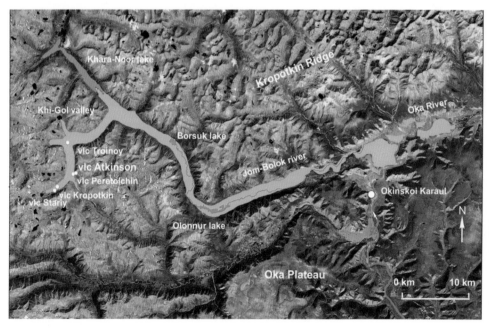

The Jom-Bolok river
The river (marked blue) is dammed intermittently for some 70km by the lava (marked orange)
from the extinct volcanoes, including the Atkinson Volcano in the Khi-Gol valley.
(After Arzhannikov *et al.*, 2016, with minor modifications)

two other cones that day, but it is now known that there are altogether ten in the area (of much interest to vulcanologists), which is today called the Valley of Volcanoes or the East Sayan Volcanic Field. The lava flow was extraordinary: it proved to be 70 km long, up to 4 m wide, and 150 m deep (five times Thomas's estimate), with an astounding volume of 7.9 cubic km. It is now thought that Atkinson's extinct volcano probably erupted twice, some time between 5,000 and 7,000 BC and then between AD 682 and 792, when Mongolian chronicles 400 years before the birth of Genghis Khan suggest that the Mongols witnessed an eruption and fled the area. His rather confusing watercolour of the crater (but not the cone) appears in his first book, and the *Illustrated London News* after his return to England published an impressive whole-page engraving of it; he produced a striking watercolour of the Khara-Noor lake, which almost certainly had formed when the lava had dammed the Jom-Bolok.

After their tiring but triumphant expedition, they returned to their base 'quite exhausted by the intense heat which is refracted from the Black Lava'. On the way Thomas saw a sable for (surprisingly) the first time and soon despatched it. (What happened to the valuable fur, one wonders?) Their tent was scarcely up that night when 'the Thunder began to bellow in the Mountains' and the rain began to pour 'down in Torrents which continued all night'.[45] The following morning they rode off 'in very heavy rain – all the small streams we had passed before … were now quite Torrents' and they took shelter in a tent.[46]

After further exploration, they started back to the Oka, glad to find shelter in a Cossack home which, however, they agreed was worse than the storm because of the number of 'screaming tiresome children' and their terrible noise.

When the rain abated a little Thomas sought out a good place for their tent on the bank of the river, the level of which had risen greatly since they had crossed it only a few days earlier, and 'there had been so much rain … that the Water was now most unusually high. I watched the rising of the Water with considerable interest … mark after mark was covered so quickly' that they consulted the Cossacks and the oldest inhabitant who all thought it would not reach them as it had never been so high before.

> It was however thought prudent to have a Watchman…. Soon after dark we turned into bed and I felt convinced we should have to move ere morning [and] one of our cossacks fixed upon a place higher on the Bank for our Tent should we have to Move in the Night. It is no pleasant feeling laying down to sleep near such a roaring Flood as this was now. I was kept long awake by its noise.[47]
>
> At three oclock the Bouriat called me and ran to tell the Cossacks the water was now at the Mark we had fixed and was rising fast…. Lucy was up with Alatou [fast asleep in her arms in the still pouring rain] and our canvass home was removed to a much higher point than the one selected last night…. At 7 oclock I found the Water had risen three feet and all the little islands were now covered. All chance of our

crossing the River was now at an end untill the Water subsided. There was no help for us, only to wait with patience, but when we should be able was extremely doubtfull.... About 3 oclock I saw one of the two Boats carried away by the flood, and the other was tied fast to a Larch tree [formerly on the bank] which stood now near the centre of the River, with no means of getting at it as all would be swept away that attempted [it]. The water had now reached the place selected for our Tent. Fortunately I had decided to be higher up on the Bank.[48]

To Lucy 'what was most remarkable was the incredible number of large trees that were swept past ... I never saw such a sight'. Later they came across some grief-stricken Buryats: the flood had 'swept away two of their dwellings, women, children, and all; it was heartrending to hear them wailing for them'. No one 'remembered such a flood'. On waking the third day, they found a clear, bright sky and the water level had fallen a lot. The goats and lambs frisked about and greatly delighted Alatau, who loved all animals. He much amused the Cossacks and Buryats by filling his pockets, unnoticed, with bark (used for lighting fires) and producing it when required.

On 24 July they prepared to cross the river, a slow process as only one person at a time could be paddled across. Before they left Lucy wanted to thank a Cossack's wife who had done the Atkinsons several kindnesses, including making bread for them. Lucy tried hard to offer her some money, but in vain, and after some hesitation she told Lucy 'the greatest kindness' she could do her, 'if she dared' ask it, would be to give her a tumbler so that when the priest visited them (which he did a few times a year) she would be able to offer him tea – and he was expected soon. Lucy acceded, adding a few other items, and 'left her the happiest woman in the place' with its only tumbler.

They slept that night in a Buryat aul, finding in one yurt 'a very pretty black-eyed young woman, with cheeks like roses ... of a delicate tint ... in a closely fitting black velvet jacket, which became her amazingly', and her head ornamented. The Atkinsons were intrigued to find in the yurt 'a picture of their [lamaist] deity, very nicely painted on silk' and in all yurts an altar bearing several brass cups filled with offerings: 'butter, tea, coffee, milk and sugar' and 'a strong spirit made from milk' which they drank a lot.

Reaching the Oka again, they found it too flooded and rapid to cross and realised they had to take a mountain route, which was both difficult and dangerous because of the rain. At the summit there was only a morass 'which was positively frightful; the men had several times to get off their horses to drag them out of the deep mire' through which they had to wade for hours and they were forced to encamp after a tiring ten-hour ride on the only dry spot they could find – blocks of granite on the side of a steep hill with 'not a single level spot' – so Lucy found it very difficult to spread their bearskins. She looked forward to a bed of down to compensate for all that her 'poor bones' had endured; 'at times they are really sore, as if I had been beaten'. (In the next town, she regarded her

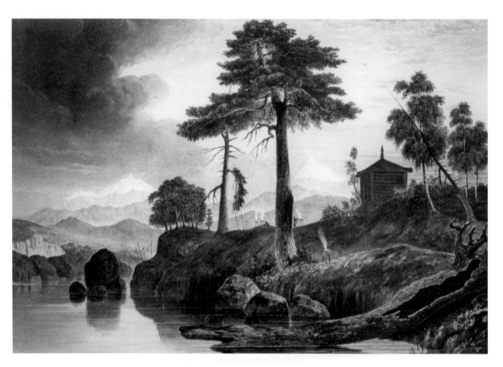

'Bouriat temple and Lake Ikeougoune'
The Buryat people who settled around Lake Baikal built this small Buddhist temple by the edge of Lake Ikeogun, held in great reverence by the Kalkas. Here they would sacrifice milk, butter and animal fat, which they burned on small altars.

bed, 'nothing but the bare boards of a bedstead covered with my bearskins, as a perfect luxury'.)

Their next hazard was sand hills near another river, and Lucy thought it would be impossible to keep her seat. One of the Buryats fell, making the others laugh. But in the only place possible to climb the far river bank was 'a deep hole filled with mud, sand, [and] water' into which the horses' hind legs sank 'deep and they plunged awfully', spattering them all with mud. Lucy was 'highly flattered when Thomas said, "However you keep your saddle I cannot understand". It would never have done to have been unhorsed after this.'

Their track onwards was along the now 'very pleasing' Oka valley, and one night they stayed again in a Buryat aul, of which Lucy wrote, 'You should see my son amongst them, dancing Bouriat dances; he has also learned one of their native songs, which he and a Cossack sing together, to the great delight of the Bouriats.' They dreaded crossing the mountain of Nuhu-Daban as it seemed 'almost impassable' after the long downpour. But 'Providence ... guided our steps; otherwise it might have been our last ride' as they were in a dense fog and could not see a yard ahead.

Further on they stopped at a Buryat temple filled with offerings of coloured silks hanging from the ceiling and banners hanging from grotesque heads. They greatly regretted not seeing any service and would have liked to hear the chanting and the cymbals, trumpets, bells and 'immense sliding trumpet', but the principal Lama 'was so *drunk* [Lucy's italics] that he could not officiate'.

They rode on to Lake Baikal by

> another atrocious road ... a sea of mud ... the floods had made great ravages all over the country. Not a bridge was left standing and the Roads near the River have been swept away ... we found people engaged seeking Lapis Lazule which is often brought by a flood. One Woman told Lucy she and her husband had found 12 lb. which they sell to the Bouriats for seven roubles per lb.[49]

They had to wait two days at Kultuk on Baikal's south-west coast while a boat was prepared for them. The first night, in the house of the village headman, Lucy could not close her eyes as it was a repeat of the night spent plagued by a mass of insects in the Altai. Next morning when the headman asked about their night Lucy 'complained bitterly to him about the *insects*' and said she would now sleep in the boat, but he advised them to sleep 'in the flour magazine' which they did the next night and, having missed so much sleep, slept soundly till dawn. When their host now enquired how they had slept, he said he hoped the rats had not disturbed them unduly and Lucy 'almost shrieked' and asked if there really were rats. 'Oh yes,' he said, and told them that he sometimes slept there in the summer as being cool and 'they annoy me very much, but I thought perhaps you would not mind it.'

As for Baikal, by far the deepest and oldest lake[50] in the world (though this

'A natural arch on the Baikal'
Thomas claimed that there was little to paint at Lake Baikal, although he produced several sketches including this one which he published in his first book. This arch was apparently much smaller in reality, here exaggerated. Lucy is portrayed sitting on the rock in the hat that appears in other paintings, so if Thomas omits her from print, he appreciates her at least in paint.

was not known at the time), the Atkinsons were both disappointed, Thomas 'greatly' so, according to his journal where he stated that there was nothing either grand or picturesque on the shores. But that verdict was after only one day and one sketch.[51] Lucy however thought Baikal was certainly well worth seeing, although not for an artist unless visited before Altin-Kul. Thomas relegated only the last two and a half pages of his 598-page first book to Baikal even though, he says, he spent twenty-eight days on it.[52] And his second book gives it less than a chapter, although he concedes that 'a picture of extraordinary beauty and grandeur' was provided by the four-mile rapids past the great, sacred – and supposedly miraculous – Shaman rock: the Angara's outflow on the west coast from Baikal, the only river flowing out of the lake compared to the 300 and more flowing in.[53]

But if the great lake did not appeal, the storms did. Heaven knows the Atkinsons had experienced enough already, but Lucy thought the storms on Baikal were 'very fine' and that it 'was magnificent to remark the changes that came over the lake.'[54] At one moment, Lucy writes, the Atkinsons

> would be looking at it when it was as clear as crystal, and revealing everything within; the rocks at the bottom discernable at a great depth, and on them at times even the little fish lying dead; when suddenly a storm would rise, entirely changing its aspect, heaving it into billows, and hiding everything from view.

They embarked along the lake with four rowers and a helmsman, stopped for the night – to be almost eaten by mosquitoes – and next day 'turned out at dawn' (as so often) along the coast of 'the same Monotonous character', thought Thomas, mostly cliffs. 'At 8 oclock we got to Listvenitza [then Listvenichnoye but now Listvyanka, a village on the west coast]', just beyond the Angara, 'our men completely done up' – not surprisingly if they had been rowing all day, and next day 'our old men would go no further'.[55]

Because of the many violent storms on the lake, which sank many boats, two steamers (or at least their engines, boilers and machinery) made in St Petersburg had arrived by land in the 1840s for the important west–east crossing, with the hulls built at Baikal by peasants under supervision. The Atkinsons hoped that the ships' 'director' could give them new rowers, but as he would not return till late at night they settled into the steamboat house. 'A Strong gale sprang up and tossed the Baikal into waves like a sea – we sat on the Shore and enjoyed a scene which called to mind the scenes of our youth,'[56] although Thomas's childhood was spent far from the sea.

Next morning the smaller steamer of the two was at the pier, and it was agreed that if the Atkinsons could wait for two days it could take them to Goloustnoye, a village further up the west coast, 'as it would only be ten versts out of her course'. They drank tea with the director of the little pier and his mother – 'I cannot say much either in favour of their <u>Manners</u> or <u>Hospitality</u>'

(underlining by Thomas).[57] 'Again we had a strong gale with rain in the Evening' and 'in the night the rain poured down in torrents. What a country for wind, rain, and fog' and the director (who now turned out to be very civil and was to give them a free passage) told them that 'in June and July the fogs are so great that you cannot see 20 paces'.[58]

They 'turned out' at 4 o'clock next morning – even earlier than usual – and sailed at 8.30. The captain, they found, was an elderly Swede who, to mutual delight, spoke English, having served in the Royal Navy. He had been eight years on the lake, 'sometimes as smooth as glass, at other times in fearful storms', and told them that when one particular wind blew from the mountains (he must have meant through the Sarma valley on to the lake, Baikal's strongest wind) he said the lake was 'then very savage' (underlining by Thomas) and navigation very difficult. Baikal's great depth was unknown at that time, but the captain found some parts very shallow and others unfathomable, finding no bottom with 200 fathoms of cable.

After the captain dropped them off they were rowed up the coast and round a headland and that night slept under a large boat they found on the shore.[59] Next day Thomas, up with the dawn, found 'the effect of the coming day was exceedingly beautiful.… From this point Eastward nothing but water is seen, and the Sun rose up like a great Ball of fire quite red by the Haze from the Water.' They set off again by boat and after twelve hours reached 'a very pretty bit of rock

'Baikal, Oriental Siberia'

scenery' which he sketched and had just finished when a dense fog materialised, making everything invisible beyond twenty paces (as they had already been warned) and, though it cleared a little later, 'the waves rolled in with great fury'.[60] There followed several days of bad weather – calm interspersed with violent gales – which made it dangerous to continue their voyage.

Fortunately, Saturday morning before daybreak at least was 'nearly calm'. They returned to their boat, and soon a strong breeze blew up which drove them on to rocks twice – the second time 'truly dangerous and I expected every moment the boat would be dashed to pieces…. At last we succeeded in getting the boat off'[61] and the Buryat boatmen kept the boat upright but almost drove Lucy crazy with their singing. However, 'they seemed so perfectly happy that I had not courage to ask them to cease their Baa-a-a-a!'

Two hours later the Kultuk wind began to blow – fortunately in their favour – and they began again despite the rough sea and 'a great deal of water … pouring in, but we could keep it under by baling'. Having made five further sketches that day and the next, one of them of Baikal's largest island Olkhon, Thomas confirmed his first impression: 'there is really no fine scenery on this lake. There are some fine Rocks but such a sameness',[62] although he believes that some parts 'would be highly interesting to the Geologist', and his journal for 1851 ends here, although confusingly he uses some of the blank pages for his travels in the following year (1852) and after that a list of his 1851 sketches.[63]

That last night at Baikal they slept at a widow's cottage in Listvenitza on the west coast, and heard that her husband had been a fisherman who had drowned in a storm. His colleagues had spotted him in the astonishingly clear water lying at the bottom of the lake – granted not a deep section – as if asleep. Several times the Atkinsons 'had a chance of lying at the bottom themselves, especially when the wind suddenly rushes down the valleys, when it catches the frail boat, and nearly capsizes it', as Lucy wrote.

Back to Irkutsk and then they made 'a little journey' (by their standards: only some 500 km) on to the river 'Hook' (perhaps Uk) near Verkhneudinsk for Thomas to sketch a waterfall for an Irkutsk resident. He and the archbishop considered this fall '*finer* than the *Falls of Niagara*' but Lucy dismissed it as 'a trumpery thing' which Alatau could have jumped over when a little bigger. They slept several nights in their carriage on the way and they and their Cossack coachman were asleep after a change of horses when Lucy was woken 'by a heavy hand' on her face. She said to Thomas 'Your hand hurts me', and dozed off again. At the next station she found that her bag had gone. It contained both copper and silver coins and she always kept it behind her head as she was 'paymaster' and could find it immediately. The bag was 'a sad loss', as apart from the two bags of money there were a lot of other things: Thomas's telescope, earrings and beads as presents, Alatau's socks and shoes, a tiny pocket bible (given to Lucy), bags of dried fruit for 'the child' and a host of other items. They informed the police but heard nothing from them 'nor ever will', thought Lucy, who learned that there were many robberies at that station – even from

the Governor's carriage. But Lucy noted that all this was nothing compared to Thomas 'having taken cold, and being confined to his bed for fifteen days'. Another bout of illness for him, but why fifteen days for a cold? Was his health deteriorating?

On their way to the waterfall at Verkhneudinsk, they stopped at a salt zavod where there seemed to be no security, although all the workers were convicts. And the room where Lucy slept had no bolt or lock despite the fact that the maid relegated to her and sleeping in the next room had *murdered her master* (Lucy's italics) and the children's maid had poisoned her mistress. Their hostess told her that when she arrived years earlier she was really scared of being murdered, but now she maintained 'they are the best servants she ever had; she prefers them to any other' and most of them 'had been driven to commit crime by the brutal conduct of their masters'. But Lucy stresses that all this was by no means typical in Russia, although some crimes were certainly extreme, and once the Atkinsons went to see one convict in chains guarded by Cossacks who had confessed to *seventy* (her italics) murders, had escaped and was awaiting trial with, surprisingly, 'an exceedingly pleasing and mild face'.

They returned to Irkutsk where in November Alatau celebrated his third birthday with a ball to which

> all his little companions were invited ... right merrily have they enjoyed themselves: such romps, and dancing too; the musician being a *musical box*. I gave them a surprise at supper, viz. a Christmas pudding. How the little eyes were dilated when they saw it come flaming into the room! ... the first plum-pudding ever made in Irkoutsk.

The next day many people came for a *taste* (Lucy's italics) 'and all regretted they had not seen the grand sight'.[64]

According to Lucy, Alatau had cost her nothing for clothes except for one piece of silk bought in Kopal. All she needed to buy were shoes and socks from St Petersburg. In Barnaul she was 'loaded with material for dresses', some in Russian peasant style, and a friend, S. from St Petersburg (probably Sofia, her previous charge), sent many more dresses, while another was a present from the wife of the civil governor's wife, Madame Zarina, of 'most beautiful' thick pink Chinese silk trimmed with silver lace and buttons which the boy wore with a black velvet cap (also a present), being 'greatly complimented on his appearance.... My son is a most fashionable young gentleman.'

At the beginning of 1852 there was 'no end of balls and evening parties', but the far weightier matter was the possible amnesty for the Decembrist exiles, who had been 'in a great state of excitement' for the two previous months. They fervently hoped, indeed believed, that the twenty-fifth anniversary of Nicholas I's accession would mark 'their liberation from exile'. But the day of accession came and went and then a fortnight passed which could have brought a courier from St Petersburg. 'They were forced to abandon the last hope.'[65]

Then a mounted Cossack arrived in haste – at last! – but no, he had come because of the escape of a young Polish exile whom the Atkinsons knew – 'no more than twenty years and of noble extraction'. He had not reported as he should have done from the village he had legitimately visited and had somehow procured a merchant's passport, knowing that the Tsar's pardon was not forthcoming. Cossacks were sent in all directions, but it was the postal officials who stopped him and he was imprisoned in Omsk. His fellow exiles all declared, Lucy noted, that if they had considered escaping they 'would never have been taken alive' as punishment would start with 'public flagellation in the town from whence he had fled, and then banishment to the mines for life, with no hope of release'.

But, against all expectations, it proved to be true that he had escaped from prison and, it was thought, would have tried to reach the Kazakh steppe but, if the Kazakhs took him prisoner, the Atkinsons knew they would sell him as a slave or, like a Russian prisoner of the Kazakhs they had once seen, insert a horsehair into his heel, which would lame him for life and turn him into a cow-herd.

Thomas and Lucy were looking forward to their visit to Kyakhta, south-east of Baikal on the border of Outer Mongolia, then part of the Chinese Empire. Lucy was glad to leave before the carnival time of Maslenitsa as she was tired by the number of balls in Irkutsk, particularly the preparation for them. She was going to one ball in a dress she had worn before when two young friends – and Thomas in support – 'made such a fuss … that I was forced to go out and buy a new one', and 'scarcely a week passes without a ball or an evening party', not to mention plays. When the Atkinsons took a box for the opening play of the season Alatau 'made his *début*' among the audience; the only child there, 'he was in ecstasies, and applauded as loudly as he could'. His appearance set a fashion, for the next time Lucy went it 'was crowded with children'.

Almost every Sunday in Irkutsk the Atkinsons would dine with the mayor of Irkutsk, Mr Basnin (with whom they had left their belongings temporarily), a very clever merchant with a collection of 'valuable Chinese ornaments … a splendid library, besides extensive hot houses' on which he spent great sums buying plants, yet knew nothing about them, and none of his family had 'any real love for flowers'. But he enjoyed simply walking through his hothouses after dinner, smoking his cigar. Fortunately he had a friend with not much money who did love plants and was only too pleased to be in charge of them, and it amused Lucy and Thomas to see the mayor 'asking permission to cut his own flowers, or even to gather a strawberry'.

The Atkinsons set off for Kyakhta in early February: 'a visit of pleasure', considered Lucy. They started at 2 a.m. in order to cross Lake Baikal by day. The fifty-five versts took them four hours to complete in a keen wind and temperature well below freezing. Fortunately General Muravyov had lent them his warm and comfortable sledge, but despite being wrapped in furs Lucy found it difficult to keep warm and had to have her feet rubbed often. Yet Alatau was so warm, he claimed, that he 'threw off his furs and sat for a while with his

Kyakhta, Russian and Chinese trading towns, separated by neutral ground
On the Siberian–Mongolian border between the Russian and Chinese Empires, Kyakhta was the most important trading post between the two, dealing in huge quantities of, above all, tea and cottons from China and furs from Russia. Town view, printed in Paris, 1783.

arms naked' even though 'the poor horses were bleeding at the nose', and the yamshchik had often to rub them with snow and sometimes run alongside to keep from freezing himself. The view was 'one dreary snow-white waste' with waves of ice frozen as they rose.

Once across the lake they continued through the beautiful scenery along the Selenga, Baikal's greatest tributary of all 300 or so. The hoar-frosted trees sparkled 'like diamonds and rubies' and they stopped four versts before the important Russian–Chinese trading centre of Kyakhta at Troitska, short for Troitskosavsk, its administrative centre, where they were to stay with the Director of Customs.

Cross-border trade here had begun in 1727, and a few hundred yards south of Kyakhta just across the border was the complementary Chinese trading town of Maimachen (meaning 'buy–sell town', today Altanbulag). Its *dzarguchei* or governor gave the visitors a hearty welcome and they dined with him one day and supped with him another (and asked for chopsticks). They ate off plates the size of saucers with a choice of twenty dishes – the first course boiled, the second stewed, the third roast and finally a choice of 'delicious' soups. One Chinese meanwhile looked after Alatau and before the end of the meal the *dzarguchei* 'politely excused himself, and went to have a game with the child ... rolling about on the sofa, he quite as delighted as the boy'.

The Atkinsons found Maimachen a town with a temple, a court of justice and a small theatre with very narrow streets where small one-storeyed wooden houses were set round courtyards. Flags and coloured lanterns 'stretched across the streets' in the evenings. The shops – where no goods were displayed but all kept in cupboards – seemed spotlessly clean and tidy (though no Chinese women were allowed). Dealings, still by barter, between the two towns took place only between sunrise and sunset when Maimachen's gates were locked with a 'ponderous' key. Basically only the merchants trading with China were allowed to stay in Kyakhta, some of them very rich agents for Russian concerns. All others, including the Atkinsons, had to stay at Troitska, both the administrative headquarters and the site of the customs house where all Russian and Chinese goods had to be deposited before being bartered (although money was starting to take over). By now Maimachen was 'the only town whence Russia has obtained her tea', as Thomas says.

The Chinese goods arrived by camel caravan across the Gobi desert and the Mongol steppes: cottons, silk, 300,000 lbs a year of dried rhubarb,[66] but above all tea – 'much in the form of hand-packed bricks ... which even served for a time as units of currency' in Kyakhta. Half a century before (in 1800) the better-quality loose tea arriving through Kyakhta had already risen to nearly 700 tons a year (compared to 567 tons of brick tea), nearly 2 million roubles' worth. (The tea the Atkinsons had been drinking had probably all come from Kyakhta.) In return Russia was sending to China millions of good-quality fur pelts, particularly Siberian squirrel (the sable had already been decimated) and began to turn to the beaver of North-West America which reached Kyakhta in its tens of thousands. It was no wonder that this small town became known as

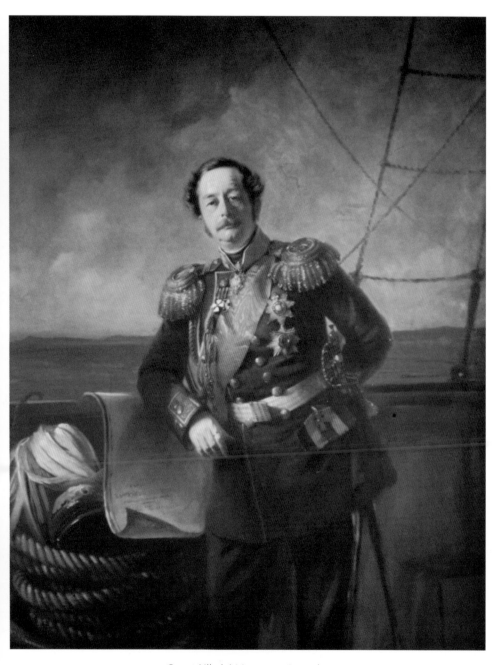

Count Nikolai Muravyov-Amursky
A relative of both Lucy's former employer in St Petersburg and of the exiled Muravyov Decembrist, this General Muravyov was the incorruptible Governor-General of East Siberia based in Irkutsk and lent the Atkinsons a warm sledge to cross Baikal in winter.

'the village of millionaires' and could boast a stone cathedral as well as a museum.

On their way back to Irkutsk the three Atkinsons stopped at the settlement of Selenginsk on the Selenga river (now known as Novoselenginsk), where three British missionaries had tried (unsuccessfully) to convert the Buryats to Christianity earlier that century. The Bestuzhev family lived here, with whom Lucy was 'perfectly charmed'. The two brothers, Nikolai and Alexander, who had both served in the British Navy, were Decembrist exiles and had been joined by their three sisters, who were not allowed to return, the eldest of whom reigned like a benevolent major-domo, treating her siblings like children. Indeed, she called her younger twin sisters 'the children'.

She took Lucy to see the farm her brothers had started, showing her 'the cow-house, fowl-yard, stables and coach house'. Her younger brother, Alexander, had indeed taken up coach-building, of which she was very proud. She told Lucy she wanted him to marry and wished she would give him some advice. Lucy was then shown the ice-cellar with an adjoining room as a dairy, and then in this sister's 'private apartment' heard the sad story of their mother, who had applied several times to the Tsar for permission to join her sons. Her hopes rose and fell over time and at last permission was granted. They immediately sold their 'house, furniture, horses and carriages', said goodbye to their friends and set off to Moscow only to find there an *ukaz* or official order cancelling the permission, with no reasons given. The greatly shocked and saddened mother appealed to the Tsar again, but 'after weary waiting' her longing to see 'her beloved sons' affected her so much that she died just as permission was finally received a second time.

Nikolai, the elder brother, was a gifted painter and has left many excellent portraits of his fellow Decembrists and at least one of himself. Some time after the Atkinsons' visit he had gone into Irkutsk to see 'his companions in exile' and, starting back, had been begged by a poor woman to take her to Selenginsk to her husband. She was quite prepared to sit atop with the coachman and Nikolai 'most cordially' agreed to take her, but as there was room for only one in his carriage and it was very cold, he gave her his seat and caught cold on the box, which was to prove fatal.

Thomas could not write up anything about the Decembrists in his first book because of his dedication to the (next) Tsar, Alexander II,[67] so Lucy's account of their visits to these political exiles was of great interest to Russian readers and it was news to them that the Bestuzhev sisters had joined their brothers.

The enlightened and indeed outstanding Governor-General of East Siberia, Muravyov, at last an honest and incorruptible man, was very aware that the Chinese had left unoccupied the left bank of the great Amur river, flowing out effectively into the Pacific Ocean – even though the 1689 Russian–Chinese treaty of Nerchinsk had ceded it to them – and he was determined that Russia should control the strategically and geographically important mouth of the Amur – a vacuum till then – before Britain ('Great Game' in mind) or America moved in; which is why, when he heard that Thomas's early travelling companion Austin was building a raft to go down the Shilka, a tributary of the Amur, he

gave orders that he be brought back 'dead or alive'. It was indeed on the Shilka that Muravyov, having gone back to St Petersburg to get the Tsar's approval, assembled 'a huge flotilla of boats and barges' with troops, horses, artillery, specialists and supplies which in May 1854 (when the Atkinsons were finally back in London) sailed nearly 3,000 km down the Amur to its mouth. Four years later the Chinese formally accepted Russian possession of the Amur's left bank and the Tsar honoured Muravyov with the title of Count Amursky, his surname now Muravyov-Amursky.[68] In 1860 came the Treaty of Peking, which granted Russia the whole area between the Amur's north-flowing tributary, the Ussuri, and the Pacific coast. That same year the port of Vladivostok (meaning 'Hold the East!') was founded, followed by the construction of the Trans-Siberian Railway (1891–1916). But all that was for the future.

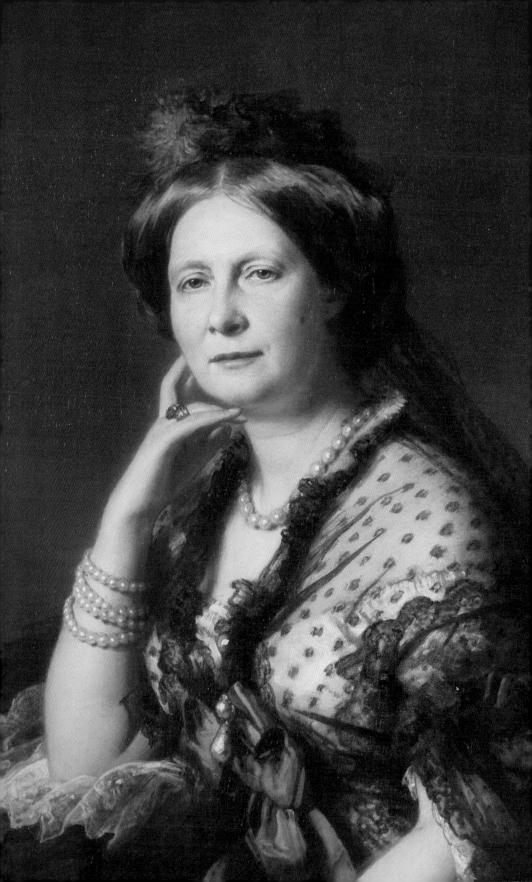

Chapter Seven

Barnaul, Belukha and back to St Petersburg

I. Belukha and Barnaul

By July 1852 the three Atkinsons had moved west, back to Barnaul in the Altai, a slow progression as they knew it was the last time they would see so many friends and Thomas inevitably wanted to go on sketching. They stayed with a friend in a house overlooking the Ob, which they found had now shrunk to much the same size as St Petersburg's Neva, whereas the previous June it had been almost twelve versts wide from the mountains' melting snows.

Next day, when all the mountains were white (in August), they rode to Kokshinsk, where Thomas and Lucy had stayed four years before, and were greeted with delight at the news of the 'Barona's' (i.e. *barinya's* or 'lady's') son. Thomas was now very keen to climb Belukha (he spells it 'Bieloukha'), the highest mountain in the Altai and indeed all Siberia, its twin summits of 4,435 and 4,506 m connected by a wide saddle. (There is a higher one, Kluchevskaya Sopka, on the Kamchatka peninsula.) On that earlier visit it had been too late in the year even to try. Now in August, 'very anxious as the fine weather was going fast', he was determined to attempt it, particularly since it was as yet unclimbed – and is still a sacred and indeed mystical mountain today. He set off without Lucy and Alatau over 400 miles south-south-east from Barnaul, successively by carriage, telegas and horse, and his first night away 'slept in a dirty room. in the night I was awoke by the thunder bellowing in the Mountains but not near. tho the rain poured down. How much I should have liked to have been in our clean room and sleeping with my <u>dear little wife</u>' (his underlining).

For the last stage of the journey he was accompanied by Yepta, a Kalmyk hunter, and three others. Nearing Belukha, they began by fording dangerous rapids on the Turgan and Katun rivers which had once taken the lives of fourteen Chinese. Thomas admired the Turgan valley's 'magnificent cedars' intermingled with birch with their 'rich orange and yellow tints' and poplar varying from orange to deep crimson, while above them rose rocky ridges of brown and purple and, beyond, the Altai's snowy summits 'looking like frosted silver against the deep ethereal blue'.

He was kept busy with his sketches but the mountains – particularly on horseback – proved very difficult, with zigzag tracks and high perpendicular rocks, and in some places they had to descend. 'A fine view' of Belukha finally presented

Mount Belukha
Siberia's highest mountain (4,506 m), eternally snow-clad, known for its double saddle, is regarded as particularly holy by the indigenous Altaians. Thomas made two attempts to climb it but was defeated by the weather conditions, precipices and six glaciers. It was first climbed only in 1914.

itself: 'a stupendous mass', its summit formed by two enormous peaks, shored up with innumerable buttresses forming ravines filled with glaciers down to the edge of precipices overhanging the Katun valley, while on the mountains' lower spurs he found many flowers among the 'rich short grass': red primula, sweet-scented violet and several sorts of anemones. In ten or twelve days, he considered, they would all be covered with snow for at least nine months. Further on he collected seed. What happened to it on his return?

That first night in his tent with the pouring rain outside he 'thought of all our nights spent in such places. How much I wished for Lucy!' And after only two hours' sleep he was woken by thunder 'and the rain pouring through his tent like a scotch mist'. The lightning soon appeared to come from the 'top of the trees' and 'the thunder made the ground shake. I never heard anything to equal it before', and this continued the whole night'.[1] His journal records that he had to drink his evening tea alone, and, touchingly, 'A mountain life is pleasant but 40 times more so with Lucy and the little man' – a second instance of the very rare indications of his feelings towards them.[2]

The next day the weather worsened, a strong cold wind increased and a snowstorm began. Although increasingly concerned that they might be trapped in the mountains by a heavy fall of snow, they nevertheless continued past the source of the Katun in its mass of ice, up and down mountains towards their goal, with intermittent rain and fog and the snow-capped summits above. Thomas's desire 'was to see and sketch the Mountain' and he 'expected on gaining each summit to see it but was ever disappointed', foiled by other high peaks. Then 'suddenly it rose up before me without a cloud' and from one crest 'we had the Bielouka before us in all his grandure'. Thomas sketched four views, all, alas, lost today.

The icy glacier – one of six surrounding Belukha – coupled with the 'mighty precipices' several hundred feet above them, and now a snowstorm, forbade further upward progress, and after about nine days in the mountains he turned, disappointed, back to Lucy and Alatau in Barnaul. A modern trekking guidebook warns that 'the unstable weather patterns in these parts mean that even in summer you may often find yourself in dangerous winter storm conditions', which is exactly what had happened.[3]

But that autumn the three Atkinsons, reunited in Barnaul, still made excursions into the countryside. Lucy claimed:

> There is no place equal to Siberia for a pic-nic, we can settle down on any spot we choose, and ramble about at will. Each lady takes it in turn to act the hostess, and forward servants with the necessary supplies to the place of encampment. These assemblies are the most joyous you can possibly conceive. The ladies start first with the children; then follow the gentlemen, when all kinds of games are played, in which the latter, old and young, join in right good earnest; casting all cares to the winds, they become children for the time, jumping, leaping, running, and dancing.

At the New Year Lucy was faced with yet more balls, concerts and theatres in Barnaul in honour of the new *nachalnik* (director), Colonel Stroleman, who had succeeded their friend Colonel Sokolovsky, now promoted to General. In his new position Stroleman had to give a grand ball on New Year's Eve to the whole town – 'a brilliant assemblage full of mirth, congratulating each other as the bells toll forth the new year ... when the champagne is poured out, and there is a general kissing all round'. All the ladies had magnificent new dresses – Lucy's was white – which had arrived by post. Unfortunately, halfway through the evening the brilliancy of the ball was literally extinguished when all the lights went out and almost total darkness reigned. The Stroleman, unprepared for the number of candles needed (usually bought at the great Irbit fair), had bought stearin candles in Barnaul, which proved to have no wicks. Fortunately, some others were found, but not nearly enough for the event, to the great disappointment of the ladies and, Lucy was to write, 'it is said that such trivial things make up a woman's life' – though certainly not in *her* case.

Alatau celebrated his fourth birthday with a 'grand ball' in Barnaul. 'All our friends, old, young, and middle-aged, came and right merrily was the evening spent.' Lucy had intended to have only three musicians, but 'the whole band' arrived and Mme Stroleman sent off to her country house for a couple of dozen chairs as well as her head cook, better than Lucy's – the first mention of Lucy's cook – and 'her principal waiting man; indeed each house one visits there is always the same set of servants, the one borrows of the other for every festival'.

Continuing their homeward journey west, the Atkinsons arrived in Ekaterinburg in the Urals 'just in time for the [Easter] carnival' and were welcomed warmly by all their old friends, but the church bells nearby 'never ceased during the whole of Easter week'.

The grandest ball at Easter was given by General Glinka who, in Siberian style, walked round his guests rather than sitting with them, attending to their needs. Lucy sat next to a friend of the general's, 'a comely lady of fifty, extremely amusing and good natured'; she had recently married an elderly man who had had to be carried up the stairs to the church and sit during the wedding ceremony and had such 'repugnant' eating habits that his wife ate alone. She told Lucy that she had married 'simply to give me a position in society; for even at my age I am obliged to be very circumspect ... am fond of cards, and enjoy society amazingly'. She could, she said, now come and go as she pleased with no one thinking it improper, had enough money of her own and wanted nothing from her husband but a position. Furthermore, she devoted herself to his daughter, forgoing much 'to accompany her into society', and now *she* was to be married. The Atkinsons were surprised (and amused) to hear of the English mechanics now living in Ekaterinburg, struggling to outvie each other in magnificence and ostentation.

They left the Great Post Road on their way further west to say goodbye to the Decembrists at Yalutorovsky. It took three days as their friends had 'a thousand questions ... about their comrades, from whom they had been separated for years.... What a welcome we met with! As for the little mountain [Alatau], he

was nearly devoured.' The next day they visited a school for both boys and girls set up by the exiles, where drawing was taught on paper but writing taught on a level of sand atop the desks. One of the exiles they encountered was the old Vasily (Wilhelm Sigismund von) Tiesenhausen, who was very excited as he had just learned he had been pardoned after twenty-eight years of exile – 'he could think and speak of nothing else but his return to his wife'. The few days he had to wait were 'as irksome to him' as his many years of exile. Much later the Atkinsons heard that, after the first meeting with his wife in Courland (today's Latvia), he became dissatisfied, finding her appearance much altered and 'no companionship in her society', having grown apart after so long; he had become 'just as anxious to return to Siberia as he was to leave it', deprived of his old companions in exile.

While in Yalutorovsky a young British naval officer and his wife arrived en route to his ship at Okhotsk on the Pacific coast. She dreaded the long journey ahead and believed she would die. Lucy tried to comfort her – in vain. When the couple left, the naval husband was unfavourably compared to Thomas, and their friends still remembered years after their first visit 'with what care and attention I [Lucy] had been placed in the sledge, and covered up … whereas she, poor woman, had to get in herself, without assistance'. They agreed that Russian men 'were far behind Englishmen in the care of their wives' and Thomas and Lucy found 'a snugness and comfort' in their sledge which the naval pair did not comprehend.

They carried on to Irbit to see the famous fair, attended by people from all over the world, with many different costumes and languages. Almost everything imaginable was on sale, including the piles and piles of iron-bound, mostly red, boxes, which the Atkinsons had seen in every peasant's house, containing their treasures. It was surprising how many people they met at the fair whom they knew, some from the Kazakh steppe who recognised them 'and screamed out "'Aman!" meaning "Good day"'.

In early June they stopped south of Ekaterinburg at the Sysertsky Zavod ironworks to be shown over the extensive hothouses and their 'magnificent collection of plants' by the owner, Mr Salemerskoi. Further south just outside Zlatoust they came across an encampment of some two hundred peasants on their way to Siberia to start a new village. Lucy noted it was not unusual to find entire villages only recently abandoned by order of the authorities. The Atkinsons wandered round looking for scenes for Thomas to sketch, encountering for the first time Bashkir[4] men and women alike in sheepskin coats and trousers, their dwellings 'in a most wretched condition' and the inhabitants 'ever dirtier and more dissipated near town or priisks'.

They now waited for 'good winter roads to start for St Petersburg', where they hoped to join their friends for Christmas, and Lucy thought:

> It makes me sigh when I think I shall shortly quit Siberia, its blocks of
> ice, its snow-clad mountains, its lovely scenery, and all that is sublime

in nature, to return to a town life, which has not the same charms for me. I could almost wish I were a Kazakh, wandering forth like them, under a serene sky, in search of mountain pastures. Happy people! free and unfettered by any customs of so-called civilised life.... I now look back on all those scenes, and repeat what we have often and often said, that willingly would we face ten times more toil and difficulty rather than go down to mother earth without having beheld them.

II. St Petersburg

Their arrival in St Petersburg on Christmas Eve 1853 was certainly well timed. It was six years since the pair had set off, and now there were three of them. We can imagine that they went straight to the house of General Muravyov and his family, where they would have had so much to say, not least because so many of the Decembrists they had seen were relatives and friends; and the General, as a founder member of the Russian Geographical Society (now 'Imperial' as of 1850), would have been particularly interested in their travels. Sofia, Lucy's erstwhile charge, would now have become a young lady of twenty. She and Lucy would have been delighted to see each other again after so long – and, of course, there was the young Alatau too.

Thomas is thought to have brought his large watercolours back in great rolls. On the last day of the year he wrote to Nicholas I for the third time, informing him that he had returned after nearly seven years away, reminding the Tsar of his gracious permission and the purpose of the travels. Now, having made very many sketches and collected 'much material for a picturesque description' of that area, he solicited the Tsar's permission to remain in St Petersburg under his Imperial Majesty's protection 'for four or five years in order to prepare my work for publication'. It is not at all clear what sort of book he had in mind: the extensively illustrated 600-page volume that he ultimately produced or a folio of colour plates with brief descriptions. But why did he need as much as 'four or five years'? (And how could he afford that, other than by selling many watercolours?) A reply from the Emperor appears not to exist, but at all events the Atkinsons were still in St Petersburg three and a half years later.

After the Christmas and New Year festivities were over the three settled in '10 [i.e. 10th] Line, House Gutschow' on Vasilyevsky Island, facing across the river the fashionable English Embankment, where in the English church Alatau was baptised in early February by the British Minister (doubtless after no little discussion of the chosen names). Sofia stood as sponsor together with two British expatriates, J. Lumley Savile and Edward Cayley.[5]

We must suppose that Lucy, daughter of a schoolmaster and herself an ex-governess, would have been teaching Alatau, now five, and that Thomas would have started (or continued) writing his first book, turning preliminary sketches into watercolours, but first preparing a selection for the Emperor. His journals had

ended with his travels and neither he nor Lucy included their subsequent stay in St Petersburg in their future books, but happily we have Thomas's correspondence in the capital: the letters he received and some copies of those he sent, passed down through his descendants.[6]

From them we know that Thomas visited the British Embassy shortly after his return, for in mid-January Sir Hamilton Seymour, the British Ambassador, wrote to Lord Clarendon, Foreign Secretary, in London, regarding Russia's 'advance in India', and reported that Atkinson was glad to make information available to Her Majesty's Government but anxious not to be credited, as his 'literary and scientific pursuits' (scientific?) necessitated 'some years longer in Russia'.[7] This letter must surely refute the notion that Thomas was a British spy.

In March 1854 the Crimean War began and at once 'a barrier of ice' went up (in St Petersburg at least), separating the Russians and the British, even close friends. Many British employees of Russian firms lost their jobs and 'Those swines the English' was a common expression. But of this we hear nothing in the Atkinsons' three books, not even a mention of the war. Relations fortunately recovered quickly with the peace, almost exactly two years later.[8]

In late April Thomas wrote to Alexander von Humboldt, reminding him of his valuable letter of introduction to Admiral Lütke. He told Humboldt in a few words of his seven years' exploration and sketches and, specifically, the extinct volcano that he had discovered. We do not know if there was a reply.

However, he does acknowledge in his first book the help of Baroness Edith von Rahden and Miss Euler, 'a worthy descendant' of the outstanding eighteenth-century Swiss mathematician and physicist Leonhard Euler (1707–1783; he had lived a few doors from the Atkinsons' residence, as a plaque today testifies). They were both ladies-in-waiting – and Miss Euler probably the entrée for the Atkinsons – to the Grand Duchess Elena Pavlovna, unhappily married to the Grand Duke Michael, the Tsar's younger brother, who cared only for the army. Born Princess Charlotte of Württemberg in 1807, Elena Pavlovna was beautiful, charming and intelligent and, unlike her husband, interested in the arts and good causes. She founded the St Petersburg Conservatoire as well as the earliest version of Russia's Red Cross and a nursing order for Russian troops in the Crimean War (*vide* Florence Nightingale), and took an important role in the emancipation of the serfs.

She liked to gather in her Thursday salons 'all that was then the cream of St Petersburg wit, scholarship and talent: learned men ... and statesmen'.[9] But she never permitted any familiarity and protocol forbade her from being the hostess on such non-official occasions, either in the magnificent palace still known by her husband's name as the Mikhailovsky Palace – now the Russian Museum – or, after his death, in her splendid palace on Kamenny Island[10] where the Atkinsons were to attend on her 'with his drawings'.[11] Presiding for her officially at these salons would be her principal lady-in-waiting, the Baroness von Rahden, a fellow-German, 'intelligent and cultured' and 'one of the most remarkable women of her age ... [with]: a great strength of will ... [and] a brilliant and enlightened mind'.[12]

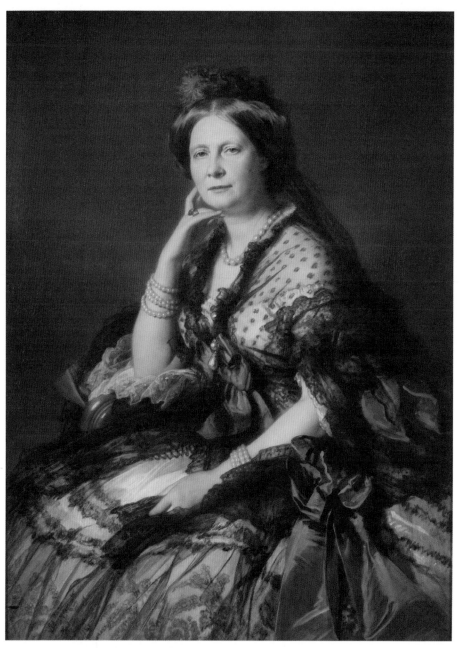

Grand Duchess Elena Pavlovna by Franz Xaver Winterhalter, 1862
The aunt and good friend of the next Tsar, Alexander II, she was a conduit to Tsar Nicholas, to whom Thomas was keen to sell his paintings.

Thomas and Lucy were invited to her salon, doubtless as interesting people, an important step for him as in January 1855 (despite the Crimean War) he 'had the honour' to lay his views 'before her Imperial Highness who was pleased to say that they had afforded her much pleasure and that at some future time she wished to see the others',[13] and the same month Thomas was requested to bring his pictures to the Grand Duchess in two days' time.[14] That was obviously a success, as five days later Miss Euler wrote asking Thomas to take his drawings to the Minister of the Imperial Court, Count Adlerberg, at the Winter Palace: 'His Majesty the Emperor will see them at one o'clock.'[15] This was thrilling news for Thomas, who must have longed for this and must have been working on a selection of his watercolours that he hoped to show to the Tsar.

However, next month Adlerberg[16] wrote to him that, although the Tsar had now seen his pictures and 'was much pleased, [he] did not consent to purchase them', which must have been a great disappointment. Thomas replied the next day, saying that, since he wished to exhibit seventy-three he had finished before sending them to England, he hoped that the Tsar would 'graciously condescend to permit me to say that the few which have been laid before' him gave satisfaction, to which Adlerberg replied, authorising Thomas to state that the pictures 'had [indeed] met with His Imperial Majesty's approbation'.[17] This somewhat qualified success was just in time, for four days later Nicholas died unexpectedly of pneumonia.

All would have been very subdued in St Petersburg with court mourning, but Thomas must have kept busy with his large watercolours and perhaps his book too. In July 1855 he received a letter from Lord Bloomfield, who had been secretary and then envoy in St Petersburg from 1844 and subsequently ambassador in Berlin from 1851. Bloomfield thanked Atkinson for his letter and sketch of Chinese Tartary, delivered in Berlin to his wife, who was 'greatly pleased with the drawing' of 'thoroughly remarkable scenery',[18] and two months later Bloomfield's office wrote saying they would be forwarding the parcel expected from Winsor & Newton, doubtless keenly awaited. This cannot have been the first time that he needed new watercolours.

It was not until February of 1856 that Thomas, probably in despair after the long silence from the Grand Duchess's two ladies-in-waiting, braved protocol by writing to the Grand Duchess herself via the Baroness, hoping she 'would pardon him for daring to intrude upon her', to say that when she had seen some of his small pictures of Siberia she had 'most kindly condescended to say' that she would 'visit his collection and see his larger works'. Since then he had finished twelve large pictures of 'the most magnificent scenery of Siberia, Mongolia and Chinese Tartary'[19] – three of them 'of colossal dimensions ... such as have never been attempted by any artist',[20] and he hoped that her Imperial Highness would 'still condescend to visit the collection'.[21]

But a few days later in a short note[22] to Baroness von Rahden, he deeply regretted that the Grand Duchess had been ill, so would with great pleasure take his pictures to the palace whenever convenient to her. In March he was finally able

to have an audience with her to show his sketches and another in May to show his large pictures. Presumably he used the opportunity to ask her deferentially to forward a letter to the new Tsar, Alexander II, her nephew and close friend, as the next month he heard from Baroness von Rahden that 'the Grand Duchess Helen has instantly forwarded your letter to His Majesty the Emperor'.[23] The Baroness hoped Thomas was already informed of the Tsar's wish to see his pictures, ending with her best wishes for his 'success in this affair'.[24]

His letter to Alexander recalled that 'His Late Imperial Majesty was most graciously pleased' to permit him to travel to Siberia in order to sketch the scenery, and explained that he had devoted seven years to his journey, producing 'a great number of sketches' and collecting 'a vast mass of material for a picturesque description'. He had, he wrote, spent more than two years since his return preparing his work for publication and had 'completed the illustrations for two volumes, also, many large pictures', stressing again the size. He greatly hoped that they would interest the Emperor 'as they are from regions never before sketched or even visited by any European'.[25] And he now prayed for permission to dedicate his work to the Emperor 'as a token of my profound respect' – it was forthcoming – and hoped he might be permitted to submit these views personally 'and … point out some of the Grand features of your Imperial Majesty's mighty Empire'. He then made another request:

> This has already been a work of great labour and expense, and very often of most severe privations, and will still take up most of the remaining years of my life. I now pray your Imperial Majesty to grant me the permission to receive the paper, colours, glass, and other materials requisite to continue my work Free of Duty as this presses very heavy upon me: already it has cost me more than five hundred roubles silver.

And he added further that as artists were often absolved from paying the Custom House dues and he was now devoting all his energies to complete his work on Siberia, he sincerely hoped and prayed that the Emperor 'will graciously condescend to allow the amount of Duty I have paid to be returned to me'.[26]

But it seems that Thomas's request for compensation was never granted. However, as a man of drive and determination he tried his luck again with Elena Pavlovna through the Baroness. He called on the latter in April but she was out. He wrote three weeks later explaining that he hoped for an interview with the Grand Duchess, sincerely hoped that her health had recovered and was now the more anxious to lay his pictures before her 'as the navigation will shortly open' when he can send his works to England. Shortly afterwards he heard from Count Alexander Nikolayevich Tolstoy (1793–1866), formerly the Grand Duchess's equerry and now Lord Steward of the Imperial Court,[27] that the Tsar had 'graciously expressed a wish' to see his drawings and watercolour paintings. Thomas thanked the Count the next day, although he thought the Tsar could not be aware of their large dimensions,[28] impossible to put on a table. Thomas added

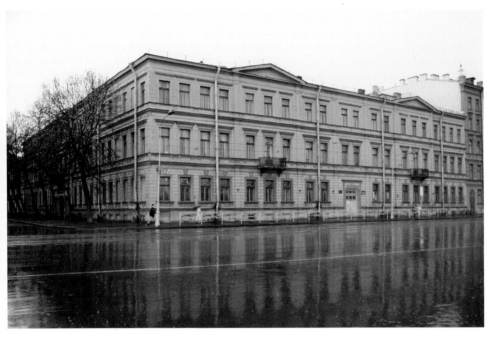

The Atkinsons' apartment block in St Petersburg

that he had a frame for each size, so could change them in a minute as he could for the illustrations for the first two volumes (was he really contemplating more?) of his work on Siberia, i.e. fifty-eight drawings completed. He humbly prayed that the Emperor would name a day when Thomas might submit them himself at the Winter Palace.[29]

Four days later he wrote to Tolstoy announcing that he had placed his pictures in the Winter Palace as instructed, and a month later (20 July) wrote again regarding the Emperor's 'gracious condescension to receive him' which he had hoped would be soon owing to the forthcoming coronation (in early September). He apologised for intruding at this time, and 'nothing but absolute necessity would have induced me to do so … I am no longer a young man and this work will still take many years to complete. This makes me count every month as it passes with intense anxiety.'

On 30 July he wrote again to the Tsar, thanking him for permission to submit his watercolours personally, but he now feared that the matter 'may have escaped your Imperial Majesty's reccolection' and hoped that the Tsar might permit Thomas to dedicate his book to him. Fortunately, that permission was forthcoming in early August, but he seems to have given up the hope of showing the Emperor his watercolours except after his return from London. He had expected every day to be summoned, and the moment he had the date he would, he wrote to the Baroness, prepare his departure, and prayed she would not deem

him ungentlemanly in mentioning his one picture bought by the Grand Duchess. 'This small matter [of 250 roubles silver] has no doubt escaped Her Imperial Highness' reccollection' and he asked the Baroness to arrange payment without giving offence and deeply regretted troubling her.[30]

In those two years in St Petersburg Thomas was in touch not just with the Romanov ruling family but with leading noble families, judging from two surviving letters, one from a Sheremetev, another from a Dolgoruky. In addition, Count Esterhazy of the old Hungarian noble family requested the pleasure of calling at the Atkinson residence with some friends 'in order to admire Mr Atkinson's Siberian album'.[31] An 'E. Liprandis', perhaps Ivan Petrovich Liprandi, 'secret service officer, major general of Spanish and Italian descent',[32] noted duellist and friend of Pushkin, sent Thomas four letters, so much gratified and delighted by 'your beautiful collection of pictures' that he wished to buy 'the Baikal View (the one by Moonlight which [we] admired so much)'; he sent Thomas 250 silver roubles, which he understood was the price, and on its arrival spent 'an hour admiring it'.[33]

One of the friends the Atkinsons made in St Petersburg was a young member of the small American colony, Andrew Dickson White, attaché for six months (1854–5) to the American Minister and later not only Minister twice himself but co-founder of Cornell University and its first president for nearly two decades. His St Petersburg journal has eight brief references to the Atkinsons – generally 'called upon' or 'dined with', but in his autobiography he was to write:

> As to Russian matters it was my good fortune to become intimately acquainted with Atkinson, the British traveler in Siberia. He had brought back many portfolios of sketches and his charming wife had treasured up a great fund of anecdotes of people and adventure so that I deemed for a time to know Siberia as if I had lived there. The Atkinsons had also brought back their only child, a son born on the Siberian steppe, a wonderfully bright youngster. He bore a name which I fear may at times have proved a burden to him, for his father and mother were so delighted with the place that they called him after it, Alatau Taur Chiboulak.[34]

On 19 August 1856, before he sailed for England, Thomas wrote to the British Ambassador in St Petersburg, Lord Wodehouse (later 1st Earl of Kimberley), sincerely thanking him for his great kindness in giving him letters of introduction to Lord Palmerston and Lord Clarendon, respectively. We do not know why he wanted them but 'I am sure they will be of great value to me'. He said he had packed up seventy of his pictures to take to London but would leave many in St Petersburg as Lucy (and presumably Alatau) would remain, and he intended to return 'by the last steamer in October'. If, he added, 'any of your Lordship's friends feel an interest in the scenery from these distant Regions my rooms are ever open to them'. And he took up the case of a compatriot, Mr [John] Gullett, 'who is

now doing much good to the people of Siberia by establishing these [unspecified] machine works', requesting the Ambassador to bring the affair to the Minister's notice at a more convenient period than the impending coronation, so 'rendering a very important Service to a most deserving and honest man'.[35]

We imagine that Thomas returned to England ahead of his family in order to expedite publication of his views or even his book, but he evidently failed, either on this or his final departure, to provide 'the usual formal Guarantee' for a passport and did not bring the sum required, despite a letter from Lord Wodehouse. He must have wondered what the future held for him back in his native land, after so many years, so many adventures so far away and so many watercolours: fame and if possible fortune too?

When the three returned together their, surely, considerable luggage would have included the big rolls of his paintings, the sketch-books of his many drawings, his journals, geologically interesting rock specimens, 'a variety of extremely beautiful vases and cut gems from Ekaterinburg', which would be exhibited at a scientific and literary party at the Royal Society, a *rubashka* or Russian peasant-style shirt and even a handsome brass samovar.

Hawk Cottage

Beaufort Street

Chapter Eight

Return to England

ON THEIR RETURN the three Atkinsons settled into Hawk Cottage, a 'ramshackle but picturesque residence'[1] in what was then Old Brompton on the western edge of London, with only fields and orchards to the north, today just off the busy Brompton Road. It was a two-storeyed cottage with a small garden and a palisaded fence on an unmade road. They took on one young maid, probably Helen Ryan if the reference which Lucy requested from her previous employer was good.

Thomas had been away for seven years, Lucy for sixteen (eight years with the Muravyov family and another eight with Thomas), and London was growing the while. In Thomas's lifetime, indeed, its population doubled from under one million to two and a half.[2] While he was in Russia Queen Victoria had come to the throne, the Crimean War had taken place, Britain's Corn Laws were finally repealed (1846), 1848 became known as the Year of Revolutions (eight in Europe) and the Crystal Palace had been built in Hyde Park for the Great Exhibition. During his long absence 'the writer of Thomas's entry in the *Dictionary of the Architectural Publication Society* killed him – on paper. And his reappearance in the doubtless foggy, smoky streets of London was a surprising resuscitation to many of his old acquaintants.'

Hawk Cottage
On their return to London the three Atkinsons settled into Hawk Cottage, Old Brompton, then on the edge of the countryside, now on the Brompton Road, where they were visited by (unknown) high-born Russians.

Opposite: Detail of map of Chelsea showing Hawk Cottage
and Beaufort St where Rebekah was living.

The first letter we know Thomas received on his return to England was sent on behalf of Lord Palmerston, the Prime Minister, writing from his estate at Broadlands in Hampshire on 8 October 1856, acknowledging Thomas's letter of five days before and thanking him for 'the offers therein made' (if we only knew what they were!), but could not avail himself of Mr Atkinson's kindness until his return to town.[3] Henry Blackett of his future London publishers, Hurst and Blackett, wrote the same month asking for the manuscript of 'Eastern [sic] & Western Siberia' by 1 January 1857 – hardly two and a half months ahead – although we don't know when Thomas began it. On its receipt they would pay Thomas £150 towards his proportion of the profits and produce the book 'in the most handsome and attractive manner [true], with elegantly bound copies for the Emperor of Russia and Queen Victoria', and later the same month for Lord Clarendon, Secretary of State for Foreign Affairs (who had been attaché in St Petersburg for three years). His private secretary informed Thomas by letter that 'The Queen will receive you at Windsor Castle to examine your drawings … tomorrow at 2.30 o'clock'[4] and it is likely that he presented one or more watercolours, but the Royal Collection has no knowledge of them.

His return thus got off to an astonishing start. The same month he went to Germany, according to a letter to him from Sir Roderick Murchison, President of the Geographical Society (Royal only from 1859, founded in 1830), taking books and letters to the latter's scientific friends including Alexander von Middendorff, of whom more anon:[5] 'I cannot express', wrote Murchison, 'how highly I have been gratified by making your acquaintance nor can I adequately express the admiration I entertain for such a traveler and such a delineator of the grand natural features of the heart of Asia as yourself.'[6]

Later that autumn the leading London gallery Colnaghi's put on a special exhibition of Thomas's Russian work which the *Art-Journal* called 'a most extraordinary collection of water-colour drawings.... We could fill a page or two...', but they did not, producing a very lame review, and sadly the exhibition was not a great commercial success.[7]

The following autumn of 1857 saw the publication of his first book, *Oriental and Western Siberia: A Narrative of Seven Years' Exploration and Adventures in Siberia, Mongolia, the Kirghis Steppes, Chinese Tartary, and a Part of Central Asia*, dedicated to Alexander II who rewarded him with a diamond ring. At 611 pages, it contained twenty well-printed lithographs, thirty-two wood engravings and a fold-out map of his route (not entirely accurate). It proved a great success and there was a second edition the following year, but it was an even greater success in America: it was published in New York in 1858 by Harper and Brothers, then in 1859 by a second publisher, J.W. Badley, in Philadelphia, going into seven editions. There was a Spanish edition but no French one, only an article in the *Tour de Monde*, and in Germany merely a lengthy extract in an 1864 travel anthology.[8] And, strangely, there was no Russian edition either then or since, other than a translation of that German anthology and one chapter translated only recently.[9]

The book brought him fame in his native land, not so much as an artist

but as 'the Siberian traveller', and paved his way into Victorian London society. The reviews generally greeted it with praise, but *The Times* in its review of over 6,000 words criticises its lack of information (not so, surely), 'the many tedious details through which the reader has to wade' (certainly the many landscape descriptions are verbose), the total lack of any year (agreed), apparently a four-year gap in the narrative between the end of one chapter and the beginning of the next, the lack of any latitude, longitude or elevation, and the silence on Russia's approach towards British India. Nevertheless, *The Times* condescended, its plentiful illustrations 'will find it a place in many London drawing rooms' and the average reader is recommended to read the last half first, 'much the best written'.[10]

Other reviews were distinctly more positive. *The Daily News* called it 'a book of travels which in value and sterling interest must take rank as a landmark in geographical literature' embellished by 'coloured illustrations and woodcuts of a high order'. *The Art-Journal* found it 'a most entertaining narrative', difficult to put down, and found national pride in the 'energy, boldness and daring of our fellow-countryman'.[11] *The Athenaeum* considered it 'an animated and intelligent narrative'.[12] *The Saturday Review* wrote that despite the 'somewhat monotonous descriptions', the disjointed style and imperfect English, this is a 'very remarkable work … most important, instructive, and amusing'.[13]

The Observer of 29 November 1857 wrote that no work of modern travel

> records greater energy or privations and dangers braved by a traveller determined to investigate for himself the physical peculiarities of an immense territory. What Livingston has done for Europeans in opening up Southern and Central Africa, Mr Atkinson has achieved in his seven years' exploration and adventures in Siberia, Mongolia, the Kirghis Steppes, Chinese Tartary, and a great part of Central Asia. His book … merits a place in every library and in every collection of works of travel.

And across the Atlantic the *New York Daily Tribune* gave it a long review starting: 'Few of the recent books of travel, which have attained such an extensive and well-deserved popularity, surpass this volume in rare and curious information, or in the combination of picturesque effects with solid intelligence.' It also included three long excerpts, praising the author's power of description, and concluded it was 'not only for the cursory reader, but entitled to a place in the libraries of the studious'.[14]

In January 1858, following its publication, Thomas sought election to London's Geographical Society. He was proposed by Murchison, the President (and founder member), from personal knowledge, with four supporting signatures, and was elected a Fellow. Murchison, with whom he was to have many dealings and who had preceded him to the Urals, was also head of the Geological Society, of which Thomas also became a Fellow, addressing it on the bronze relics he had found in a Siberian goldmine. Murchison has been described as 'imperious … ambitious, tyrannical, possessed of seemingly limitless energy and ego … [although he] could also be urbane and charming'.[15] Some of the same attributes

'Discussing the journey to Nor-Zaisan'
An incident in Thomas's first book: the two Kazakhs are wearing horseskin coats.

could be equally applied to Thomas, whose one-time travelling companion Charles Edward Austin had also returned to England and in 1858 joined both the Geological and Geographical societies as a Fellow. It is interesting in the latter case that, although Murchison proposed Austin similarly as a candidate from personal knowledge, the six seconders did not include Thomas.

That same year, 1858, started with the first of many letters from William Spottiswoode, outstanding mathematician and physicist, junior partner of the printers Eyre and Spottiswoode and future president of both the British Association and the Royal Society. He had returned from a 'very successful tour' in Russia which he wrote up as a book[16] and thanked Thomas for his 'very valuable letters'.[17] Thomas evidently had great charm, was much in demand in London society, and many people wanted to see his sketches. He was in touch with the great and the good, Charles Dickens for one, whose books in translation were immensely popular in Russia.[18] Thomas had written to him – Tolstoy's favourite author – and he replied to Thomas's 'very interesting letter':

> I have been deeply touched by your communication to me of the approval and good will of those unfortunate gentlemen among whom your wanderings have carried you [the Decembrist exiles]. If you ever see any of them pray assure them that I believe I have never received a token of remembrance in my life with so much sadness mingled with so much gratification.... God help them, and speed the time when their descendants shall speak of their sufferings as of the sacrifice that secured their own happiness and freedom.[19]

The embossed cover of *Oriental and Western Siberia*
Thomas's first book (1858) was dedicated to Alexander II; making his name as
'the Siberian traveller', it launched him into London society and election into the
Royal Geographical Society and Geological Society.

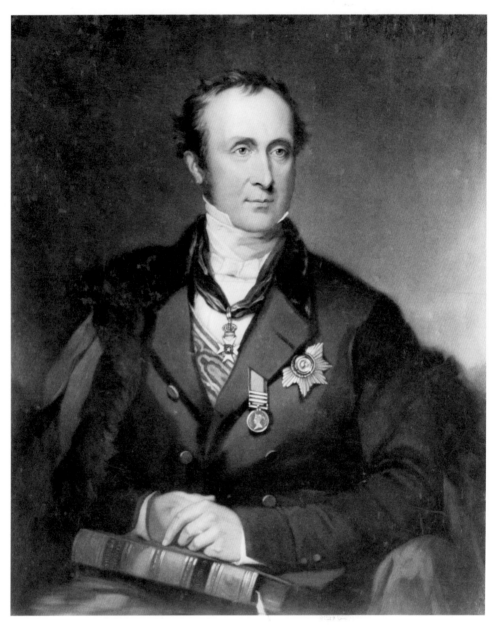

Sir Roderick Murchison, four times President of the Royal Geographical Society

He also heard from Thackeray, another other great literary figure of the time, to whom he had sent one or more manuscripts which unfortunately were mislaid.[20]

A well-known English artist of that era, James Duffield Harding (1797–1863), thanked Thomas for the 'very handsome vol.' of his travels, and said, 'It is strange that from unexplored fields in the frozen and torrid zones we should simultaneously have such travellers as you and Dr Livingstone.'[21] And after Thomas shared a platform with Livingstone at the RGS, the *Illustrated London News* headed its report 'The Travellers Atkinson and Livingstone', which must have greatly pleased Thomas. Evidently his name was put forward to receive the RGS's Gold Medal of 1858. But Colonel George Everest, the first Surveyor-General of India, after whom the world's highest mountain is named, for one did not approve: 'although his merits as an artist are unquestionably great, yet as a geographer they are of little or no account'.[22]

And the same month Palmerston's Private Secretary sent thanks from Downing Street for Thomas's letter with its account of 'your work on Siberia'.[23] Lord Clarendon, via the Foreign Office's Assistant Under Secretary, T.V. Lister,[24] thanked Thomas for his 'most interesting work' and advised him (re Thomas's query) to forward a copy of his book to the Tsar through the Russian Legation in London; he said he would consult Queen Victoria and Prince Albert about Thomas's offer to present them with copies of his books in person. Lister added that he was himself reading the book with great pleasure.[25] Sure enough, Thomas was invited to Windsor Castle in late December to present 'the elegantly bound copy' of his first book to the Queen and Prince Consort[26] – his second meeting with the monarch.

The same month of December Thomas was invited to the Geographical Society's very select Club Dinner,[27] as there was much interest in his book and many requests to see his watercolours. Lister of the Foreign Office, for instance, had a friend, both architect and watercolourist, who 'expressed … so strong a desire to see your drawings & sketches that remembering the pleasure & interest they afforded me' he hoped he would be allowed to see them.[28]

Early in 1858 Spottiswoode, who was to print Thomas's second book, sent him two requests from his friends to see his sketches, and Francis Galton, scientist, explorer, founder of eugenics[29] and cousin of Charles Darwin, later knighted and FRS, sent a homely invitation to both Atkinsons to dine.[30] The Rev. Charles Kingsley, author of *The Water-Babies*, *Westward Ho!* and other books, thanked him 'much' for his 'splendid book' which he was shortly to review,[31] and Thomas answered Kingsley's queries including one on the population of Central Asia which he 'was fully persuaded [was] on the increase, that is when you reach the plains of Mongolia beyond the influence of Russian Brandy. This has been more fatal to the Tribes than Gunpowder.'[32]

There was a sizeable correspondence with Henry Blackett which included a request for a note of introduction to Faraday, the famous inventor and electrical pioneer,[33] and there was a query regarding the northernmost latitude at which he had met the 'Bearded Vulture' (or lammergeier, *Gypaetus barbatus*).[34] His answer was approximately 44 degrees latitude in the Alatau mountains.

In June 1858, more than a year and a half after their return, there was a first sale of his watercolours at Christie's –perhaps he was waiting for publication in the hope of better sales. Of the sixty-three 'watercolour drawings' only half were sold, which must have been a huge disappointment. Three more sales at Christie's followed across three years (1861–63) of nineteen watercolours – some repeats from the first sale and a few new ones – plus the original drawings for his two books: all apparently unsold. This was even more disappointing, particularly because of his success otherwise. But, as was pointed out, the unknown landscapes were not very likely to appeal to people who would never see them in person and to whom they would mean almost nothing.

In September 1858 John Arrowsmith, the cartographer who had produced the fold-out map for Thomas's first book, returned the rough drawing of his map for his second book and sends his 'kind remembrance to Mrs Atkinson'.[35] That month Thomas spoke in Leeds twice at the British Association for the Advancement of Science on the volcanoes of Central Asia, 'illustrated by a beautiful series of drawings', and on a journey 'through parts of the Alatou in Chinese Tartary'. And the next month the Leeds Philosophical and Literary Society, 'naturally proud of their Country man', invited him to lecture. He accepted with much pleasure but wrote that he had hitherto

> resisted all attempts to bring me before the public in such a capacity [as a writer] and many have tried in vain. I have a great dread of making myself ridiculous or appearing egotistical by relating matters connected with my wanderings. However my first effort will be in my native county [yet he had only just spoken twice in Leeds] and I can only hope that the good people of Leeds who listen to my description of the regions and people so little known will let kindness govern their criticism [a surprising touch of false modesty].[36]

In January 1859 Thomas was unanimously elected an honorary member. He deemed it an honour 'to be associated with a society of yours and such men in my own native county' and it was 'some recompense after the years of toil besides which it makes me feel that I have added a few scraps of information to the knowledge of my countrymen'.[37]

In October he was invited by the Ethnological Society of London[38] to read his paper 'on the migration of the Kirghis [Kazakhs] through their Mountain Passes to their Summer Pastures', a 'very personal, non-scientific account' which he had read at the British Association in Leeds (under a different title). More significantly, that month Lord Clarendon, the Foreign Secretary, surfaced again, happy to receive Thomas the following Monday (10 October 1858) – to discuss Russia's advance?

In December Spottiswoode invited Thomas to hear the new President of the Royal Society speak, reminding Thomas that he had offered to make a drawing of one of Spottiswoode's 'Eastern sketches'. Although he knew that

Thomas was much occupied in writing his second book, he might 'sometimes like a little change of occupation' and would be pleased to pay £50 for it.[39]

In January 1859 Thomas was proposing to sell his watercolours at Colnaghi's, but his publisher Blackett warned him against this, advising him (it turned out wrongly) that in May and June instead he would be 'certain to find a sale, they [his works] are unique, no one has trodden this way before',[40] and he proposed at the end of the month to give Thomas £100 for his projected work on the Amur ('two slight volumes' at this time), sending his kind regards to Mrs Atkinson. A note in February from Lord Clarendon's office sent his 'best thanks' for his copy, which 'he will read with very great interest'.[41]

That month he was invited to the House of Commons to address committees on two successive days: first by William Ewart, MP and humanitarian reformer – asked to choose his subject, he opted appropriately for Russia's penal system[42] – and secondly by the Colonisation & Settlement India Committee chaired by Ewart,[43] which questioned him on the commerce and products of the regions he had visited. A year later Ewart thanked Thomas[44] for showing his daughters his 'interesting drawings' and was to write again, inviting Thomas to dinner, as he was about to speak in the House of Commons on Britain's trade with Central Asia and Russia's competition there and wanted some facts.[45] As for the prestigious Royal Society, among the most important exhibits at a scientific and literary party at Burlington House (then its headquarters) was 'a variety of extremely beautiful vases and cut gems from the imperial establishment of Ekaterinburg, in Siberia, exhibited by Mr Atkinson'.[46]

In March Blackett asked if Thomas had given consideration to 'a work on the Amoor [Amur]'[47] and in May asked him to see Captain Speke (John Hanning Speke, 1827–64, the famous African explorer), ideally as soon as possible as he had just returned from discovering and naming Lake Victoria, and Blackett feared he might publish elsewhere.

There were other public appearances at a lower level; for instance, Thomas offered to exhibit some Siberian sketches to north London's Hampstead Society and answer questions, and was inevitably invited to talk about his travels.[48] Many (undated) friendly invitations came from Admiral H.T. Murray, an illegitimate son of William IV (according to the adult Alatau), living in Albany, an exclusive address off Piccadilly.[49] The invitations were inter alia to meet Burton, of Central Africa fame, and the elusive Captain Pim, whom the Atkinsons had been expecting in vain in Irkutsk.[50] And an invitation to dinner came from another Murray and his wife: John Murray, the best-known publisher of the time, who had made his name (and fortune) with Scott and Byron. Then on New Year's Day 1860 Windsor Castle informed Thomas that the Queen had permitted him to dedicate to her his work on Central Asia.[51] This Yorkshire village lad could hardly have done better than dedicate, with their permission, his first book to the Emperor of Russia and his second to the Queen of Great Britain.

The aristocracy entered the scene too. Thomas wanted to see at the War

Department Earl de Grey and Ripon (elected president of the RGS in 1859 and, as amateur architect, first president of the RIBA, 1835–59).[52] We do not know the reason for that visit, but they must have at least touched on architecture. The Earl marked his 'high esteem' for Thomas by sending a cheque for £25 for any drawing that he would choose 'which I shall always value highly'.[53] He later felt confident that he would be 'greatly pleased with the drawing. I like the subject you have chosen very much',[54] and the next year (1860) he 'gladly' accepted Thomas's offer of exhibiting his 'drawings' at the Earl's Geographical Soirée.[55] Lord Ashburton, President of the RGS between two of Murchison's presidencies, invited him to dine, bringing a portfolio of his sketches; Lord Somers was 'very anxious to see his drawings',[56] and the 3rd Earl of Ducie sent £90 for his two.[57] Conceivably Ducie may have planted some Siberian species, obtained from Thomas, at his home, Tortworth Court, near Bristol, then noted for its worldwide specimens. In 1860 the Duke of Manchester[58] (who had ordered Thomas's second book) was keen to invite both the Atkinsons to his castle (Kimbolton), although it was never to happen.[59] And Russian aristocracy appeared on the scene, including Prince P.E. Dolgoruky (descendant of the twelfth-century founder of Moscow),[60] whom he had probably met in Russia and to whom, for reasons unknown, he had sent (to Revel, now Tallinn) '200 lb silver' – very odd.[61] On one occasion[62] Mr and Mrs Atkinson were invited to an exhibition, so once again she was not excluded totally from what was basically a man's world.

Thomas's publisher Blackett believed that the interest in Thomas's second book would depend on the information about 'the Amoor', which so far (late April) he had totally omitted,[63] and he was increasingly concerned about the incomplete manuscript, writing on 8 May that 1 June was 'the very latest time the book should appear'.[64] By 12 July everything was finally ready except the map which was 'fast driving me mad' (Blackett to Thomas).

But the book was out by the end of the month.[65] *Travels in the Regions of the Upper and Lower Amoor and the Russian Acquisitions on the Confines of India and China*, a sequel to his first, successful book, bore on the title page after his own name the initials 'F.R.G.S.' and 'F.G.S.' plus 'Author of *Oriental and Western Siberia*'. There was a long subtitle, too. Having presented papers to learned societies and been elected to two of them, he included those initials, aspiring to be seen as more than an artist and travel writer and indeed downgrading his first book as 'nothing beyond a narrative of incidents and observations … to explain and illustrate pictorial representations'. Now, 'the higher interest of the subject has induced me to attempt to produce information of a more elevated character … [for] the Geologist, Botanist, Ethnologist, and other scientific scholars…'.[66] The book went into a second edition the following year, trading off the success of its predecessor, but it was a curious and rather unsatisfactory book in many ways. Despite the main title, only the last five of the nineteen chapters refer to the Amur, almost entirely written in the third person, so the reader may well wonder if this really is a personal description. And once again Lucy and Alatau

were totally omitted; a wife would have been bad enough, totally inconsistent with such macho travels in perilous places, but a baby was unthinkable!

In his first chapter, Thomas explained that recent Russian acquisitions in Central Asia stretched out 'far towards the Himalaya; and in 1857 that vast tract of country, the valley of the Amoor [was] said to have been ceded by the Emperor of China to the Emperor of Russia'. What had been published 'in the public prints', however, 'had no foundation in fact', there had been no reliable description of the area and 'no recent traveller, it was believed, had penetrated [it].… In short … it was a *terra incognita*'.[67] But, as he 'had passed several years exploring this remote portion of the globe' (true perhaps of Siberia and Central Asia but not the Amur) and was the only European who had been permitted to enter the new Russian territory (true again of Central Asia except for Austin and, of course, Lucy – Alatau had not entered it, strictly speaking, having been born there), he concluded that his wanderings might be 'of some interest' to his countrymen.

He pointed out the economic significance of this huge addition of territory – 'incalculable' mineral wealth and a 'prodigious' amount of agricultural produce. But his optimistic predictions were too early to be sound: West Siberia was to prove far more significant both economically and agriculturally. And he stressed that as Russia had 'now very nearly approached the possessions of Great Britain in India' it would not be unreasonable to expect, considering the speed of Russia's advance 'in the East', the desire to expand south, and 'a further stride across the Himalayas to Calcutta' might seem inevitable to 'the English statesman', although Thomas was careful to stress that there was no proof of such intention.[68] Nonetheless this was the age of the so-called 'Great Game': the rivalry between Russia and Britain for parts of mainland Asia. Thomas's first-hand information would certainly have been of interest to his own government, but he was hardly a player; he had his own artistic agenda.

His first fifteen chapters take us back to Kopal and the Kazakh steppe, the elopement of the young Sultan Suk's intended and her tragic fate (two chapters' worth), and, basically, overmatter from his first book. This one is enlivened by his first chapter: reports reached Barnaul that, first 3,000, then 7,000 and later 10,000 'Asiatics' were invading West Siberia, rapidly advancing, and furthermore that they were led by Atkinson himself. It was said that some towns were defended, others deserted and many troops despatched, but the whole thing was an absurdly inflated myth, based on the escape of forty Circassian prisoners from a Siberian goldmine. Yet was it true at all?

The Athenaeum gave the book eight and a half columns including several long quotes, and felt that 'The entire volume is admirable for the spirit, unexaggerated tone, and the mass of fresh materials by which this really new world is made accessible to us'.[69] The *Literary Examiner* of 28 July 1860 believed

> his activity seems indefatigable … and he is of all Englishmen, probably of all men, the one who knows most about the remote Asiatic

tracts to which he has devoted his entire attention. His enjoyment of life and adventure among the encampments of the great horde of the Kirghis Tartars is delightfully fresh, and gives vivacity as well as accuracy to all his descriptions.

Even if some reviews were critical there was a positive note from Lord Palmerston's secretary at 10 Downing Street at the end of July 1860, sending his 'best thanks for the highly interesting work on the Amoor', and another note of thanks from Gladstone, the future Prime Minister, thanking Atkinson 'very particularly' for sending him his new work on the Amoor (*sic*). 'I do not doubt from your high reputation but its matter … is in due keeping with the importance of the subject and the beauty of the form'.[70] Thomas's hope of presenting his book personally to Queen Victoria (to whom it was dedicated) came to naught as she was 'much occupied' with her departure to Scotland, so he was asked to send it instead,[71] and within three days received thanks from the Queen and Prince Albert 'for his valuable and interesting addition to their libraries'.[72]

However, Thomas's health had now started to decline and in August Blackett was 'exceedingly glad to hear the change [probably to the South Wales coast] is doing you good' and hoped that he and 'Mrs Atkinson' – the customary appellation – 'will take in a good share of health and strength for the winter'.[73] In September, however, he wrote to say that Thomas owed him altogether £112 12s 5d for his first book (where had all the money gone? free copies? living the life of a gentleman? had he forgotten his imprisonment for debt many years before?), the Amur book had not yet paid its expenses and, happy though he would be to grant Thomas a further advance as requested, 'some limit must be put upon advances'.[74]

But that September John Spencer Stanhope, the squire of Thomas's native village, Cawthorne, wrote from Cannon Hall where Thomas's father had been stonemason and his mother housemaid, thanked Thomas for his letter and 'splendid book' which he would read with much interest, was sorry to hear of his health problems and hoped for his speedy recovery. Thomas was thinking of a visit to shoot, and Spencer Stanhope hoped to be at home to receive him although 'we have scarcely anything to shoot at'.[75] The squire's younger brother, the Rev. Charles – Thomas's supporter all his life – wrote to thank him for the very handsome volume ('much more interesting than the first, as the area covered is more unexplored'). He valued the present from the author who 'does not forget an old friend who knew him in his low estate. I honour you the more for your true [nobility] in not ignoring your origins.' He also invited Thomas to stay (in Weaverham, Cheshire, where he was vicar, and there *was* much game) and was sorry to hear of his health.[76] Thomas did stay, they went hunting together that autumn[77] and then went on – Thomas an honoured guest – to Cannon Hall, which led to Thomas's proposing the son of his host, the squire (a great traveller in his youth and Thomas's inspiration), for election to the Royal Geographical Society – a true reversal of roles.

Thomas was the chief speaker at Cawthorne's harvest festival,[78] where he was

'very warmly received' by 'the large assembly' and presented a signed copy of his second book to the village library.

> A slight *contretemps*, however, marked this visit. Walking in Cawthorne shortly after his arrival, Atkinson encountered one of the cronies of his youth. The man who had passed his life in the same little trivial round in his native village failed to grasp the gulf which now separated him from the man of European reputation, the great architect, the great author, the world-wide traveller, and the acquaintance of an Emperor. Clapping his old comrade heartily on the back, this friend of a dead past hailed Atkinson with the approving, if somewhat tactless comment, 'And soa, lad, you've cum back to lay yor ould bones amōōng ous!' Atkinson, it is said, failed to appreciate the familiarity of this typical Yorkshire welcome, and did not again honour Cawthorne with his presence.[79]

He went on with the Rev. Charles to Earl Fitzwilliam's Wentworth Woodhouse in south Yorkshire, reputed to have been the largest privately owned house in Europe,[80] where he was the 'lion of the evening' at one of its great dinners, and to other country houses.

Arrowsmith wrote in early October, very sorry that Thomas was not gaining strength as fast as anticipated, and hoped that a little dry weather would help him greatly. In November Spottiswoode wrote again, very glad to hear that Thomas had arranged with Longman's for the publication of a third work (probably about the Decembrist exiles).

Despite the state of his health, Thomas was planning a second trip to the north in late November, invited to Yorkshire country houses, if not stately homes: among them Farnley Hall, where J. M. W. Turner was a frequent guest for almost twenty-five years.[81] He does seem to have gone to the north, but on his return to London was taken 'very ill' and Christmas was his worst ever. The doctor wanted to send him to a warmer climate, but funds would not permit. However, Cawthorne's squire did send him a box of ham and some famous Cannon Hall grapes, and another Yorkshire friend sent a turkey and some Yorkshire bacon by train to be enjoyed on Christmas Day. He was thanked for sending in return two photographs, one of 'yourself and your dear Alatau', the other an 'interesting photograph of Alatau's birthplace' (does that still exist, and who would have had a camera there in the 1840s or 50s?). The Rev. Charles wished (by post) the three Atkinsons a happy Christmas – and wrote again in February 1861, having heard nothing and impatient to know if Thomas's health was improving. Then, 'very much grieved' to hear that it had worsened, he offered to get him a cottage on the Isle of Wight and suggested different medicines.

Blackett wrote twice, once to say 'very glad to hear of your presentation to Her Majesty' – so did he present his second book in person after all? – and secondly to say that the final advances of £30 and £70 were brought forward; Thomas now had a credit of £7 14s 1d and, having carefully considered the question of buying his remaining interest in the two books, he was happy to settle for 100 guineas.

In May Lucy wrote to the Rev. Charles on his behalf saying that it has become 'one continued and painful illness – he is now reduced to a complete skeleton, having had so many drawbacks to his recovery', particularly when thrown from an omnibus on to the pavement, breaking one rib and injuring two others, which their doctor said, 'not another man in ten thousand would have survived', followed by a severe cold. Thomas asked her to write that at present 'he appears to be of no earthly value to anyone excepting … Madame Tussaud, and provided she would pay the price he would have no objection to being exhibited as a living mummy'. She added that Thomas had received 'another splendid ring' from the Tsar, a large emerald set in diamonds, a mark of approbation for the volume on the Amur.[82]

With Thomas's health deteriorating, he and Lucy finally left London for some sea air – and a hoped-for return to health – on the east Kent coast at Walmer, where they lodged in a modest house on the front. (Lucy's great-uncle and benefactor, Joseph Sherrard, who had voyaged to Australia, the Pacific and Latin America in the Royal Navy, had died in Walmer in 1835.)[83] In early September Lucy wrote to the Rev. Charles:

> For months past I had been anxious about him, and when we had to leave home for the sea side, I felt loth to quit my home. Arrived at Walmer, we had a most comfortable and pretty lodging, facing the sea. Here he had the sofa drawn to the window where he used to lie and watch the beautiful vessels passing to and fro; – he appeared so happy gazing on England's wealth. Then I used to lead him down to the sea-beach and there he, stretched on a mattress, dozed away his days. When awake I read to him, and all went on well; still I knew he was growing daily weaker: his step became heavier, and he leaned with greater weight upon me. At length we were compelled to call in a doctor, and he urged the necessity of staying indoors altogether, but before this I must tell you the very great interest he excited in everybody: the poor sailors and fishermen used to look upon him with such pitying eyes, and as he passed near a form on which some of them sat they would rise to allow him to pass. Even the little children, when they had perceived he was asleep, would pass by on tiptoe. One fine little fellow not four years of age, with beautiful dark Italian eyes, came to me one day and asked if the gentleman was very ill. I answered that he was ill; he looked very searchingly into his face, and then went and laid his head down beside him on the pillow. I could but look and think what a beautiful *facsimile* of winter and spring; there was the opening and closing bud – the one leaving the world, and the other just entering upon it; instantaneous came the thought, which is happiest, he who had fought the world's battles, or he who was just about encountering them? …
>
> Reluctantly I abandoned our short walk; then came the time when he could no longer, even with my aid, walk to his bedroom. Then I had a sailor to carry him. You should have seen the honest rough fellow take

him up as if he were a baby; and then when he laid him down, it was with such a look of sorrow and pity, he would say, 'I *wish* you better, sir.' I quite loved that man. Then came a time when he could no longer wash himself, for long I had dressed and undressed him; then came the day when he would have only a dressing gown on; then that was cast aside on his last day. On the night before he left us I watched and never supposed he would see daylight again, and yet his sleep was calm and beautiful; he awoke about every half-hour, and then the breathing was very heavy, and the incessant ais! ais! but he never once murmured – not a sound passed his lips – he was perfectly collected, his mind never wondered for a moment. I had never been near the death-bed before – but there was that about him told me he was not too long. When daylight came I sat down on the bed beside him and ventured to tell him that it might please the Almighty to take him, but he seemed so tenacious of life and so hopeful, I thought perhaps he feared death. I asked him, but he said very mildly and gently, 'I *hope* not.' He became very anxious to leave his bed, after I had talked with him some little time. I had him carried to his sofa; I could have carried him, but he would not let me – his sorrow always was that I had so much to do for him, and yet he never liked me to be out of his sight a moment. He appeared all the morning to be in deep prayer, he had his hands constantly clasped; once he asked me to raise him; I placed him in a sitting posture. He then asked for the middle and side windows to be closed, and the blinds drawn down; he looked to the east, clasped his hands, and I for the first instant thought he was amused with the vessels – but I shortly perceived he was in prayer – he remained thus for a quarter of an hour, and then asked to be laid down. I did so, – then he asked for all windows to be open, and the blinds drawn up. At this moment the sun shone forth, and with a smile he said, 'What a beautiful glim of sunshine.' Ten minutes before he quitted us he enquired for the doctor; I told him I had sent for him. I was kneeling beside him when I saw the change come over him; he tried to speak, but could not. He then as I held his head fixed his eyes upon me, and so passed off into eternity like an infant closing his eyes for sleep, – there was no struggle – so calm, so placid, and so beautiful he looked – there was no pallor of death – the hands to the last were just as when living – it was the forehead which was so marble like. Poor Alatau – my heart bled to see my child – he and his father were such good friends. I was obliged to put my own sorrow on one side to comfort my child....

Yours very sincerely

Lucy Atkinson[84]

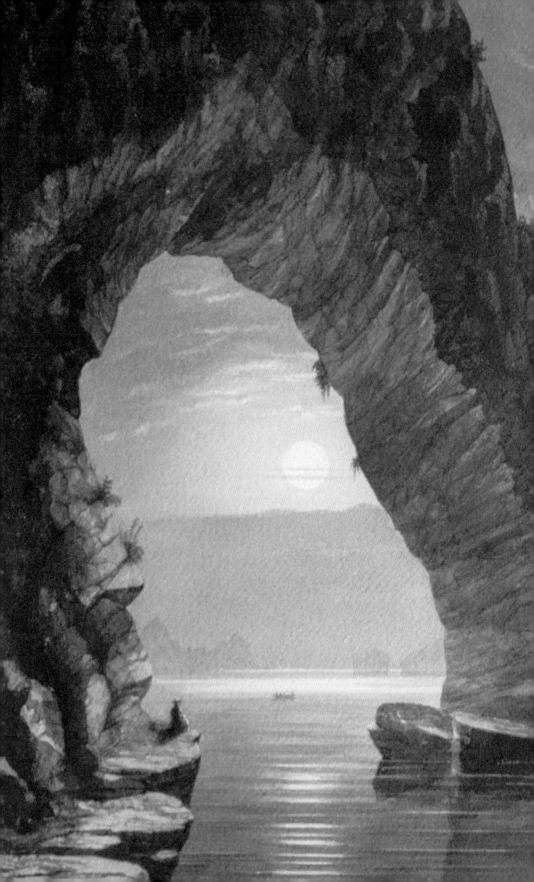

Chapter Nine

Lucy and Alatau

THOMAS DIED ON 13 August 1861 (the year Prince Albert also died) from 'atrophy of the stomach', atrophic gastritis or chronic inflammation of the stomach's mucous membrane layer. The funeral was in the little old church in Walmer.[1] Thomas was buried in the quiet graveyard, with no stone then or since to mark his passing or his remarkable career. And today it is not known exactly where he lies. Perhaps his was indeed only a pauper's burial.

Lucy returned to widowhood in London and had the consolation of reading some of the laudatory obituaries of her late husband. *The Critic* wrote of 'The great traveller whom we have lately lost' and the long *Times* obituary (2 September) noted that:

> The story of Atkinson's life will probably never be precisely told; … but could the biography be written, it would be found one of the most curious and thought-suggesting.… Atkinson displayed in the course of his wanderings great power of endurance, and much address; so that his works have added important particulars to the knowledge of Russia and Asia.… The distances which he occasionally traversed in a single day … were extraordinary; and during the whole of his travels he seems to have never lost a chance of recording what he saw with pencil, colours, and note-book.… No Englishman was better acquainted than he was with the fact of the progress made by the Russians in the direction of India or more competent to give an opinion on [relevant] questions.…

He was, declared the *Annual Register* for 1861, 'a traveller of much celebrity' and, starting from

> very humble parentage … was entirely self-taught … [and] became a ready draughtsman and a pleasing writer. To these he added a considerable scientific knowledge, and a manner so gentlemanly and winning, that none whom he encountered in his travels or at home could suspect the roughness of the original material. With such singular powers Mr Atkinson was certain to rise.…

And in the same vein Joseph Wilkinson, quoted in *A History of Cawthorne,* p. 215, noted:

> If it be a noble thing to add to the stock of human knowledge, Atkinson

Opposite: Detail of watercolour p.215

had gained a high degree of glory. He was in the truest and best sense a self-made man. Those who met him in later years in the drawing-room or country-house, were struck by his undefinable grace and bearing, which are sometimes thought to be the monopoly of ancient race.

The Critic of 14 September under 'Art and Artists' devoted about eighteen inches of small-print columns to his architectural career, largely based on *The Builder*,[2] and observed that 'No man was ever more successful in making friends'. It also noted that he had been reported as dead by an architectural dictionary (see Chapter 8).

The Art-Journal of October should perhaps have the last word. It wrote that

> A remarkable man was Mr Atkinson – one whose name will take a high rank among great English travellers…. The difficulties, dangers, and deprivations he encountered on his travels would have deterred a man of less energy and perseverance than himself from proceeding; but he encountered and overcame all, returning eventually to England with a large store of geographical and geological information, and an immense number of valuable water-colour drawings, many of large size,

and his two books 'form a valuable addition to our standard geographical literature'.

But there were major traumas ahead for Lucy. The first was that, although Thomas left very little money, it was not to come to her. When she applied to the Treasury for a pension apparently due to Thomas[3] she 'was met by the astounding assertion, backed by abundant proof, that she was not legally his wife, inasmuch as he had been married before he went to Russia to a lady who was still living in England'. Why no claim in his lifetime, considering his very public figure? The reason, according to Francis Galton (later Sir Francis Galton, FRS), who was to prove a good friend of Lucy's,[4] was that

> no news of him had reached the claimant, who occupied a different grade of society, until a friend of hers told her of his death. This tragic termination affected many of us greatly. We recollected that Atkinson had avoided bringing his wife (as we thought she was) to the forefront, and it had been remarked at the time of the publication of his book of travels that he made the scantiest references to her, and never used the word 'wife'. It was a wonder, and it is so still, how he dared to settle in London and risk a serious criminal charge [indeed prisonable]. Friends gathered round Mrs Atkinson, as I must still call her, and helped her in many substantial ways.[5]

In October, letters of administration, in the absence of a will,[6] were granted of the 'effects under £300' (today, astonishingly, £32,700)[7] to the 'lawful widow

and relict', Rebekah Atkinson of 5 Beaufort Street, Chelsea, where she had been living for ten years in the house of a widow and her children. The previous census ten years before had listed her there as 'Visitor', married, aged fifty-four, but the 1861 census now listed her as a boarder further along the street at No. 56, with her occupation given as 'Private' which meant, surprisingly, existing on private means. She was listed as 'Assistant' to the head of the house, Mary Anne Palmer, 'Boarding House Keeper', and Thomas, Lucy and Alatau were all listed in the same census as living in Hawk Cottage only 1.4km away, in a much smaller city than today. Thomas's estate was to be re-sworn in March 1863 at under £20.

As for her two daughters by Thomas (who had seemingly deserted the family, taking John with him), Martha, the elder, had married a solicitor, James Wheeler – with Thomas indeed as a witness – and had a son and three daughters. Wheeler had become a prosperous railway solicitor to, among others, the Trent Valley railway of which, curiously, Thomas Gooch, present at Thomas's death and also FRGS, was chief engineer. Emma, the younger sister, remained unmarried and was always to live with Martha.[8]

How could Thomas have been so deceitful after all he and Lucy had gone through together? He was surely a real romantic, detached from reality and able to shut the matter out of his mind except when he realised it was too risky to mention Lucy and Alatau in either book. The other reason to omit them must have been that travelling with a wife and small child would greatly diminish the intrepidity of his extraordinary story. Did Lucy tacitly accept her – and Alatau's – omission from both books for that reason? And Thomas also had an odd sense of time: over-conscious of the times of departures and arrivals and the length of journeys, but totally blind to the passage of days or indeed weeks, and – astonishingly – prepared for even more years of Russian travel. He was blind, too, it seems, to questions of money, and how they afforded it all remains a mystery.

It was a double shock for Lucy: bad enough for her to discover that her husband of thirteen years and the father of her child was a bigamist and had never told her after all those years of travel together; and then to find that any money he had would go to the first wife. She was left virtually penniless, and there was no more money to come from either book following the settlement with Blackett, the publisher. And if only half of the Christie's watercolours had sold, there was little hope there. Fortunately, however, Murchison, now Vice-President (between two of his presidencies of the now Royal Geographical Society), was to be of crucial help to both her and Alatau at this very difficult time. In September, barely a month after Thomas's death, he began to solicit funds to educate Alatau when he spoke in Manchester at the meeting of the British Association for the Advancement of Science (which he had helped to found). Atkinson's published volumes, he said, 'had been received with much approbation by the public, and had been read with much avidity' and he 'knew of no traveller that had penetrated where this remarkable man had been', adding, 'In his travels he had a spirited wife who accompanied him throughout' and, as (now) Vice-President of the RGS, he said it was his duty to appeal to the public

to establish a fund to educate his son, 'that fine boy', 'born in such a remarkable spot' and 'bearing so remarkable a geographical name' so that he should … 'prove equal to his father'.[9]

In the RGS archives there is a long, handwritten list of sixty-five subscriptions dated 20 January 1862 totalling £291 1s 4d to the 'Atkinson Fund' for Alatau. Murchison heads the list (almost all are FRGS), with the donation of £20 (£2,231 today) followed by many names of the great and the good including George Bentham, botanist and President of the Linnean Society (and son of Sir Samuel Bentham, brother of the philosopher Jeremy, who had an interesting Russian career himself), Sir William Hooker, director of Kew Gardens, William Fairbairn, the President of the British Association, Francis Galton, John Murray, the leading publisher of the time, Speke, the African explorer (surprisingly, not FRGS), four earls and a duke. In the event, nearly £360 (£40,000-odd today) was raised altogether.

By November 1861 Lucy and presumably Alatau had moved from Hawk Cottage to 9 Lilly Terrace, New Road, Hammersmith (now 71 Goldhawk Road).[10] On 11 November she wrote on black-edged paper to the poet and politician Richard Monckton Milnes, later first Baron Houghton, well known in his lifetime for his acts of kindness:[11]

> Pray receive my heartfelt thanks for the kindly interest you have taken in me.… We [Mr Humphrey, her solicitor, and herself] find Mr Wheeler [Rebekah's son-in-law] has deceived in one thing – he sent a paper to me, demanding in the name of Mrs Rebekah Atkinson that everything should be given up to her – she having taken out Letters of Administration, wheras she had done nothing of the kind.…
>
> I earnestly beg of you not to think my husband guilty – he was too good a man to deceive me.
>
> … [Thomas] was the kindest and gentlest of husbands, and the best and tenderest of Fathers. I hope one day to be able to present Alatau to you, and you will then judge what a Father he has been to him – a bad man would not have brought him up as he has done.
>
> I beg of you not to alter the former opinion you had of my husband.…
> It is cruelty to attack a man when he cannot defend himself.…[12]

But Lucy had finally to accept that the story was true.[13] She was, however, very lucky to have had the support of Murchison who appealed on her behalf – countersigned by well-known names of the time – to Palmerston, the Prime Minister.

There was, however, a third trouble awaiting her. The title of his second book may have been foisted upon him by his publishers, but the awful truth is that he never got to the Amur at all, although the frontispiece illustration from one of his watercolours portrays 'A view on the Amoor west of the Khingan Mountains'. In fact, the Amur begins only at the confluence of two rivers due *north* of the Khingans. What were his motives for this deception, which fortunately did not

come to light till after his death but was to become common knowledge before the century was out?[14] It is likely that his rise to fame, thanks to his first book, as well as his rise in society, went to his head and Lucy did not want to dissent. But his main motive may simply have been lack of money and encouragement to write about the Amur as of particular interest at the time. While his first volume is deliberately sparse on dates and the chronology very distorted, we know that the Atkinsons returned from Russia by December 1857, as he was writing then from his publisher's address in London, and there is no mention of any Amur travel in his journals, all dated.[15]

And while his first book has a map of their extraordinary Russian travels (admittedly badly drawn), the second has a map of the Russian Empire but no route at all. It is, unhappily, an unsatisfactory sequel to his first book in other ways too: a strange combination of subject matter – material left over from his first book including the long story of the elopement of the young Sultan Suk and his love, whom we have met in the first book, and its tragic end. The Amur and its tributaries are not touched upon till p. 405, with a lengthy topographical and historical description of the area, almost entirely impersonal, and finally a long appendix of the fauna and flora of the Amur region. It is a very interesting area, certainly, and unique as the world's northernmost monsoon forest, with its distinctive ecosystem, but Thomas's is a compression (it emerged after his death, fortunately) of the far more detailed scholastic tome compiled after the naturalist, geographer and teacher Richard Maack's expedition, published in St Petersburg in 1859 under a long title beginning *Journey on the Amur*.[16]

Inserted in the London Library's copy by its former owner J.F. Baddeley (1854–1940), British scholar and author who knew Siberia and the Russian Far East, is his pencilled comment – a very bald statement – that from p. 406 'to the end is simply stolen from Maack and then without acknowledgement. Atkinson himself was never near the Amur.' And the lengthy subtitle is, regrettably, a plain falsehood announcing his 'adventures among' seven peoples of the area including the Manchus, Manyangs and Tungus.

Thomas's ostensibly impressive Appendix consists of five pages of lists in Latin and English starting with the 'Mammalia in the valley of the Amoor' divided into Upper, Middle and Lower Amur, followed by birds, trees, shrubs and flowers. Then he proceeds on the same basis as regards the Kirgiz steppe, Alatau, Karatou and Tarbagatai as a separate section (though why should they be listed in a book on the Amur?) and the same for 'the Trans-Baikal and Siberia'; finally, the 'Trees, shrubs and flowers found in Siberia and Mongolia' (omitting mammals and birds), but nowhere fish or insects. But Baddeley has once again pencilled in the first page of the appendix 'Every word [his underlining] of the Appendix is stolen without acknowledgement from Maack and others.' Even so, Thomas greatly reduced Maack's original appendix, and some (uncredited) naturalist knowing English and Russian would have had to translate the original Russian into English – no mean task, and done at some point in 1859/60 (perhaps in only months, by whom, one wonders?).

Maack's book came with a huge-format companion volume of illustrations, some of which Thomas also plagiarised from the original, although in his preface he does at least concede that: 'With regards to the illustrations … I have added a few characteristic portraits [of local indigenes], copied from a work recently published by the Russian government' but with no further citation.[17] But it would have cost him nothing to acknowledge Maack, assuming he would have had the latter's authorisation which might not, of course, have been forthcoming for fifty-odd pages. And of what interest would these long lists have been to the English reader? His avowed intention 'to produce information for the Geologist, Botanist, Ethnologist', etc. in the event rests very largely on Maack. It is painful for this author – and perhaps the reader – to end this long account of such an impressive life by including Thomas's very negative side, but balance demands it.

As for his first book, there must be some doubt about his two chapters on Mongolia, full of personal description and adventure as they are and even incorporating three portraits of sultans. There is no mention of Mongolia (or the Amur) in Lucy's book or in his journals or list of sketches, and the two relevant lithographs in his first book are of 'Buryat Mongolia' north of the Russian border. No journals exist for 1852 or 1853 – perhaps lost – and there *was* an opportunity between reaching Barnaul in July 1853 and tackling Belukha, but there is nothing to substantiate it and the likelihood of crossing the Chinese Empire's border into Mongolia was basically dismissed after his death.

Is it, however, so heinous to distort or embellish the truth in a travel narrative? At least two highly regarded modern writers have apparently done so: Patrick Leigh Fermor and Bruce Chatwin. But in Atkinson's case his impressive reputation in his lifetime and acceptance, both by learned societies and London 'society', relied on veracity, and he must be held to account for deliberately deceiving – in part only, however – his public, not to mention (such impertinence!) the Emperor of Russia and the Queen of Great Britain. The temptation was too great for this talented, ambitious and determined self-made man, who had achieved so much against the odds and deserves both criticism and admiration – although only the former for his bigamy.

A classic case of at least alleged deception must be that of William Jameson Reid, who wrote the 499-page *Through Unexplored Asia* (Boston, 1899) about a journey through Western China/North-Eastern Tibet in 1894 but was rumoured not to have been further than Boston central station. There is also the case of the great Charles Darwin, who deliberately altered the chronology of *The Voyage of the Beagle* (1839) in the interests of his readers, but advised them accordingly.[18]

Yet Lucy, delightful as she undoubtedly seems, was not entirely truthful herself when she wrote about Thomas to Palmerston in April 1862 (probably still in an understandably overwrought state), 'for fourteen months before his decease [i.e. from June 1860] he was incapable of undertaking any kind of occupation whatever; [true perhaps, but she omits his one trip at least to the north in the autumn of 1860] owing to illness brought on from overworking himself and taxing his strength beyond its endurance'.

Letter from the widowed Lucy Atkinson to John Murray, her prospective publisher.

She had started to write her own travel account before Thomas died and was advised by the publisher John Murray to write it as a series of letters to a friend. Five months after Thomas's death[19] she wrote, still on mourning writing paper, to Murray, thanking him for his 'kind encouragement'

> to proceed with my simple story, when I have quite concluded it – if it does not please you why there is no harm done – understand. I do not mind trouble, if by writing it over fifty times I could at length succeed, I would most willingly do so – pray do not hesitate in telling me what you disapprove.
>
> To speak frankly your letter lay some short time on my table ere I dared to open it to know my fate.
>
> In the style I have sent you I can write more letters, equally if not more interesting I so feared you would say they were trash.[20]

Two months later Lucy applied in her penury as 'a Widow' for relief to the Royal Literary Fund,[21] citing her late husband's profession as 'Architect, Artist & Author' with the titles of his two books and inserting 'one son aged thirteen'. She would

not have applied, she wrote, but for the death of her husband, due to which

> I am left with an only son, totally unprovided for, he [Thomas] having
> expended the whole of his own means during his researches, in Siberia,
> Mongolia & Chinese Tatary … after our marriage in Moscow in
> 1848 – I accompanied him over a period of six years. It was during
> our wanderings in Chinese Tatary that our only son was born under
> peculiarly difficult and trying circumstances.
>
> This journey was performed without the aid of any society
> whatsoever and entirely at his own cost [questionable].
>
> I am now reduced to the necessity of disposing of my wardrobe
> and a few little valuables I possessed, for our maintenance … [but it is
> interesting, if understandable, that she did not sell either ring from the
> Tsar].
>
> And moreover, I may add, even before my husband's death, we had
> commenced doing so – always hoping he might recover and be able to
> resume his labours.[22]

Strong letters of support were written the very next day or the day after, inter
alia from John Murray (whom Lucy, 'a very exemplary woman', had requested
would make known to the Fund's Committee her 'extremely destitute condition
… left without any means of support'), Galton, Spottiswoode, Lord de Grey and
Ripon, the former President of the Royal Geographical Society and 'personally
acquainted' with Lucy's 'sad circumstances', and Murchison, who had 'taken the
deepest interest in her welfare' and enclosed an appeal to 'Geographers & Men of
science and Letters for the purpose of educating her only son born in Chinese
Tartary'. These were supported by a copy of Lucy's marriage certificate to 'a
widower'.

In his letter (of 28 February) to the Royal Literary Fund Galton wrote:

> She was her husband's devoted companion and helpmate in all his
> Asiatic wanderings (which I need not dwell upon here as they are
> well known to the Public.) She was, I can testify from direct personal
> knowledge, the supporter and Encourager of his artistic & literary
> labour. And she is now by his premature death, – I say premature for
> he was planning new journeys – as an artist-traveller when his illness
> commenced, – reduced to the greatest financial Embarrassment.
>
> The education of her boy is indeed provided for, by means of a
> subscription raised for that purpose but her own fortunes are in
> immediate need of support.

He had, he continued, known Lucy and Thomas 'with, I may almost say, intimacy,
for the last two years. I sincerely esteemed them both and believe her eminently
deserving of a donation from the Literary Fund.'

On 17 March Lucy wrote to the Fund with 'sincere and heartfelt thanks' for the £80 'so liberally afforded me', a sum (now worth almost £9,000) which 'will enable me, I trust, to carry out my project of giving to the world an account of my wanderings in the distant regions of Chinese Tatary &tc where, not only no European, but not even a Siberian [i.e. Russian] Lady, ever set her foot before'. And a few days later she wrote to John Murray again, thanking him for his letter to the committee: '£80 … is a great assistance to me', asking if she should send the incomplete manuscript or wait till it was finished, and presuming she was 'doing right in taking up the journey exactly as we made it'. She sends her 'kindest regards to Mrs Murray and yourself', an indication of personal friendship.

Lucy was fortunate in her supporters, particularly Murchison, and through him the Fellows of the Royal Geographical Society. In late March, a 'Memorial in favour of Mrs Lucy Atkinson' was drawn up, addressed to the Prime Minister, Lord Palmerston, earnestly recommending the grant of a small pension by the Crown. It attracted fourteen distinguished signatories, headed by Murchison, and including the Arctic explorer (and accomplished watercolourist) Admiral Sir George Back, the Assyriologist Henry Rawlinson, later baronet and President first of the RGS, then the Royal Asiatic Society, peers of the realm, and the President of the Royal Society, General Sir Edward Sabine. The Memorial explained Lucy's travels with her late husband including 'the countries of the Kirghis Hordes, into which no Englishman had ever before penetrated', mentioning his well-known works

> descriptive of these regions … justly appreciated by the public, whilst his paintings have obtained considerable praise for their graphic descriptions of the wildest scenes.
>
> Owing to the heavy expenses attending his travels, Mr Atkinson died in poverty, and left no provision for his Widow and her only Son, now 13 years of age….

And, it continued, certain geographers,

> who value the labours of Mr Atkinson, have, indeed, subscribed £300 [nearly £34,000 today] … for the education of this fine boy … however, the Widow is left destitute, and we therefore sign this Appeal in the persuasion that, as the relict of an original explorer, who, expending his own means in the extension of Geographical Sciences, was also a popular writer and a skilful artist. Mrs Atkinson comes, we think, legitimately within the scope of the Royal Grant, which has often been assigned to the Widows of persons of distinction in Science, Letters, and Art.[23]

Meanwhile on 7 April the anxious Lucy sent a direct appeal herself to Palmerston, soliciting a small pension in view of

the benefit my husband has done to Society at large, in bringing back and giving to them in pen and pencil his experiences of countries, for the most part totally unvisited by Europeans.... I should not have applied to Your Lordship, had we not by his death, been left totally unprovided for, he having spent the whole of his own means in prosecuting his researches in the before named regions. The journey having been performed at his own cost, without the aid of anyone or any society whatever [perhaps].

Hoping Your Lordship will pardon my addressing you.

I beg to remain
My Lord
Yours Obediently
Lucy Atkinson[24]

Then Murchison wrote a six-page letter to the Prime Minister, whom he knew and to whom he had already spoken about the matter, enclosing the Memorial. He explained that, when Atkinson was in Moscow (*sic*) in 1847 en route to Siberia, 'he fell in love with the lady ... then a Governess' to the Muravyov family. After a year away, he returned 'to claim his promise', and the two were married by an English clergyman, a marriage which produced one son. He describes Atkinson as 'one of those resolute Englishmen who to the honour of our country rose from the humblest beginnings to distinction', and his widow 'the companion of these most arduous explorations which have brought to our acquaintance vast unknown regions'. He goes on to assure Palmerston that

poor Atkinson never received a farthing from the Government or the Czar. He travelled at his own expense – exhausting thereby all the savings of a previous life as an architect and artist in the full persuasion that his paintings and sketches of the wild countries would bring such prices in England which would entirely repay him.

Alas! He was miserably deceived. Few people care to give money for the representation of scenes which they can never visit and the unfortunate traveller reportedly collapsed and died during your first residence there.[25]

The only advantage to him in Russia (and I had the same) was an Imperial order to travel whithersoever he pleased [not really so in Atkinson's case].

Pray take this good case into your favourable consideration, for I am sure that it stands on as strong grounds as most of those cases of former grants of pensions from the Crown.

On 26 May, Lucy, understandably still overwrought, wrote a poignant letter to

Lord Ashburton, at that time President of the RGS:

> All my husband's property I have delivered over to the principal creditor, but as I fear there will not arise sufficient funds to liquidate the debts, I am endeavouring with my feeble efforts to make the wherewithal to do so, and if I am successful it will be the proudest day of my existence.
>
> Should this man be able to prove (which I doubt) that the first wife is living still I look upon myself as the one entitled to pay my husband's debts and clear his memory. In the sight of God I am his wife and I have to the best of my ability acted the part of one to him. I never deserted him for an instant either in sickness or in poverty, and I have followed him through dangers which many a man would have shuddered to encounter, and he has ever been to me a good husband during a period of fourteen years that I have been married to him.
>
> I am sorry to trouble your Lordship on matters of not the slightest importance to you, but I have been obliged to say so much on my own behalf as Mr Wheeler has written to all the principal persons at the Geographical [nothing now in their archives], and though not in direct terms still has worded his communications in many instances as to lead them to conclude I had been living in an improper way with Mr Atkinson, having done so, it is just possible he may have written to your Lordship.
>
> The way Mr Wheeler has attacked my character is the more despicable and cowardly as I told him when he (my husband) had married me. The manly way would have been to attack the culprit if such there was, and not the poor victim.

A month later Lucy wrote again to Murray, her prospective publisher, exhorting him not to think she had been spending her time idly:

> Since I saw you I have had a good deal of trouble and anxiety — that is over for the present, and whatever comes in future, I trust it will not produce the same effect upon me. I tried hard, very hard to collect my thoughts to write, but I could not do much, and threw my pen down in despair. Last Monday I resumed it, and I hope nothing more will come to interrupt me for a while....
>
> I do not know if my feeble efforts will be of any use. I deeply regret not having the assistance I had hoped to have had — then my letters would have been very different. I could have said more, but fear not to be quite correct, and as this is not fiction it is better to write only of what I am quite sure...
>
> With kindest regards to Mrs Murray and yourself.[26]

Lucy's efforts were anything but feeble. *Recollections of Tartar Steppes and their*

Inhabitants, which came out in 1863, is a lively (and badly neglected) gem of Victorian women's travel, half the length of her husband's first book, and without a trace of rancour; it has, mercifully, a table of dates of their travels as well as four engravings, possibly from her husband's watercolours, and is a delight to read, full of excellent – and often amusing – anecdotes. She emerges as tough, spirited, humorous, independent and resourceful, and a good shot and horsewoman as well as a caring wife and mother – the real hero of the story. Murray's formula of writing it as a series of letters worked extremely well.

The reviews were, rightly, very positive. *The Westminster and Foreign Quarterly Review* (1 July 1863, 254–5) considered that 'Mr Atkinson was singularly fortunate in the companion he chose for his wanderings; few ladies can tell a more adventurous tale and still fewer could have exhibited such courage and powers of endurance … to travel 7,000 miles in a single year, and for the most part *en cavalier* … is a feat of which any lady may be proud…. Altogether this volume can have few competitors, either in novelty of subject or interest of detail, while it is written in a cheerful and animated way that gives it an additional charm.' And *The Literary Gazette* (14 March 1863), which mentioned the untimely loss of her husband 'to be deplored by … [interestingly] thousands', wrote that the adventures and exploits that she shared 'throw into shade the most daring undertakings of all previous lady travellers'.

The Athenaeum[27] in its seven-column review quotes and pontificates at some length but does not really review the book at all. Interestingly, it cites her Christian name, which she kept off the title page, credited only as 'Mrs Atkinson'. Professor Anthony Cross, well known for his work on past Anglo-Russian relations, wrote a nine-page introduction to a new impression of Lucy's book in 1972,[28] in which he observed that her 'account of meetings with survivors of the Decembrist uprising … has long been of interest and importance for [particularly Russian] historians' and that she writes 'with unassuming modesty and the ring of truth'.[29]

Following in her husband's footsteps, Lucy presented the RGS with a copy of her book, inscribed on the flyleaf: 'The Geographical Society from the Authoress [perhaps to avoid using her Christian name]. March 2nd, 1863'. And presumably for that reason the title page is inscribed simply 'Mrs Atkinson'. In May Palmerston's private secretary wrote to Murchison[30] informing him that Lucy had been allotted a Civil List pension of £100 a year, which would have very greatly pleased her, as much as the success of her book.

Lucy can hardly have sent out many free books, but we know she sent a copy of her 'little volume' to one supporter, the first Baron Houghton (formerly Richard Monckton Milnes), which, modestly, she did 'not pretend to think' would interest him, 'but it probably may the ladies of your family: if so I should feel happy to have contributed to their gratification'.[31]

There is an interesting (undated) vignette of Lucy when she had regained her composure, 'a bright-eyed, intelligent woman, small in stature', penned by Sir William Hardman, FRGS,[32] who sat next to this 'very remarkable lady' at a dinner party (date unknown). Fortunately, she was still *persona grata* socially. He

was impressed that she had given birth 'lying on skins on the bare ground'. She would rather, she said, 'be attended in sickness by *men rather than women*; they make far kinder and more attentive nurses', and 'the way in which the Cossacks nursed and played with her baby was strange to see'. She loved Russians, she said, and hated Poles when in insurrection, referring to the Polish uprising against Russian rule of 1863 (doubtless conscious that her previous employer General Muravyov had been sent to put it down).[33]

The novelist George Meredith was a fellow guest on that occasion, 'in high spirits and talking fast and loud', and claimed that the view from Surrey's Hindhead was very like Africa. 'Mrs Atkinson pricked up her ears, and bending forward across the table asked in a clear but low voice, "And pray, Sir, may I ask what part of Africa you have visited?" Poor Meredith; he had never been further south than Venice!' But 'No one could be more amused at his own discomfiture than he was himself.'

Later, the talk was of some cannibals who were to visit Britain as a 'sensation exhibition', and the question of feeding them arose. '"Oh!" says Meredith, "there will be no difficulty about that, we shall feed them on the disagreeable people, and those we don't like."' Hardman, who tells the story, was amused at the notion and, turning to Lucy, said, 'I wonder how many persons would survive if every one disposed in that fashion of those he did not like!' '"Yes, indeed", she replied, "there would be very few, if any, and that gentleman (meaning Meredith) would be one of the first to go!" Conceive my amusement, picture to yourself the chaff, the laughter, when I reported this to Meredith! We all liked the little woman immensely, and mean to improve the acquaintance.' But unfortunately, there is no record of this happening.

Alatau, meanwhile, was sent to Rugby School thanks to the subscription of nearly £300 (today nearly £33,000)[34] raised by Murchison and, primarily, other Fellows of the RGS.[35] Possibly having been taught by Lucy on his own, he must have found it a life-change to attend a Victorian English public school; he was inevitably teased for his outlandish names, and a couplet went the rounds:

Alatau Tamchiboulac
Rode about on an elephant's back.

Lucy's widowed mother and four youngest siblings[36] had emigrated to New South Wales, joining three already there, leaving Lucy with a brother and sister in England of whom we know nothing. It is thought that Lucy may have returned to Russia, probably to see her old charge, Sofia, now married with her own children.

In July 1869, seven years after Thomas's death, writing from '4 Paragon, New Kent Road' in the East End to Murchison, she writes to say how grateful she is 'for the pains you have taken to draw up the appeal to the Premier [evidently for a pension]'. And she adds: 'Trusting that Mr Gladstone [then Prime Minister] will be pleased to look upon it favourably.'[37]

And in December she writes after receiving news from Murchison of a £50

pension (some £5,800 today),[38] 'In consideration of her services to literature'[39] writing now from the Grand Hotel Royal, Nice, Alpes Maritimes, where she was probably the companion to some well-off English lady:

> How I am to thank you I hardly know – no language I would use would ever show how deeply grateful I am – your generous aid enables me to feel easy about my old age. I now know when the time arrives for me to give up my previous employment [unknown] I shall not be an outcast and I am sure your own kind heart must feel as gratified in having secured to me the grant of a Pension as I felt rejoiced at obtaining it.

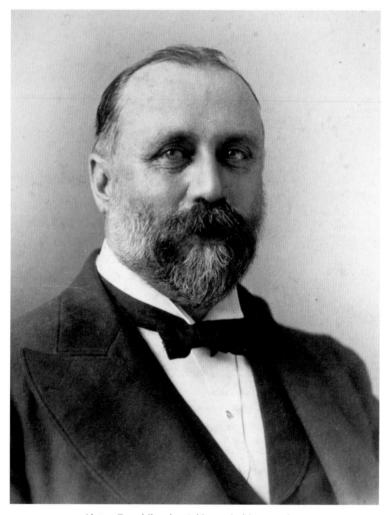

Alatau Tamchiboulac Atkinson in his maturity.

She does not feature in the 1871 census; perhaps she was in Russia. But the 1881 census tells us that Lucy had moved to 43 Mecklenburgh Square (in Bloomsbury, today perhaps the best preserved of all London's Georgian squares), the home of her cousin Benjamin Coulson Robinson, a retired 'Serjeant-at-Law',[40] his wife, Hannah, and his aunt, Maria. Lucy was probably acting as housekeeper (and poor relation). Thomas had proposed Robinson for membership of the RGS in 1860 and the latter had donated generously to Alatau's education.[41] A year after Robinson's death in 1890, Lucy was a visitor[42] 'living on own means' (a relief!) maybe quasi-permanently in the house of Robinson's sister Sarah and her husband Thomas Weatherall Sampson, a prosperous ship-broker living at 376 Camden Road, Holloway, further north and not so grand.

Lucy and Rebekah probably never met. Rebekah died on 7 May 1872 from paralysis, aged seventy-seven, according to her death certificate.[43] Despite the rigours of her travels, Lucy was to live on until 13 November 1893, thirty-two years after Thomas's death, dying at the age of seventy-six from acute bronchitis, oddly enough at 45 Mecklenburgh Square, two doors away from her old residence at 43, rather than Camden Road, her more recent home. By her will she appointed Alatau as sole executor, left her daughter-in-law Annie, 'the wife of my dear and only son', £100 with £100 legacies totalling £900 to her grandchildren, and the residue to Alatau. In due course her estate was proved, surprisingly, at £3,071 5s 9d, equivalent to at least £360,000 today. Where could the money have come from? Sampson died the same year as Lucy, leaving over £50,000 (now £5.98 million), so perhaps Lucy benefited from his fortune.

She was buried in Tower Hamlets cemetery, Stepney, in London's East End, joining her father there as well as Benjamin Coulson Robinson. Unlike Thomas, she has a gravestone, paid for by Alatau, that commemorates the last resting place of this remarkable and thoroughly admirable woman.[44] The inscription is in bad condition today but it is possible to make out:

<div style="text-align:center">

Sacred
to the memory of
Lucy Sherrard Atkinson
widow of
Thomas Witlam Atkinson, FRGS, FGS
Born April 16th 1819
Died November 3rd 1893.
We have loved thee with an everlasting love,
Therefore to divine kindness were drawn thee.[45]

</div>

As for Alatau, he was to have an interesting and successful career – surprisingly in Hawaii. He resolved to teach after Rugby, following in his maternal grandfather's footsteps. After attending a training course in the North of England, he taught for two years at Durham Grammar School (Murchison's alma mater, another good deed) and in 1868 married Annie Elizabeth Humble, daughter of an

Alatau and his family outside their house in Hawaii.

artist. Their first child – christened 'Zoe' (after an earlier love, the Italian Zoe Giovanetti, who became her godmother) and also 'Lucy Sherrard', a token of Alatau's feelings for his mother – was born at the end of the year, when he sailed with wife and new-born child for the Sandwich (now the Hawaiian) Islands.

He established his own school, St Alban's College, which he ran for many years before becoming principal of the famous old Fort Street School. In addition, he set up a free school system open to all races, insisting on English as the taught language in these multi-ethnic islands in mid-Pacific, always with a vision of Hawaii's future, leaving many prominent men of Hawaii in 'heavy debt to the distinguished educator', not just in schools but via the press and platform. He also began reformatory schools for juvenile offenders, became Inspector General of Hawaii's schools, which he reorganised, frequently visiting all the islands, and then moved on to journalism, becoming editor of the *Hawaiian Gazette* and then *Hawaiian Star*, as such largely shaping public opinion in favour of American annexation (1898), on which he was determined. He twice administered an official population census of the islands, produced significant papers on education, and produced satirical verse and cartoons: an astonishing career after such an extraordinary start!

Although Lucy never saw Alatau again, she kept very much in touch (no letters survive, although she wrote to Murchison after her son's arrival in Hawaii

that he was 'enchanted with the island and its climate – his school was doing very well').

He and his family – his wife Annie, three sons and four daughters – lived in a comfortable two-storeyed house with verandas on all sides and had a beach hut on Waikiki. Despite his high-profile career, he was never well off with so many children to bring up and may have sometimes taken in lodgers; one daughter thoughtfully eloped to save her father the cost – and debt – of a formal wedding. Zoe, the eldest, married R.C.L. Perkins, an Englishman who collected insects, birds and snails in Hawaii for the Royal Society, which resulted in the first comprehensive work on the islands' fauna, a three-volume *Fauna Hawaiienses*. One son, also Alatau, ended as acting governor in 1903. Another son, Robert, and his wife, entertained the Prince of Wales, later Edward VIII, and his party when in the Pacific in 1920 at a traditional poi supper at their home.

Alatau died in Honolulu suddenly on 24 April 1906, aged fifty-eight. Hawaiian obituaries speak of his warmth, good-natured enthusiasm and his comradeship and loyalty to associates: 'enthusiastically fond of Hawaii', he believed in its great future, and to it he devoted a capacity for decision, 'rare executive ability', 'great talents, an indomitable energy and enthusiasm that never failed or altered [shades of his father], and a luminous zeal',[46] while a 1925 history of Hawaii described him as 'one of the most brilliant and widely loved men of his period ... his strong personality left a marked impression upon ... [its] cultural life'.[47] He is the one real-life figure to enter the pages of James Michener's best-selling novel *Hawaii*, where he writes: 'the characters ... are imaginary – except that the English school-teacher Uliassutai Karakoram Blake is founded upon a historical person who accomplished much in Hawaii'. And one road commemorates Alatau today: Atkinson Drive in the centre of Honolulu.

Epilogue

THOMAS AND LUCY are almost forgotten in their native land today. They have, for instance, been totally omitted from the vast three-volume encyclopedia *Literature of Travel and Exploration* (2003, ed. Jennifer Speake), which their extraordinary story hardly deserves. Nonetheless they are not entirely neglected.

Thomas appears in several other works of reference, and besides reprints of their three books there have been new studies published (see Bibliography), including an article in the *European Review of History*, February 2009, on *The Nest of Invasions* (1930) by the Romanian novelist Mihail Sadoveanu, inspired by Atkinson's travel accounts. Two Atkinson watercolours were exhibited in Moscow's Tretyakov Gallery *Unforgettable Russia* exhibition in 1997 and three in the Cooper Gallery, Barnsley, Yorkshire, in the *Hidden Artists of Barnsley* exhibition in 2015, where a mock-up of a Kazakh yurt was created for children. And while most of Thomas's architecture has gone, a £3,000,000-plus project has been mooted to redevelop St Luke's Church on Manchester's Cheetham Hill, his best-regarded work, now a shell. (For the architecture that remains see Appendix I: Architecture.) At least their books have soared in value in the antiquarian market: in 2017 Lucy's book was on sale in London for £800 and Thomas's first book in Arizona (of all places) for $750.

In 1883 Atkinson was one of the eight nineteenth-century travellers, all British plus Marco Polo, selected as *Some Heroes of Travel* by W.H. Davenport Adams for 'all English-speaking lads and lasses, who will [hopefully] learn from its pages [seventy-one devoted to Atkinson] how much may be accomplished by patience, perseverance, and energy'. And no fewer than twenty-eight encyclopedias in several languages have entries, large or small, on him.

Thomas's Yorkshire birthplace of Cawthorne is today a quiet and attractive village; its seventeenth-century one-room school, which young Tom attended when his father did not need him, is now the parish hall. The headstone that he cut so well for his parents is well preserved, and the fine altar tomb that he designed in the church and that set him on his career now has a plaque commemorating him. His modest birthplace remains unnoticed, but Cannon Hall is now a museum and its landscaped grounds a park, sold by the Spencer family to Barnsley Council in 1951. The village now has its own museum, and the pub is still appropriately the Spencer Arms.

Opposite: 'St Luke's, Cheetham Hill, Manchester'
A nineteenth-century engraving.

Russia has of course seen far more changes than England: revolution and civil war, Soviet power, World War II and the end of the Soviet Union. The Atkinsons' route east from Moscow is still called the Vladimirka, now a busy four-lane highway snow-ploughed in winter, while the frozen Volga is a highway no longer for sledges but roughly paralleled by an important motorway. Service stations have replaced the old post-stations, and the era of those countless horses is now well past. Passports (and visas) are still required for most foreigners, although their travel is much less circumscribed than in Soviet times.

The Urals were closed to foreigners for many Soviet years because of their heavy industrial and hence strategic importance, as those zavods that Thomas knew expanded exponentially into some of the world's largest plants in Stalin's 1930s drive for industrialisation. Many entire industries or factories were evacuated east to the Urals and Siberia in wartime and played a crucial role in the Soviet victory. The picturesque Chusovaya river on which Thomas travelled along the Urals inevitably lost its economic role to the railways but today attracts many rafters and canoeists in summer.

Further south, similarly, the Altai's scenery increasingly appeals to international visitors and the Atkinsons' beloved Lake Teletskoye's surroundings to new settlers, while the spectacular Mount Belukha is just one part of a UNESCO World Heritage Site. In contrast, however, is some of the planet's worst industrial pollution, and Nizhny Tagil, which the Demidovs founded and Thomas visited, is particularly notorious. The Atkinsons' landscape – and climate – has also been changed along several of the great rivers, which have seen some of the world's biggest dams and hydro-electric projects developed, with enormous reservoirs. Both West and East Siberia have been straddled by great oil and natural gas pipelines from some of the planet's largest deposits, the gas now heating many European countries and the oil going increasingly to Asia, the revenue crucial to Russia's economy.

The Atkinsons would have been astonished by Siberia's population growth. This huge area saw a massive increase of some seven million inhabitants in the last century of the Tsarist era, principally triggered by the emancipation of the serfs in 1861 and the construction of the Trans-Siberian railway (1891–1901). Literacy (then rare) has long been universal, and there are now at least twenty-five universities between the Urals and the Far East coast.

Muravyov-Amursky himself, who claimed the Amur region for the Russian Empire, leading to the naval base of Vladivostok and Russia's Pacific coast, fell unfairly into disfavour and retired to France, as did Alibert, whose mountain-top graphite mine is now deserted. But several houses of the Decembrist exiles – venerated as patriotic and revolutionary heroes – are preserved as museums, and Lake Baikal's unique properties have made it a subject of international scientific research.

The natural wealth that Thomas recorded was to prove only a fraction of the whole. Much may have changed, but the Atkinsons would recognise some of the old wooden houses, preserved, for instance, in Irkutsk. Most villages would look

much the same apart from the television aerials, telegraph poles and asphalted main streets. The Atkinsons have left their name behind on Siberia's map at the Atkinson Volcano.

The Cossacks, indispensable to them as guides and guards, were sent by Muravyov in their hundreds as settlers to the Amur area, and the Semirechye host (or self-governing semi-military community) was formed in the 1860s to hold Russia's new Central Asian possessions, which by 1865 were to reach Persia, Afghanistan and China. When civil war followed the 1917 Revolution the Cossacks fought on both sides; all the hosts were soon disbanded and the Cossacks harshly victimised. In World War II they once again fought on both sides, with much tragedy at the end. But since the end of the Soviet Union the Cossacks have at least had many of their old traditions restored.

Surprisingly, some modern atlases still use the term 'Kirgiz Steppe', even though the whole area has long been Kazakhstan. By 1868 Russia had annexed the rest of what was then the Kirgiz steppe despite more than 300 uprisings;[1] they had confiscated nomadic grazing lands and applied harsh taxes, so that livestock breeding suffered badly and a civil war followed the collapse of the Tsarist era. History has not been kind since then. The better-off herdsmen were dispossessed and deported, while kulaks or farmers from Ukraine and central Russia were deported *into* the empty steppes of north Kazakhstan. Forced collectivisation was a disaster. Migration was forbidden, so the thin soil became exhausted: nearly two million died of starvation and another million moved to China.[2]

Under Stalin, Kazakhstan saw a huge network of prison camps established in the steppe, with Solzhenitsyn one of its countless prisoners. Whole peoples were deported here, either just before or during World War II: Volga Germans, Chechens, Crimean Tatars and others considered actual or potential collaborators, which brought yet another high death toll, largely from cold or starvation. There have been three major environmental disasters. In 1954 Khrushchev's 'virgin lands' campaign put over 250,000 sq. km of vulnerable steppe under the plough, leading to desertification. Between 1949 and 1991 the Cold War brought nuclear tests to the north-eastern steppes (the 'Polygon' of over 5,000 sq. km): 470 atomic and hydrogen bomb tests above and then below ground, causing terrible radioactive damage. Lastly, the Aral Sea, far to the west of the Atkinsons' route and formerly the world's fourth largest lake, shrank by 90% due to the diversion of rivers for irrigation.

However, Kazakhstan, which declared its independence in 1991 and is the richest of the five 'stans' of Central Asia, is almost as big as Western Europe, immensely rich in minerals and with a dynamic president (who belongs to the Senior or Great Horde, according to his official biography – so the Horde system still exists). It is blessed too with much natural beauty, increasingly attracting tourists, arriving primarily by the fast-growing Air Astana. Named after Kazakhstan's modernistic if not futuristic brand-new capital, its designs often based on traditional Kazakh motifs, it has been funded by mineral wealth, particularly oil and gas. And of great significance is the huge and active Baikanor

Cosmodrome, the world's largest, in southern Kazakhstan, which saw Gagarin's first manned space venture in 1961.

Kopal (today Kapal or Qapal), that fort where Alatau was born and the Atkinsons lived for eight months, is today a village off the beaten track, with a few remnants of the Cossack fort and a small museum; the nearby Arasan spring, known for 3,000 years, which the Atkinsons visited, is now a small but well-known spa.

One branch of Alatau's family still lives on the island of Hawaii, in possession of Thomas's correspondence (including Dickens's letter), having very appropriately presented his as yet unpublished journals to the Royal Geographical Society, which had been so supportive of both Lucy and Alatau after Thomas's death. Alatau's twenty or more other descendants live today in England, Sweden, New Zealand and the US mainland, owning photographs of Alatau's family and the only known photograph of Thomas (though sadly no likeness of Lucy), a *rubashka* or Russian shirt, a handsome samovar and two silver bracelets.

But none of the family has any of Thomas's watercolours, nor do they know where they are. According to one Hawaiian obituary of Alatau he had several, but they seem to have disappeared. One granddaughter, the late Marjory Whitehead, who had visited from England in his lifetime, remembered seeing a pile of watercolours about a foot high in the house of one of the sons. Alas, the house was burnt to the ground. This would in theory have explained the disappearance of so many, but she remembered them as flower paintings, which was not at all his genre, and one wonders if those were by Lucy, although she is not known to have painted at all. Fortunately, however, neither Thomas's five journals nor his correspondence (including his letters to two Tsars) were burnt.

Some of Thomas and Lucy's descendants came to Cawthorne in 2015 for the installation of the plaque to Thomas in the church. In 2016, thanks to the Kazakh Government's generosity, many of them attended high-level Atkinsonian festivities in Kopal, where a statue of Alatau was unveiled, and in 2017 a smaller group went riding through Siberia's remote East Sayan mountains to the Atkinson Volcano and there installed a commemorative plaque. And every day one of Alatau's great-granddaughters wears on her finger (as her mother did even when swimming) the diamond and emerald ring given to Thomas by the Tsar.

The Tsar's diamond and emerald ring, given to Thomas by Alexander II.
Illustration by Boris Kemper, Vienna.

North Elevation.

T.W.Atkinson. del. H.E.Kendall, Arch. 1836. G.Gladwin. sculp.

VILLA OF T.R. KEMP ESQ. M.P. BELGRAVE SQUARE.

London. Published March 1 1837 by J.Taylor, High Holborn.

Above: 'Villa of T.R. Kemp Esqr. MP. Belgrave Square (Façade)'.
Below: 'Villa of T.R. Kemp Esqr. MP. Belgrave Square (Plan)'. The architect Basevi, for whom Thomas had worked, designed the terraces of London's Belgrave Square, and another architect for whom he had also worked, H.E. Kendall, designed this corner villa. Thomas's name and initials appear beneath each.

T.W.Atkinson. del. H.E.Kendall, Arch. 1836. G.Gladwin. sculp.

VILLA OF T.R. KEMP ESQ. M.P. BELGRAVE SQUARE.

London. Published March 1 1837 by J.Taylor, High Holborn.

Appendix I

Thomas Witlam Atkinson, 1799–1861 Architect

1799, 6 March: born Cawthorne village, Yorkshire. Son of master mason on Cannon Hall estate who would take him from school in summer to help him from the age of ten as labourer then stonemason. His elder half-brother Charles gave him valuable lessons in writing and drawing, and mathematical instruments were an important gift. Mason and stone-carver at St George's church at nearby Barnsley. (source: HC)

*c.*1820: moved to Ashton-under-Lyne to teach drawing in a school and work as stonemason and sculptor to architect Francis Goodwin on Church Commissioners' St Peter's, 1821–24, 'large and ambitious' (NP), the first of six Commissioners' churches he worked on. Also helped rebuild north side of Ashton's St Michael's and All Angels, 1821.

Clerk of works for George Basevi at St Thomas's, Stockport (AH). Church Commissioners' neo-Grecian church, constructed 1822–25 (NP). Drew plan and elevation for Basevi of corner mansion, Belgrave Square. (BM Library)

Clerk of works for H.E. Kendall, St George's, Ramsgate (HC), after death of its architect, Henry Helmsley. Constructed 1824–27. Church Commissioners. **Extant.** (NP)

1825–27: All Saints Church, Cawthorne, Yorkshire (ICBS 00694, Folios 20ff): grant for new south aisle & chancel. Ground plan by TWA, Society of Antiquaries, 1825.

Moved to London 1827 to study architecture, then to practise it. (HC, AH, RIBA)

1829: published *Gothic Ornaments selected from the different Cathedrals and Churches in England* with 44 plates drawn & lithographed by himself & his half-brother, Charles, with whom then in partnership (HC), having made close study of Gothic detail, particularly in Lincolnshire churches.

1829–30: reconstructed St Margaret of Antioch, Bowers Gifford church, Essex (in partnership with his half-brother Charles). **Extant.** (ECRO & ICBS, via HC)

1830: Gothic altar tomb in All Saints Church, Cawthorne, in memory of Walter Spencer Stanhope (d.1821), previous squire at Cannon Hall. Exhibited at RA (HG, AG). TWA's first work (plaque alongside) besides a fine headstone for his stepmother and, later, father; this so impressed the squire's son, Charles, that he persuaded him to leave the village and seek his fortune, acting as quasi-patron from then on and writing TWA's (unpublished) life story after his death.

Town house (unidentified). Design for alterations or rebuilding. Two contract drawings, on each: 'Witness to the signature of the said Thomas Arnoll Davis (s)/T.W. Atkinson/Witness to the signature of the said Richard Deans/Willm Page clerk to/Mr Atkinson 8 Upper Stamford St/1 Sept. 1830'. (RIBA)

1830–42: eight exhibits at London's Royal Academy (HC). See 1871 catalogue of RIBA Drawings Collection for four drawings for an unidentified house by TWA, dated 1830.

1831: Hough Hill Priory. Contract drawing, signed 15 March (RIBA). Watercolour by TWA in Astley Cheetham Art Collection, Tameside, Metropolitan Borough Council. (NF)

St Nicholas, Lower Tooting. Watercolour by TWA (engraved by C. Rosenberg) in Guildhall Art Gallery, London. Grade II listed from 1955. **Extant.** (WP)

1831–2: Gothic-style St George's, Commissioners' church, Hyde, Cheshire, in partnership with half-brother Charles. **Extant.** (HC)

1832: Hough Hill Priory, Stalybridge (WP), for David Cheetham, MP (NF). Gothic revival. See 1831.

Drawing of above exh. at RMI (Royal Manchester Institute). (HG)

Ibid., his second work to be exh. at RA (plus St Nicholas, Tooting, see below). 8 Upper Stamford St, London. (AH, HC)

St Nicholas, Lower Tooting, Gothic revival. View exhibited at RA (plus Hough Hill Priory, above) & RMI (AH). Saxon tower of previous church demolished. **Extant.** (WP)

'Approved design for district bank at Ashton-under-Lyne exhibited, RMI'. (AH)

Barnby Hall, Cawthorne, view exhibited, RMI. 'Now erecting for John Spencer Stanhope', new squire at Cannon Hall. TWA to Winstanley, RMI, 2 Aug. 1832. **Extant.** (AH)

House designed for John Ashton Esq., entrance front view, at RMI. (AH)

Chapel, two views of, second view 'now erecting in Wales', RMI. (AH)

Portland House, TWA architect, view of, RMI (AH), perhaps Portland Place, Ashton-under-Lyne (TLS) for John Samuel Swire, 2nd generation of Swire conglomerate. Not evident on 1848 Ordnance Survey.

Unidentified house, view of garden front, exhibited at RMI (but TWA designed?). (AH)

26 July: TWA from 8 Upper Stamford St, '...obliged by your informing me when the drawings are to be sent to the Manchester Exhibition', to RMI. (MCL, RMI)

3 Aug.: TWA from 8 Upper Stamford St to Royal Manchester Institute to which sent drawings. (MCL, RMI)

1833, 3 Jan.: TWA from 8 Upper Stamford St to RMI: 'when does my drawing go post exhibition to London?' (MCL, RMI)

6 Aug.: TWA from 8 Upper Stamford St to Winstanley, secretary (?) RMI. (MCL, RMI)

Twelve drawings sent to RMI for committee's selection:

1. Manchester and Liverpool District Bank, to be erected in Spring Street, Manchester.

Manchester & Liverpool District Bank, Spring Street, Manchester. Demolished.

2. Manchester and Liverpool District Bank, Hanley, 'now erecting'.
3. Proposed design for the Tree Grammar School, Birmingham.
4. SW view of design for Proprietary School, Wakefield, Yorks.
5. Rectory Home 'now erecting' for Rev. F.R. Raines, Milnrow, nr Rochdale.
6. Entrance gateway and cottages for Cheetham's cotton mill, Stalybridge.
7. Laurel Cottage, Hither Green, Kent, erected for F. Atkinson.
8. Lodges for Charles Hindley, Dukinfield.
9. Tomb for Walter Spencer Stanhope, Cawthorne Church.
10. Lodge for Daniel (sic) Cheetham, Hough Hill Priory.
11. Design for Kirkstall Church, Yorks.
12. Lodge for Daniel (sic) Cheetham, Hough Hill Priory.

6 Aug.: TWA from 8 Upper Stamford St to Winstanley: has forwarded two cases of drawings to RMI exhibition. (MCL, RMI)

Manchester & Liverpool District Bank, Hanley, Staffs (HC). Drawing, 'view of the Bank', RMI. (AH)

Laurel Cottage, Hither Green, Kent, RMI (see item 7, 6 Aug. 1833, above).

Two designs of lodge for D. Cheetham (Hough Hill Priory), RMI. (AH)

Lodges for C. Hindley, Dukinfield, RMI. Not in Pevsner. (AH)

Proprietary school, Wakefield, Yorks, SW view of design, RMI. Not in Pevsner. (AH)

Tomb to W. Spencer Stanhope, Cawthorne Church, RMI. Exhibited at RA, 1830. **Extant.** (AH)

Design for Kirkstall Church, Yorks, RMI. (AH)

Church, perspective view of design in English style, RMI. (AH)

Rectory House for the Rev F.R. Raines, Milnrow, Rochdale, RMI. Not in Pevsner. **Extant?** (AH)

Entrance gateway & cottages for Cheetham's Cotton Mill, Stalybridge, RMI. (AH)

1834: moved to Manchester 1834 February/March and opened office at 25 Piccadilly (VS citing MG). Began partnership with Alfred Bower Clayton. (VS)

Manchester and Liverpool District Bank, Spring Gardens, astylar Italianate (HC): his principal work in Manchester (RIBA), together with St Luke's. RMI, 1833

Manchester & Liverpool District Bank, Hanley, Staffs. Demolished.

(HC). 'Said to have raised the tone of Manchester's architecture', *The Builder*, 31 Aug. 1861. 'The first initiative of the architectural taste for which … Manchester has since become remarkable.' Demolished.

1835, Aug.: tenders invited for Bank and Manager's House, Burslem, Staffordshire, for Commercial Bank of England. TWA, now at Store Street, Manchester, assumed separate commission from Manchester and Liverpool District Bank.

1835–41: St Mary the Virgin Church, Hope under Dinmore, Herefordshire (ICBS 01941 Folios 22ff). Grant for enlargement/gallery. Ground plan (before and after work); gallery (after work). (ICBS, building specs available)

1836: Crescent Terrace at Beulah Spa, Norwood (RIBA). Wrongly attrib. to TWA; John Atkinson, architect, see Colvin 3rd edn (HC), but apparently not built.

Brighton Grove Villas, Wilmslow Road, Rusholme (Prospectus). Architects: TWA and Clayton. Proposal to sell off plots around a lake, but only lodge, gates and two buildings completed. Partnership with Clayton formally dissolved 15 Oct.

Sudeley Castle, Glos., architectural work or merely a view? RMI. (WP)

Barry design used.

1836–39: St Luke's, Cheetham Hill, reputedly TWA's best building, 'probably the finest Gothic example' of a Church Commissioners' church in Manchester. In fact, built by subscription in fashionable area (WP). Spire and roof (dry rot) removed & redevelopment mooted. Mendelssohn played on fine organ. Grade II listed. Greater Manchester Building Preservation Trust. Shell **extant**.

1837: Design for altarpiece, St Luke's, Cheetham Hill, RMI. (HC)

1837–39: Church of St Barnabas, Openshaw. TWA still in Store Street, Manchester. Foundation stone laid 5 June 1837. Opened 31 March 1839. Demolished Nov. 1959. Signed lithograph in William Salt Library, Stafford. (RIBA)

St Luke's, Cheetham Hill, Manchester, today.
St Luke's, generally regarded as Thomas's best architectural project, lost its spire and its roof. It has been saved from demolition, and it is hoped to redevelop it for mixed use.

Lodges at Brighton Grove, Manchester, w/c, RMI (AH). Stone lodge post **extant.**

Public buildings at Derby, design for, w/c, RMI. (AH)

1838: Bankrupt: according to notice regarding meeting of his creditors, he was 'superintending the erection of divers houses and other buildings at the time of his bankruptcy'. At some stage in Fleet Prison. Many changes of address at this period, perhaps to escape creditors.

Dwelling house, 'in old English style', erected nr Manchester, view of, RMI. (AH)

Roman Catholic Church, Mulberry Street (near Albert Square), Manchester. Architectural competition to rebuild it, won by Richard Lane. Three other entries inc. one by TWA 'elicited much commendation', but the scheme was not progressed. (MAS)

Houses at Weaste and Broughton Park, probably for Slater and Bradshaw, tendered.

3 Dec.: TWA and J.G. Irvin from 5 Oxford St: the Architectural Society about to quit their rooms, seek room at RMI for monthly meetings and exhibitions. (MCL, RMI)

1838 (or later?): Markree Castle, Co. Dublin. 'Rough sketch elevations, poss. of alterations to an existing building'. 1838. (AH)

1839: Proposed observatory, Kersal Moor, Salford. Apparently TWA's last commission in the Manchester area following bankruptcy (VC), but not built. Drawing by John Edgar Gregan (1813–1855), TWA's assistant in Manchester till 1840, p. 24 in Jonathan Schofield: *Illusion and Change: Manchester*. The 1852 view of Manchester from close to intended site, *ibid.*, p. 12, shows too many belching chimneys to be appropriate for an observatory.

1839: No architecture exhibited at RMI but two views of Rome, one of Athens, York Minster, Sweetheart Abbey near Dumfries, & 'wolf & game', RMI. (HC)

1830s: St Luke's Place, Smedley, Manchester: perspective, colour print. RIBA Library Drawing Collection (Ref. No. RIBA 83583) with note: unclear if built or when designed, but known that TWA designed Italianate villas in Manchester area.

1840: St Luke's Church, exh. RA. Address: 'Manchester'. (HG)

Monument to Mrs John Wallis to be erected in Blackley Churchyard, sketch, RMI (no further exhibits at RMI). (AH)

Catholic Church, Manchester, exh. RA. Address: 'Manchester'. (HG)

Tomb. Design in a Gothic style, side & end elevations. Designed: 'T.W. Atkinson Archt/2 Parliament Street/2 Dec. 1840'. (HG)

J.E. Gregan, TWA's assistant, leaves. (RIBA)

By 1840: Italianate villas in Manchester neighbourhood (WP) for Messrs Hodgson, Heelis, Slater, Bradshaw & others. (NP)

Houses at Ashton & Stalybridge for Messrs Swire, Lea (or Lees) & Harrison, probably Wm Harrison of West Hill, Stalybridge (HC), now West Hill School (TLS), 'red-brick-and-stone Gothic'. (B)

1841: Italian-style villas, Cheadle. (HG)

(n.d.): House at Stockport for Mr John Walmsley of Wallnut Cottage, Heaton Norris.

F.T. Bellhouse & Edward Hall in TWA's office as pupils. (HC)

1842: Palace of Nawaub Nazim at Moorshedabad, designed by Major-General Macleod, but s. & d. T.W. Atkinson 1842. A pair exhibited at RA. Fine model once in Hampton Court Palace (HC?): sold Christie's 29 Sept. 1979. No further exhibits at RA. (C)

Address: Rutland Cottage, Downshire Hill, Hampstead, London (WP), with son John William (Jack) to whom taught art.

1843 TWA to Hamburg (AS). TWA design for 6 Berg Strasse, Hamburg, signed & dated, another design for 'Zimmerarbeit' signed & dated 'July 1843'. (HC, DNB, S, H)

1844: Competition announced for St Nikolaikirche, Hamburg (WP, HC, AG, C), to replace great medieval church destroyed by fire in 1840s.

TWA's design (elevation) for new St Nikolaikirche published in *Der Freischütz* (S, H)

1845: George Gilbert Scott's design wins competition for new St Nikolaikirche (destroyed in WWII; shell remains). (S, H)

1846: TWA to St Petersburg, apparently abandoning architectural career, unless another architectural competition (?). Begins new career as artist, traveller (& author).

1857: returns to London.

1861, 13 Aug.: TWA dies, Lower Walmer, Kent. (DNB)

'Atkinson had few pupils': in Manchester F.T. Bellhouse and Edward Hall, F.S.A., who both moved to London; F.H. Groves, R.B. Critchlow of Southampton, J.E. Gregan (see above), a Mr Cuffley and J.W. Hance, founder and secretary in 1836 of an Architectural Society of Manchester, were all somehow connected with him. *The Builder*, 31 Aug. 1861, p. 590; TWA obituary.

Sources

AG	Algernon Graves, comp. *A Dictionary of Artists who have exhibited works in the principal London exhibitions of oil* [sic] *paintings from 1760 to 1880*
AH	Arnold Hyde, compiler of biographical files, Manchester City Art Galleries
AS	Allgemeines Sauer, *Künstler-Lexicon*, Vol. 5 (compilation of all entries of all countries)
B	*The Builder*, 31 Aug. 1861
C	Christie's sale catalogue
ECRO	Essex C.R.O. D/P 387/6/1
HG	H. Graves, *Royal Academy of Arts. A Complete Dictionary of Contributors and Their Work from its Foundation in 1769 to 1904*, London, 1905
HC	H. Colvin, *Biographical Dictionary of British Architects, 1000–1840*, 2nd, 3rd and 4th edns
ICBS	I.C.B.S. plan in Society of Antiquaries' Library
LG	*London Gazette*
MAS	Report of Manchester Architectural Society Conversazione in *Manchester Guardian*, 18 July 1838, p. 2
MCAG	Manchester City Art Galleries. Typescript biog. of A.B. Clayton, rec'd 19/2/99
MCL, RMI	Manchester Central Library, TWA letters to Royal Manchester Institute
NF	Nick Fielding, *South to the Great Steppe*, 2015
NP	Nikolaus Pevsner, *The Buildings of England* series: *Cheshire*, 1971 *Kent: North-East & East* (John Newman, ed.), 3rd edn, 1983 *South Lancashire (Lancashire 1, The Industrial and Commercial South)*, 1969 (no ref to TWA or CA in Yorkshire volumes)
RIBA	Catalogue of the Drawings Collection of the Royal Institute of British Architects, London 1968
RMI	Royal Manchester Institute. Signifies TWA exhibited at RMI, according to AH. TWA letters to RMI submitting works for exhibition
CS	Cecil Stewart, *The Stones of Manchester*, London, 1956

JS	Jonathan Schofield, *Illusion & Change: Manchester: Dreams of the city & the places we have lost*, n.d. See 'The amazing Mr Atkinson', pp. 20–25, 'plan after plan for Manchester all to no avail', p. 21
TLS	Tameside Local Studies Library
VS	Victorian Society: *Architects of Greater Manchester 1800–1940*, Neil Darlington notes, 13 Feb. 2018. Dates etc from contemporary sources
W	Wikipedia
WP	Wyatt Papworth, *Dictionary of Architecture*, Architectural Publications Society, 1892

Another view of the half-demolished St Luke's, Cheetham Hill, Manchester

Thomas Witlam Atkinson, 1799–1861
Summary of his Artistic Career

AFTER LEAVING HIS architectural career behind him aged forty-seven Atkinson[1] became an artist, spending the next seven years (1847–53) travelling almost 40,000 miles – possibly the greatest travels by any artist – particularly in Siberia, but also the Urals and today's Kazakhstan, returning with 'many hundreds of clever watercolour drawings … most valuable as representations of places hitherto unknown to Europeans'.[2] His own total was '560 sketches of the scenery',[3] i.e. an average of eighty a year, perfectly possible for sketches, although improbable for finished watercolours, particularly the large sizes he favoured. He certainly spent three days on one. His journals (now held at London's Royal Geographical Society) mention at least thirty for 1847 and eleven for 1848; they list for the years 1849–1852 respectively 109, twenty-eight, fifty-four and two, a total of 234, i.e. less than half his own total given above.

The subjects were usually remote and picturesque landscapes, and, sadly, most of the finished watercolours have been lost or are now unidentified, probably because his works are mostly unsigned, his style and he himself forgotten, his Russian scenes unrecognised in England. Only eight bear signatures (one on the reverse), one a monogram, and in three other cases his signature *is* appended with a date to long captions possibly in his own hand, but only on separate strips of paper the width of the painting – all too easy to mislay or destroy.

With so few paintings known, it is not surprising that he is today an unremembered figure, with brief references perhaps in many art encyclopedias, but totally omitted, for instance, from the *Grove Dictionary of Art* (thirty-four volumes, 41,000 articles), 1996, and the 753-page *Yale Dictionary of Art and Artists*, 2000. Yet in his lifetime Atkinson became a celebrity back in England, albeit as 'the Siberian traveller' rather than 'artist', after the publication of his first and very successful book *Oriental and Western Siberia*. But his paintings merit attention: large watercolours of wild and sublime nature, scenes of grandeur: 'rushing torrents, roaring waterfalls, precipitous crags, unattainable mountain peaks'.[4] He was a true romantic topographical artist (although he also portrayed the Kazakh way of life, including portraits of sultans), along with Caspar David Friedrich and nineteenth-century American landscape artists such as Frederic Edwin Church (1826–1900) or Albert Bierstadt (1830–1902), who also painted 'unknown territories' but largely in oils.[5] Yet engravings of his work – a medium which overtook watercolours in the later nineteenth century – seem very rare despite the many engravings in his two books.

Dramatic landscapes and, often, skies were his scene and, as a former stonemason, rocks and geological formations were his prime subjects. It is not known who, if anyone, influenced him, as most of his painting was done in Russia.



Maybe he had seen the exhibition of Turner's watercolours in London (1819–20). In Russia, watercolours developed in the eighteenth century, although mainly for architectural drawings, and in the next century the brilliant Bryullov and others worked in watercolours as well as oils, with the best-known landscapes produced by Alexander Ivanov.

He may well have been the first topographical artist in Siberia and Kazakhstan, although the earliest known images of the former are possibly those published in the late seventeenth century by the Danish diplomat Ysbrandt Ides and the French Jesuit Philippe Avril (who probably briefed artists after their return). The eighteenth century brought two artists, Johann Christian Berkhan and Johann Wilhelm Lürsenius, as part of the academic detachment of Bering's Great Northern Expedition, although cartography was then inevitably more important than topography, which seems to have been limited to distant views of towns.

Did Atkinson, like Bierstadt, invent subjects to a large extent, 'incorporating characteristic elements of the region rather than depicting identifiable places'?[6] In three surviving cases, at least, he surely did not, for the very detailed captions he added to them, identifying exactly what he was painting, will scarcely have permitted any artistic licence. Possibly the same holds for many others of his paintings, although no other similar captions are known to exist. However, his subject matter is still generally so remote that it remains an open question and, according to one Siberian historian,[7] Atkinson was prone to exaggerate scale, particularly by the size of the conifers he often depicted atop great cliffs – an Atkinson 'trademark'. Yet the implausible geological formations, as in his painting of Lake Kolyvan in the Altai, feature in old guide books as a famous sight. And if his paintings are indeed the first representations, exaggerated or not, of these isolated scenes as he claims in his preface, they surely merit a better place in – particularly Russian – art history.

Born in 1799 of humble parentage in a Yorkshire village, Atkinson was seen to have artistic talent when young and graduated from a stone quarry, carving stone and helping architects, to a successful career in architecture himself (see Appendix I). Aged thirty, he published *Gothic Ornaments*,[8] a folio of fine lithographs by himself and his half-brother, Charles. He was to exhibit four times at London's prestigious Royal Academy and, failing to win a competition for a major church in Hamburg,[9] travelled on to St Petersburg to begin a new career as a topographical watercolourist with an ostensibly 'open passport' requested from Nicholas I. He had sent the Tsar forty-nine drawings (synonymous with watercolours then) of 'English views and architecture of Italy, India, Egypt, Greece', where he had apparently travelled, perhaps on the run from his creditors, but the Hermitage considered them 'lacking the quality' expected of English watercolours, although deserving some attention, so the Tsar bought none.

Atkinson's style was to improve, crucially helped by Winsor & Newton's 'invaluable' moist colours utilising glycerine's moisture-retaining properties, which he was able to use 'on the sandy plains of Central Asia, in a temperature of 144°F (62.5°C); and in Siberia ... frozen as solid as a mass of iron, when the

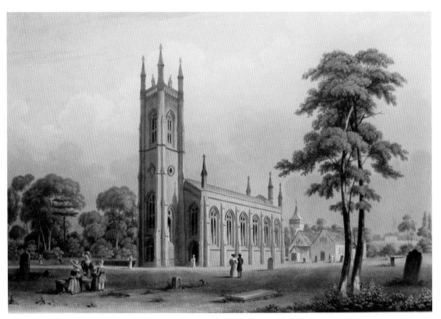

St Nicholas, Lower Tooting, watercolour by TWA

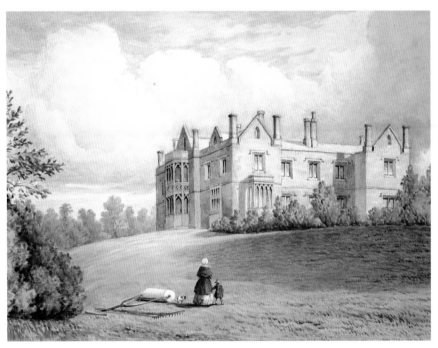

Hough Hill Priory, Stalybridge
Designed by Thomas for David Cheetham; demolished. Watercolour by TWA exhibited
R.A. 1832.

Observatory proposed to be erected at Kersal Moor, Salford, Manchester
Designed by Thomas but never built.

temperature was 11° below the point where mercury becomes solid'.[10] The air temperature is exaggerated[11] but Winsor & Newton's watercolour boxes once bore a testimonial that their colours had survived Atkinson's extremes of temperature. Perhaps his pencils originated from Alibert's mine,[12] if not from Borrowdale; his paper may have been English (popular in Russia together with French paper at the time), and we do not know if he was using sable brushes, which would have been appropriate since the sable is native to Siberia.

Now forty-eight, he spent the first year of his travels (1847) in the Urals, the Altai and 'the Kirghis steppes', today Kazakhstan, and returned to St Petersburg where he presented Nicholas I with twelve small watercolours (now in the Hermitage) of his expedition down the picturesque Chusovaya river in the Urals. The next year he married – bigamously – Lucy Finley, a twenty-nine-year-old English governess in St Petersburg, with whom he travelled for the next six years, with many adventures through the most scenically dramatic parts of southern Siberia and Kazakhstan. It was the mountain scenery that primarily attracted him: the Altai, Eastern Sayan and the Tien Shan's adjoining Alatau, after which they named the son born to them en route, with whom they travelled thereafter and who astonishingly survived.

Self-criticism was not in Atkinson's nature. But, self-confident, he was a romantic with talent, charm, egotism – and determination. Lucy later wrote of him: 'my husband does not permit impossibilities without proving them to be so'.[13] Through her connections in St Petersburg, they visited many Decembrist exiles in Siberia, including Nikolai Bestuzhev, a talented artist himself, well

known for the fine watercolour portraits of his fellow Decembrists.[14] Atkinson used sketchbooks, presumably small, as they travelled much on horseback through difficult terrain, across rivers and sometimes in 'torrential rain'. It was in the long spells in Irkutsk and Barnaul (and later St Petersburg) that he worked up his pencil sketches into finished watercolours.

They returned to Russia's capital finally in December 1853 and remained there for two years, Atkinson probably writing his first book and preparing watercolours for two albums which, for reasons unknown, were never published. He became increasingly anxious for Alexander II (the new Tsar) to see his watercolours, stressing the size – up to 213 by 142 cm: 'some of much greater dimensions than have ever been attempted in watercolour paintings[15]... from regions never before sketched or even visited by any European'.[16] Eventually the Tsar did see them and 'was much pleased'[17] but bought none; neither, apparently, did the Russian state. Atkinson must have been hugely disappointed but aimed at least to exhibit seventy-three finished paintings for a few weeks before he sent them to England, where they were shown at Colnaghi's, a leading London art dealer, in late 1856 – no sale records survive – and at the Royal Geographical Society in 1857.

Returning to London with his family in that year, he published the first book of his travels, *Oriental and Western Siberia*, 611 pages illustrated with twenty colour lithographs and thirty-two wood engravings – omitting all mention of wife and son. He dedicated it to Alexander II, who rewarded him with a diamond ring. The book, a great success, brought him fame, lectures and election to the Royal Geographical Society and the Geological Society. Four successive sales of a total of seventy-four watercolours took place at Christie's between 1858 and 1863 but with varying results.[18] His second book, *Travels on the Lower and Upper Amoor*, 1860, with no lithographs but eighty-three engravings, brought a second ring from the Tsar, but later proved to be in part a plagiarism of a recent Russian geographical work.[19] The title (foisted on him by his publishers?) is distinctly dubious, as is the title-page lithograph of the Amur, since Atkinson seems never to have been in the area and writes about it almost entirely in the third person. He is not known to have painted again – he was a traveller rather than an artist, travel really being his forte. When he died in 1861, Lucy was left virtually penniless, as any money went to Rebekah, Atkinson's first wife. Lucy published two years later her own (wonderful and absurdly neglected) account of their Siberian travels, *Recollections of Tartar Steppes and their Inhabitants*, with five unattributed engravings, perhaps taken from her husband's work.

Today all but forty-one of Atkinson's watercolours have disappeared without trace. See the catalogue raisonné below for the survivors, which comprise, among others, sixteen in Russia (twelve of them in the Hermitage), four in London's Royal Geographical Society, one in the Victoria and Albert Museum, one in the Harris Museum Art Gallery, Preston, two in Athens and fifteen in private British collections. Eleven of these last were bought in 1997 by a London dealer at a Christie's sale of contents from Raby Castle, Yorkshire. They were identified only a year or two later by chance.[20]

How to quantify Atkinson's total – including the lost – oeuvre? We know he intended to send seventy-three watercolours back to England from St Petersburg and brought back from Siberia 'many portfolios of sketches';[21] to the Christie's total of seventy-four we should add seven colour lithographs in his first book, making eighty-one *plus* a watercolour of the river Hook (see LA p. 307) and another of Kopal in the 'Kirghis steppes' sent to Prince Gorchakov, Governor-General of Western Siberia, 'I believe the first water-colour… [of] this part of Asia'.[22] These two at least are probably still in Russia, and perhaps some of the Colnaghi/Christie's watercolours have returned there too.

Dr Galina Andreeva, curator of the 1997 *Unforgettable Russia* exhibition in Moscow's Tretyakov Museum, asked all the Russian Federation's museums to notify her of any Atkinsons, but only two (in Krasnoyarsk) were added to the list.

To these can be added a possible fourteen more of the Chusovaya River as indicated by Atkinson's numbering system[23] – neither lithographs in Atkinson's first book nor in Christie's sales. There is one more, which exists only as a photograph of a dramatic mountain scene (the Altai?) in London's Witt Library at the Courtauld Institute; it is indubitably in T.W. Atkinson's style, not J.A. Atkinson's as attributed; but provenance, date and scene depicted are all unknown. This brings the total to ninety-eight, of which sixty-six – almost two-thirds – are lost. But even then, this does not take into account the Colnaghi's sale or what may have been sold (or presented) in Russia. And it is impossible to tell whether the 115 engravings in his two books and the five engravings in Lucy's book (unattributed, but likely to be from her husband's work) are from drawings or finished watercolours. But if the last, the total of missing paintings would be even higher.

Where the rest are is a mystery. A small pile of watercolours certainly perished many years ago in a fire that destroyed a grandson's house on Hawaii, but they were apparently flower paintings, not his subject at all. Could they have been by Lucy? But there are no indications that she ever painted.

How good was Atkinson as an artist? Vivian Mantel-French, a distinguished contemporary watercolour painter,[24] regards him as extremely talented and says: 'He produced really beautiful paintings rather in the style of John Sell Cotman, using flat washes, and his sense of atmosphere and interest in shapes is well before his time. He was very intelligent regarding the shape of the land, understanding it as a former stonemason and architect, and portrayed it with sensitivity and a beautiful atmosphere. He achieved his effects through glazes with a limited palette, and much of his work was done in a studio from sketches which is why he achieves such accuracy.'

His legacy is now hardly appreciated, but perhaps one day he will earn recognition even on the basis of the paintings which survive. It is greatly to be hoped that more will be discovered.

Catalogue Raisonné

Watercolours (and one drawing) on paper

1–12. Chusovaya River, Urals. 1847, 12 watercolours, all 21.5 x 29.8 cm, cat. nos 11174–85, inscribed 'Tchoussovaia' followed by a number between 1 and 26, thus denoting a possible 14 others of the series. Presented by the artist to Nicholas I. Hermitage Museum, St Petersburg.

13. *Kolyvan Lake in the Altai Mountains, Western Siberia.* 1847, s. & d., 33.5 x 51 cm. Long inscription on original mount detailing scene. Sale, Christie's 12 Dec. 1972; sale, Sotheby's 20 Feb. 1985. Exh. Barnsley, Yorks, 2015 (see page 300). Private collection, England.

14. *Altin-Kool [Lake Teletskoye] in the Altai Mountains, Western Siberia.* 1848, s. & d., 40.5 x 59 cm. Long inscription on original mount detailing scene. Sale, Christie's 12 Dec. 1972; sale, Sotheby's 20 Feb. 1985. Exh. Barnsley, Yorks, 2015 (see page 300). Private collection, England.

15. *A View on the Altin-Kool [Lake Teletskoye].* 1849, TWA monogram and d. 29 July 1849. Inscribed 'To Mr Basnin [mayor of Irkutsk] As a remembrance from T.W. Atkinson 10th March 1850'. Pushkin Museum, Moscow.

16. *A Night Scene at our Encampment on the Altin-Kool [Lake Teletskoye], Altai Mountains.* 1849, 61 x 88 cm (size of glass). Christie's sale 1858, bought Sir R.I. Murchison, donated 1930 by Roderick Murchison, nephew, to Royal Geographical Society, London.

17. *Lake Teletskoye, Altai Mountains.* 1850, s. & d. bottom right: 'T.W. Atkinson to M. Wasilievsky. Dec 10th 1850' (probably from sketch of 1849). Paper laid on canvas, 61.5 x 90.3 cm. P.I. Kuznetsov (merchant and goldmine owner) coll., A.P. Kuznetsova coll., from 1920 Krasnoyarsk Krai Museum of Local Lore, History and Economy, from 1958 Krasnoyarsk V.I. Surikov Art Museum, inv.529 ZHA-161. Exh: *Unforgettable Russia*, Moscow, 1997 (see page 300), no. 167, illustrated in catalogue with additional notes by A.A. Abisova.

18. *The Altai.* Mountain landscape, watercolour, gouache, paper on canvas, 59.1 x 88.3 cm. State Russian Museum, St Petersburg, inv. r.21976. Acquired 1935. Exh.: *Unforgettable Russia*, Moscow, 1997 (see page 300), no. 166, & additional notes as in no. 17.

19. *The Black Irkout, Oriental Siberia.* 1852. Whatman paper, 43 x 58 cm, s.& d. on mount 'T.W. Atkinson, 1852'. Long inscription on mount in artist's hand detailing scene. Kegan Paul, Trench, Trubnor & Co., 43 Great Russell St, London WC1. Bought by Victoria & Albert Museum for £12 12s, received 25 November 1954. Register no. P5-1954.

20. *The Borgon in the Altai.* 1853, s. & d. 'T.W. Atkinson, 1853'. 61.5 x 83 cm (size of glass). Christie's sale 1858, bought Sir R.I. Murchison, donated 1930 by Roderick Murchison, nephew, to Royal Geographical Society, London.

21. *Source of the Terric-Sou, Actou [White] Mountains, Chinese Tartary.* Date unknown, 66 x 100 cm (size of glass; the largest of Atkinson's known watercolours). Christie's sale 1858, bought Sir R.I. Murchison, donated 1930 by Roderick Murchison, nephew, to Royal Geographical Society, London.

22. *River Bea – Altai Mountains, Western Siberia.* No date. No size available. Torn in three places. Christie's sale 1858, bought Sir R.I. Murchison, donated 1930 by Roderick Murchison, nephew, to Royal Geographical Society, London.

Nos 23–33: provenance Christie's, 9 June 1858, bought Duke of Cleveland; by descent to Lord Barnard; bought by dealer, Christie's sale, Raby Castle, Yorkshire, 1 April 1997, cat. as 'English School, Circa 1840. Mountainous Landscapes in China (?)', the mounts bearing the original lot numbers of Christie's 1858 sale. Private collections, England.

23. *A Natural Arch on Nouk-a-Daban.* 41.2 x 58.8 cm, full-page tinted lithograph facing p. 593, *O & WS*.

24. *The River Terric-Sou, Kara-Tou, and Kirghis Steppe.* 40.6 x 59 cm, full-page tinted lithograph facing p. 564, *O & WS*.

25. *The River Djem-a-Louk.* Watercolour, 48.1 x 65.3 cm, full-page tinted lithograph facing p. 582, *O & WS*.

26. *Bouriat Temple and Lake Ikeougoune, Mongolia* (in fact Buryatia). 41.7 x 60 cm, full-page tinted lithograph facing p. 445, *O & WS*.

27. *A Natural Arch on the Baikal.* 48.4 x 66.2 cm, text engraving, *U & LA*, pp. 373 & 386 but note two figures in engraving, not one, and different background.

28. *Looking Down on to the Kirghis Steppe.* 41.5 x 58.9 cm, text engraving, *U & LA*, p. 236, but only the rock at right is identical to that in the engraving, the rest quite dissimilar.

29. *Tchim-Boulac, Alatou Mountains.* 1858, 48.6 x 66.3 cm. Similar but not identical to full-page tinted lithograph, *O & WS*, p. 570.

30. *Kessil-Tas, in the Kirghis Steppe.* 41.1 x 59.3 cm, alternatively 48.6 x 65.6 cm, text engraving, *O & WS*, p. 540.

31. *A Waterfall near the Source of the Kopal, Alatou Mountains, Chinese Tartary.* Acsou River gorge (?), 48.7 x 66.2 cm.

32. *A Waterfall through Mountains, possibly Dzhungarsky Alatau, Kazakhstan.* Exh: Barnsley, Yorks, 2015 (see page 300).

33. *Zabata-Noor and the Aba-gol Mountains, Mongolia.* Size unknown. Christie's sale 1858, lot 35, sold for £11.11.0.

34. *No. 69. A Waterfall near the Source of the Amoor in the Khingan Mountains, T.W. Atkinson 1852.* Signed on label attached to reverse, 66.1 x 99.1 cm. Christie's, lot 89, 29 April 1999, est. £2–3,000; bought in. Bonhams & Brooks, London, 28 March 2001, lot 55, £200; Sotheby's, 15 November 2001, unsold; Bonhams, London, 24 June 2003, lot 190, unframed; sold for £35 including premium. Perhaps his least satisfactory known work: overcrowded composition and in poor condition.

35. *Kara-Noor [Lake], Formed by Lava of the Djem-a-Louk, Saian Mountains, Mongolia* (in fact Buryatia). 1852, s. & d. 'Atkinson/June 1852' on mount, 40 x 58 cm. Private collection. Christie's, 9 June 1858, lot 27; Christie, Manson & Woods, 16 June 1862, lot 195; Christie's, Amsterdam, 16 January 2007, lot 308, sale no. 2732, E1440. Sphinx Fine Art, London. Reproduced inside front cover in Russian scientific journal *SCIENCE First Hand*, 5 June 2013, with article 'The Valley of Volcanoes, East Sayan', pp. 66–7.

36. *A View of Zlatoust Looking towards Alexander Sopka and the Urals Beyond.* 1854, inscribed on the reverse with title, plus: 'No. 25 ... T W Atkinson 1854.' Pencil and watercolour, 66 x 99 cm. Christie's, South Kensington, 1 Dec. 2005. Joint lot 228, one of a pair with no. 37. Est: for the pair £5–7,000. Sold for £12,000.

37. *A View of Zlatoust from the River Ay.* Pencil and watercolour, heightened with white, on paper, 66 x 99 cm. Christie's, South Kensington, 1 Dec. 2005. Joint lot 228, one of a pair with no. 36. Est: for the pair £5–7,000. Sold for £12,000.

38. Pencil sketch of unidentified (fanciful?) Russian wooden chapel on loose sheet of yellow paper found in Atkinson journal.

39. *Nave of York Cathedral* [sic]. Date unknown, 60.3 x 46.4 cm. Dewhirst Bequest, 1903. Harris Museum, Art Gallery & Library, Preston, UK.

40. *Athens: Partial View with the Olympeion and the Acropolis in the Background.* Date unknown, 37 x 54 cm. Most probably bought by the Museum's founder, Lambros Eutaxias, unconfirmed. Museum of the City of Athens, cat. no. 33.

41. *Athens: Imaginary Greek Landscape.* S., date unknown. Museum of the City of Athens, cat. no. 34. 45 x 33 cm. Provenance: as no. 40.

Exh.:
Moscow: *Unforgettable Russia. Russians and Russia through the eyes of the British XVII–XIX centuries.* State Tretyakov Gallery, 1997.

Barnsley, Yorkshire: *The Hidden Artists of Barnsley; Barnsley Art on Your Doorstep,* 2015

The above is an expanded version of the author's article in English and Russian, 'Lost (and Found): the Russian Watercolours of Thomas Witlam Atkinson, "the Siberian traveller"', in the catalogue of 'Unforgettable Russia...', State Tretyakov Gallery, Moscow 1997, where two of TWA's paintings were exhibited.

Notes

All unattributed T. W. Atkinson quotations are from his *Oriental and Western Siberia* (O & WS), 1858, or in later chapters *Travels in the Regions of the Upper & Lower Amoor* (U & LA), 1860.

All unattributed Lucy Atkinson quotations are from her *Recollections of Tartar Steppes*, London, 1863, published under the name of 'Mrs Atkinson'.

TWA j.: T. W. Atkinson journal. Atkinson's journals are in the Royal Geographical Society, formerly in the possession of Paul Dahlquist. The two dates for entries from 1850 on represent Western (or Gregorian) and Eastern (or Julian) calendars, the latter twelve days behind and used in Russia until after the 1917 Revolution, although the Russian Orthodox Church still retains the Julian calendar.

His last journal was to be of 1851, although the Atkinsons did not return to St Petersburg until December 1853. It generally devotes one date per page, is in tiny faint pencil throughout, other than the inked dates atop.

The almost total lack of dates in his two books probably obscures the fact that he was travelling with wife and small child, and conceals his seemingly fictitious visit to Mongolia in his first book. But the dated journals are nevertheless sometimes confusing, because of the difference between European and Russian dates and his habit of inserting entries completely out of context and often even in a different year, when he runs out of paper.

Occasionally, his misspellings have been corrected in pen – presumably Lucy's corrections.

Prologue

1 The Central State Archive of St Petersburg, No.161, II. 85, 1846, file 58, p.3.
2 William Atkinson's will, 1st November 1826.
3 Wilkinson. The description of Atkinson's early life is taken almost entirely from Wilkinson's memoir.
4 By his step-uncle, Matthew Bates, of Tivy Dale, Cawthorne, the brother of his father's first wife.
5 Wilkinson, op. cit.
6 Ibid.
7 Stirling, *The Letterbag of Lady Elizabeth Spencer Stanhope*, II, 95.
8 William Atkinson divided his estate equally between his two daughters, Ellen and Anne, leaving nothing to Thomas, perhaps because they had split or he had benefited him already.
9 Wilkinson 353, citing the Rev. Charles Spencer Stanhope's unpublished memoir of Atkinson, now lost. Spencer Stanhope, tenth child, born 14 October 1795, Vicar of Weaverham, Cheshire, and for fifty-two years non-resident (in effect absentee) Vicar of Cawthorne. Married Frederica Goodenough 1840. Died 1874, aged seventy-nine. Stirling, op. cit., I, xviii, ix, xx.
10 Her death certificate states that Rebekah Atkinson died on 7 May 1872 aged seventy-seven, so she must have been born in 1795 and aged twenty-four on her marriage.
11 International Genealogical Index. Baptised 22 August 1792.
12 Stirling, op. cit., I, xxix.
13 Ibid., I xvii, xxix.
14 Dr Thomas Dimsdale, pioneer of smallpox inoculation, was given the title of Baron by Catherine the Great.

15 Stirling, op. cit., II, 19; I, xviii. It was an intelligent and well-educated family: even the daughters 'having learnt French, German, Latin and Italian … are now at a loss to find something to know, and talk of learning Russian. They will be dyed blue-stocking up to their chins.' Philip, a younger brother, became page of honour to both George III and IV and ultimately British Army general. Ibid., I, xxiv; II, 106.

16 Wilkinson, 353, quoting from Charles Spencer Stanhope's unpublished memoir of Atkinson.

17 Proceeding alone from Cadiz, he was handed over to the Napoleonic authorities, spent eight weeks in a dungeon wrongly accused of a plot and expecting death at any time. Transferred to a fortress, he was given parole which suddenly became invalid, and after many hair's-breadth escapes, he managed to reach Germany and finally return to Cannon Hall. But returning to France after Waterloo, he had to flee France a second time, just ahead of Napoleon's return from Elba. Stirling, op. cit., I, 200, 217, 241, 278.

18 Wilkinson, 354.

19 Colvin, *Biographical Dictionary of British Architects, 1000–1840,* 4th edn, 2008.

20 Records of Manchester.

21 DNB & Society of Antiquaries, 3 April: The Manchester Historical Recorder 136.

22 According to Records of Manchester only two drawings by him seem to have survived and those unauthenticated, but his attractive watercolour of Flint Castle is in the National Library of Wales.

23 Proceedings of the Royal Geographical Society.

14 Ibid.

Chapter 1

1 Pitcher, *When Miss Emmie was in Russia,* 9.

2 Born in Russia of an Italian noble family, the young Rikord had entered the Russian navy, serving for four years in the North Sea on patrols designed to aid Britain against Napoleon, 1794–7. He was authorised to stay in London to learn English, French and naval science; serving in the Royal Navy, he helped capture several Spanish ships and visited many foreign ports. Returning to Russia in 1805, he was promoted to captain, appointed governor of Kamchatka (1817–22), and admiral in 1843. A founder member of the Imperial Russian Geographical Society, 1845.

3 Andrea Wulf, *The Invention of Nature: The Adventures of Alexander von Humboldt, the Lost Hero of Science,* London, 2013.

4 Thomas was to be in touch with Humboldt in 1856.

5 Warnes, *Chronicle of the Russian Tsars,* 168.

6 Lady Londonderry in Cross, *St Petersburg,* 160.

7 Andrew Buchanan (1807–1882), later Sir Andrew Buchanan, Bt, ambassador extraordinary to Russia in 1864. Resident at nearly every European court, first as attaché, afterwards as ambassador (Oxford Dictionary of National Biography).

8 Nesselrode, who, surprisingly, spoke very little Russian, had become Russia's foreign minister in 1816 in the reign of Nicholas's elder brother, Alexander I, and remained in post for 30 years, right through the Napoleonic wars.

9 23 August.

10 Lev Alekseevich Perovsky, Minister of Internal Affairs (1841–52).

11 Austin was to make two tours of Siberia, the first partially with Thomas, when he crossed the Altai mountains to the Chinese border; on the second, with his wife, he visited several places of exile, again reaching the Chinese border, and then lived for some time in Irkutsk. He went on to survey new railway lines in Brazil, the Crimea and the Ottoman Empire, and in later years worked on several patents, including a new form of ship's propeller. Source: Minutes of the Proceedings of the Institute of Civil Engineers, which elected him a member in 1858.

12 Maria Markova: Fond No. 1689, op.1, 1847–9, files No. 4. 1848, 05, No. 5790, St Petersburg State Historical Archive.

13 See Catalogue raisonné.

14 Surely most unlikely.

15 Vine Street had been quite a well-to-do street for merchants, etc., but by the end of the 1830s, after the 'Asiatic' cholera epidemic, which actually began in Sunderland in 1831 and was to claim some

52,000 lives across the country, the street had badly deteriorated, with open dung-heaps, and was demolished in the late 19th century. John Lilburne (1614–1659), 'Freeborn John', Leveller and radical, once owned a mansion in Vine St, and it was also the home of Captain Joseph Wiggins (1830–1905), who pioneered a mercantile sea route from the North Sea to Western Siberia. Source: Sunderland Antiquarian Society & www.historyhome.co.uk.

16 Pitcher, xi.

17 The conspiracy culminated in December (hence the name) 1825 in a failed revolt in St Petersburg for political reform. Three Muravyov-Apostols (a different branch of the family) were also Decembrists, and a cousin, Sergei Muravyov-Apostol, had been hanged as one of the conspiracy's five leaders.

18 Ulam, *Russia's Failed Revolutions*, 120.

19 Figes, *Natasha's Dance*, 19–20.

20 Mironenko, *Dekabristy. Biograficheskii spravochnik.*

21 Count Sergei Sheremetev, *Graf Mikhail Mikhailovich Muraviov i ego doch* [Count Mikhail Mikhailovich Muravyov and his daughter], St Petersburg, 8 April 1892. Sofia Mikhailovna Sheremeteva (*née* Muravyova, 1833–1880), married S.S. Sheremetev in 1856, and had 11 children. Her health was not good and she died at the age of 46. She is buried with her parents in a memorial chapel in the Alexandro-Nevskaya Lavra monastery. Her husband and a son lie outside.

22 He would have told her he was a widower, but we simply do not know what had happened to his first wife Rebekah meanwhile.

23 Robinson, *Postmarks.*

24 Collie & Diemer, eds, *Murchison's Wanderings in Russia*, 46.

25 His journal also states 5 March, yet his subsequent book gives 6 March for his arrival at Ekaterinburg, 1707 versts to the east.

26 A portable barometer, adapted for safe transportation, used in measuring the heights of mountains. *Webster's Revised Unabridged Dictionary*, C. & G. Merriam Co., 1913.

27 Teissier 29.

28 But, according to his first book, between 12 and 1 midday (page 11), so an odd discrepancy when he is always so concerned to record times of arrival and departure.

29 It was on this hill that stood the Ipatev house where the Romanov family and their servants and doctor were murdered in 1918. The house was pulled down by Boris Yeltsin, then regional head of the Communist party, on Moscow's orders in 1977, and the Cathedral of the Blood now stands on the site, echoing the cathedral of the same name in St Petersburg where a bomb fatally wounded Alexander II.

30 Howe, *The Soviet Union: A Geographical Study*, 343.

31 The Northern Urals are higher than the Central or Southern Urals, but even then their highest point, Mount Narodnaya, at 1,895 m, is only 550 m higher than Ben Nevis (1,345 m). (Scottish visitors have likened the gently undulating southern chain to the Lammermuir Hills of southern Scotland.)

32 Humboldt predicted diamonds, because of the gold and platinum present in alluvial deposits, 'and within a few days of his arrival [in 1829] the first diamond was discovered'. Collie & Diemer, eds, *Murchison's Wanderings in Russia*, 23 note. While Princess Maria Volkonskaya was changing horses in Ekaterinburg on her way to join her Decembrist husband in Siberian exile, 'local merchants tried unsuccessfully to draw the "rich princess's" attention to amethysts, opals, chalcedonies, topazes, aquamarines, emeralds, and other varieties of rock crystal, all exhibited on the counters in huge mounds. Magnificent malachite doors like those in the Winter Palace, superb urns, vases, malachite tables and stools could be bought at incredibly low prices, a king's ransom for some enterprising merchant. But what use would they be to Maria? She looked utterly indifferent and ordered the coachman to speed on.' Sutherland, *The Princess of Siberia*, 142.

33 Lincoln, *The Conquest of a Continent*, 137.

34 Ibid., 95.

35 RT/Russiapedia: *Prominent Russians.*

36 Janet M. Hartley, *Siberia: A History of the People*, Yale University Press, 2014.

37 Thomas Esper, 'The Condition of the Serf Workers in Russia's Mettallurgical Industry 1800–1861' in *The Journal of Modern History*, Vol. 50, no. 4, Dec. 1978, 583.

38 Lincoln, *The Conquest of a Continent*, 96.

39 RT/Russiapedia, op cit.

40 In his time in the Urals Thomas amassed 72 varieties of these semi-precious stones and, though it must have been a problem to transport them, some at least were exhibited in London on his return.

41 The nuts of the large cones of the Siberian pine *Pinus sibirica* are still harvested today, often by banging on the tree-trunks. The tree can grow to both a great age (the oldest cross-dated age is 629 years in Mongolia) and great size (e.g. 48 m tall and 350 cm in circumference on the Altai's Kedrovy Pass). Source: The Gymnosperm Database.

42 But there are no descriptive notes in his 1847 gazetteer-cum-journal, only dates without even naming the month. Could there have been a journal now lost? Without it he surely could not have remembered all the details in the first ten chapters of this, his first book. 37.

43 12 were presented to the Emperor and are now in the Hermitage collection.

44 Collie & Diemer, eds, op. cit., 238.

45 Quoted by Atkinson, 46, from Murchison, *The Geology of the Oural*, 125: an artist, furthermore, who could also use words well despite his inadequate education.

46 Source: The gymnosperm database. But Thomas seems to differentiate wrongly between these 'magnificent pines' and the Siberian 'cedar'. The latter term is a common mistranslation of the Russian word *kedr* instead of 'pine' which he mistakenly calls *Pinus cembra* rather than *Pinus cembra var. sibirica* or simply *Pinus sibirica*.

47 Kachkanar still has very large deposits of (albeit low-grade) iron ore, increasingly relied on. Howe, op. cit., 350–51.

48 Kalesnik, *Rossiiskaya Federatsiya: Ural*, 1969.

49 Collie & Diemer, op. cit.

50 The Voguls, now known as Mansi, a local indigenous Finno-Ugric people.

51 A rare reference to his watercolours per se; normally it is either 'pencil' or 'drawing'.

52 A School of Design had been founded 70 years before and had sent several students to Italy to study for some years with Italian artists in order to decorate the sheet-iron tables, boxes etc. previously made here.

53 Collie & Diemer, op.cit., 107. Anatoli turned to diplomacy and became Russian ambassador to Tuscany, where he acquired 42 hectares of marshy land and built the lavish Villa San Donato, from which he took a princely title. Besides doing much public good in Tuscany, he amassed a fine art collection, its highlights now in London's Wallace Collection.

54 Collie & Diemer, op. cit., 234–5.

55 See Captain James Abbott's tribute to Anosov in *A Journey from Heraut to St Petersburg* (1843) quoted by Atkinson, 120–21. Above Anosov's grave in Omsk a plaque reads: 'In this place was buried the great Russian metallurgist Anosov Pavel Petrovich, 1787–1851.' *Pamyatniki Sibiri. Zapadnaya Sibir i Krasnoyarskii Krai*, Moscow, 1974, 191.

56 Then the centre of the gold region in the southern Urals.

57 Nerchinsk was the main prison of East Siberia, specifically for political prisoners/offences from 1826 to 1917. Wikipedia. Inmates were part of the katorga – or penal labour – system, primarily in the area's extensive silver ore mines. The 19th century saw a total here of more than one million convicts.

58 Cochrane, *Narrative of a Pedestrian Journey through Russia and Siberian Tartary, to the Frontiers of China to the Frozen Sea and Kamtchatka*, 2 vols., London, 1824.

59 O & WS 167. The 'Kirgiz Steppe' still appears in some modern atlases although it is now a misnomer for the 'Kazakh steppe' of the huge Central Asian Republic of Kazakhstan.

60 Date uncertain. September of 1847(?).

61 TWA j. 28 August 1847.

62 Ibid., 1 September 1847.

63 Ibid., 2 September 1847.

64 TWA j. Sunday 7/19 and Monday 8/20 September 1847.

65 Ibid., 20 September/2 October 1847.

66 Ibid., 20 September/2 October 1847.

67 Ibid., 21 September/3 October 1847.

68 Ibid., 22 September/4 October 1847.

69 Relatively shallow, but allegedly 65 million years old, formed in the late Cretaceous period and, if so, three times the age of Siberia's Lake Baikal, usually reckoned by far the world's oldest lake at some 25 million years old. The Irtysh flows through it and is its only outlet.

70 The notebooks varied slightly in size: the one for the next year was about 12 by 8 cm to fit a large pocket. He called it 'Rough notes from my Journal 1848', and divided each page in three equal parts with two horizontal ink lines, heading each page with the pre-written date of both the Gregorian and Julian calendars. But it was far more than 'rough notes': a succession instead of usually complete sentences and, far more often, paragraphs in fortunately now larger ink or pencil, written in a regular sloping hand with idiosyncratic spelling (retained here throughout) and punctuation (minimally edited for better understanding). Perhaps a journal was his original intention, but it became instead two long books.

Chapter 2

1 The association of British merchants in Russia was known as the British Factory. Acknowledgements to Prof. Anthony Cross.
2 All Lucy's dates are according to the Western calendar, twelve days ahead of the Russian Orthodox calendar.
3 Irakli Abramovich Baratinsky (1802–1859), brother of the poet Evgeny Baratinsky.
4 Princess Abamelek Anna Davydovna (1814–1889), princess by birth, translator of Pushkin (who dedicated a poem to her), Lermontov and other Russian poets into French.
5 In this, his second year of travels (1848), Thomas began to record events and observations in a series of small, now entirely blank notebooks (no longer a gazetteer), one per year. However, he inserted throughout in advance two horizontal lines in ink on each page, thus dividing them into three equal sections with the dates inserted atop each, now using either pen or pencil. But his system inevitably did not work, for not only are there many days left blank for one reason or another but he found there was not enough space for certain entries so had to continue them pages later, e.g. p. 68 is continued on the whole of pp. 125, 126, and half 127; and this is only one of several examples, though possibly the longest. Yet there are few pages blank at the end of this journal.
6 Interesting that they had enough money to pay Nikolai's wages a year in advance (obviously keeping more in reserve). Despite a great deal of hospitality, due above all to the Tsar's entrée, how they were able to pay all their expenses remains a puzzle, and there is no evidence that Thomas was a British spy. Lucy's wages for the past eight years must have been a help at the very least, assuming she had spent little of her savings.
7 Major-General Vladimir Andreevich Glinka (1790–1862), a former fringe member of the Decembrist movement, head of the Urals' mines (1837–56) and later senator.
8 His idea it was to build a factory in Ekaterinburg producing large-scale machinery such as steam engines and hydro-turbines.
9 Ivan Dmitrievich Yakushkin (1793–1857), one of the leading Decembrists. In 1816 he had founded a secret society, the 'Union of Salvation', together with two Muravyovs (Alexander and Nikita), two Muravyov-Apostols (Matvei and Sergei) and Prince Sergei Trubetskoi, who enters the story later.
10 This was Drosida Ivanovna Artenova (1817–1886), the widow of Wilhelm Karlovich Küchelbecker, Decembrist, well-known poet and great friend of Pushkin from their time at the Tsarskoye Selo Lycée. She was not a peasant, as Lucy thought, but a postmaster's daughter.
11 He was one of three brothers who spent their childhood in Europe, where their father was variously ambassador, and were schooled in Paris. Interestingly, their parents kept the existence of serfdom in Russia secret from them until their very return to the motherland.
12 Pyotr Dmitrievich Gorchakov (1789–1868). Ten years older than Atkinson, Gorchakov was a tall, dignified and much-decorated professional soldier, ending as full general. Veteran of the 1812 Napoleonic War and other foreign campaigns of the Russian Army, he served in the Caucasus and Russo-Turkish and Crimean Wars. Governor-General of Western Siberia, 1836–51. His brother Mikhail served as Viceroy of Poland.
13 Now Kuibyshev of Novosibirsk region, not to be confused with the former Kuibyshev of Soviet times which has now reverted to its original name of Samara.
14 It is almost always to Lucy that we are indebted for such anecdotes. Thomas was much more interested in the actual travels and topography.

15 See Natalia Volkova, *The English in Siberia. Adventures and anecdotes. Thomas Witlam Atkinson and Mrs Lucy Atkinson.* Barnaul, 2012.

16 TWA j. 1848, 52.

17 John Bell, *A Journey from St Petersburg to Pekin 1719–22*, edited by J.L. Stevenson, Edinburgh, 1965.

18 So-called 'Russian service', as it is now known, i.e. each course served on large platters from which diners helped themselves.

19 Oddly, not included in his long list.

20 TWA j. 14 June.

21 TWA j. 15 June.

22 TWA j. 16 June.

23 TWA j. 17 June.

24 TWA j. 18 June.

25 TWA j. Monday 7/19 June. LA words identical to TWA journal.

26 Kalesnik, *Zapadnaya Sibir*, 330.

27 'Mistaken Foreign Myths about Shambhala', Alexander Berzin, The Berzin Archives, 2003, online.

28 Due both to their terrain and location in a crossroads of civilisation, the Altaian people are predominantly rural even today and made up of five small ethnic identities with their own Turkic languages: Altaj-kiži and Telengit in the south (primarily livestock herders in high mountains and wide steppe) in one language group, and Kumandin, Tubalar and Chelkan (mostly hunter-gatherers in low mountains and dense forest) in a relatively small part of the north in another, dissimilar, language group. These last three languages have, sadly, now almost disappeared.

29 Or Kalmyks, a traditionally Buddhist Mongolian people who migrated in the 17th century from Dzhungaria, now living principally in Kalmykia, west of Kazakhstan.

30 Virginia le Page, *Shambhala: The Fascinating Truth behind the Myth of Shangri-La*. Quest Books, USA.

31 Mikhail P. Gryaznov, *South Siberia*. Ancient Civilizations series, London, 1969. Many of these famous treasures are now in St Petersburg's Hermitage Museum.

32 In his book Thomas gives the prices in pounds, shillings and pence: thus a pood of white flour cost 3s 4d, a pood of beef between 2s and 3s 2d, a pood of salmon 6s, a brace of grouse 6d, a hundred eggs 1s, and both raspberries and strawberries 8d for 2 gallons.

33 Having studied with a pupil of Linnaeus as well as with von Humboldt, at the age of 29 Semenov made an 18-month journey via the Altai to the virtually unknown Tyan Shan mountains on the Russian–Chinese border, collecting geographical and botanical specimens and recording both topography and meteorology. Beginning with one serf servant, only much later was he given a Cossack escort. See Colin Thomas, ed., *Travels in the Tian Shan, 1856–1857* by Pyotr Petrovich Semenov, London 1998. Thereafter he organised many important scientific expeditions, compiled encyclopaedias and major statistical reports and for 40 years ran the Imperial Russian Geographical Society, of which he became Vice-President in 1873. In 1882 he became a senator and in 1897 a member of the State Council. Encyclopedia.com.

34 By the term 'dinner' Thomas and Lucy generally mean lunch, a meal Russians tend to eat in the afternoon; the Atkinsons hardly ever use the word 'lunch', if at all.

35 Standard at that time for all Russia.

36 The many apparently military ranks which the Atkinsons mention so often were usually not military at all but civilian, originating from Peter the Great's 1722 table of ranks which developed in three main categories – military, civil and court – so that, for instance, mining engineers would wear uniform according to their rank (roughly ten) up to general with a 'parade dress' and ceremonial sword for higher ranks.

37 A portrait of one of Sokolovsky's two sons, Alexander Lukich, has been attributed to Thomas Witlam Atkinson, although it was painted in oils, which Thomas is not known to have used otherwise. Alexander Lukich, a talented son, was to publish eight volumes of his Shakespeare translations.

38 The men would dig large holes 50 or 60 paces apart and usually 5 to 6 ft down to the gold-bearing bed of sand and gravel; the sand would be washed off; the officer would note the proportion of gold; and Sokolovsky, who had for long been compiling an exemplary geological map of the Altai, would decide in Barnaul which deposits would be economic to exploit.

39 'Altai' means 'Gold Mountain' in Mongolian, and it was Altai gold, mined for millennia, from which

the Scythians fashioned their magnificent (and rightly famous) gold artefacts. Altaian gold evidently reached the Greeks, and perhaps the superb pieces from the tomb of Philip of Macedon, Alexander the Great's father, now in Thessaloniki's museum, came in their unwrought state from the Altai. In June 2015 geologists announced the discovery in the Anuy river valley north of the Altai mountains of a huge gold deposit weighing just over 22 tons and worth up to $850 million. *The Siberian Times,* 2 June 2015.

40 Author's calculation.
41 TWA j. Tuesday 8/20 June.
42 TWA j. Wednesday 9/21 June.
43 TWA j. Thursday 10/22 June.
44 TWA j. Friday 11/23 June.
45 TWA j. Saturday 12/24 June.
46 Author's estimate.
47 TWA j. Sunday 13/25 June.
48 TWA j. Tuesday 15/27 June, 57.
49 TWA j. Wednesday 16/28 June.
50 TWA j. Thursday 17/29 June.
51 TWA j. bottom 64.
52 TWA j. Friday 9/21 July.
53 Nuts of the Siberian pine (*Pinus sibirica*), still mistakenly called cedar or kedr.
54 TWA j. 11/23 July; LA.
55 TWA j. Monday 12/24 July.
56 The nomadic – and shamanistic – Kalmyks, now known as Altaians, whom the Atkinsons were about to encounter, were (and still are) one of Siberia's smaller Turkic minorities. Population in the 2010 census was below 75,000. Jacquemoud 26. Mongoloid in appearance, their dress and language at the Atkinsons' time still owed much to the invasion six centuries earlier by Genghis Khan's horde, led by his son.
57 TWA j. 25 July.
58 LA; TWA j. 26 July.
59 TWA j. 26 July.
60 Thomas's near-obsession with recording in his journal and later in his books the distances they were travelling was perhaps to impress both himself and his readers. TWA j. Tuesday 13/25 July.
61 LA; TWA j. Thursday 15/27.
62 LA; TWA j. continued from 66 Thursday 15 July.
63 TWA j. 28 July.
64 TWA j. 16/28 July.
65 TWA j. 28 July.
66 TWA j. 29 July.
67 His underlining. The Natural History Museum (Plants Division) think he must be referring to *Matteuccia struthiopteris*, ostrich fern or ostrich feather fern, common in the Altai, where it grows in swathes up to c. 1 m tall.
68 TWA j. Sat 17/29 July. Lucy uses the same words.
69 They set off early, says Lucy; Thomas says at 10 o'clock. A slight discrepancy.
70 Lucy mentions Byron; she has already referred to Orpheus. Her education, particularly with her father a teacher, must have been much better than Thomas's, and her years as a governess must have greatly helped too.
71 TWA j. Monday 19/31 July. If Lucy wins with her anecdotes, Thomas wins with his descriptions.
72 TWA j. 20 July/1 August.
73 'When the wind comes down from the Mountains', Thomas noted, 'the waves rise to a great hight and make a tremendous noise as they lash the Rocks It is very dangerous for any boat on the lake even in a moderate wind but in a squall no boat could live. Our Kalmucks were uncommonly attentive to certain signs in the Sky and mountains erer [ere] they would put off into this broad basin. I thought them cowards at first but I soon found they understood very well the difficulties and dangers to be encountred'. TWA j. Tuesday 20 July/1 August 1848.

74 Thomas depicted the exotic scene in a large watercolour now in the Royal Geographical Society, London.

75 Forsyth, *A History of the Peoples of Siberia,* 184.

76 Forsyth, op.cit., 184.

77 *Bolshaya Sovetskaya Entsiklopediya,* Moscow, 2002.

78 Kalesnik, *Kazakhstan,* 361.

79 Shamanism: the animist religion still practised by many of Siberia's indigenous peoples today where the shaman or tribal priest is believed to enter a powerful spirit world by achieving a different layer of consciousness, usually by means of a ritual drum. Every place, every inanimate object is believed to have its own individual spirit. Many Altaians still believe in spirits who live in upper, middle and lower worlds. Jacquemoud 65–69.

80 It was the valuable furs, particularly sable, of the immense Siberian taiga which had propelled Russia's conquest of Siberia. See Hartley, *Siberia: A History of the People,* 2014.

81 2s 9d and 3s 8d a month.

82 Blanchard, Russia's *Age of Silver,* 98. The monumental 18th-century tomb of St Alexander Nevsky (1211–1263) now in the Hermitage was made of one and a half tons of pure Altai silver. Petersburg city.com.

83 Blanchard, op. cit.

84 Semenov, note 30.

85 TWA j. Tuesday 31 July/12 August.

86 Semenov, 31.

87 Semenov, 46.

88 Now in north-eastern Kazakhstan and renamed Semey to avoid association with the Semipalatinsk Test Site of atomic bombs for 40 years (1949–89).

89 Dostoevsky, *Notes from the House of the Dead,* 1861–2, 1.

90 The Tatars or Tartars: a Turkic (and Muslim) people with their own language living in both Europe (e.g. Crimean Tatars) and Asia in five major groups, the largest being the 6 million or so Volga Tatars of Tatarstan – the Atkinsons came through its capital of Kazan – and Bashkortostan (formerly Bashkiria). The 500,000 Siberian Tatars (2002 census) live in a west–east strip including the Altai. Lucy was to call her book *Recollections of Tartar Steppes and Their Inhabitants,* using the wider Russian connotation of the time, namely that anyone with oriental features in the Empire was loosely called Tatar.

Chapter 3

1 Atlas SSSR, Moscow, 1983.

2 Wheeler, *The Modern History of Soviet Central Asia,* 7.

3 Ibid., 11.

4 The word 'horde', originally from the Turki 'ordī' or 'ordū', meaning 'camp', signified the civil and military structure of nomadic steppe peoples – highly organised in Genghis Khan's time, not at all the disorganised rabble we understand today. *Aziatskaya Rossiya* ('Asiatic Russia'), cited by Wheeler, op. cit., 12, 238 etc.

5 Olcott, 57.

6 R.A. Brown, French article, 51. Cited by Wheeler, op. cit., 237, 239.

7 Ibid., 237.

8 Olcott, 65–6.

9 *Aziatskaya Rossiya,* cited by Wheeler, op. cit., 53.

10 TWA j. 5 September 1848.

11 Teissier, ed., *Into the Kazakh Steppe,* 2014, p.10.

12 Ian R. Christie, *The Benthams in Russia* 1780–1791, Oxford/Providence 1993.

13 Even eight years later travellers – and the Atkinsons may well have been the very first apart from the Cossacks, troops, merchants and settlers – could not take this route south without an escort of two to five Cossacks. Semenov 46.

14 TWA j. 59 & LA 86 almost identical wording.

15 TWA j. 133.

16 Ibid., 84.
17 Ibid., 134 – continued from 84.
18 See lithograph, TWA, O & WS, 279.
19 TWA j. 7 September 1848.
20 TWA j. 85, 8/20 September 1848.
21 TWA j. & LA 87 identical.
22 TWA, U & LA 33–34. He would hardly have included this in his first book, dedicated to Alexander II.
23 Atlas SSSR & Semenov, 51, footnote: 288 km.
24 TWA j.
25 Schreiber, 85.
26 TWA j. 136 continued from p. 85, 10 September.
27 TWA j. 138.
28 TWA j. Saturday 11/23 September 1848.
29 TWA j. 11 September.
30 TWA j. 12 September.
31 TWA j., 129 continued from 86.
32 TWA j. 130, 13 September, & LA 100, identical phrase.
33 Ibid.
34 TWA j. 13 September.
35 TWA j. 131, 13 September.
36 Ibid., 13 September.
37 Ibid.
38 TWA j. 14 September.
39 Olcott, 278.
40 TWA j. 14 September.
41 Ibid
42 LA. 103, TWA 141, 15 September, almost identical.
43 TWA j. 15 September, LA phrase 103 identical.
44 TWA j. 141, 15 September.
45 Ibid., 15 September.
46 Ibid.
47 Semenov, 53.
48 TWA j. 16 September.
49 Ibid.
50 LA105, '13 days, 2 of which lost by our staying on the way' at Ayaguz. Arrival Kopal 20 September, no departure date given for Ayaguz. TWA j. indicates 11 days' journey: left Ayaguz 9 September, no arrival date given for Kopal. TWA 114, U & LA 154.
51 Baron Alexander Ludvigovich Wrangel came of a well-known Baltic German family which produced the Arctic explorer (after whom Wrangel Island is called) and the White general of the Civil War. He graduated from St Petersburg's élite Corps de Pages, joined the army in 1838, and, still a young man, was appointed major in December 1847 and then, from the following January, as the first *pristav* or superintendent of the Great Horde, commandant of the Kopal area and adjutant to Gorchakov. Discharged in 1850 because of illness, he went on to several further postings.
52 'Alatau' in Thomas's journals is always spelt 'Alatou', the Kazakh as opposed to the Russian transcription, but 'Alatau' became the permanent version after their return to England. Source: Sergei Proskurin.

Chapter 4

1 Less than a hundred years earlier, the Atkinsons' compatriot, Dr Thomas Dimsdale, an early proponent of vaccination, had successfully vaccinated Catherine the Great and her heir, the 14-year-old Grand Duke Paul, which set an example to Russia and indeed to Western Europe. See Prologue.
2 Diplomatically, Thomas avoids saying that one of them was Gorchakov, Governor-General of Western Siberia, to whom he and Lucy were indebted for authorisation to visit the Kazakh steppe.

3 Atkinson archive, Hawaii. Dahlquist Coll.: TWA correspondence, 19 November 1848.

4 He was to set it himself: 'rough surgery but it succeeded'.

5 TWA 1849 journal: Intriguingly, inside the front cover, written almost entirely in a very small pencil hand (other than a list of his sketches at the end, partially in pen), is a loose, handwritten slip of paper which reads: 'Captain Jack R.N. [Royal Navy] commanding Her Majesty's Ship Thunder. 101 Guns' (there was no such ship; maybe HMS *Thunderer*). Was this captain of the Royal Navy someone whom the Atkinsons met somewhere in Russia? We simply do not know, and there seems to be no connection with Russia, or indeed the Crimean War.

6 Levshin 249, 268, 302–3.

Chapter 5

1 Named after the Dzhungars, a West Mongolian tribe that conquered the Kazakhs in the 18th century. 'Dzhungaria' today denotes roughly the northern half of China's north-westernmost province of Xinjiang.

2 According to the latest data. This is the summit (188-odd m short of Mont Blanc) of Semenov-Tienshansky (called after the great 19th-century explorer and geographer) straddling the Kazakh-Chinese border.

3 Kalesnik, *Kazakhstan*, 100.

4 TWA j. 6 May 1849.

5 Semenov, 149.

6 TWA j. 6 May 1849.

7 Schreiber, 252–3.

8 TWA j. 5 May 1849 and LA 127.

9 TWA j. for 17 July and 16 December 1848, 6 May 1849.

10 Despite Lucy's words, is there some artist's licence here? The travellers give only one measurement in this mountain sequence of less than 1,000 feet.

11 TWA j. 12 May 1849.

12 Geoff Welch, RSPB International Management Plans Adviser, suggests that this may be a female or immature Pine Grosbeak *Pinicola enucleator* and the second probably a white-tailed Rubythroat *Luscinia pectoralis*.

13 TWA j. 13 May 1849. (Both Thomas's journal and Lucy's published words are almost identical here.)

14 TWA j. 13 May 1849.

15 Koumiss, fermented mares' milk, an obvious drink for nomads.

16 TWA j. 14 May 1849.

17 The Caspian or Turanian tiger, *Panthera tigris virgata*, now extinct, was historically found across the huge area between the west of the Caspian and Xinjiang. The last one in Kazakhstan was reputedly killed in 1948.

18 TWA j. 15 May 1849.

19 Ibid.

20 'The valley head is 3,000 m high and surrounded by glacier-covered peaks.'

21 TWA j. 16 May 1849.

22 It does not appear among the illustrations in either of his books.

23 TWA j. 17 May 1849.

24 TWA j. 19 May 1849. Successive waves of nomadic peoples in the area gave way to settled agriculturists and towns in the 11th to 12th centuries, only for the Mongols to bring a violent halt to development.

25 Schreiber 49, 122, 127.

26 Ibid.

27 TWA j. 22 May 1849.

28 TWA j. 23 May 1849.

29 Lucy's book was written as a series of letters to a friend.

30 TWA j. 8 June 1849.

31 Schreiber, 287.

32 Subspecies of the Caspian red deer *Cervus elaphus maral*. Strictly speaking, the maral of this area is known as the Tien Shan maral or wapiti, *Cervus canadensis songaricu*, one of the largest species of deer in the world with massive antlers prized for their medicinal properties when 'in velvet', so farmed in the Altai and China. The world-wide population of around 50,000 is declining fast.

33 This must be *Ovis ammon poli* or Marco Polo sheep, named after the great traveller and found in the mountains of Central Asia. A subspecies of argali, this largest of all sheep can weigh more than 135kg, and also has the longest (spiral) horns, up to 190 cm in length (*National Geographic News,* 7 March 2006).

34 Schreiber, 264.

35 Lucy may have meant the temperature of the ground surface or their thermometer may have been faulty, as the earth's record temperature is 58°C (136°F) in the Libyan desert, although there are reports of even higher temperatures. (Wikipedia.)

36 Thus called as it was thought to be cured by the touch of a king. This was scrofula, tuberculosis of the lymphatic glands, especially in the neck. Particularly common in children, it is usually spread by unpasteurised milk.

37 Nearly 2,500 sq. km compared to 18,000. Kalesnik, *Kazakhstan*, 52.

38 Red silk, on the other hand, would denote a sultan; not necessarily in mourning, but to appropriate a spot as a camping ground.

39 See also the systematic Levshin, 1832 (in Russian).

40 See Carruthers, 1914.

41 The Uyghurs or Uighurs, one of the oldest Turkic-speaking peoples of Central Asia, today live mostly in the Uyghur Autonomous Region of Xinjiang, a total of 10 million in China altogether, and another 300,000 in the former Soviet republics of Kazakhstan, Uzbekistan and Kyrgyzstan.

42 Perhaps the *kaldi* as chief officer was allowed his wife.

43 This is, in fact, the birthplace of the apple: its history starts here. It was proved in 2010 by genome sequencing that the 2,000 or so varieties of the domestic apple *Malus domesticus* descend from *Malus sieverskii,* which still grows on the slopes of the Tien Shan in Kazakhstan and China – the last surviving wild apple trees in the world. In Kazakhstan nearly three-quarters of them have gone in the last 30 years (particularly because of housing developments), and it is on the International Union for the Conservation of Nature's Red List of threatened species. Once Kazakhstan's wild apple forests stretched into Almaty (the former capital, whose earlier name was Alma Ata, meaning 'father of apples'); ten years ago only 20% survived. Sensibly, China has applied to have its wild apple forests designated as a World Heritage Site. And, because the domestic apple is beset by disease and pests and the DNA pool is shrinking, the survival of the apple's true ancestor is important.

44 Schreiber, 406.

45 No. 4328 (31.12.1849). Very different from the later Soviet era when so many parts of the largest country in the world were forbidden to foreigners. Perhaps the Atkinsons' Cossack escorts were there as guides, guardians, interpreters *and* official eyes.

Chapter 6

1 Thomas records the 'Articles left with colonel Sokolofsky June 1850:
box with picture etc etc etc
Long leather Box
Large Iron case with paper
Gun Box
Large green Box
Long wood Box
Kirgis saddle'.

2 TWA j. 12 June 1850.

3 LA letter of 23 January 1862. She means St Petersburg's St Peter and St Paul Fortress and its prison, which held notable/political prisoners.

4 Lenin and his wife Krupskaya were exiled to Shushenskoye from 1897 to 1900.

5 The second largest river system after the Ob-Irtysh flowing into the Arctic Ocean: including its main tributary, the Angara, the Yenisei is more than 5,000 km long and has the greatest flow – 630 cubic km per annum compared to 370–400 for the Ob, 358 for the Amur (and only 90 for the Rhine).

6 Eight Decembrists were deported here, and in Stalin's time it became an important Gulag centre. The Trans-Siberian Railway (1895) was a major step in its development, and World War II saw the evacuation of dozens of factories from Western Russia and Ukraine. Today its population has grown to just over a million. (Wikipedia.)

7 TWA j. 4/16 August 1850.

8 www.krasplace.ru/zolotopromyshlennost-enisejskoj-gubernii ('Gold-mining industry of Yenisei gubernia), 2015.

9 TWA j. 10/22 August 1850.

10 He helped one of the exiled Decembrists to copy and distribute his political pamphlets. T.A. Pertseva, *Irkutsk v panorame vekov: ocherki istorii goroda*. Irkutsk, 2003.

11 Most likely on the Bolshaya Peskina river, near modern Yuzhno-Yeniseisk.

12 TWA j. 23–24 August 1850.

13 TWA j. 13–14/25–26 August 1850.

14 TWA j. 30 August/11 September 1850.

15 Now used for the university library's special collection.

16 TWA j. 22 September/4 October 1850.

17 TWA. d. 26 September/8 October 1850.

18 An engineer officer, LA 280.

19 TWA j. 29 September/11 October 1850. This may well be the framed and glazed picture of Altin-Kul which they left with Mr Basnin, the Mayor, while they were away that summer. TWA j. 1851, flyleaf verso: 'A list of our Effects left in Irkoutsk 23 May/4 June with Mr Basnin the Mayor'.

20 TWA j. Saturday 30 September/12 October 1850.

21 See Christine Sutherland, *The Princess of Siberia*, 282.

22 LA 240. The British traveller S.S. Hill, who got to Kamchatka, wrote his own account in two volumes, which Lucy narrates with amusement: *Travels in Siberia*, London 1854.

23 Great-granddaughter of Lomonosov, the great Russian scientist. 'Beautiful, highly cultivated, daughter of a famous general Rayevsky who was a hero of the Napoleonic Wars, she had been married for only a year to the fabulously rich Prince Sergei Volkonsky, scion of a great family.' Sutherland, 5.

24 Sutherland, 108.

25 Bobrick, 293, quoting Maria Volkonskaya's words.

26 Bobrick, 292.

27 About 10 km from the Chinese border.

28 LA 243. Unfortunately, probably now lost.

29 In August 1846.

30 TWA j. 4 June 1851, LA IX. In Lucy's book she mistakenly gives 23 May as the date they 'Left Irkoutsk for the mountains', having copied the date of the Russian calendar from Thomas's journal.

31 TWA j. 10 June 1851.

32 Buryat Mongols, the largest indigenous people of Siberia: Mongol, Lamaist, and reputedly descended from Genghis Khan, with both winter and summer dwellings – unlike the Kazakhs with their portable yurts – and herds of horses and cattle but few sheep. TWA j. 9 June 1851, LA 263.

33 TWA j. 11 June 1851.

34 O & WS facing p. 593.

35 O & WS, 592–3.

36 V.P. Solonenko, I.A. Kobyalitsky, *Vostochnye Sayany* ('East Sayan Mountains'), 1947.

37 TWA j. 2 July 1851.

38 TWA j. 30 June 1851.

39 Despite the inaccessibility, Alibert's mine ran very profitably for fifteen years, blessed by the fact that the famous Borrowdale mine in the English Lake District, hitherto the world's only source of good-quality graphite, was becoming exhausted. His graphite was transported first by reindeer, then down the Amur river to Russia's eastern coast and on through the Pacific and Atlantic finally to Hamburg, when 'the Siberian pencils' would be encased in fine wood from Florida and distributed worldwide;

they were marketed in Switzerland later as 'Caran d'Ache', a pun on the Russian word for pencil, *karandash* (www. fabercastell.com).

40 It was here in the Sayan region, some believe, that the reindeer was first domesticated at the beginning of the first millennium AD by the local Samoyedic population. (Wikipedia.)

41 Now the village of Sayany.

42 O & WS 582. It is intriguing that Thomas for the otherwise blank entry in his journal for Tuesday 15 July 1851 writes 'St Swithin' (underlined), which according to English folklore denotes rain or its absence for the next forty days, his only apparent reference to English customs.

43 Alexei V. Ivanov et al., 'Jom-Bolok Holocene volcanic field…' in *Bulletin of Vulcanology*, November 2011, Vol. 73, 9, 1279–94.

44 TWA j. 17 July 1851.

45 TWA j. 19 July 1851.

46 TWA j. 20 July 1851.

47 TWA j. 20 July 1851.

48 TWA j. 21 July 1851.

49 TWA j. 13 August 1851.

50 Between 20 and 25 million years old and over 1½ km deep, with below that an astounding 7 km of sediment: John Massey Stewart, 'Baikal's hidden depths', *New Scientist*, 1990, No. 1722. The locals call it a sea while the Buryats call it a 'Holy Sea'. But see also Chapter 1 note 70.

51 TWA j. 17 August 1851. Thomas's finished watercolour survives of a possibly fanciful arch on Baikal's shoreline cliffs. It includes a small representation of Lucy in her distinctive hat. They both agreed that the Altai's Altin-Kul, now Lake Teletskoye (where he had depicted her as an even smaller figure in a canoe), surpassed anything at Baikal.

52 This seems to be one of a very few discrepancies between Thomas's journal and his two books: according to his journal he spent 19 days on the lake. TWA j. 13–31 August 1851.

53 U & LA 381. But no longer; both the rock and the rapids have gone since the lake's level has risen, due to a major dam and power station at Irkutsk.

54 Baikal is famous today inter alia not only for its depth and age, but for its volume (one-fifth of the planet's unfrozen fresh water thanks to the combination of depth and surface area), its huge number of endemic species including its freshwater seals and its remarkable transparency.

55 TWA j. 18–19 August 1851.

56 TWA j. 19 August 1851.

57 TWA j. 20 August 1851.

58 TWA j. 20 August 1851.

59 TWA j. 23 August 1851.

60 TWA j. 24 August 1851.

61 TWA j. 30 August 1851.

62 TWA j. 30 August 1851. An unfair judgement, as he visited only a quarter of the lake and really only the west side.

63 His 'catalogue of Sketches made in 1851' dates from 28 May ('a view of a Bouriat Temple on the summit of the white Mountain near the River Ikeougoune') to 29 September ('A view of a Monastery where Basil Mouravioff lies Buried'), a total of 54, all dated. Then he adds, confusingly, 'Sketches made on a journey to the Bielouka in 1852 – seemingly only two – both views on the Kara-goll'. There follows an intriguing (but undated) list of their expenses in the Baikal area. (Lucy was still paymaster, as we have seen.) They range from 10 kopeks for yamshchiks, 20 kopeks for 'Post horses' and 25 kopeks for lodgings at Goloustnoye, various payments to Cossacks and Buryats, and 2 roubles for 'Alatau doctoress of the Gold priesk' to 20 roubles 'stolen from our carriage' – a sizeable theft – and, most expensive of all, 21 roubles for Alatau's reindeer 'including saddles'. Nothing is said about reselling the reindeer. The total was 231 roubles. One is again puzzled as to the source of their money – could it have been Lucy's accumulated wages over the years as governess?

64 LA 285. Christmas pudding was served (as well as caviar) at the concluding dinner of the British–Soviet Siberian week in Novosibirsk in 1978.

65 LA 287. An amnesty came only four years later in August 1856, when Alexander II succeeded Nicholas and restored the Decembrists' rights, titles and privileges.

66 *Rheum palmatum* or Chinese rhubarb, a remedy for many health problems, particularly constipation.

67 At this point in the 1851 journal there appear to be two sets of entries for August – one in normal date order, another inserted just before the May sequence.

68 Lincoln, *Conquest of a Continent:*, 193–6.

Chapter 7

1 TWA j. Monday 30 August 1852.

2 Ibid. Monday 3 September 1852.

3 F. Maier, *Trekking in Russia and Central Asia: A Traveler's Guide,* Seattle, 1994. Belukha was finally conquered only in 1914 by the Russian brothers R.V. and M.B. Titanov and is now part of a World Heritage site, the Golden Mountains of Altai.

4 A Turkic people on both sides of the southern Urals with their own republic of Bashkortostan within the Russian Federation; capital: Ufa.

5 Certificate of Baptism, Guildhall, London. John Lumley Savile (1818–96), diplomat, created Baron Savile 1888. History of Parliament online.org.

6 Paul Dahlquist Coll., Hawaii.

7 19 January 1854.

8 Rebecca McCoy, London 1855, quoted by Anthony Cross in *St Petersburg and the British*, 2008. 'Many British employed by Russian companies lost their jobs but some stayed and became Russian citizens.' Roderick Heather, *An Accidental Relationship,* London, 2008. The Crimean War ended 30 March 1856.

9 Preface to the correspondence of Iu. Samarin and Baroness von Rahden (1861–76). Iurii Fedorovich Samarin, 1893. First Russian edition.

10 Commissioned by Catherine II for her son, later Tsar Paul.

11 Miss Euler to TWA, 22 May/3 June 1855. Dahlquist Coll.

12 During the Crimean War she helped with the training of combat nurses and in the later Russo-Turkish War 'medical trains', as well as recruiting many society ladies to help the Red Cross. After the Grand Duchess's death she became lady-in waiting to the Empresses successively of Alexander II and III.

13 TWA to Baroness von Rahden, 28 April 1855.

14 Baroness von Rahden to TWA, 19 January 1855 (?).

15 Vladimir Fedorovich Adlerberg (1791–1884). Ed. Euler to TWA, 26 January (1855).

16 Adlerberg to Atkinson, 9/21 February 1855.

17 Atkinson to Adlerberg, 10/22 February 1855, and Adlerberg to Atkinson, 14/26 February 1855. Russian State Archive, fond 472, ref. 108/945.

18 Lord Bloomfield in Berlin to TWA, 6 July 1855.

19 'Chinese Tartary', roughly the eastern part of Central Asia, then inhabited by many tribes of nomadic Tatars. In his first book Thomas wrote separate chapters on the 'Kirghis [i.e. Kazakh] Steppe' and 'Chinese Tartary', of which the former was part, so to differentiate is misleading.

20 He would probably have been unaware that many of the thousand and more watercolours prepared by John Soane's pupils between 1806 and 1820 to illustrate his lectures at the Royal Academy were up to 3 or 4 ft long. David Watkins entry on Soane, ODNB, now preserved in the Soane Museum.

21 TWA to Elena Pavlovna, 21 February 1856.

22 1 March 1856.

23 Baroness von Rahden to TWA, 10/22 June 1856.

24 Bodleian Library, Oxford.

25 Not exactly true, as regards visits anyway. Thomas was not to know of the journeys of Carpini and William of Rubruck in the 13th century, although neither visited Siberia, or Ides and Spafary in the 17th, or John Bell in the 18th century, who all did. And Lucy mentions in her book John Dundas Cochrane, the 19th-century 'pedestrian traveller' across Siberia a little before the Atkinsons.

26 TWA to Alexander II, 26 April 1856.

27 Fedorchenko, 2004, 457–8.

28 Up to 3 archines by 2, approx. 150 x 200 cm = 1.5 x 2 m.

29 TWA to Count Tolstoy, 15 June. No year stated.
30 TWA to Baroness von Rahden, no date. About 10 August 1856.
31 Dahlquist Coll.: March, no date.
32 Wikipedia.
33 Dahlquist Coll. Letter from E. Liprandis, Sunday 8 April.
34 *Autobiography*, Vol. I, p. 464. Cornell email 4.06.2010: Cornell University.
35 Bodleian Library, Oxford.

Chapter 8

1 Galton, *Memories of My Life*.
2 Data from *The London Encyclopedia*, ed. Ben Weinreb and Christopher Hibbert.
3 Lord Palmerston to TWA, 8 October 1856.
4 Spencer to TWA, 25/26 October (1856). Atkinson's journals are now in the Royal Geographical Society archives, kindly presented by Paul Dahlquist. Sir Spencer Cecil Brabazon Ponsonby-Fane (1824–1915), Private Secretary to Lord Clarendon 1853–57.
5 Alexander Theodor von Middendorff (1815–1894): Russian (of German-Estonian descent), zoologist and explorer of Siberia, Central Asia and the Far East.
6 Dahlquist Coll.: R. Murchison to TWA, 29 October 1856.
7 Unfortunately, Colnaghi's records were destroyed in World War II.
8 *Reisen in den Steppen und Hochgebirgen Sibiriens*, comp. A. von Etzel and G. Vagner from the works of Atkinson, Middendorff, Radde, etc. Gustav Radde (1831–1903): a German naturalist and explorer who, inter alia, participated in the East Siberian expedition of 1855–59 and was awarded prestigious medals by the Geographical Societies of both Britain and Russia.
9 See *The English in Siberia. Adventures and Anecdotes: Thomas Witlam Atkinson and Mrs Lucy Atkinson*, trans. into Russian from English by N.S. Volkova, Barnaul, 2012.
10 *The Times,* 8 January 1858, 5.
11 *The Art-Journal,* 1858, 30.
12 *The Athenaeum,* 28 November 1857, 1477–9.
13 *The Saturday Review*, 13 February 1858, 167–8. See also Bell's *Life in London and Sporting Chronicle*, 13 December 1857.
14 *New York Daily Tribune,* 4 June 1858, 3.
15 Richard Milner, Senior Editor, *Natural History Magazine*, American Museum of Natural History, letter in *The Linnean*, 2000, Vol. 16, 12–13.
16 *A Tarantasse Journey through Eastern Russia in the Autumn of 1856*, London, 1857. Spottiswoode was to be buried in Westminster Abbey.
17 Dahlquist Coll.: W. Spottiswoode to TWA, 14 January 1857.
18 A.N. Wilson, *Tolstoy*, 861.
19 Dahlquist Coll.: Charles Dickens to TWA, 8 September 1857. According to the Atkinsons' descendants there was another letter from Dickens, now lost.
20 28 March, no year. Dahlquist Coll.
21 Dahlquist Coll.: J.D. Harding to TWA, 1 December 1857.
22 RGS archives.
23 Dahlquist Coll.: Charles George Barrington (1827–1911) to TWA, 5 December 1857.
24 Later Sir Thomas Villiers Lister (1832–1902).
25 Dahlquist Coll.: T.V. Lister to TWA, 12 December 1857.
26 Dahlquist Coll.: Col. C.B. Phipps to TWA, 18 December 1857.
27 Dahlquist Coll.: J. Arrowsmith to TWA, 14 December 1857.
28 Dahlquist Coll.: T.V. Lister to TWA, 11 January 1858.
29 'The selection of desired heritable characteristics in order to improve future generations...' With acknowledgements to britannica.com.
30 Francis Galton to TWA, 13 November 1858.
31 14 May 1858.

32 TWA to Kingsley, 19 May 1858.
33 2 August 1858.
34 3 September, J.H. Gurney.
35 21 September 1858.
36 TWA, 9 October 1858.
37 TWA to P. O'Callaghan, 10 January 1859. NB from Old Brompton.
38 Later merged with the Royal Anthropological Institute.
39 W. Spottiswoode to TWA, 7 December 1858.
40 Henry Blackett to TWA, 10 January 1859.
41 Spencer Ponsonby to TWA, 4 February 1857 (*sic*, 1859?).
42 W. Ewart to TWA, 10 February (1859) and 'Miss Ewart & her sister' to TWA, no date.
43 B. Rose to TWA, 11 February 1859.
44 21 March 1860.
45 31 March, no year.
46 *John Bull & Britannia*, 21 May 1859.
47 28 March 1859.
48 All these letters were addressed to T.W. Atkinson Esq., 'esquire' being the customary appellation for a gentleman, which Thomas had now become.
49 His hair turned white during a night off the east coast of Africa when he thought his ship would be lost. Note appended by Alatau in 1905.
50 Not the young naval officer referred to on page 231.
51 1 January 1860.
52 Royal Institute of British Architects.
53 13 August 1859.
54 25 August.
55 8 (or 4?) February 1860.
56 16 February.
57 5 September.
58 William Drogo Montagu, 7th Duke of Manchester.
59 13 August 1860.
60 14 May.
61 Dolgoruky to TWA, 18 August. Dahlquist Coll.: note from Dolgoruky's secretary (?), 14 May 1860.
62 May 1860.
63 20 April 1860?
64 8 May 1860.
65 Showing the interest at the time, three other books on the Amur appeared in 1860–61, notably the geographer-cartographer E.G. Ravenstein's detailed *The Russians on the Amur*.
66 U & LA, vii.
67 U & LA. But Atkinson had already visited, on Murchison's behalf, Middendorff, who had reached the lower Amur valley from the eastern seaboard by 1845 (Wikipedia). The Irish H.A. Tilley reached Nikolayevsk near the mouth of the river on a Russian ship in 1859 (see his *Japan, the Amoor and the Pacific,* 1861). But, above all, there was Maack's expedition: see Chapter 9.
68 U & LA.
69 *The Athenaeum*, 28 July 1860, 117–19. Other reviews appeared in, for instance, *The Art-Journal*, 1860, 346–7; *The Quarterly Review*, 7 January 1861, Vol. 110, Issue 219, 179; the *London Review*, 1 January 1861, Vol. 15, Issue 30, 439; and *Obshchestvennye Zapiski* of Irkutsk, August 1860, 39–44.
70 26 July 1860.
71 1 August 1860.
72 4 August.
73 8 August.
74 Blackett, 25 September 1860.
75 17 September.
76 Rev. Charles Spencer Stanhope to TWA, 19 September.
77 Rev. Charles Tiplady Pratt, *History of Cawthorne*, 1882, 104.

78 1 November, Wilkinson, *Barnsley Worthies.*

79 *Annals of a Yorkshire House, From the Papers of a Macaroni and his Kindred,* 1911.

80 Sold to a special preservation trust for £7 million in 2017.

81 (Wikipedia), 13 November 1860.

82 Lucy Atkinson to Rev. C.S. Stanhope, 6 May 1861 via Wilkinson, *Barnsley Worthies.*

83 Acknowledgements to Marianne Simpson and Nick Fielding's blog 'Siberian Steppes'.

84 Lucy Atkinson to Rev. C.S. Stanhope, 6 May 1861 via Joseph Wilkinson, *Worthies, Families, & Celebrities of Barnsley & District.*

Chapter 9

1 Old St Mary's, Walmer, which the Duke of Wellington had attended for over 23 years when he had been Lord Warden of the Cinque Ports, staying in Walmer Castle, his official residence.

2 Architectural journal from 1843.

3 Hayles, 2015.

4 Charles Darwin's wealthy half-cousin, polymath, explorer (RGS gold medallist), and 'father of eugenics', with a reputed IQ of 200, who died as late as 1911.

5 Galton, 177.

6 The Principal Registry of Her Majesty's Court of Probate, 31 October 1861.

7 Bank of England Inflation Calendar.

8 Hoe, 2014. A few biographical dictionaries have mistakenly claimed Emma Willsher Atkinson, writer, as a daughter.

9 *Leeds Mercury*, 14 September 1861.

10 Acknowledgements to Hammersmith Local Studies.

11 Richard Monckton Milnes, charming, eccentric, brilliant conversationalist, Yorkshire poet and MP whose forebears won the monopoly of the North England cloth trade with Russia and used Russian timber for their houses. Stirling, *Letter bag*, 194. He and Florence Nightingale had a seven-year courtship which she ended.

12 Lucy Atkinson to Richard Monckton Milnes, 11 November 1861. Wren Library, Trinity College, Cambridge.

13 The case was certainly not unique. After the satirist and illustrator of Dickens George Cruikshank died in 1878, for instance, a younger woman and ten children were found a few streets away, unknown to his second wife.

14 Anthony Cross, Introduction to *Recollections of Tartar Steppes*, vii, citing *The Athenaeum* No. 3750, 9 September 1899, 341.

15 TWA writes to Murchison from 13 Great Marlborough St (address of Hurst and Blackett, TWA's publisher) presenting 'my work on Siberia, Mongolia etc' to the RGS, 4 December 1857.

16 Maack, 1859. Richard Maack (1825–1886), Estonian by birth, made a two-year expedition to the Amur, returning with massive collections. A.M. Torkanov, *Maack, Richard Karlovich*, short biography.

17 U&LA viii.

18 According to J. Tallmadge. Cited by Anka Ryall in 'A Woman in the Wilderness: The Travel Narratives of Thomas and Lucy Atkinson' in *Proceedings from the Third Nordic Conference for English Studies*, Hasselby, Stockholm, 1986. Ryall notes that Lucy 'is fully able to live up to the masculine standard of wilderness heroism. In many ways she presents herself as what anthropologists call "an honorary male".'

19 Lucy Atkinson to John Murray, 23 January 1862.

20 Ibid.

21 Founded in 1790 and 'Royal' from 1842. Set up in 1790 to help indigent authors. Since then it has helped more than 5,000 authors including Coleridge, Conrad and James Joyce. The fund's annual income is now swollen greatly by £90 million from Disney Enterprises, which bought the rights to A.A. Milne's *Winnie the Pooh* in 2001.

22 Lucy Atkinson to the Committee of the Royal Literary Fund, application on the death of her husband, 1 March 1862. British Library.

23 Memorial in favour of Mrs Lucy Atkinson signed by R. Murchison and 15 others to Lord Palmerston, March 1862. Public Records Office, PRO TI/6421B.

24 Lucy Atkinson to Lord Palmerston, 7 April 1862. Public Records Office, now National Archive.

25 At Walmer Castle, where Palmerston stayed when Lord Warden of the Cinque Ports.

26 Lucy Atkinson letter to John Murray, 26 June 1862.

27 28 February 1863, 285–7.

28 Frank Cass, London, 1972, reprinted in *Anglo-Russica,* Selected Essays by Anthony Cross, Berg, Oxford.

29 Five of Lucy's chapters and one (XIX) of Thomas's first book were translated and published there in 2012 as *Anglichane v Sibiri*…. (see Chapter 8, note 9). The same year part of Thomas's chapter XIX (on Barnaul) appeared in the journal *Altai*, No. 2, 2012, 131–7.

30 p.69, Evelyn Ashley to Murchison.

31 Lucy Atkinson to Lord Houghton, 20 July 1863. Wren Library, Trinity College, Cambridge.

32 S.M. Ellis, ed., *A Mid-Victorian Pepys*, London, 1923, 310–11.

33 He has been known since as 'the Hangman of Vilna' (now Vilnius, then the capital), having hanged 127 men and sent another 9,000-odd to Siberia, and was rewarded by Alexander II by the suffix to his surname 'Vilensky', thus joining his similarly honoured brother Muravyov-Karsky and cousin Muravyov-Amursky. Lucy's attitude seems surprisingly harsh.

34 Bank of England Inflation Calendar.

35 Galton was one of the two trustees. RGS Archives.

36 Matthew, George, Thomas and Mary Ann (later Mrs Francis Smith). Marianne Simpson, 9 March 2015.

37 BL MSS Murchison Papers Vol.1. Add 4612572: 74.

38 1870, 21 January. Mrs Lucy Sherrard Finley £50.

39 *Literature and The Pension List. An Investigation Conducted For The Committee Of The Incorporated Society Of Authors.* By William Morris Colles, of the Inner Temple, barrister-at-law. Published for the Incorporated Society of Authors by Henry Glaisher, 95 Strand, WC., 1889. http://www.archive.org/details/literaturepensio00coll.

40 Of the now long defunct Serjeants' Inn, unsatisfactorily combining barristers and solicitors.

41 Robinson's reminiscences, *Bench and Bar: Reminiscences of One of the Last of an Ancient Race*, London, 1899 (2nd edn), published by Hurst and Blackett, Thomas's publishers, went into three editions.

42 According to the 1891 census.

43 There are contradictions regarding her age in the three censuses of 1851, 1861 and 1871 when given as 54, 60 and 72, although ten years apart and birth years given as 1797, 1801 and 1799.

44 Susanna Hoe text.

45 Adapted from Jeremiah 31:3. 'The Lord hath appeared of old unto me, saying, Yea, I have loved thee with an everlasting love: therefore with loving kindness have I drawn thee.' Courtesy of Sally Hayles, Pippa Smith and Marianne Simpson.

46 *Hawaiian Star*, 30 April 1906.

47 George F. Nellist (ed.), 1925.

Epilogue

1 Schreiber, 57.

2 Ibid., 58.

Appendix II

1 His namesake (no relation) John Augustus Atkinson (1775–1830) was known for his aquatints and watercolours of Russia, e.g. *A Picturesque Representation of the Manners, Customs, and Amusements of the Russians*, London 1803–04, and his oils of Russian history painted for Catherine II and Paul I.

2 *Dictionary of National Biography,* Supplement, 1901, & ODNB, 2004.

3 TWA O & WA vii.

4 Honour, *Romanticism*, 1979.

5 Canadian landscape artists such as Krieghoff date from the early 1840s.

6 Andrew Wilton and Tim Barringer, *America Sublime: Landscape painting in the United States 1820–1880*, London, 2002, p. 234.

7 Dr. A.V. Tivanenko, Ulan-Ude.

8 *Gothic Ornaments selected from the different Cathedrals and Churches in England*, 1829. Pugin's *Specimens of Gothic Architecture* [also] *selected*, 2 vols, 1821, 1823, beat him by a few years although it is not strictly comparable.

9 St Nikolaikirche, see Appendix I.

10 TWA O & WA vii.

11 But Atkinson is roughly correct: glycerine and mercury share freezing/solidifying points.

12 See Chapter 6.

13 LA 162.

14 LA 242.

15 St Petersburg State Historical Archive, with acknowledgements to Maria Markova. TWA letter to Count Tolstoy, high court official, 15 June 1856. English watercolourists were painting ever bigger works at that time to compete with oils, particularly at exhibitions, e.g. Peter de Wint's *On the Dart,* 1848, 55.8 x 93 cm (now Fitzwilliam Museum, Cambridge), but still 7 cm smaller than Atkinson's largest.

16 Ibid. TWA letter to Alexander II, 26 April 1856.

17 Ibid. V.F. Adlerberg, Minister of the Imperial Court, letter to TWA, 9 Feb. 1855.

18 At Christie's first Atkinson sale (9 June 1858) sixty-three paintings were auctioned (only thirty-one sold). The second sale, in June 1861, was of nineteen watercolours – twelve repeats of the first sale and five new ones – plus the 'original drawings' for his two books; all apparently unsold. A third sale, in 1862, the year after Atkinson's death, repeats unsold work from the previous sales, adding six new ones; but only one (of Cyprus) was sold. The last, fourth sale a year later, of Atkinson's 'remaining works in water-colours', produced nothing new (but seems to have sold all items).

 Add to the above, provenance unknown: three watercolours, one of Kopal sent to Prince Gorchakov, Governor-General of Western Siberia, one of the river Hook painted for Zanadvorov, one of mountain landscape with river or lake foreground, known only from photograph in Witt Collection, plus possibly fourteen missing of the Chusovaya River (see catalogue raisonné item 1).

 Contrarily, a portrait in oils of Alexander Sokolovsky as a youth was almost certainly misattributed to T.W. Atkinson in the exhibition (and catalogue) *Unforgettable Russia:* wrong style, medium and subject. The artist was possibly Carl Peter Mazer (1807–1884), Swedish painter and draughtsman, who lived 1838–54 in various parts of the Russian Empire including Siberia, painting many portraits, largely untraced. See entry in Jane Turner (ed.), *The Grove Dictionary of Art*, 1996.

19 Maack, 1859.

20 Coincidentally or not, Raby Castle had been owned in its long history by the Earls of Westmorland, one of whom recommended Atkinson in 1846 to the protection of St Petersburg's British Embassy.

21 Andrew Dixon White, *Autobiography*, New York, 1906.

22 TWA U & LA 155.

23 TWA numbered the paintings now in the Hermitage as between 1 and 26 although there are only twelve of them.

24 Past-President of Watercolour New Zealand.

Bibliography

Unpublished primary sources

TWA journals: T. W. Atkinson, four unpublished travel journals, 1847–53, Royal Geographical Society

TWA correspondence: Dahlquist Collection, Hawaii

— British Library; includes MSS Murchison Papers Vol. 1. Add. 4612572: 74

— Manchester Central Library (letters to Royal Manchester Institute submitting works for exhibition)

— Bodleian Library, Oxford

— Russian State Archive, St Petersburg

Lucy Atkinson correspondence: Wren Library, Trinity College, Cambridge

— John Murray Archive, National Library of Scotland, Edinburgh

Scott, George Gilbert, notebooks, Vol. 2, RIBA

Published primary sources

Atkinson, T. W., *Gothic Ornaments selected from the different Cathedrals and Churches in England*, London, 1829

TWA, O & WS: Atkinson, T. W., *Oriental & Western Siberia: A Narrative of Seven Years' Exploration and Adventures in Siberia, Mongolia, the Kirghis Steppes, Chinese Tartary, and Part of Central Asia*, London, 1858

— Reprint of Harper and Brothers edn, New York, 1858, University of Michigan, pb, 2005. No map or colour plates, different pagination

— Part of Chapter XIX in the Barnaul journal *Altai*, No. 2, 2012, 131–7

TWA, U & LA: Atkinson, T. W., *Travels in the Regions of the Upper and Lower Amoor and the Russian Acquisitions on the Confines of India and China. With adventures among the mountain Kirghis; and the Manjours, Manyargs, Toungouz, Touzemts, Goldi, and Gelyaks: the hunting and pastoral tribes*, London, Hurst & Blackett, 1860. Reprinted Vanguard Books, 1996; University of Michigan, 2008

— Incorporated Church Building Society (I.C.B.S. plan of St Margaret's, Bowers Gifford; Society of Antiquaries)

— *The Amoor and the Steppes (Travels in the Regions of the Upper and Lower Amoor, and the Russian Acquisitions on the Confines of India and China; with Adventures among the Mountain Kirghis, and the Manjours, Manyargs, Toungouz, Goldi, the Gelyaks, the Hunting and Pastoral Tribes. By Thomas Witlam Atkinson, author of 'Oriental and Western Siberia'. With a Map and numerous Illustrations. Published by Harper and Brothers), Harper's New Monthly Magazine,* Vol. XXI, June–Nov. 1860

— *An Account of an Ascent with the Kirghis through the Mountain Passes to their Summer Pastures at the foot of the snowy peaks the Ac-Tou, Chinese Tartary.* Transactions of the Ethnological Society, Vol. I. New Series. London, John Murray, 1861, 93–105

— *La Siberia Oriental y Occidental y la Tartaria China por Tomas Witlam Atkinson.* Nuevo Viajero Universal, Madrid, 1860

— *Voyage sur les frontières Russo-Chinoises et dans les steppes de l'Asie Centrale par Thomas Witlam Atkinson (1848–1854), Le Tour du Monde – nouveau journal des voyages,* Hachette, Paris, 1863, 337–84

— *Reifen in den Steppen und Hochgebirgen Sibiriens: und der angrenzenden Länder Central-Asiens. Nach Aufzeichnungen von T. W. Atkinson, Ä. Th. v. Middendorff, G. Radde u. A. Bearbeitet von Anton von Etzel und Hermann Wagner.* Leipzig, Verlag Otto Spamer, 1864

— *Journey through Siberia and the neighbouring countries of Central Asia. According to descriptions T. W. Atkinson, A. T. von Middendorff, G. Radde et al.,* ed. A. von Etzel & H. Wagner, St Petersburg, 1865. (*Puteshestvie po Sibiri I prilegayushchim k nei stranam tsentralnoi Azii. Po opisaniyam T. U. Atkinsona, A. T. Fon- Middendorfa, G. Radde i dr.* Sostavili A. Fon-Etzel, i G. Vagner. Perevod s nemetskogo N. Deppisha, St Petersburg 1865)

Some Heroes of Travel or chapters from the history of Geographical discovery and enterprise. With maps. Compiled and rewritten by the late W.H. Davenport Adams. London, Society for Promoting Christian Knowledge, 1893, 157–228 (re T. W. Atkinson, *Oriental and Western Siberia,* London, 1858)

LA: Atkinson, Lucy, *Recollections of the Tartar Steppes and their Inhabitants,* London, 1863

— Reprint, *Russia Observed* series, New York, 1970; Scholar's Choice, Rochester, NY, 2015

Secondary sources: publications on the Atkinsons

Cross, Anthony, *Anglo-Russica* (Selected Essays), 1993: 'The Testament of a Forgotten "Wife"'

— Introduction to *Recollections of Tartar Steppes,* vii, citing *The Athenaeum* No. 3750, 9 September 1899, 341

Fielding, Nick, *South to the Great Steppe: The Travels of Thomas and Lucy Atkinson in Eastern Kazakhstan, 1847–1852*. London, FIRST Books, 2015

— 'Thomas and Lucy Atkinson: pioneering explorers of the steppe' in *Asian Affairs*, March 2018

— siberiansteppes.com

Hayles, Sally, 'Thomas Witlam Atkinson (bap. 1799–1861) – On the Edge' in *The Hidden Artists of Barnsley*, Barnsley Art on Your Doorstep, Barnsley, Yorkshire, 2014

Hoe, Susanna, *Lucy and Thomas Atkinson: Complicated Lives in Russia and Beyond*, HOLO Books website, 2014. Chapter 1 updated

— *Travels in Tandem: the Writing of Women and Men Who Travelled Together*, Oxford, 2012.

Massey Stewart, John, 'Lost (and Found): the Russian Watercolours of Thomas Witlam Atkinson, "the Siberian traveller"', in exh. cat. *Unforgettable Russia: Russians and Russia through the eyes of the British XVII–XIX centuries*, Tretyakov Gallery, Moscow, 1997

— Entry on Atkinson in *Ekaterinburg Entsiklopediya*, Ekaterinburg, 2002

Ryall, Anka, 'A Woman in the Wilderness: the travel narratives of Thomas and Lucy Atkinson' in *Proceedings from the Third Nordic Conference for English studies*, Hasselby, Sweden, 25–27 Sept. 1986

Sadoveanu, Mihail, *The Nest of Invasions* (1930), 3 vols, New York & London, 2003. See *European Review of History*, Feb. 2009, on this Romanian novelist inspired by Atkinson's travel accounts

Seago, T. Taylor, 'A Victorian Who Followed Marco Polo', *Country Life*, 16 July 1964, 150–51

Simpson, Marianne, 'Seeking descendants of Lucy Atkinson', *Inside History* magazine, Australia and New Zealand, 9 March 2015

— *Alatau Tamchiboulac Atkinson (1848–1906)*, Feb. 2017. See Fielding blog above

Wilkinson, Joseph, 'Worthies, Families, & Celebrities of Barnsley & District' in *Barnsley Chronicle* series, 1880–82

Secondary Sources: UK, Australia, Germany, Hawaii

Allgemeines Künstler-Lexicon (Dictionary of Artists), Vol. 5, Saur Verlag, 1991 (compilation of all entries of all countries)

Axon, William E.A., ed., *The annals of Manchester: a chronological record from the earliest time to the end of 1885*, Manchester and London, 1886

Australian Dictionary of Biography, Melbourne University Publishing, 1966–2007

The Builder, 31 August 1861 (Atkinson's obituary)

Catalogue of the Drawings Collection of the Royal Institute of British Architects, London, 1968

The Civil Engineer and Architect's Journal, a leading London journal which began in 1837 (the year of Queen Victoria's accession).

Clayton, A.B., typescript biography of, received 19/2/99 by Manchester City Art Galleries

Colvin, Howard, *Biographical Dictionary of British Architects, 1000–1840*, New Haven and London, 2nd & 3rd edns; 4th edn, 2008

Complete Yorkshire, Ward Lock Red Guide, London, 1982

Craig, C.J., in Kerr, Joan, ed., *Dictionary of Australian Artists: painters, sketchers, photographers and engravers to 1870*, OUP, Melbourne, 1992

Dibb, A.J., *Like a Mighty Tortoise: A History of the Diocese of Manchester*, Oldham, 1978

Dictionary of National Biography, Supplement, 1901, & *Oxford Dictionary of National Biography*, 2004

Dixon, Roger, & Muthesius, Stefan, *Victorian Architecture*, OUP, 1978

Ellis, S.M., ed., *A Mid-Victorian Pepys*, London, 1923

Engels, Friedrich, *The Condition of the Working-Class in England*, Moscow, 1973

Fisher, Stanley W., *A Dictionary of Watercolour Painters, 1750–1900*, New York & London, 1972

Galton, Sir Francis, *Memories of My Life*, New York, 1909

Grant, Col. M.H., *A Dictionary of British Landscape Painters. From the 16th to the early 20th century*, F. Lewis, Leigh-on-Sea, reprinted 1976

Graves, Algernon, *The Royal Academy of Arts Exhibitors 1769–1904*, Vol. I, 1905, reprint Nabu Press, 2010

— *A Dictionary of Artists who have exhibited works in the principal London exhibitions of oil [sic] paintings from 1760 to 1880*, London, 1884; reprint, Franklin, New York, 1970

Hill, Rosemary, *God's Architect*, Allen Lane, London, 2007

Honour, Hugh, *Romanticism*, Allen Lane, London, 1979

Jackson, Barry, *Cawthorne 1790–1990: A South Yorkshire Village remembers its past*, 1991

Kidson, Peter, *et al.*, *A History of English Architecture*, Penguin, London, 1979

The Manchester Historical Recorder, 1874; reprint, RareBooks, 2012

Manchester: Records of, with acknowledgements to David Taylor

Nellist, George F., ed., *The Story of Hawaii and its Builders*, Hawaii, 1925

Papworth, Wyatt, ed., *The Dictionary of Architecture with illustrations*, Architectural Publications Society, 1852–92, Vol. 1

Pevsner, Nikolaus, *The Buildings of England* series: *Cheshire*, 1971; *Kent: North-East & East* (John Newman, co-author), 3rd edn, 1983; *South Lancashire (Lancashire 1, The Industrial and Commercial South)*, New Haven & Harmondsworth/London, 1969 (most edns revised)

Port, M.H., *Six hundred new churches: The Church Building Commission 1818–1856*, Reading, 2006

Pratt, Rev. Charles Tiplady, *History of Cawthorne*, 1882, 104

Royal Geographical Society, Proceedings, 26 May 1862

Saunders, Ann, *The Art and Architecture of London,* 2nd edn, London, 1988

Scott, Sir George Gilbert, ed. Stamp, Gavin, *Personal & Professional Recollections: The Autobiography of the Victorian Architect*, Stamford, 1995

Smith, D.J., *Aspects of Life in Old Cawthorne, South Yorkshire*, Sheffield, n.d.

Stewart, Cecil, *The Stones of Manchester*, London, 1956

Stirling, A.M.W., *The Letterbag of Lady Elizabeth Spencer Stanhope*, London, New York, 1913

Ware, Dora, *A Short Dictionary of British Architects*, London, 1967

Weinreb, Ben, & Hibbert, Christopher, *The London Encyclopedia*

Woodward, G.L., *The Age of Reform 1815–1870*, Oxford, 1946

Secondary Sources: Russia, the Kazakh Steppes and Central Asia

Ågren, Maria, ed., *Iron-making Societies. Early Industrial Development in Sweden and Russia, 1600–1900*, New York, 1998

Aleksandrovskaya, O.A., & Firsova, G.A., *Nauchnoe nasledstvo: Estestvennonauchnoe nasledie dekabristov.* v. 24, Nauka, Moscow, 1995

Andreevsky, I.E., ed., *Entsiklopedicheskii Slovar'*, 82 vols, St Petersburg, 1890–1904

Arzhannikov, S.G., Ivanov, A.V., Arzhannikova, A.V., Demonterova, E.I., Jolivet, M., Buyantuev, V.A., Oskolkov, V.A., Voronin, V.I., *Journal of Asian Earth Science*, Elsevier, 2016, v.125, 87–99

Atlas SSSR, Moscow, 1983

Blanchard, Ian, *Russia's 'Age of Silver'*, London & New York, 1989

Bobrick, Benson, *East of the Sun: The Conquest and Settlement of Siberia*, London, 1992

Bolshaya Sovetskaya Entsiklopediya, Moscow, 2002

Brockhaus & Efron, *Entsiklopedicheskii Slovar*, 1890–1907

Brown, Archie, *et al.*, *Cambridge Encyclopedia of Russia & the Former Soviet Union*, Cambridge, 1994

Channon, John, with Hudson, Robert, *The Penguin Historical Atlas of Russia*, London, 1995

Collie, Michael, & Diemer, John, eds, *Murchison's Wanderings in Russia*, British Geological Survey, Keyworth, Nottingham, 2004

Dukes, Paul, *A History of the Urals: Russia's Chronicle from Early Empire to the Post-Soviet Era*, London & New York, 2015

Fedorchenko, V.I., *Dvor rossiiskikh imperatorov*, Krasnoyarsk, 2004

Figes, Orlando, *Natasha's Dance: A Cultural History of Russia*, Allen Lane, London, 2002, 19–20

Forsyth, James, *A History of the Peoples of Siberia: Russia's North Asian Colony 1581–1990*, Cambridge, 1992

Glinka, G.V., ed., *Aziatskaya Rossiya*, St Petersburg, 1914

Grozdetsky, N.A., *Soviet Geographical Exploration and Discoveries*, Moscow, 1974

Gryaznov, Mikhail P., *South Siberia*, Ancient Civilizations series, London, 1969

Hartley, Janet M., *Siberia: A History of the People*, Yale, London & New Haven, 2014

Howe, G. Melvyn, *The Soviet Union: A Geographical Study*, London, 1968, rev. edn 1983

Hudson, Hugh D. Jnr, *The Rise of the Demidov Family and the Russian Iron Industry in the 18th century*, Oriental Research Partners, 1986

Ivanov, Alexei V., *et al.*, 'Jom-Bolok Holocene volcanic field…', *Bulletin of Vulcanology*, Nov. 2011, Vol. 73, 9, 1279–94

Jacquemoud, Clement, *The Altaians. A Turkic people from the Mountains of Siberia*, Musée Barbier-Mueller, Geneva, 2015

Kalesnik, S.V., ed., *Rossiiskaya Federatsiya: Ural*, Sovetskii Soyuz series, Moscow, 1969

— *Rossiiskaya Federatsiya: Kazakhstan*, Sovetskii Soyuz series, Moscow, 1970

— *Rossiiskaya Federatsiya: Zapadnaya Sibir*, Moscow, 1971

www.krasplace.ru/zolotopromyshlennost-enisejskoj-gubernii ('Gold-mining industry of Yenisei gubernia'), 2015

Levshin, Alexei, *Opisanie Kirgiz-kaisatskikh ord I stepei: Chast 3*, Moscow, 2011

Lincoln, W. Bruce, *Petr P. Semenov-Tian-Shanskii: The Life of a Russian Geographer*, Newtonville, 1980, 120

— *The Conquest of a Continent: Siberia and the Russians*, Ithaca & London, 1994

Maack, Richard, *Puteshestvie na Amur…, v 1855 godu*, Siberian Dept. of the Imperial Russian Geographical Society, St Petersburg, 1859

Mironenko, S.V., *Dekabristy. Biograficheskii spravochnik*, Moscow, 1988

Murchison, R.I., *The Geology of Russia in Europe and the Ural Mountains*, London, 1845

Olcott, Martha Brill, *The Kazakhs*, 2nd edn, 1995

Pamyatniki Sibiri. Zapadnaya Sibir i Krasnoyarskii Krai, Moscow, 1974

Pertseva, T.A., *Irkutsk v panorame vekov: ocherki istorii goroda*, Irkutsk, 2003

Reid, Anna, *The Shaman's Coat: A Native History of Siberia*, London, 2002

Rezun, D., ed., *Kratkaya entsiklopediya po istorii kupechestva i kommertsii Sibiri*, 4 vols, Novosibirsk, 1999, Vol. 3, 160

Robinson, Philip, *Postmarks & Postal History of the Russian Empire Period*, 2nd edn, 1990

Russkii Biograraficheskii Slovar'

Samarin, Iuri Fedorovich, preface to *The Correspondence of Iuri Samarin and Baroness von Rahden (1861–76)*, trans. of 2nd edn, Ontario, 1974

Seaman, W.A.L., & Sewell, J.R., *Russian Journal of Lady Londonderry 1836–37*, History Book Club, 1973

Seaton, Albert, *The Crimean War: A Russian Chronicle*, HarperCollins, London, 1977

Schreiber, Dagmar, *Kazakhstan: Nomadic Routes from Caspian to Altai*, Hong Kong, 2008

Semenov, Petr Petrovich, ed. Thomas, Colin, *Travels in the Tian' Shan' 1856–1857*, Hakluyt Society, London, 1998

Sheremetev, Count Sergei, *Graf Mikhail Mikhailovich Muraviov i ego doch*, St Petersburg, 8 April 1892

Shmidt, S.O., ed., *Katalog lichnykh arkhivnykh fondov. Otechestvennykh istorikov, Vyp. 3: Vtoroi pol. XIX-nachalo XX v. Ch. 1: A-B*. Moscow, 2012, 879

Shteingeil', V. I., *Sochineniia i pis'ma*, Tom 1. Zapiski i pis'ma. Irkutsk, 1965, 490. A Decembrist's memoirs and Siberian exile after 1825

Shumyatsky, B.Z., ed., *Sibirskaya Entsiklopediya,*Vol. 1, 1929 *et seq.*

Sutherland, Christine, *The Princess of Siberia*, London, 1985

Tochenov,V.V., ed., *Atlas SSSR*, 1983

Ulam, Adam B., *Russia's Failed Revolutions*, New York, 1981

Vasilyev, D., *Rossiya i Kazakhskaia step: administrativnaya politika i status okrainy. XVIII-pervaya polovina XIX veka*, Moscow, 2014. Russian legal system and Kazakhs, military occupation, Russian and Kazakh leaders in 1800, maps, etc.

Volkova, N.S., *Anglichane v Sibiri*, trans. as *The English in Siberia. Adventures and Anecdotes: Thomas Witlam Atkinson and Mrs Lucy Atkinson*, Barnaul, 2012

Warnes, David, *Chronicle of the Russian Tsars*, London, 1999

Wheeler, G.E., *The Modern History of Soviet Central Asia*, London, 1964

White, Andrew Dickson, *Autobiography of Andrew Dickson White*, New York, 1906

Wilton, Andrew, & Barringer, Tim, *America Sublime: Landscape painting in the United States 1820–1880*, 2002

Yale Dictionary of Art and Artists, 2000

Znamenitie Rossiyane XVIII–XIX vekov. Biografii i portreti, Po izdaniyu velikogo knyazya Nikolaya Mikhailovicha, *Russkie portreti XVIII i XIX stoletii*, St Petersburg, 1996

Newspapers and journals

The Art-Journal, 1858; 1860, 346–7

The Athenaeum, 28 Nov. 1857; 28 July 1860, 117–19

Blackett, 25 Sept. 1860

Hawaiian Star, 30 April 1906

Leeds Mercury, 14 Sept. 1861

London Gazette (now *The Gazette*)

London Review, 1 Jan. 1861,Vol. 15, Issue 30, 439

Manchester Free Gazette, n.d. (Manchester Central Library)

New York Daily Tribune, 4 June 1858, 3

Obshchestvennye Zapiski of Irkutsk, Aug. 1860, 39–44

The Quarterly Review, 7 Jan. 1861,Vol. 110, Issue 219, 179

The Saturday Review, 13 Feb. 1858, 167–8. See also Bell's *Life in London and Sporting Chronicle*, 13 Dec. 1857

The Siberian Times

The Times, 8 Jan. 1858

Background reading

Atkinson, John Augustus, *A Picturesque Representation of the Manners, Customs, and Amusements of the Russians*, London, 1803–04

Beeson, Nora, ed., *Traveling Across North America 1812–1813. Watercolors by the Russian Diplomat Pavel Svinin*, New York & St Petersburg, 1992, 192. Biographical comments by Beeson

Christie, Ian R., *The Benthams in Russia 1780–1791*, Oxford & Providence, NJ, 1993

Cochrane, *Narrative of a Pedestrian Journey through Russia and Siberian Tartary, to the Frontiers of China to the Frozen Sea and Kamtchatka*, 2 vols, London, 1824

Cross, Anthony, *St Petersburg and the British: The City through the Eyes of British Visitors and Residents*, London, 2008

Heather, Roderick, *An Accidental Relationship; Stories of the British in Tsarist Russia*, London, 2008

Hill, S.S., *Travels in Siberia*, London, 1854

Hopkirk, Peter, *The Great Game: On Secret Service in High Asia*, 1990

Kobyalitsky, I.A., & Solomenko, V.P., *Vostochnye Sayany*, 1947

Krausse, Alexis, *Russia In Asia. A Record and a Study 1558–1899*, London & New York, 1899

Laumulin, Chokan & Murat, *The Kazakhs: Children of the Steppe*, Folkestone, 2009

Le Page, Virginia, *Shambhala: The Fascinating Truth behind the Myth of Shangri-La*, Quest Books, USA

Maier, F., *Trekking in Russia and Central Asia: A Traveler's Guide*, Seattle, 1994

Massey Stewart, John, 'Baikal's hidden depths', *New Scientist*, 1990, No. 1722

McCoy, Rebecca (publ. anonymously), *The Englishwoman in Russia...*, London, 1855

Nerhood, Harry E.W., *To Russia and Return*, Ohio, 1968

Okladnikov, A.P., ed., *Istoriya Sibirii*, Leningrad, 1968, 3 vols

Pitcher, Harvey, *When Miss Emmie was in Russia: English governesses before, during and after the October Revolution*, London, 1977

Ravenstein, E.G., *The Russians on the Amur: Its Discovery, Conquest and Colonisation...*, London, 1861

Speake, Jennifer, ed., *Literature of Travel and Exploration,* 3 vols, 2003

Stejneger, Leonhard, *Georg Wilhelm Steller: The Pioneer of Alaskan Natural History*, Cambridge, MA, 1936

Tallmadge, J., 'From Chronicle to Quest: The Shaping of Darwin's "Voyage of the Beagle"', *Victorian Studies* 23, 325–45

Teissier, Beatrice, ed., *Into the Kazakh Steppe. John Castle's Mission to Khan Abulkhair*, Oxford, 2014, 10. First English translation of appendage to *Materialen zu der Russischen Geschichte seit dem Tode Kaisers Peter der Grossen*, II, Riga, 1784

— *Russian Frontiers: Eighteenth-century British Travellers in the Caspian, Caucasus and Central Asia*, Oxford, 2011

Wardell, J.W., *In the Kirghiz Steppes*, London, Galley Press, 1961

Wight, Robert, *Vanished Khans and Empty Steppes: A History of Kazakhstan From Pre-History to Post-Independence*, Hemel Hempstead, 2014

Williams, Stephanie, *Olga's Story* (re Kyakhta), London, 2015, pb 2016

Glossary

aul nomadic camp consisting of yurts

balagan a simple shelter of poles, birch bark and branches, open on three sides but nonetheless protecting from rain

banya traditional steam bathhouse

baran ram

baranta/barymta punitive Kazakh raid launched against the aul of a clan rival primarily to seize livestock

buran/bouran a fierce snowstorm

chimbar wide Kazakh trousers

kalat/khalat traditional robe

katorga hard labour

koumiss/kumis/kumys fermented mare's milk

kibitka covered wagon

pavoska/povozka unsprung carriage or post-chaise

perekladnoi changing carriages or horses or both at post-stations

pood old Russian unit of weight, approximately 16.38 kg

priisk mine, quarry or open works for precious metals

pristan landing-stage, wharf, jetty

Réaumur scale, named after René Antoine Ferchault de Réaumur, who first proposed a similar scale in 1730 (°Ré = °C × 4/5 = ([°F] − 32) × 4/9)

sarafan a Russian woman peasant's sleeveless dress

shuba heavy, long fur coat

ssylka banishment, exile, sometimes for life

tarantas springless carriage, sometimes hooded, can be of wickerwork

Tatars Turkic-speaking Sunni Muslim people in three main groups: Volga, Siberia and Crimea

telegas big four-wheeled cart or wagon for carrying objects rather than people

troika any type of cart or carriage pulled by three horses abreast

verst archaic measure equalling approximately one kilometre (1.06 km)

voilok camel-hair felt cloth

vozok a closed sleigh, essentially a long, windowed box mounted on a sledge

yamshchik coachman

yurt a portable dwelling used by nomadic and semi-nomadic people including the Kazakhs and Altaians, with a felt-covered circular wooden frame easily assembled and dismantled

zavod plant, factory, works

NOTE: captions in quotation marks use Thomas's original spelling.

Acknowledgements

VERY SPECIAL ACKNOWLEDGEMENTS to Paul Dahlquist (great-great-grandson of Thomas and Lucy), who very kindly lent me Thomas's unpublished journals of his Russian travels, and to his wife Charlene who was good enough to type out some of his correspondence for me and photocopy the rest.

My particular thanks too to the Atkinsons' other descendants in the UK, the USA and New Zealand, who have been most helpful: the late Marjorie Whitehead (who visited Alatau twice in Hawaii), her daughter Belinda Brown, Belinda's husband Peter and son William, Paul Dahlquist's sister Molly Fay in the US and especially the ever-helpful Pippa Smith in the UK, while her sister, Rose Whitehead, in New Zealand, kindly had the only known image of Thomas specially photographed for me. (Alas, there is no photograph of Lucy.) I also want to add Marianne Simpson in Australia, descendant of Lucy's brother William York Finley, who has researched assiduously into that line and Alatau's life and written (February 2017) the authoritative but as yet unpublished 37-page text 'To a Higher Destiny: Alatau Tamchiboulac Atkinson (1848–1906)'.

I am also most grateful to Maria Bardina, *née* Markova, of St Petersburg, who did valuable research for me in that city (resulting in her diploma on the subject), and her parents Vladimir and Irina for their help and warm hospitality.

I owe special thanks, too, to a long line across many years of part-time secretaries-cum PAs: Ashley Cockrill, Jane Gowman, Louise Hooley, Julia Hughes, Maria Lenn, Dafne Ter-Sakarian and above all Maria Bogomolova for her intelligence, dedication and loyalty for so long and her understanding of her own country. This book could not have been written without her.

Grateful thanks also to the following:

Russia. *St Petersburg* The State Hermitage Museum's deputy director Prof. G. V. Vilinbakhov and its curators Elizaveta Renne and Galina Printseva; Galina Vasilyeva, Museum of the History of St Petersburg; the Central State Archive of St Petersburg; the State Russian Museum; the State Historical Archive; the Russian Geographical Society; the late Prof. Nikolai Vereshchagin and family; Zoya Belyakova, writer of history. *Moscow* Lenin Library; Galina Andreyeva, Tretyakov Gallery; Dr Dmitry Fedosov; Dr Elena Gagarina, now Director, Kremlin Museums, formerly Pushkin Museum of Fine Art; Ekaterina Popova; Dr Dmitry Shvidkovsky; Dr Leonid Sitnikov; Prof. Sergei Gorshkov for his friendship and

hospitality across many years. *Ekaterinburg* Boris Petrov; Dr Vladimir Shkerin; Sergei Shumilo. *Irkutsk* Sergei Arzhannikov, Institute of the Earth's Crust; Irkutsk State University, Rare Books Department; Jennie Sutton. *Ulan-Ude* Dr Sergei Shapkhayev; Dr A.V. Tivanenko; Gennadiy Yefirkin. *Krasnoyarsk* Krasnoyarsk Krai Museum of Local Lore, History and Economy.

United Kingdom. The British Museum, Print Room; the Tate Gallery; the Victoria and Albert Museum; the Courtauld Institute of Art; the Fitzwilliam Museum, Cambridge; Christie's; Colnaghi's; Sphinx Fine Art; the Geological Society; the Linnean Society; the Royal Academy; the Royal Geographical Society, particularly Alasdair MacLeod, and Eugene Rae and Joy Wheeler of the Library; the Royal Institute of British Architects; the Royal Society; the Royal Society of Asian Affairs; the Society of Antiquaries; the Society of Genealogists; Leeds Russian Archive (Richard Davies), Brotherton Library, University of Leeds; Harris Museum and Art Gallery, Preston; Dr Williams's Library (Library of Protestant Dissent); National Archives, formerly Public Records Office; the School of Slavonic and East European Studies; the Society of Authors (Kate Pool); the Bodleian Library, Oxford; Cambridge University Library and Wren Library, Trinity College; the British Library, particularly Christine Thomas; the Family Record Centre, Guildhall Library; the International Genealogical Index; the London Library, particularly Yvette Dickerson and Guy Penman. *Public Libraries* Westminster Reference Library. *Local History Libraries* Ashton-under-Lyne, Barnsley, Bradford, Leeds, Sheffield. *Local Studies Libraries* Essex County Regional Office, Hammersmith, Kensington, Stalybridge, Tameside, Walmer, Westminster & Chelsea; William Salt Library, Stafford. *Manchester* David Taylor and colleagues, Manchester Central Library; Arnold Hyde, compiler of biographical files, Manchester Art Gallery; the Victorian Society, particularly Mark Watson, Neil Darlington for his expertise and Warren Mitchell, one of the key figures who saved St Luke's, Cheetham Hill, from demolition and is now its unofficial custodian. *Yorkshire: Barnsley* Hugh Polehampton and his colleagues, particularly Sally Hayles. *Cawthorne* Cannon Hall Museum, Cawthorne Village Museum, Barry Jackson, local historian. *Stalybridge* Astley Cheetham Art Collection (Tameside, Metropolitan Borough Council).

Greece. Museum of the City of Athens. **New Zealand.** Vivian Mantel-French; Dr Peter Russell. **Norway.** Anka Ryall, The Arctic University of Norway. **Poland.** Dr Agnieszka Halemba, Institute of Ethnology and Cultural Anthropology, University of Warsaw. **USA.** Bishop Library, Hawaii; Cornell University; Library of Congress, Washington, DC; New York Public Library.

Individuals. I thank the following for their help in many different ways: John Archer, Stockport; Megan Bick; Martin Bonham-Carter; Ben Carey; Rev. Bob Coles, St Mary's, Minster in Thanet, Kent; David Collins; Emeritus Prof. Anthony Cross; Maya Donelan; Prof. Paul Dukes; Françoise Durrance; Rosanna Eadie;

Nick Fielding; Simon Francis; Prof. Simon Franklin; John Gash; Adrian and Shena Gobelman; Adrian Goodman; Edmund and Jane Gordon; the late John Gordon; Keith Hill; Susanna Hoe; the late Ken Horne, Churchwarden, St Mary's, Walmer, Kent; Andrew Horton; A.G. Lees; Marina Mitko; David Morton; Virginia Murray, then at John Murray, the publishers; Prof. Leonée Ormond and her son, Marcus Ormond; Prof. M.H. Port for kindly assessing Appendix I on architecture; Sergei Proskurin; Ken and Sally Richardson; Philip Robinson; Stuart Thompstone, University of Nottingham; Bill Thomson; Geoff Welch, RSPB; Suzanne Zack, Fine Art Consultant, for kindly assessing Appendix II on art.

Prof. Janet Hartley and Dr Natalia Murray for their much-appreciated comments on the jacket and for the latter's contribution to Appendix II.

To Unicorn, my publishers: my thanks to Ian Strathcarron, chairman, for having faith in this book, to Elisabeth Ingles, editor, for her skill, experience and endless patience, and to Felicity Price-Smith, designer, for her artistry.

Lastly, my family: my sister-in-law, Anthea Dutot, who read through and gave advice on the unabridged manuscript, my late mother, late sister Margaret and brother-in-law, Reg Bliss; my son Hamon for his useful research, son-in-law Karl Grupe for his excellent support, photography and so much driving, and especially his wife, my daughter Julia, who made a crucial and time-absorbing contribution on the illustrations: photography, digitisation, and other skills. Finally, my late wife Penelope for her forbearance and lasting encouragement and support.

My apologies to any whose names have inadvertently been omitted after a long period of gestation. I would be glad to include them if there is any later edition.

Index

Illustration references are in italic

Abakan River 191–193, 201
Abakumov, Captain 125, 128, 132–133, 140, 141, 157, 158
Adlerberg, Count Vladimir Fedorovich 235
Aktau 156, 165, 169, 185
Alakol (Ala Kul) Lake 171, 172, 173, 175–176, 180
Alatau Mountains 115, 116–117, 147, 185
Alexander I, Tsar 36, 190
Alexander II, Tsar: dedicatee of TWA's book 55, 224; gives rings to TWA 242, 254, 264, 278, *279*, 295; influenced by Grand Duchess Elena Pavlovna 236; recipient of TWA's book 247; shown TWA's pictures 236–237, 295
Alibert, Jean-Pierre 206–208, 276, 294, 312–313n39
All Saints Church, Cawthorne 281, 282
Altai 68, 72–74, 76–77, 292. *See also* Barnaul
Altai Lady 74
Altai Mountains 72–73, 80–99, 147, 200–201, 227–228, 276
Altin-Kul (Lake Teletskoye) 84–90, 131–132, 189, 197, 202, 276
America 238, 242
Amur 224–225, 249, 250–251, 260–261, 276–277
Andreeva, Dr Galina 296
Andrei Ivanovich, Dr 120, 130–131
Angara River 194, 196, 201, 216
Anglo-Russian relations: anglophilia of Russian rulers 21, 22, 26; 'Great Game' 101–102, 224, 233, 251
Anna Pavlovna 135, 136
Anna Petrovna 44
Anosov, General Pavel Petrovich 51, 59, 76, 78
Anosov, Madame 76, 77–78
Arasan spring 147, 148, 157–158, 278
archaeological sites 74, 151, 156–157
architecture 12–13, 258, 275, *280*, 281–289, 292
Arrowsmith, John 248, 253
Ashburton, Francis Baring, 3rd Baron 250, 267
Ashton-under-Lyne 281, 282
Astashev, Ivan Dmitrievich 70, 71, 195–196
Astashev, Madame 195–196
Atkinson, Alatau Jr 273
Atkinson, Alatau Tamchiboulac: baptism 232; birth 120–121, 123–124; birthday celebrations 219, 230; daily care 123–124, 169–170; dangers to 173, 186; death 273; development 195; education 232, 259–260, 264, 265, 269, 271; engenders affection 138, 178–179, 187, 195–196, 201–202, 222, 230–231; family 271, *272*, 278; ill health 124–125, 148, 169, 186, 195, 201–202, 204; later life 271–273; love of animals 43–44, 162, 212; Lucy's will 271; name 120, 238; not included in TWA's books 251, 259; personality 212, 214, 273; photograph 253, *270*; in society 220; statue 278
Atkinson, Anne (sister of TWA) 10
Atkinson, Annie 271, 273
Atkinson, Charles 11, 281, 292
Atkinson, Ellen (sister of TWA) 10
Atkinson, Emma (daughter of TWA) 11, 61, 259
Atkinson Fund 259–260, 264, 265, 269
Atkinson, John William (son of TWA) 11, 13, *18*, 19, 259, 288
Atkinson, Lucy Sherrard Finley: birth of

Alatau 120–121, 123–124, 268–269; carries messages from exiles 61, 62, 66–67; death 271; early life 25–26; faith 25, 167; family 25–26, 269; as a governess 26, 241; health 113–114, 144, 169, 180, 186, 195; income 263–267, 268, 269–270; later life 271, 272–273; marriage 264, 266, 267, 294; not included in TWA's books 251, 259; personality 64, 79, *152*, 163, 268; popularity 275; portrayal *256*; pregnancy 120; *Recollections of Tartar Steppes and their Inhabitants* 224, 263, 265, 267–268, 295; relationship with Thomas 163, 182; robbery 218–219; skill at riding 80–81, 92, 118, 175–176, 214, 268; skill at sewing 124, 144, 180, 187; skill at shooting 80, 89, 115, 172; in society 68, 197, 250; speaks Russian 91, 112, 113; subject of painting *215*, *256*; supporters 264–265, 269–270; wedding 61

Atkinson, Martha (daughter of TWA) 11, 61, 259

Atkinson, Martha (mother of TWA) 10, 11

Atkinson, Rebekah 11, 61, 258–259, 260, 267, 271, 295

Atkinson, Robert 273

Atkinson, Thomas Witlam: on alcohol 105–106, 136–137, 138, 140–141, 247; appearance 177; bankruptcy 287; birth of Alatau 121, 131; childhood 7–11, 216, 275, 281, 292; death 255, 257–258, 289, 295; desire to travel 12, 22; diaries 27–28, 58, 137, 218, 232–233, 278, 291; dogs 29, 68–69, 126; exaggeration 258–259, 260–262, 295; flute-playing 84, 162; funding of journey 266, 305n6; hunting 117, 153, 211; ill health 42, 54, 97, 163, 218–219, 253–254, 262; interest in botany 90, 159; interest in geology 218; on Lucy 214, *215*, 227, 255; on Lucy and Alatau 156, 229, 250, 258, 259; marriage to Lucy 61, 264, 266, 294; marriage to Rebekah

Mercer 11, 258–259, 260, 262, 294, 295; personality 64, 165, 243–244, 257–258, 273, 294; photograph 253; popularity 242–243, 275, 291, 295; prison 287; public appearances 248, 249, 250, 252–253; publications *See Oriental and Western Siberia; Travels in the Regions of the Upper and Lower Amoor*; in reference works 275; relationship with Lucy 163, 178, 182; on Russian expansionism 105, 143; skill at shooting 115, 173; in society 30; style of painting 291–292, 296; sympathy 128, 130, 143; on technology 76, 206–208; waterfalls 197; will 258–259; working method 196, 197, 201, 232–233, 291, 295, 296

Atkinson, William (father of TWA) 10, 11, 252, 281, 301n8

Atkinson, Zoe 272, 273

Atkinson Volcano *209*, 210–211, 233, 277, 278

Austin, Charles Edward 24, 26–27, 29, 54, 57, 104, 224, 244–245, 302n11

Ayaguz 104–107, 131–132, 141, 185

Baddeley, J.F. 261

Balikty river 151, 156

Baratinsky, Irakli Abramovich 29, 64

Barnaul, West Siberia 74–79, 144, 186–187, 189, 227, 229–230, 295; first journey 53–54, 58, 77

Barnby Hall, Cawthorne *15*, 282

Basevi, George *280*, 281

Bashkir people 231

Basnin, mayor of Irkutsk 202, 220, 312n19

beekeeping 91

Bek, Sultan 173, *174*, 182

Belaya Gora (White Mountain) 48–49

Belgravia Square, London *280*

Bell, Dr John 70

Belukha (mountain) 73, 92, 94, 227–228, 276

Bentham, George 260

Bentham, Samuel 103–104, 260

Bestuzhev, Alexander 224

Bestuzhev family 224

Bestuzhev, Nikolai *198*, 224, 294–295

Biya Valley 79–84

Blackett, Henry 242, 247, 249, 250, 253

Blagodat 45–46

Bloomfield, John, Baron 235

Borovoye, Lake *52*

Boulania, Sultan 168

Bradley, J.W. publishers 242

Brighton Grove Villas, Rusholme 285, 286

British Association for the Advancement of
 Science 244, 248, 259–260

Buchanan, Andrew 22, 24, 25, 26, 302n7

Buddhism 73, 151, *213*, 214, 224

Burton, Richard 249

Buryat people 204, 208, 211–214, 218, 224

Cannon Hall *9*, 10, 11–12, 252, 253, 275,
 281

carbon monoxide poisoning 186

Castle, John 103

Catherine II, the Great 103–104

Cawthorne: All Saints Church 281, 282;
 Barnby Hall *15*; in the modern day 275;
 TWA & Lucy's family visit 278; TWA
 visits 252–253; TWA's childhood 7–11,
 281

Cayley, Edward 232

Cheetham, David *293*

Chernoistochinsk iron works 48

China/Chinese people: appearance 89,
 176, 177; Atkinson family visit 176–179;
 border with Russia 147, 172, 176, 180,
 206, 224–225, 251; hospitality 178;
 officials 177–180; trading with Russia
 132, *221*, 222; women 222

Christianity 138, 140, 151, 224

Christie's auctioneers, London 248, 295,
 296

Chuguchak 176–177, 178

Chusovaya river: subject of paintings 276,
 294, 296; travel *31*, 32, 36–41

circus, travelling 69

Clarendon, Lord (George Villiers) 233,
 238–239, 242, 247, 248, 249

Clayton, Alfred Bower 284–285

Cochrane, John Dundas 53

Colnaghi Gallery, London 242, 249, 295,
 296

Cossack-Kazakh relationship 102, 104, 108,
 112, 114. *See also* Kopal (Kapal)

Cossacks 32, 36, 53, 55, 79, 80, 91, 277;
 approach to personal property 91;
 characteristics 125; service to the Tsar 96,
 102, 194. *See also* Kopal (Kapal); Yermak

Crimean War 233, 235

Cross, Prof. Anthony 268

Darwin, Charles 262

Davydov, Vasili Lvovich 189

Davydova, Alexandra Ivanovna 189

Decembrists: Decembrist uprising 22;
 communication with Charles Dickens
 244; family of General Muravyov 26, 66;
 houses now museums 276; in Irkutsk
 197–199; in Krasnoyarsk 189–190;
 portraits 294–295; possibility of amnesty
 219; relationship with Atkinson family
 230; in Selenginsk 224; subject of
 publication 253, 268; in Yalutorovsk
 66–67. *See also* Muravyov family

de Grey and Ripon, Earl (George
 Robinson) 249–250, 264

Demidov, Akinfiy 33

Demidov, Anatoliy 48

Demidov, Nikita 32–33

Demidov, Nikita Akinfeyevich 41

Demidov, Prokofiy 33

Demidov works 32–33, 40–41, 48–49, 276

Dickens, Charles 244, 278

Dimsdale, Dr Thomas 12, 301n14, 309n1

disease 12, 124–125, 130–131, 140, 170, 201–202. *See also* healthcare

Dolgoruky, Prince P.E. 238, 250

Dostoevsky, Fyodor 99

Dzhungarian Alatau 147, *149*, *184*

Dzhungarian Gates 172

Eagle Mountains 94

East Sayan *203*, 204, 206, 208–211

Ekaterinburg 29–31, 33, 34, 65, 230

Elena Pavlovna, Grand Duchess (Princess Charlotte of Württemberg) 233–236, *234*, 238

engravings 242, 268, 291, 295, 296

escorts: Adiyol 126; Alexei 89–90, 92, 95, 96, 107; Columbus 170–171, 172, 175, 176, 177, 180, 182, 185; Falstaff 173, 176, 185; George 173, 177, 178, 185; Mikhail 99; Pavel 107, 158; Pyotr (Peter) 107, 111, 112, 117; Yepta 227

Ethnological Society of London 248

Euler, Leonard 233

Euler, Miss 233, 235

Everest, Colonel George 247

exhibitions: Colnaghi Gallery 242, 295; modern exhibitions 275; Nicholas I's recommendation 235; at public appearances 249, 250; Royal Academy 282, 288, 292, 293; Royal Manchester Institute 13, 282, 283–284, 287, 289; of Russian items 239, 249

Eyre and Spottiswoode publishers 244

Fahlenberg, Peter 190–191, 193

Fairbairn, William 260

Finley, Lucy Sherrard. *See* Atkinson, Lucy Sherrard Finley

Finley, Matthew 25, 271

flooding 211–212

Fort Street School 272

Galton, Francis 247, 258, 260, 264

Gebler, Dr F.V. 58

Geographical Society. *See* Royal Geographical Society

Geological Society 244, 250

Germany 13, *17*, *18*, 242, 288, 292

Gerngross, Colonel Andrei Rodionovich 54, 97, 140

Giovanetti, Zoe 272

Gladstone, William Ewart 252

Glinka, General Vladimir Andreevich 34, 65, 230

gold mining 70, 76, 78, 193, 194

Goloustnoye 216, 313n63

Gooch, Thomas 259

Goodwin, Francis 281

Gorchakov, Prince Pyotr Dmitrievich 68, 99, 102, 131, 132, 141, 142, 145, 154, 185, 296

Gothic Ornaments selected from the different Cathedrals and Churches in England (Thomas & Charles Atkinson) 281, 292

graphite mines 206–208, 276, 312–312n39

Great Narym 55

Gregan, John Edgar 287, 288, 289

Gullet, John 238–239

Hampstead Society 249

Harding, James Duffield 247

Hardman, Sir William 268–269

Harper and Brothers publishers 242

Hawaii 271–273, 278, 296

Hawk Cottage, Old Brompton 241, 259, 260

healthcare: alcohol 140–141; for children 124–125, 163; doctor's care 54, 97; hot springs 148, 202, 204; lack of food 157, 159, 180, 182; typhus hospitals 130–131. *See also* disease

Hermitage, St Petersburg 21, 25, *38*, 96, 292, 294, 295

Hooker, Sir William 260

Hordes: history 101, 102–103, 172; in the modern day 277; religious leader 151

Hough Hill Priory, Stalybridge 282, *293*
Humble, Annie Elizabeth 271–272, 273
Humboldt, Alexander von 7, 15, 21, 233
hunting 76, 77, 117, 132–133, 153, 211
Hurst & Blackett publishers 242, 249, 250, 259

ibe (wind) 171–172
Imperial Russian Geographical Society 21, 232
India 101–102, 233, 243, 249, 251, 257
industry, state controlled. *See* gold mining; graphite mines; iron-working; silver mines
Irbit Fair 49, 75, 230, 231
Irkut rivers 204, *205*, 206
Irkutsk, Eastern Siberia 53, 189, 196–197, 199, 200, *205*, 218, 219–220, 276, 295
iron-working 32–34, 36–37, 39, 40, 41–43, 45, 48–49, 50–51, 76–77, 231
Irtysh River 54, 55, 73, 101, 102, 103
Irvin, J.G. 287
Islam 151, 176, 308n90
Ivan the Terrible 28, 32
Izmailov, Ivan Ivanovich 125, 140, 144–145
Izmailov, Madame 135

Jenkinson, Anthony 103
Jom-Bolok river 208–211
Journey on the Amur (Maack) 261–262

Kachkanar 42–43, 44–45
Kainsk 68–69
Kalmyk people 73–74, 80, 84–85, 89–90, 306n29, 307n56; customs 82–83; sacred places 147, 148, 151, 156
Kamchatka 21, 94, 201
Karatal river 148
Katun River 73, 94, 131, 227, 229
Kazakh people: attitude to women 162–163, 175–176, 182, 184, 185; characteristics 106, 152–153, *181*, 204; customs 159, 163, 171, *174*, 185; eviction

of Kazakh people 53, 102; hospitality 106–107; Kazakh-Cossack relations 104, 108, 111, 112, 114; lectures by TWA 248; music *181*; nomadism 110, 168; oppression 105, 141–143, 277; pastoral lifestyle 152, 163–164; prisoners 220; religious beliefs 151, 171; subject of sketches 182, 183; uprising 277
Kazakh Steppe 68, 91, 99, 101–121, *103*, 141–143, 185, 251, 277–278
Kazan 28–29, 64
Keil, Colonel 79–80
Kendall, H.E. *280*, 281
Kenisary Kasim 102–103
Kersal Moor Observatory, Salford (design) *294*
Khara-Noor lake 211
Kholzun mountain range 90
Kimberley, 1st Earl of (John Wodehouse) 238
Kingsley, Rev. Charles 247
Kirgiz people. *See* Kazakh people
Kirgiz steppe. *See* Kazakh Steppe
Klyuchevskaya Sopka 94
Kokshinska (now Kokshi) 92, 227
Kopal (Kapal) 91, 102, 105, 106, 114, 115, 117–121, 123–145, 147, 154, 157, 170, 251, 277, 278, 296
Kora River 131, 152, 154
Krasnoyarsk, Eastern Siberia 189, 193, 197, 296
Kungur 29
Kushvinsk (later Kushva) 42, 45
Kyakhta 220, *221*, 222, 224

Lake Baikal 204, 214–218, 220, 222, 238, 276; hot springs 202, 204; map *196*
Lake Balkhash 148, 154, 158, 164, 171
Lake Ikeogun *213*
Lake Kolyvan 77–78, 96–97, *98*, 292
Lake Teletskoye. *See* Altin-Kul (Lake Teletskoye)

lectures given by TWA 247, 248, 249, 252–253, 295

Leeds 248

Lepsy River 116, 168–169

Lilly Terrace, Hammersmith 260

Liprandi, Ivan Petrovich 238

Lister, Thomas Villiers 247

Listvenichnoye (now Listvyanka) 216, 218

lithographs 148–150, 213, 242, 281, 292, 295, 296

Livingstone, David 247

Loginov, officer 118, 125, 133

Longman publishers 253

lost pictures 148, 184, 242, 278, 291, 295, 296

Lütke, Admiral Friedrich 21, 233

Maack, Richard 261–262

Mahomed, chief *152*

Maimachen (later Altanbulag) 222

Manchester 13, 275, 283–287

Manchester & Liverpool District Bank branches *283, 285*

Mantel-French, Vivian 296

Mercer, Rebekah. *See* Atkinson, Rebekah

Meredith, George 269

Michael, Grand Duke 233

Middendorff, Alexander von 242

Milnes, Richard Monckton 260, 268

Minusinsk 190, 192–193

Mongolia/Mongols 204, 211, 220, *221*, 222, 262

Moscow 27, 58–59, 61, 264, 296

mosquitoes 94, 95, 169, 176, 214

Motygino 194, 195

Mount Botogol 206–208

Mrassa River 78–79

Munku Sardyk mountain 206

Muravyov, Alexander 26

Muravyov, General Mikhail Nikolaevich 26, 66, 189, 232, 269

Muravyov, Sergei 303n17

Muravyov-Amursky, Count Nikolai 189–190, 195, 196, 201, 220, *223*, 224–225, 276, 277

Muravyov-Apostol, Matvei Ivanovich 66–67

Muravyova, Madame 189, 197

Muravyova, Sofia 26, 59, 61, 219, 232, 269

Murchison, Roderick 41–42, 44, 48, 50, *155*, 242, 243, *246*, 259–260, 264, 265, 266, 268, 269–270, 271

Murray, Admiral H.T. 249

Murray, John 189, 249, 260, *263*, 264, 265, 267, 268

navigation problems 113, 173

Nerchinsk 53, 199, 201

Nesselrode, Count Karl 22, 24–25, 102, 117–118, 185

Neva River 21, 227

Nevyansk 32, 49, *50*

Nicholas I, Tsar 7, 15, 21, 22, 24–25, 200–201, 232, *234*, 292, 294; anniversary 219; on Atkinson paintings 235; curiosity of villagers 93; death 235; pictures from TWA *38*; tribute paid by Kalmyks 96

Nizhny Novgorod 28, 36, 62–64

Nizhny Tagilsk 48, 276

Nizhnyaya Tura works 42

Nor-Zaisan Lake 55, 57, *244*

Nouk-a-Daban, Eastern Siberia *203*, 206, 214

Ob River 72, 74, 77, 79, 99, 227

Observatory at Kersal Moor, Salford (design) *294*

Oka river *203*, 206, 208, 211–212, 214

Okinskoi Karaul 208

Okzhetpes *52*

Omsk 68, 102, 145, 154, 220

opium 132, 133

Oriental and Western Siberia 242, *245*, 251, 261, 275, 291, 295, 296

Padalka, Vasily Kirillovich and Elizabeth 193
paint. *See* Winsor and Newton paint
Palmerston, Henry Temple, 3rd Viscount
 26–27, 238–239, 242, 247, 252, 260, 262,
 265–266, 268
pastoral lifestyle 152
Paul I, Tsar 102
Pazyryk valley burials 74
Perkins, R.C.L. 273
Perm 29, 36
permissions to travel 25, 27, 62, 68, 177,
 178, 185, 189, 200–201, 232, 276, 292; for
 exiles 224
Perovsky, Lev Alekseevich 24, 302n10
Peskino, Eastern Siberia 195
Peter I, the Great 21, 32, 33, 36, 70, 102,
 306n36
Phelps, Richard 49
Pim, Captain 249
plagiarism, accusations of 261–262
Portland House, Ashton-under-Lyne 283
provenance problems 296

Raby Castle, Yorkshire 295
Rahden, Baroness Edith von 233, 236,
 237–238
Rawlinson, Henry 265
*Recollections of Tartar Steppes and their
 Inhabitants* (Lucy Atkinson) 267–268,
 275, 295
Reid, William Jameson 262
religious beliefs 94, 140, 147, 151, 156–157,
 161, 163, 171, 176, 224; baptism of Alatau
 232; burial sites 156–157; of the Buryat
 people 212, 213, 214; house spirits 200;
 prayers for safety 193–194; relics 243;
 sacred places 73, 213, 227
reviews of TWA's work 242, 243, 251–252,
 292, 296; of LA's publication 268
Reynolds-Moreton, George, 3rd Earl of
 Ducie 250
Rikord, Admiral Peter 21, 302n2

Robinson, Benjamin Coulson, Hannah &
 Maria 271
Robinson, George, Earl de Grey and
 Ripon 249–250, 264
Roërich, Nikolai and Elena 73
Royal Academy 282, 292, *293*
Royal Geographical Society 242, 243–244,
 246, 247, 250, 252, 260, 264–265, 267,
 268, 271, 278, 291, 295
Royal Literary Fund 263–265
Royal Manchester Institute 13, 282–287
Royal Society 244, 248, 249, 273
Russia 276–277; Anglo-Russian relations
 101–102, 224, 233, 235p, 243, 249;
 anglophilia of Russian rulers 21, 22,
 26; artists/development of art 291–292;
 characteristics 64, 191; concerns over
 travelling 185; customs 75, 93, 96,
 123–124, 200; education 75, 99, 190, 231;
 expansionism 101–102, 105, 141–143,
 248, 251, 257, 277; love for children 191;
 low rate of violent crime 219; men and
 women 231; restriction of movement 96

Sabine, General Sir Edward 265
Saidyp 80, 90–91
St Alban's College 272
St Barnabas, Openshaw 286
St George's Church, Barnsley 11, 281
St George's Church, Ramsgate 281
St Luke's Church, Manchester *274*, 275,
 286, *286*, 287
St Margaret of Antioch, Bowers Gifford
 281
St Mary's Church, Cawthorne 9, 12, *13*,
 278
St Mary's Church, Manchester 287
St Mary the Virgin, Minster, Thanet *14*, 285
St Michael's and All Angels, Ashton-under-
 Lyne 281
St Nicholas, Lower Tooting 282, *293*
St Nikolaikirche, Hamburg *16*, *17*, 288

St Peter's Church, Manchester 13, 281

St Petersburg: TWA's first journey 21, 27, 292, 294; Lucy and Sofia leave 59, 61; TWA's second journey 201; Atkinson family settle 231, 232–238, 295; gold mining. *See also* Hermitage, St Petersburg, Palace Square *23*

St Thomas's Church, Stockport 281

sale of pictures 249, 250, 259, 295, 296

Salemerskoi, Mr 49–50, 231

salt marsh 110–111

Samoyed people 208

Sampson, Thomas Weatherall and Sarah 271

Sarkand river 158, 159–160

Saryesk-Atyrau desert 168–169

Savile, John Lumley 232

Scott, George Gilbert *17*, 288

Scythians 74, 156–157

Selenginsk (Novoselenginsk) 224

Semyonov, Pyotr Petrovich 75, 116

Semipalatinsk (now Semei) 99, 102

Semirechye region ('seven rivers') 117, 148, 173, 277

Seymour, Sir Hamilton 233

Shaitansk 40

Shambhala 73

Sheremetev family 238

Sheremetyeva, Pelageya Vasilyevna 26

Sherrard, Joseph 254

Sherwood, John 190

Shilka river 224–225

Shushenskoye 190

Siberian pine 44, 304n41

silver mines 32, 53–54, 77, 95, 97

Sinitsyn, Madame 196, 200

Small Kalami [Kalmanka] River 194

Sokolovsky, Colonel 76–79, 80–81, 90, 186, 187, 230

Sokolovsky, Madame 77

Souk, Sultan 138, *139*, 141, 142–144, 148, 251

Speke, Captain John Hanning 249, 260

Spencer Stanhope, Charles *9*, 12, 252, 253, 254, 282, 301n9

Spencer Stanhope, Elizabeth 12

Spencer Stanhope, John *9*, 12, *15*, 252, 282

Spencer Stanhope, John Roddam 12p

Spencer Stanhope, Walter 11–12, 282, 284

Spottiswoode, William 244, 247, 248–249, 253, 264

stonework 9, 10, 11, 12, *13*, 275, 281, 292

Stroganov family 32, 33, 36, 41

Stroleman, Colonel 72, 78, 230

Stroleman, Madame 78, 230

Swire, John Samuel 283

Syssertsky iron-works 49–50, 231

Tamchiboulac spring 148, *150*

Tashtyp, Eastern Siberia 191

Tatar people: appearance 107, 178; interpreter 178; merchants 99, 151; sacred places 147; school 99; village 102–104

Tate, Peter 65, 66, 67

Techenskoi, Mr 140–141

Techinskaya, Madame 120–121, 123, 124, 125, 126, 135

Teric-sou valley *155*

Tiesenhausen, Vasily (Wilhelm Sigismund) von 231

Tolstoy, Count Alexander Nikolayevich 236–237

Tomsk 58, 59, 69–71, 76, 96, 189, 195

Travels in the Regions of the Upper and Lower Amoor 250–252, 260–261, 295, 296

Treaty of Nerchinsk (1689) 225

Treaty of Peking (1860) 225

Tretyakov Museum 296

Troitskosavsk 222

Trubetskaya, Princess 197, *198*, 199, 201–202

Trubetskoy, Prince Sergei 197, *198*

Turgan river 227

Unforgettable Russia Exhibition 296
Ural Mountains: geography/history 30–33,
 36; geology 21, 32, 37, 39–40; mining
 21, 33–34, 65, 276; permissions to travel
 22–23. *See also* Ekaterinburg
Urusov, Prince 28, 62, 64
Ust-Kamenogorsk 54
Utkinsk 36, 40
Uyghur people 176

Vasilyevsky Island, St Petersburg 232
Vassilievsky, Mr 195, 197
Verkhneudinsk 218–219
Victoria, Queen 24, 242, 247, 249, 252
Villiers, George, 4th Earl of Clarendon
 233, 238–239, 242, 247, 248, 249
Vladimirka 28, 276
Vladivostok 225, 276
volcanoes 94, *209*, 210–211, 233, 248, 278
Volga River 24, 28, 36, 64, 276
Volkonskaya, Princess Maria 195, 197–200
Volkonsky, Prince Sergei 197–200
Vronchin, Fyodor 22

Walmer, Kent 254, 257
water, lack of 107, 110–111, 113, 115,
 116–117, 173
waterfalls 92, *149*, 197, 218–219
Wentworth Woodhouse 253
Western Siberia 33, 53, 185
Westmorland, John Fane, 11th Earl 26–27
Wheeler, James 259, 260, 267
White, Andrew Dickson 238
Whitehead, Marjory 278
Winsor and Newton paint 22, 200, 235,
 292, 294
Winter Palace, St Petersburg 21, 23,
 235, 237
Witlam, Martha. *See* Atkinson, Martha
 (mother)
Wodehouse, John, 1st Earl of Kimberley
 238

women, attitude to: in China 222; England
 251; Kazakhs 144, 162–163, 182, 184;
 marriage 175–176, 200; Russians 200,
 230
Wrangel, Alexander Ludvigovich, Baron
 117–118, 124, 125, 126, 131, 133, 134–
 136, 137, 140, 144, 148, 154, 156, 157
Wylie, Sir James 190

Xinjiang 147, 172, 176

Yakushkin, Ivan Dmitrievich 26, 66
Yalutorovsk 66–67, 230–231
Yenisei River 189, 191, 193–194, 201
Yermak Timofeyevich 32, 36, 41
Yorke, Mary Anne and William 25

Zlatoust 50–51
Zmeinogorsk 54, 96–97, 99, 125, 185–186
Zyrianovsk, Kazakh Steppe 54–55, 94–95

Illustration Credits

Maps, pp.31, 73, 103, 196: created by Paul Hewitt, www.battlefield-design.co.uk. Modern names appear in brackets.

Front endpaper map and pp. 45, 50, 74, 119, 129, 139, 150, 152, 174, 181, 192, 217, 244, 245 from TWA O & WS (see p.301)

pp.100 'On the Desert', 108, 122 'Caravans on the Irtisch', 134, 142, 164, 184, 245, 256 'Lucy at Baikal', detail of similar but not identical engraving 'A Natural Arch of the Baikal' from TWA U & LA (see p.301)

Frontispiece, pp.153, 179, 183 Lucy Atkinson, *Recollections of Tartar Steppes* (see p.301)

p.4: Courtesy Rose Whitehead; p.6 'Imaginary Greek Landscape' by TWA, © Museum of the City of Athens, Vouros-Eutaxias Fdn, Athens; pp.8, 10, 13, 15, 199, 237, 245, 286 John Massey Stewart Picture Library; p.9 Barnsley Museums, Cannon Hall Museum Coll.; p.20 from 'Podvig 300-letnyago sluzheniia Rossii gosudarey doma Romanovykh', St. Petersburg, 1913, photo Julia Massey Stewart; p.16 Staatsarchiv, Senat der Freien und Hansestadt Hamburg; p.17 *Der Freischütz* newspaper; p.18 National Portrait Gallery/Christie's; p.19 by permission of Llyfrgell Cenedlaethol Cymru/National Library of Wales; p.23 Pushkin State Museum of Fine Arts, Moscow/ Bridgeman Art Library; p.35 by W. Timm, 1844; p.38 State Hermitage Museum, St Petersburg, photo A.V. Mozheiko, © State Hermitage Museum; p.46 by Vasnetsov, 1890, Archive PL/Alamy Stock Photo; back cover (detail), pp. 52, 86, 98, 149, 203, 209, 213, 215 private collections; p.63 from George Kennan, *Siberia and the Exile System*, London 1891; front cover (detail), back endpaper, pp.60, 88, 146, 155, 246 Royal Geographical Society; pp.188 (detail), 205 © Victoria & Albert Museum, London; p.198 all by N. Bestuzhev: M. & S. Volkonsky, State Historical Museum and Russian State Library, Moscow; Trubetskoy, Pushkin State Museum of Fine Arts, Moscow; *Self-portrait in Peter Prison*, State Historical Museum, Moscow; p.207 historical sketch by A.W. Faber, 1865; p.210 map by S.G. Arzhannikov et al., with minor modification, Elsevier; p.221 N. L. de Lespinasse, Götzfried Antique Maps, www.vintage-maps.com; p.223 State Art Museum, Irkutsk, photo JMS; p.228 photo Pavel Filatov; pp. 226 (detail), 234 State Hermitage Museum, St Petersburg, photo Leonard Kheifets, Alexander Koksharov, © State Hermitage Museum; p.240 Ordnance Survey, 1865 (?); p.241 R. B. of Kensington & Chelsea Local Studies & Archives; p.263 John Murray Archive, National Library of Scotland (MS 40028, ff.146–8); pp.270, 272 Courtesy Belinda Brown; p.274 Manchester Central Library; p.280 Illustrations of the Public Buildings of London, 1828, © Trustees of the British Museum; p.283 reproduced by kind permission of the Royal Bank of Scotland Group plc © 2018; p.285 reproduced by permission of the Trustees of the William Salt Library, Stafford; p.290 photo Karl Grupe; p.293 (top) Guildhall Art Gallery, City of London; p.293 (bottom) Astley Cheetham Art Collection, Tameside, Manchester B. C.; p.294 RIBA Image Library.

First published by Unicorn
an imprint of Unicorn Publishing Group LLP, 2018
5 Newburgh Street
London W1F 7RG

www.unicornpublishing.org

10 9 8 7 6 5 4 3 2

ISBN 978-1-911604-30-3

Design: Felicity Price-Smith and Vivian Head

Printed in India by Imprint Press

Front cover: 'Source of the Teric-sou, Chinese Tartary'
Back cover: 'View looking down upon the lake'
Front endpaper: This map illustrates T. W. Atkinson's routes across the seven years
1847-53, totalling nearly 40,000 miles through the Urals, Siberia and the Kirgiz steppe,
now Kazakhstan. It appeared in his first book *Oriental and Western Siberia,* London 1858,
which brought him fame as 'the Siberian traveller'.
Back endpaper: A dramatic episode in Atkinson's journal of September 1858 when
the two Atkinsons were lost at night in the vast and featureless Kirgiz (Kazakh) steppe.

at the Aoul on going into a Yourt and order-ing one to be prepared for us a Kirgis took up a Topor and threw it at his head he stooped down and it stuck fast in the door frame of the You

I instantly ordered that this man should be taken to Kopal and be there give over to the officer in command. He was immediately brought and a guard placed over him. We now sat down to our breakfast which we eat and then turned down for a sleep placing a Kirgis guard outside the Yourt.

Continued from Page 87.

Tuesday 14th September

These caused sad reflections as it might have been our case. we should then have been puts into the sund without any one knowing who or what we were

I cannot speak too highly of Lucys coura and endurance during twenty two hours on horseback frequently riding very fas in the day. and then riding through the nights across such a desert. here we might have been plundered and over powered had some of the Bands of Barantu know of our March. Our Arm were all kept in readyness and several would have bit the dust ere we had been taken. The part we rode over the night was a most singular place there must have been Thousands of th conical Mound frequently we crossed them and at other times rode round their bases. I should like much to see this place in the daylight still I ha